This is number two hundred and twenty-one in the
second numbered series of the
Miegunyah Volumes
made possible by the
Miegunyah Fund
established by bequests
under the wills of
Sir Russell and Lady Grimwade.

'Miegunyah' was Russell Grimwade's home
from 1911 to 1955
and Mab Grimwade's home
from 1911 to 1973.

Alan McCulloch's World of Art

LETTERS TO A CRITIC

Rodney James

THE MIEGUNYAH PRESS

THE MIEGUNYAH PRESS
An imprint of Melbourne University Publishing Limited
Level 1, 715 Swanston Street, Carlton, Victoria 3053, Australia
mup-contact@unimelb.edu.au
www.mup.com.au

First published 2023
Text © Rodney James, 2023
Design and typography © Melbourne University Publishing Limited, 2023

This book is copyright. Apart from any use permitted under the *Copyright Act 1968* and subsequent amendments, no part may be reproduced, stored in a retrieval system or transmitted by any means or process whatsoever without the prior written permission of the publishers.

Every attempt has been made to locate the copyright holders for material quoted in this book. Any person or organisation that may have been overlooked or misattributed may contact the publisher.

Cover design by Pfisterer + Freeman
Cover art: *Allan McCulloch* 1980, Andrew Sibley, National Portrait Gallery of Australia, © Andrew Sibley/Copyright Agency, 2023
Typeset in 11¼ pt Berthold Baskerville Book by Cannon Typesetting
Printed in China by 1010 Printing Asia Limited

 A catalogue record for this book is available from the National Library of Australia

9780522879872 (hardback)
9780522879889 (ebook)

CONTENTS

Introduction 1

1 Call to Arms 7
2 On the Road 34
3 The Critic Responds 54
4 Galvanising the Critics 80
5 Friends and Foes 105
6 Big Ideas 137
7 Exhibiting Australian Aboriginal Art 159
8 An Encyclopedia of Australian Art 178
9 Writing and Publishing 195
10 Home on the Range 208
11 The Australian Public Gallery Movement 238
12 The Later Years 264
13 Postscript: Writing Australian (Art) History 283

Notes 289
Bibliography 327
Further Reading 331
List of Illustrations 337
Acknowledgements 341
Index 345

INTRODUCTION

To repeat an old truth is to be merely academic; but to state an old truth in a new way *is to be creative.*

Alan McCulloch, 1959[1]

'FANTASTIC, I'LL SEE you in ten years' time.' Such was the response of Alan McCulloch's granddaughter, Emily McCulloch Childs, on learning that I had accepted the keenly anticipated but formidable task of writing on the Australian artist, critic, author and gallery director Alan McCulloch. My cheeky retort would return to haunt me: 'I'll see you in eighteen months.'

Alan McCulloch (1907–92) is best known as an art critic for the Melbourne *Herald*, a position he held for an unbroken period of thirty years between 1951 and 1981. Prior to that he was art critic for the *Argus* and editor of the revamped *Australasian Post*, followed by associate editor of *Meanjin Quarterly* and foundation president of the International Association of Art Critics (Australia). At the age of sixty-three, McCulloch founded the Mornington Peninsula Arts Centre (later Mornington Peninsula Regional Gallery) and became its longest-serving director. McCulloch was also a noted artist, illustrator and cartoonist, with three solo exhibitions to his credit (spread

over twenty years) and a host of books, journals and newspapers that bear his economical line drawings and sharp wit. He wrote two monographs on Australian art: *The Golden Age of Australian Painting: Impressionism and the Heidelberg School* (1969) and *Artists of the Australian Gold Rush* (1977), not to mention a small tome called the *Encyclopedia of Australian Art*, something that he (and his family) laboured over for no discernible financial reward for more than four decades.

Defining a life's work in a paragraph can never do it justice; however, what these few references make clear is that art was Alan McCulloch's vocation and an all-consuming passion. McCulloch maintained that drawing was his first love and so it was, but this love of drawing diversified and played out in a multitude of ways. There was his childhood appreciation of revered English pen-and-ink practitioners such as Charles Keene, his envy of the barbed by-lines of Australian Will Dyson and a fascination with the loaded line of political cartoonists such as George Grosz and those within the pages of Weimar Republic magazine *Simplicissimus*. To these influences add firsthand contact with American and European art and culture in the immediate post World War II period—in particular, artists that we associate with the School of Paris—as well as the emergence and championing of a new generation of modern Australian artists during the 1930s and 1940s. We can begin to appreciate how the fundamentals of making and appreciating art would inform and sustain so much of McCulloch's personality and philosophy.

Alan McCulloch witnessed some of the most turbulent events and periods recorded in human history and was a participant in many of the decisive (and often divisive) moments in twentieth-century Australian art. The 1930s Depression came at the same time that McCulloch was cutting his teeth as a young artist and illustrator; as a fledging art critic during World War II he joined in the debates between the newly formed Contemporary Art Society and conservative forces in Australian art; he followed the post-war diaspora of Australian artists and writers who left for Europe and America only to return to make an impact in the 1950s; he watched and commented

on the rise of abstract art during the period of the Cold War; and he lamented how conceptual art had gained a foothold in the early 1970s as Australia moved to a more pluralistic and open society.

It is possible then to construct a very personal take on Australian and international art, and particularly that in his hometown, Melbourne, through the lens of one man. The book that follows has been developed with this aim in mind. It takes the form of a cultural history, examining aspects of twentieth-century art through reference to Alan McCulloch and his interaction with the art world from the 1920s until his death in 1992. Unpublished primary material such as letters, fictional autobiography, essays and illustrations drawn from the McCulloch Family Papers in State Library Victoria (SLV) provide a strong focus for the writing. This archive consists of several thousand letters and manuscripts and has been described by author Kenneth Hince as 'a particularly rich, dense, and formidable collection'. The SLV also contains many additional books, pamphlets and artworks attributed to McCulloch, as well as his personal diaries, and as such has been the mainstay of much of the research.

In her erudite biography on Bernard Smith, Sheridan Palmer describes how they met towards the end of his life, late enough to glimpse the 'hardened shell of a triumphant but battle-worn man'.[2] Smith was a contemporary of McCulloch and considered the father of modern Australian art history. I was also fortunate to meet Alan McCulloch towards the end of his own long and illustrious career. Less battle-worn, McCulloch was forever an optimist. My memory of that first meeting is of an old man, his tanned, cragged face framed by white, wispy hair, stooped over an old Remington typewriter, flogging it with two bony, elongated fingers. McCulloch looked up from his task to acknowledge my presence, producing a beaming smile and cheeky grin, saying: 'A curator, you say—well, we might need another one of those.'

This was 1990 and McCulloch was in his eightieth year. He was heavily involved in overseeing the relocation of the Mornington Peninsula Arts Centre from its original converted weatherboard house

in Vancouver Street, Mornington, near the beach, to its purpose-built facilities on the other side of the Nepean Highway. This was despite protestations from his close friend, long-time *Meanjin* editor Clem Christesen, who was urging him to plan his succession. McCulloch had fought hard and long for the new gallery, and he was determined to see it through to fruition. While the gallery never eventuated at the scale and beauty he had initially hoped, he was busily involved in setting it up and securing its future growth. Little did I know then, as a young postgraduate student and would-be curator, that I would work there for many years and that I would end up writing the McCulloch biography. But in a way my fate had been already ordained. When I was conducting research on McCulloch at SLV as the inaugural recipient of the Dr Joseph Brown AO Fellowship (2008), I came across by chance the diary entry for 7 August 1990: 'Rod: 898586 Waverley: Director, asst Director, Curator, Education Officer, Director's Asst (20 hrs per week). Provision to call upon for outside assistance.'

Alan McCulloch believed that the best art stemmed from a union between the artist's personality and the conditions from which the art arose. In the process art played a valuable role in integrating individuals within their community and with the world at large. McCulloch held holistic views about art that were drawn from a broad spectrum of writers and thinkers. The sentiments and wide-ranging interests of the German luminary Goethe stand out above all else. McCulloch could not be content with writing about or making art for its own sake. Rather, he concerned himself with creating the conditions in which art and its appreciation could take root and flourish—in doing as well as contemplating.

Vitally concerned with Australia's place in the world, McCulloch embraced the art of Asia and of the Pacific, long before it became fashionable to do so. An early supporter of Australian Aboriginal art, he also championed the Indigenous art of this country through exhibitions, awards and the lobbying of new arts venues. His modestly scaled exhibition of bark paintings mounted from the expansive Museum of Victoria collection that toured to the Museum of Fine

Arts, Houston in 1965 was among the first and most impactful of its kind to leave Australian shores. In the 1950s, McCulloch was also a voracious supporter of modern artists and was one of a few to recognise the importance of European émigré artists in what they were able to bring to a relatively naive and inward-looking nation. In the 1960s and 1970s, and contrary to how he was perceived by some critics, McCulloch played a valuable role in assisting a subsequent generation of artists to gain traction and progress their art through his support to overseas residences, grants, exhibitions and acquisitions.

Within the wider domain, McCulloch was actively involved in the formation of government policy for the arts and was sought out for his views on issues of national concern. As Australians continue to debate the relative merits and possible form of a national funding body and set of principles to oversee the arts, McCulloch was a key early contributor in the advancement of opportunities and recognition of Australian art both here and abroad. He championed Australia's regional gallery moment and held to account larger state galleries over their acquisitions and exhibitions. A proud Melbournian, McCulloch supported the relocation of the National Gallery of Victoria to its present site on Southbank and argued for the creation of a city square that matched Melbourne's nascent cosmopolitan air.

Born and reared with a dose of Scottish obstinacy, a Presbyterian work ethic and the Australian sense of egalitarianism and fair play, Alan McCulloch was able to rise above circumstance and surroundings to fashion a life that lived and breathed creativity. Along the way, he made a lasting and important contribution to twentieth-century Australian art, writing, publishing, galleries and exhibitions.

CHAPTER 1

CALL TO ARMS

Alan McCulloch belonged to a generation of artists and writers whose lives were framed by two world wars and the Great Depression. The first two decades of his adult life were split between the necessity of earning a living—he worked as a teller with the Commonwealth Bank in Melbourne for eighteen years—and the release offered by painting, drawing and illustration. McCulloch read voraciously in his spare time; he was an avid gallery goer and honed his skills as a commercial artist, cartoonist, book illustrator, set designer, editor, author and painter. His aspirations were high, and he refused to be defined as one thing over another.

By the time McCulloch launched into the second part of his career in the late 1940s, he was already well versed in a wide range of skills and disciplines. Although drawing remained his first love, he developed a strong self-belief and work ethic that helped him to meet the challenges of becoming an art critic, curator and writer. He had a wry and sometimes self-deprecating sense of humour, as well as a very firm sense of fair play and ethical behaviour. With the support of family and close friends, McCulloch eventually came to appreciate what he had been encouraged by others to believe: that just as art played a significant role in his own life, so it did in society at large.

This core belief sustained his contribution to Australian culture and art over the next six decades.

Early days

Alan McCulloch provided a firsthand perspective on life in the 1920s and 1930s in an unpublished and incomplete memoir penned towards the end of his life. He recalled how his burning ambition to be an artist was instilled and then nurtured through the encouragement and example of both his parents.[1] Alexander McCulloch and Annie McLeod had met en route to Australia, on the return trip from overseas. A shipboard romance led to marriage in 1905 and the birth of their first son, Henry, in 1906, followed by Alan in 1907. Three years in Cranbourne, on the outskirts of Melbourne, then inner-city St Kilda, preceded a move to Sydney in 1910. In that year, a third son, Wilfred, was born, followed by a fourth, Jack, in 1915.

Annie McCulloch is characterised in the memoir as an unworldly though emotionally strong and focused person. Following the death of her father as a child, her widowed mother subsequently married the owner of the Cranbourne Store and lived a life of modest security. She witnessed the pomp and ceremony of England's glory days as a colonial power, made the obligatory grand tour of Europe, and experienced the art and music of both England and the Continent. According to Alan McCulloch, his mother's 'chief interests [were] family life after which came music, poetry, [and] painting in that order'.[2]

Born in Australia but growing up in the United Kingdom with his widowed father and siblings, Alexander McCulloch trained as a mining engineer, worked on cargo ships in Canada and Asia. Returning to Australia in the early 1900s, he continued this adventurous life by prospecting and taking out mining leases in remote parts of Tasmania and Victoria and working as a mine manager in Kalgoorlie, Western Australia before moving back to Melbourne, marrying Annie then moving with her to Sydney. Sitting on the

verandah of their Mosman home, he would tell the boys stories and paint watercolours of the view towards Sydney Harbour. Alexander led an unconventional life that encompassed a love of drawing, designing ships, poetry, sailing dangerously on the harbour and hard, physical work. Although practical and organised, he had been shaped to be an artist, a vocation that sons Alan and Wilfred would emulate and arguably live out in their father's 'unfulfilled ideal'.[3]

With the death of Alexander McCulloch in 1917, the family fortunes sharply declined. Annie McCulloch and her paid carer, a youthful Ms Creighton, were left with the responsibility of raising the four children. The decision was made to sell the Mosman house in Sydney, staff were reluctantly given notice, and the young family returned to live in Melbourne. They eventually settled in the south-eastern suburb of Gardiner in 1919. Alan McCulloch observed that during these years his mother struggled to maintain her 'standards of attainments for her children' and that these increasingly 'were often more than her means'.[4] An ill-advised family property investment in 1922 further exacerbated the McCullochs' financial difficulties. This also resulted in both Henry and fifteen-year-old Alan being forced to leave their prestigious Melbourne day school, Scotch College, to seek full-time work.

The 1920s coalesced as a period of financial insecurity and limited opportunities for the McCulloch clan. While the eldest son, Henry, entered the Bank of New South Wales, Alan managed to gain full-time employment as a junior clerk with the auctioneers and estate agents Sydney Arnold, Best, and Co. in Queen Street, Melbourne. This was followed a year later by his appointment to a similar position with Broken Hill Proprietary (BHP) in 1923–24. From 1925, Alan worked as a teller in a city branch of the Commonwealth Bank of Australia (CBA). He held the position to earn enough money to support his mother and siblings. A blessing and curse, the job provided a measure of financial security over the best part of two decades at the same time as it lacked the sense of humanity and life that he sought and found through art.

Black and white art

Neither Alan nor his younger brother Wilfred (who harboured similar ambitions and was a talented draughtsman and painter in his own right) had the necessary folio, qualifications or financial independence to enter a sanctioned art school. Instead, the McCulloch boys focused on educating themselves and seeking out usually unpaid illustration work and black and white art.

Alan enrolled in evening classes at the Leyshon White School of Commercial Art in Collins Street, Melbourne, which he attended in 1924–25. Wilfred also gained entry to the same course, staying for its duration and ultimately gaining full-time work. Alan lasted only two quarters, unable to find the three guineas required to continue to pay the fees.[5] The line drawing and presentation techniques taught at Leyshon White, and a subsequent period spent at the nearby Working Men's College under the tutelage of artist John Rowell, equipped Alan with enough knowledge and skills to work commercially. This training was augmented during 1926–27 by entry to evening classes offered at the National Gallery School in Swanston Street, Melbourne.

Tuition was something both McCulloch boys craved, but it was to prove profoundly unsatisfying. The day class at the National Gallery School was the more prestigious and consisted of three years of solid, academic training including a year drawing from plaster casts. Alan and Wilfred received tuition in life-drawing from WB McInnes and the school's director, Bernard Hall, at night classes. It was an experience that Alan looked back on in the most disparaging of terms. However, it taught both McCullochs conventional methods of drawing, in which objects in a composition were conceived tonally from light to dark, which would hold them in good stead.

Like-minded artists in the 1920s and 1930s were drawn to far less regimented and more self-motivated avenues. They frequented city pubs and studios where well-known artists were known to hang out and engage in public debate. At first, Alan mixed with fellow members

of the Gallery School, including James Flett, Herbert McClintock and Sam Atyeo. This circle expanded to include Arthur Boyd, Roy Hodgkinson and William Dargie, who along with Wilfred formed an informal life class, drawing the visiting Ballets Russes backstage from 1936 to 1940.[6] Melbourne's conservative, older artists spent their leisure time at the Savage Club in Bank Place. Alan was occasionally invited there in the 1930s—but the more he mixed with 'questionable personalities', such as artist and Communist Party of Australia member Noel Counihan, the less he was welcome.[7]

Artists banded together to organise sketching trips, share transport and accommodation and conduct their own life-drawing classes. These informal 'centres of learning' were augmented by the wide-ranging free education that could be had at the Melbourne Public Library (State Library Victoria), next door to the National Gallery. Alan combed the library's art stacks and pored over bound volumes of the German graphic magazines *Simplicissimus* and *Jugend*. The library held a complete set of Sydney's *Bulletin* dating from 1880, along with copies of Australia's longest-running weekly, Melbourne's *Punch*. McCulloch was initiated into the work of contemporary American and English illustrators who became a major influence.[8] He also honed his drawing skills while taking the nightly train home to Gardiner from work in Melbourne. Unbeknown to other commuters, he was secretly sketching their portraits and caricatures. Once home, he continued his creative sideline by compiling illustrations that he would then send off to the *Bulletin* and other magazines.[9]

During the two years McCulloch spent working at BHP between 1923 and 1924, a colleague showed him a collection of original *Bulletin* cartoons. His attendance at a lecture on political satire and then a succession of meetings with Will Dyson—a hero of this golden era of Australian black and white art—confirmed in McCulloch's mind that this art form had a noble purpose and suited his personality because it could be wickedly irreverent at the same time.

McCulloch identified closely with the biting political satire and portrait-caricatures of Dyson. The latter became something of a

reluctant mentor, grudgingly encouraging him to develop his career in drawing and printmaking.[10] This included Dyson demonstrating his drypoint etching techniques to the younger man and providing him with introductions to local newspaper editors. McCulloch's first illustrations were published in *Table Talk* in 1927, a venerable Melbourne newspaper for which Dyson was also a regular contributor. A drawing that dates from this period titled *Artist and patron* reveals his debt to Dyson and European artists such as George Grosz. The work became the basis for a 1937 etching that is held by the National Gallery of Australia, Canberra. McCulloch later admitted that 'I could learn more with Dyson in half an hour than I could learn at the NG [School] in six months.'[11]

Throughout the 1920s, McCulloch increasingly looked for ways to improve his skills as well as contribute to and become part of an enduring tradition of Australian and international black and white art. This tradition continued through Sydney's *Smith's Weekly* edited by JF Archibald (formerly of the *Bulletin*) and the new or at least revamped Melbourne *Punch*. In a major coup, newspaper proprietor Keith Murdoch had recruited Will Dyson from London to join the Melbourne *Herald*, where he served as its chief cartoonist.[12] McCulloch also travelled to Sydney in 1931 or 1932 to spend time with the legendary and opposite pole to Dyson, Norman Lindsay.[13] McCulloch used the meeting to expand his art practice and to raise the idea of publishing a book on Australian pen drawings. He had ambitiously started to compile the book under the aegis of Fan Frolic Press, which precociously he had created for this purpose and presumably had taken inspiration for its name from the better-known Franfolico Press.

With Norman Lindsay's support, McCulloch set about contacting artists of the calibre of Walter Jardine and JR Flanagan. Both men were successful expatriate Australian illustrators, cartoonists and poster designers, who had settled in New York in the late 1910s and early 1920s respectively. McCulloch outlined the project to

them and his idea to embrace 'the principal figures in Australian pen drawing since the advent of Phil May' by presenting 'a short biography of each together with reproductions of their work, and notes on their working methods'.[14]

The book failed to materialise; however, McCulloch's own career as a cartoonist and illustrator rapidly gained momentum. He had submitted cartoons and illustrations for employer-based publications from the mid-1920s. Some of these first drawings were published in the *BHP Recreation Review*. From the 1920s until 1939, he was also a contributor to the Commonwealth Bank's *Bank Notes* staff newsletter, receiving regular encouragement from the newsletter's Sydney-based editor E Sullivan. Sullivan was the first to congratulate McCulloch on the publication of his first cartoon in *Smith's Weekly* on 25 June 1930. He followed McCulloch's artistic development very closely, including his experimentation with a new signature that Sullivan considered 'a great improvement—"arty" and unobtrusive but effective'.[15]

McCulloch felt sufficiently confident in his abilities by early 1930 to approach the associate editor of the *Australasian* with a request to draw caricatures for their publication. His drawings were subsequently returned with the curt explanation that it was 'not our intention to add this feature'.[16] Undeterred, McCulloch approached the managing editor of the *Star* newspaper, HR Gollan, for an appointment as their cartoonist. This newspaper included the established mainstream publications *The Argus* and associated weekly *The Australasian* under its banner. McCulloch wrote in support of his unsolicited application: 'For some years I have been doing free-lance work, including joke illustrations, cartoons and caricatures, and illustrations to stories for various Australian newspapers *The Sydney Sun*, *Smith's Weekly*, *Table Talk*, and others; but have not yet occupied a staff position on any newspaper.'[17] McCulloch's bid was gallant but not successful. It would be another ten years before he would gain work as a full-time illustrator and cartoonist. It was the 1930s and the beginning of the Depression years in Australia.

Commercial work

McCulloch's commercial illustration work supplemented his bank salary throughout the 1930s and eventually became his main income. This included self-published books and illustrated stories, along with advertisements and illustration work for magazines such as the *BHP Recreation Review* and *Wireless Weekly*.

McCulloch also obtained regular work with Melbourne's Bucks Department Store, producing their annual Christmas catalogue and regular full-page advertisements for prominent brand names. Small successes such as these were appreciated and celebrated by McCulloch's family, as well as giving him wider traction in the small Melbourne art and advertising communities. In response to a paragraph in the *Argus* 'reporting the success of your book', one close relative wrote: 'Your feet are on the ladder now and I hope you will climb steadily and firmly *right to the top*.'[18]

In 1936, McCulloch was commissioned to produce a regular column with Melbourne advertising firm Samson Clark Price-Berry Pty Ltd. The editor wrote to him expressing his satisfaction: 'You can regard your hat drawings as a feather in your cap. Advertisements using these drawings, as you probably noticed, commenced about three weeks ago, and the comments on them have been very satisfactory, and what is more important still, the sales resulting from the series have been satisfactory too.'[19] McCulloch was clear about what he had to offer and how much he should be recompensed. Correspondence between him and the director of Pike Bros, who manufactured tailored suits, shows how he convinced his client to build a full picture by running a suite of ads rather than just featuring a single advertisement. Satire and humour were often at the forefront. In this case a penguin wears a double-breasted suit—in response to the heatwave then being experienced across Victoria.[20]

McCulloch's efforts received greater recognition and reward the following year. He was commissioned by Alan McCoy & Co. to

produce 'three to four comic strips a week'.[21] The magazine editor at the *Argus* also approached him with work: 'Lionel Smalley has written a perfectly delightful article about the literature of sport. Would you want an awful lot of money if I suggested that you illustrate it with some of your bizarre drawing?'[22] Building on these gains, he wrote and illustrated stories of his own that began to appear in the mainstream press, including 'Soliloquy on Silverfish', which was published by the *Argus* in May 1939. These often focused on people's struggles with the vagaries of modern life. 'The Collar Stud', a piece about the annoying contrivance of neck adornments (subtitled 'A scholarly essay on an endemic major evil in modern social life'), was originally printed in the *Argus*'s weekend magazine in July, and then syndicated to Queensland.

Alan's own art

Success as a studio artist and draughtsman was always McCulloch's primary goal. This lofty aim was recognised and encouraged by close friends, mentors and his family, who reminded him of the need to align personal ambition with the greater good.

McCulloch valued the important role played by black and white artists in the formation and critique of society, but he was equally drawn to the romantic conception of the artist as outsider. This image was propagated most famously in the 1930s through the work of nineteenth-century writers such as Henri Murger and George du Maurier. According to McCulloch, their books *Scènes de la vie de bohème* and *Trilby* had 'inflamed the sexual instincts of half the young artists of the Western world'.[23] Although he had learnt the fundamentals of academic drawing, he shared with the generation of artists who emerged in the 1930s and 1940s the idea that art was the expression of personality. The bohemian ideal in which the artist lived their life in and through their art was the thing that captivated him, as exemplified by the lives of the Lindsays or Will Dyson.[24]

McCulloch's fine art first came to public notice in 1930. Several of his drawings and etchings were included in a group exhibition at the establishment Sedon Galleries, Melbourne. Exhibiting alongside artists such as Lionel Lindsay and Sydney Ure Smith was a boon, but the real coup came with the sale of *The coming storm* for 3 guineas and a pen-and-ink sketch titled *Sirocco* for £5 5s.[25] *Sirocco*, the name given to a hot, dust-laden wind, was the first work by McCulloch to enter a public collection, purchased for the National Gallery of Victoria by the Felton Bequest Trustees. According to the *Herald* reporter, the 23-year-old Scotch Collegian and Commonwealth Bank employee had 'been practising his art for some years, and recently has come under notice of the older hands. They predict a bright future for him.'[26]

The event was also reported in the social pages, prompting this response: 'There is joy in the House of McCulloch, that artistic Malvern clan, for Alan found favour in the sight of those who manipulate the coffers of the Felton bequest. His pen drawing, *Sirocco*, now hangs in the National Gallery where, if I am not mistaken, he is the youngest exhibitor.'[27]

In the mid-1920s, McCulloch had warmed to the fashionably modern and light-filled watercolours of William Blamire Young and railed against what he perceived to be the dull monotony of the quasi-scientifically based art of Max Meldrum and his followers. Of their work he claimed: 'The paintings all looked the same—brown, green and black with thin, rough edges …'[28] His summation regarding the absence of vibrant colour could be linked to the 'formlessness' he perceived in the work of the Meldrumites, as they were disparagingly known. This was opposite to the pictorial qualities McCulloch embraced in his drawing and cartoon work, which in the manner of a Chagall favoured a line around a form. He was positioning himself as an inheritor of humanist traditions, embracing art as a form of communicating pictorial ideas, heightened emotions and fundamental ideas about human nature.

Herald art show

As was the case for many of his contemporaries, McCulloch's attitude to modern art was changed by the *Herald Exhibition of French and British Contemporary Art*. The exhibition was brought to Australia in 1939 and curated by the *Herald* art critic Basil Burdett at the behest of Sir Keith Murdoch and the *Herald* and *Weekly Times*.[29] Consisting of over two hundred works, it toured Australian venues between 1939 and 1945. McCulloch later referred to it as Australia's equivalent to the Armory Show, which first showcased modern art in New York in 1913. For the first time, he said,

> We saw the cone, cylinder and cube formulated landscapes of Cézanne. We saw the passionate impasto and swirling brushwork of Vincent van Gogh, the primeval, post-impressionist arabesques of his friend, Gauguin, the propped up soft watches of Salvador Dali, and, most controversial of all, the unbelievable distortions of Picasso and Matisse … Boyd, Tucker, Nolan, Counihan, Thake and Annois were among the milling mob of students that filled the Town Hall. We were the first in the doors in the mornings and the last out at night.[30]

Director of the National Gallery of Victoria JS MacDonald famously pronounced the exhibition as the work of 'degenerates and perverts'. McCulloch, who enjoyed good relations with MacDonald (in one of his earliest articles writing in defence of the conservative Australian Academy of Art), now sided with the march of modernism and modern art. Along with Wilfred McCulloch and their younger friend and painter Arthur Boyd, he visited the exhibition on multiple occasions, staying from morning until late in the day.

Many artists changed their style and technique in the face of the Van Goghs, Cézannes and Picassos. Arthur Boyd's pastoral landscapes and seascapes, painted near his grandfather's house in Rosebud on the Mornington Peninsula, changed from cool blues, grey and brown to a profusion of bright colours and equally strongly willed lines and

forms. Wilfred McCulloch's work also went through a major transition—so much so that it proved difficult to tell the brothers' works apart after they had returned from weekend painting expeditions.

Alan also recalled how this new influence led him to explore a completely different side of art: 'It directed me towards reading such books as Irving Stone's *Lust for Life*.'[31] It was McCulloch's first real encounter with the School of Paris, or at least its origins, and this way of living and making art became a beacon to emulate and aspire to throughout the difficult years of World War II and beyond.

A group of spirited young men, consisting of the McCulloch brothers, Arthur Boyd, Harold Beatty and National Gallery School student and poet Donald Town, established an artists' camp between Cape Schanck and Gunnamatta Beach on the Mornington Peninsula in the summer of 1934–35; it lasted until its eventual demise from neglect and army target practice in 1941. The group had met in the early 1930s. Wilfred shared a studio with Beatty while Alan was known to Beatty's family through his involvement in tennis. Beatty's sister, Peg, recorded in her diary that they frequented Tate's Tea House in the basement of the newly opened Manchester Unity Building from 1932, the first building to install an electric escalator in Melbourne. 'The Tate's Tea House group eventually included (among others) Donald Town, Colvin Smith, Lionel Smalley, Victor Ransome, and Cyril Muskett. Along with the McCullochs, Harold considered the last three of these among his closest friends for life.'[32]

Late in 1934, members of the group drove to the ocean beach at Gunnamatta about 130 kilometres south of Melbourne and set up their camp, constructing huts out of driftwood. The relaxed and carefree nature of the camp included activities such as games, competitions and bodysurfing, and the masculine bonhomie was captured much later in an article written and illustrated for the Contemporary Art Society's *Broadsheet* in 1963. The text was ghost-written by Clem Christesen from information and text provided by Alan and titled suggestively 'The last of the artists' camps', in reference to a long and rich tradition stemming from the Australian Impressionist painters.[33]

A sensitive portrait of a sunburnt Arthur Boyd was painted by Wilfred McCulloch circa 1937. Its greenish hue was generated by the light flowing through khaki canvas sheets covering the hut made of driftwood, where it was painted. A painting dating to the same period by artist Colvin Smith shows how they lived and ate in the most rudimentary of surroundings. They would live to regret using Boyd's canvases, draped over racks to dry, to clean dirty pots and pans.

While the members of the Gunnamatta artists' camp eventually went their separate ways, Alan McCulloch and Arthur Boyd kept in close touch. Sometime during the early 1940s, Boyd wrote to McCulloch from Ballarat in a barely decipherable scrawl on League of Soldiers' Friends letterhead. He had been posted to an army camp there and had rather unhappily earnt the nickname 'Wimpy'. Boyd's fascination with identity and nomenclature is illustrated here: he signed the letter 'Arthur Merric Boyd', and wrote 'Merrick [sic] I like' in a direct homage to his father. A second letter, written from the Heidelberg Military Hospital where he had been incarcerated with mental health issues, was signed 'P.R. Boyd AM V101720'.[34]

In a speech given many years later at the opening of the exhibition *The Heroic Years of Australian Painting 1940–1965*, McCulloch expanded upon this unhappy period in Boyd's life, claiming that he and a friend of the Boyds 'mounted a rescue operation which we put into effect about ten o'clock that night'. According to McCulloch: 'The mission '*not only failed* but had the important effect of having an armed guard placed on the door of his ward, where apparently the guard remained and was removed only sometime later when he became a nuisance to ward staff'. He noted, 'AB, unhappily conscripted into the army, [conspired] to fill his tent with pictures that convinced the military authorities that they had a raving lunatic on their hands.'[35]

War art

With the announcement of war in September 1939, Alan McCulloch placed his family, himself and other young contemporary artists,

including Wilfred, in the service of the state. The number of freelance opportunities contracted, including the suspension of his weekly satiric 'Gulderbrandt' cartoon with *Picture News*, due to wartime shortages and decreasing editorial space.[36] Forced to explore other options, he pondered ways in which artists could make practical contributions to the war effort.

McCulloch wrote to a Captain FG Sutton in June 1940 on 'behalf of a group of young Australian artists ... regarding their possible enlistment in the capacity of artists in the AIF'. This was followed by one to the Commanding Officer, Southern Command Defence. McCulloch's suggestion was that a 'small mobile unit' of artists be set up to design camouflage, disseminate war propaganda and record 'personalities and events in Australia's War effort'.[37] One month later, he responded to a broadcast by the Australian prime minister, Robert Menzies, calling on Australians to enlist. McCulloch wrote to Menzies personally and reiterated his view that the most useful capacity he could serve was 'as a satirist or propagandist'.[38]

McCulloch saw such measures as a way of utilising his skills and providing financial support his family; however, his efforts formed part of a much wider response. This included the influential art critic Basil Burdett who, several weeks after McCulloch had written his letters, questioned in his July 1940 column for the Melbourne *Herald* why no Australian artists had yet to be appointed despite the Australian presence in Palestine 'for months'. He highlighted the vital role that could be played by local artists documenting the war effort in an official capacity on the home front.[39]

In March 1942, McCulloch espoused these ideas in response to an agenda circulated by the recently formed Artists Unity Congress (AUC). This was a disparate association of artists driven by the perceived need to cooperate in the 'name of the national war effort'.[40] McCulloch, who had little in common with many of the artists, especially those associated with the Communist Party of Australia, began his letter to the AUC's secretary by introducing the role that could be played by artists in 'producing pictorial propaganda'.

Through the dissemination of information and by moulding public opinion, McCulloch reinforced the AUC's stated platform to defend the nation and protect its national culture. He drew upon the example of *Simplicissimus*, staking claims for it to be 'probably the most powerful propaganda weapon of the last decade'. McCulloch's proposal to set up a unit to produce a weekly or bi-weekly publication was subsequently incorporated into the ill-fated AUC proposals.[41]

The news that Wilfred McCulloch was missing in action in Singapore, where he was serving as a stretcher bearer, robbed Australian art of an emerging talent. It also reinforced the need for Alan to stay at home and continue to support his ageing mother. Throughout the war, Alan carried the guilt that he had not been called to serve in action. Alan found numerous other ways to contribute, including organising art fundraisers for the Red Cross, conducting auctions and performing ballet pantomimes with Arthur Boyd and Yvonne Lennie.

McCulloch's wartime cartoons in the *Argus* and the *Australasian Post* can be characterised as agitprop; in the manner of that time, they often depicted, literally, the brute force of Nazi Germany exacting its cruel designs on unsuspecting nations. He also used more sarcastic and humorous means to encourage people to take their wartime duties and responsibilities more seriously.

McCulloch severed his full-time position with the Commonwealth Bank in mid-1944. He did so believing that he could make a living working as a freelance illustrator, as well as in recognition of the toll the job was taking upon his physical and mental state. Cautiously, he wrote to the national services officer in Melbourne for consent to 'my carrying on my own business as a commercial artist', explaining that the demands of work in both spheres had become untenable. The reply that he received was not encouraging. It stated bluntly that even if he got consent: 'It will be necessary to transfer you to the highest priority work within your capacity to perform.'[42] Undeterred, McCulloch resigned one week later.[43] In doing so, he had to forgo severance entitlements, which the CBA withheld during war from

staff who resigned to pursue other occupations.[44] The conflicting demands between the life of an artist and the soulless work that he had had to endure had clearly become too much. Blind optimism may also have been tempered by the news in February 1944 that Wilfred had died in Singapore two years earlier, in 1942.[45]

Art, ballet and the theatre

Modern ballet was an important avenue for emerging artists such as Alan and Wilfred McCulloch to engage with contemporary art and design. Three companies that were offshoots of Serge Diaghilev's famous Ballets Russes toured Australia from 1936 to 1940 through the aegis of entrepreneur Colonel Wassily de Basil. The colonel's Monte Carlo Russian Ballet toured for nine months between 1936 and 1937. A second company, Covent Garden Russian Ballet, toured over seven months between 1938 and 1939. The third tour combined Russian dancers now based in England and America and was popularly referred to as the Original Ballet Russes. The tour began in December 1939 and concluded in September 1940; originally planned to run for ten weeks, it was extended owing to the complexities of war.[46]

Colonel de Basil actively encouraged artistic responses to his productions by providing local artists with access to rehearsals on each tour.[47] Like many of his fellow artists, McCulloch was captivated by the costumes, set design and choreography of the three ballets and attempted to incorporate aspects of each into his own art. This included the humorous 'Ballet Ideas' for Henry Bucks' Christmas catalogue in 1938 and a 40-page Ballet Russes Comedy on tour mock-up booklet, by Olga Phillipoff, that was accompanied by McCulloch's drawings based on performances of the Ballet Russes Comedy. In 1938, McCulloch published his own booklet inspired by the touring ballet, called *Ballet Bogies*. The publication included illustrations and cover designs by Alan, as well as text by Lionel Smalley and decorations by Wilfred McCulloch. Alan was a master of the

spare line depicting the quick glance and impish facial expressions. His skill in capturing the drama of the ballet was evident in numerous drawings, watercolours and improvisations.

McCulloch extended his involvement to include costume and set design. In a manuscript on the art of theatre written in 1950, he reflected upon the rich modernist traditions and the 'opportunity to design on a vast scale; here was a chance to indulge in the most desirable kind of collaboration with two other arts'.[48] He was able to develop these ideas in a subsequent essay titled 'Design for the Theatre', produced as part of the National Theatre Arts Festival held in Melbourne from February to May 1952.

McCulloch reflected on the importance 'of real set design' that was introduced to Australia through the original tour of the Ballets Russes and was henceforth 'manifest locally in the striking designs of Loudon Sainthill'.[49] McCulloch looked up to Sainthill, who had achieved a swift and lasting pre-eminence in theatre decor with his 1939 exhibition of drawings from the ballet and 1940's 'Theatre and Ballet Exhibition'. The latter show had been organised under the auspices of the British Council, arranged by local promotor Tatlock Miller and held at Melbourne's Myer Emporium. As well as presenting opportunities for hard-pressed Australian artists to make a small income during the Depression and war years, these artistic disciplines offered visual artists a chance to push their art into new directions.

Some of the Ballets Russes dancers stayed on in Australia and helped to form companies here. In Melbourne, this included Edouard Borovansky, who together with his wife, Xenia, formed a company in 1940, relying on a troupe of dancers headed by the Australian-born prima ballerina Laurel Martyn.[50] McCulloch contributed to the company's repertoire by designing costumes and sets and joined Martyn's offshoot, the Melbourne Ballet Club (later renamed the Victorian Ballet Guild), as a member in early 1944. His involvement in the club stepped up when he agreed to edit its magazine. In 1946, he served on a set design subcommittee that included his friends and fellow artists Len Annois, Alan Sumner, Harald Vike and Charles Bush.

One of Borovansky's Australian Ballet productions toured nationally and internationally, including a season at His Majesty's Theatre, Auckland, in 1944. McCulloch's set designs received enthusiastic comments from patrons of the Theatre Royal in Sydney and Adelaide, where the latter theatre was, according to one eyewitness account, full most nights.[51] A conversation in which the director, Borovansky, was thought to bear a likeness to actor Charles Boyer was translated into drawings by McCulloch: '"Then after the first night", I said, "Well did you like Boro?" She said, "Oh I love his *jaw*. Like hell *we* do!"' The lovely quivering line sketches and the set designs and specifications for Borovansky's Australian Ballet Company productions introduced a new phase in McCulloch's artist output.

An adjunct to designing costumes and decor was a behind-the-scenes visual response to the theatre and its protagonists. Annois, John Rowell, Daryl Lindsay and McCulloch exhibited some of their illustrations of members of the Borovansky Ballet at Her Majesty's Theatre, April 1944.[52] Harold Herbert recorded in the *Argus* that 'Mr Alan McCulloch in his whimsical manner draws in a thin line, members of the ballet in extraordinary poses', while 'CT', in his article 'Art and the Ballet', explained: 'Mr Alan McCulloch, widely known for his work in a lighter vein, has some pleasant drawings, and Mr John Rowell, on a more ambitious scale, shows a successful and competent portrait of Borovansky.'[53]

Norman Macgeorge, artist, patron and founder of the Contemporary Arts Society, wrote to McCulloch in January 1946 to update him on the progress of the book *The Borovansky Ballet in Australia*, which was to be published with colour plates by Cheshire Melbourne. 'I hope', he wrote 'to have it out in time to coincide with the company commencing its 1946 season.' In a measure of McCulloch's growing success, Macgeorge went on to say: '*The Sea Legend*, one of yours would be put in as an illustration, as for the *Russian Dance*, I will try and get it in.'[54] This former work had been first performed as part of Borovansky's Australian Ballet, opening at His Majesty's Theatre in

May 1944. According to the *Argus* critic, '*Sea Legend*, the third ballet, was danced by performers who included Dorothy Stevenson, the Australian choreographer, and the effective scenery and costumes were by Alan McCulloch.'[55]

Laurel Martyn created her own dance works after leaving Borovansky's company to form the Melbourne Ballet Club, also in 1946. The Ballet Club's first program premiered on 6 November 1947 at the Melbourne Repertory (later Arrow) Theatre. Four new works were premiered, including *Contes Héraldiques: The Sleepy Witch*.[56] The set and costumes were designed by McCulloch, with music by Dorian Le Gallienne. In March 1947, the same repertoire was performed at the University of Melbourne's Union Theatre. One critic commented that the 'larger stage of the University Theatre gives both the dancers and the decor artists a better chance. *Contes Héraldiques*, a light-hearted burlesque of the 19th century ballet, gains particularly from the extra elbowroom.'[57]

The decor provided by McCulloch to ballet productions over 1945–46 was a highlight of his involvement. Critics expressed their admiration, while McCulloch's friends and colleagues wrote from far-flung places to congratulate him on his efforts. Cartoonist Fred Schonbach wrote that 'Joy Lush gave me a detailed account of the wonderful job you with three other Vic artists did for Laurel Martin's [*sic*] ballet.'[58] A note from a friend called Llewellyn congratulated McCulloch 'for the wonderful decor' and encouraged him to 'come to New York' to try his luck, where the friend was currently living and staying at the Barbizon Plaza Hotel.[59]

First start: Early writing and editing

Alan McCulloch's first piece of critical writing on Australian art set in train a long, distinguished and arduous career. He was not a natural writer, but he believed firmly in the idea of art as an expression of the spirit of its place and times. He often questioned how artists, including personal heroes such as George Grosz, could maintain

the same bite and integrity once they had left their homeland and original inspirations behind. From his experience, McCulloch learnt that there was one or perhaps two standout artists in each generation and that his role was to support them in the face of widespread indifference or dissent.

A typed fragment written in support of JS MacDonald, the conservative art writer and director of the National Gallery of Victoria, and his 'courageous attempts to protect the nation's art from the ravages of the Nat. Gallery Trustees' reveals McCulloch's ire when provoked, as well as his early conservatism.[60] However, McCulloch's first published piece that gained him widespread exposure was an impassioned response to William Dobell's *Billy boy* (1943). The painting featured in the same 1944 Archibald exhibition as Dobell's infamous portrait of Joshua Smith. McCulloch singled out the former work for the way it 'shines like a beacon on a foggy night'. According to McCulloch, Dobell's paintings combined credible human qualities and convincing pictorial values. It was, he felt, remarkably in touch with the spirit of its time.[61]

The publication of McCulloch's article provoked favourable reactions from Melbourne's art community. Artist and friend Guelda Pike wrote to congratulate him on leaving the Commonwealth Bank and on his meeting with Dobell: 'How *pleased* Dobell was to hear from you and had every intention of answering', she wrote.[62] A follow-up essay on the Weimar Republic satirist George Grosz entitled 'Stickman' and 'The Painted Portrait in Art' were also critically lauded.[63] Such articles helped McCulloch to develop his writing skills, fine-tune his philosophy and, importantly, secure more permanent work.

The Argus and *The Australasian*

In October 1944, less than two months after he had left the Commonwealth Bank, McCulloch finally gained work as a 'staffer' with an appointment as art critic, contributing cartoonist and editor

of the *Argus* and arts editor for its umbrella weekly, the longstanding *Australasian* (from April 1946 rebadged *The Australasian Post*). The newly launched format for this black and white weekly provided McCulloch with a living wage earnt from art for the first time. It gave him the opportunity to advance his contributions to Australian art and culture on a national stage.

Management had high hopes for the revamped weekly, which it was seeking to 'transform into a livelier news and current affairs journal'. Author and journalist George Johnston was appointed as the inaugural editor after having been sounded out about its potential focus and viability.[64] According to McCulloch, both he and Johnston had their own ideas: 'I wanted to create an Australian *Jugend* and George wanted to create a *Time Magazine*.'[65] Despite the differences, they hatched an ambitious program. Gallery directors and artists responded favourably to the plan that was outlined in McCulloch's letters—including Art Gallery of South Australia director Louis McCubbin, who offered to help McCulloch with his plan 'to revive interest [in] black and white artists'.[66]

McCulloch commissioned artworks from a variety of previously untapped sources as well as contributing himself. An Australia-wide call for illustrated jokes by local artists went out. Entries were solicited for literary competitions, including a generous £500 cash prize for a 'Great Australian Novel'. McCulloch bravely approached emerging contemporary artists, including Albert Tucker and Arthur Boyd along with political radicals such as Noel Counihan, to become contributors. Under his watch, their work was duly accepted and published.

Of all these artists, Counihan was often characterised as the tough dilettante. However, he showed a softer side with the submission of his first drawing for the weekly, gingerly writing to McCulloch to request his 'opinion of it' and to assist in future ideas he had in mind.[67] McCulloch was also successful in recruiting the Norwegian-born painter Harald Vike to a permanent staff position. The otherwise penniless Vike, who had arrived in Australia in 1929, was henceforth commissioned to produce two weekly jokes for the *Australasian*,

three caricatures a week for the *Argus* and occasional illustrations for associated weekend magazines.[68]

Through his work at the *Australasian*, McCulloch supported emerging Australian-born illustrators and cartoonists at a time when work and opportunity was scarce. Many of these artists would go on to become some of Australia's best-known (and most highly paid) artists, including Frank Lovell, Klaus Friedberger, Cedric Flower, William Martin and the young Vane Lindesay.

McCulloch responded enthusiastically to recommendations and approaches from artists who specialised in humorous cartoons and were serving in the armed forces.[69] The Sydney artist and illustrator Cedric Flower conveyed his thanks to McCulloch and was glad he liked his drawings: 'I should like to send you some more. Frankly, I feared you would not like the drawings or the "macabre brand of humour".'[70] One friend, a soldier posted in Darwin, was equally thankful:

> Many thanks for the *Australasian* which I received. Your double spread and write up of the Archibald Prize exh were well worth the journey over. Your article and choice of pictures chosen for the page were very interesting. I loved your comic page, 'Wartime Service', it's just about everyone's experience. The last two drawings were a scream.[71]

Recent emigrants from Europe, including Frederick (Fritz) Schonbach, a native of Vienna who arrived in Melbourne in 1938, became involved. He enlisted in the Australian Army, before migrating to Brazil circa 1946. Battered by his experiences of war and dislocated from family and home, Schonbach wrote to McCulloch from his home in Rose Bay, Sydney, questioning his ability as a cartoonist and asking McCulloch for his opinion. Schonbach postulated in response to an offer to run his cartoons in the *Australasian*: 'Has my vein of humour—which has, according to many, always been on the bitterish side—has it dried up without my knowledge or is it the poor taste or lack of taste that presents Sydney joke-block merchants from

acquiring anything that is not lifted from overseas magazines, or that is not sufficiently corny to be a genuine local product?'[72]

High hopes for the *Australasian* were shared by other Australian artists and writers. Respected cartoonist Lionel Smalley wrote to the editor in May 1946 suggesting that while '*Argus* publications had always been pretty dull' there was no 'reason why this one should be'.[73] Cartoonist Bill Martin wrote directly to McCulloch in November 1946: 'Your enthusiasm has resulted in a considerable improvement in the appearance of *The Australasian*. Good luck. Keep it up.'[74] In the same year, McCulloch proposed to George Johnston that the *Australasian* contribute £50 for best exhibit at a newly initiated Victorian Artists Society nationwide exhibition of Australian drawings.[75] Sadly, the response from management was not as enthusiastic: 'Regret it is Not possible to approve this recommendation at present.'[76]

In his role as *Argus* art critic, McCulloch took the opportunity to develop his writing skills under the tutelage of Johnston. In addition to the ordinary and often run-of-the-mill exhibition reporting, he was able to engage with artists, issues and events of significance. He used his position to support exhibitions that contributed to the war effort, or that highlighted aspects of it that had not attracted commentary elsewhere. One of these was the important *Australia at War* exhibition that was held at the National Gallery of Victoria in the spring of 1945. McCulloch noted that 'Orban, Roderick Shaw, Tucker, Counihan, Boyd, O'Connor, and Bergner are all artists of versatile and original capabilities; if they can be criticized for excessive intellectualism or social consciousness these biases in themselves can promote development.'[77]

McCulloch actively promoted the work of aspiring modernists including Aileen Dent, Lina Bryans, Constance Stokes, Mary Macqueen and the German-born artist Elise Blumann at a time when female artists were often patronised or overlooked (even though they often outnumbered their male counterparts). Blumann had arrived in Western Australia in 1938 and made a new home there far away

from the turmoil of Nazi Germany. Known for her portraits and landscapes composed in modernist styles ranging from impressionism to expressionism, Blumann held her first solo exhibition in Melbourne at Velasquez Gallery in February 1946. McCulloch wrote glowingly of her work, sensing an uninhibited approach to painting that was both 'vigorous and full of life'.[78] The same exhibition was ignored by the respective art critics from the *Age* and *Herald*.

McCulloch also introduced the Australian public to historical and contemporary European artists including Franz Hübner, George Grosz, Olaf Gulbransson and Jean-Louis Forain. He alerted readers to the case of artists who had been largely written out of recent history, including the Australian Impressionist John Russell. And he went against management by giving space to socially committed and progressive artists, including members of the Communist Party of Australia and of the recently reinvigorated Contemporary Art Society (CAS).

This was a time of transition for McCulloch, in which he discarded earlier allegiances and consolidated his philosophies concerning what made great art: this meant a shift from traditionalist ideas and conservative tastes towards a more expansive understanding and appreciation of the emergence of (a second wave of) modernism in Melbourne. In 1945, reader Rosemary Vike wrote to the *Argus* editor to support McCulloch's controversial criticism of the seventh annual Australian Academy of Art exhibition. McCulloch had characterised it as droll: 'The facts are that if this exhibition indicates accepted official standards, then the outlook for the Australian artist is pretty black.'[79]

In contrast to the sanctioned artists of Prime Minister Menzies' Academy, McCulloch brought to public attention the work of new and/or emerging artists such as Boyd, Counihan, Stokes, Tucker, Roger Kemp, Danila Vassilieff and Sidney Nolan.

Equally, he was short with art that he felt to be of little consequence or stale. This characteristic can be gauged in his write-up of an exhibition of monoprints by Tom Garrett held at Kozminsky

Galleries, Melbourne. McCulloch's review, which appeared not long after he had joined the *Argus* in October 1944, concluded: 'The effect is charming, romantic, and saleable; occasionally it is poetic, but it is too remote from life, and, seen in bulk, is much too sugary to be artistically important.'[80] His stated belief that good art was born out of a dialogue with the great art traditions and inextricably linked to the spirit of the times in which it was produced now guided his response.

Compare this to his reviews written in defence of some of the contemporary artists who featured at the 1945 CAS exhibition. Many showed modernist-inspired paintings that were mystifying to the Australian public. In August 1945, McCulloch noted how he had been stimulated by a CAS group exhibition opening at Myer Department Store Gallery in Melbourne: 'Orban, Roderick Shaw, Tucker, Counihan, Boyd, O'Connor, and Bergner are all artists of versatile and original capabilities,' he wrote.[81]

In the corresponding show the following year held at Velasquez Gallery, he was moved to note that

> Exhibitionism [has] given way to more serious motives [in] … possibly its best show to date … But the things that dominate the show can only be accepted with reservations—We may admire Albert Tucker's forceful characterisation, but detest the associations evoked by the subjects. We breathe quite freely in Nolan's naïve pictures, only to be stifled by Boyd's hysterical mob scenes.[82]

A similar sense of uneasy ambiguity is apparent also in McCulloch's review of the work of Tucker, Nolan and Boyd at the Rowden White Library, University of Melbourne, which ironically followed on from a review of the eighth annual exhibition of the Australian Academy of Art. McCulloch noted 'the stimulating, if amusing contrast' between the two and then proceeded to extol the virtues of the three artists.[83] He struggled at times to come to terms with the work of Tucker, Nolan and Boyd; however, even at this early stage in his development as a critic, he was one of only a few writers in a position to bring the work of this new generation of artists to the attention of the Australian (Victorian) public.

Despite the *Australasian*'s innovative ideas and enterprising content, and an eclectic mix of contributors, the proprietors' concern over falling circulation and interest was apparent as early as October 1945.[84] McCulloch had been forwarded a copy of Bernard Smith's landmark publication, *Place, Taste and Tradition: A Study of Australian Art since 1788*, by its author for the purposes of review. His lengthy and sympathetic review of the first Marxist interpretation of Australian art history was certainly appreciated by Smith but proved to be another example of how his support for modern art and ideas was repeatedly falling foul of his management.[85]

By the beginning of 1946, McCulloch made known his strong views on the direction taken by the *Australasian*: 'its fluctuating attitudes and sporadic attempts at this and that'.[86] McCulloch was also under increasing fire for his non-compliance with editorial edicts and support of non-establishment artists. This stood in contrast to the pride he and fellow *Australasian* contributors felt when their drawings were acquired for the National Gallery of Victoria from a 'carefully selected exhibition of drawings by local artists, now at Myer's gallery, [which] is causing widespread interest'.[87]

Against his best advice, *The Australasian* transformed into *The Australasian Post* in April of that year, introducing a lifestyle-driven approach that incorporated colour photographs, a magazine format and light articles. In December, McCulloch received a letter of termination as art critic, along with one month's pay 'in lieu of notice'.[88] It did not come as a total surprise given his forthright views. McCulloch later revealed, in an interview with art historian Richard Haese, the incessant pressure he was under from *Argus* management 'to write critically of left-wing artists'.[89] He had also weathered a barrage of heavy-handed editing from the outset of his appointment. He had the ignominy of learning of his fate at second-hand, while on leave.

Whereas McCulloch had looked to create a new era of black and white art in Australia, he found instead that he was witnessing its demise. He now believed that the painter and sculptor had taken over from the cartoonist and that the best course of action, personally and

professionally, was to further his studies overseas. He had weathered an escalating torrent of criticism and his writing was frequently 'massacred' by copy editors. However, he was generous in praise for the *Argus* editor-in-chief Mr Knox, whom he acknowledged for giving McCulloch his first real break and supporting his quest to encourage 'knowledgeable, sincere, and really inspired art'. McCulloch's parting message to Mr Knox was an impassioned plea for informed criticism in newspapers, or to publish none at all.[90]

CHAPTER 2

ON THE ROAD

THE THREE YEARS that Alan McCulloch spent abroad in America and Europe from 1947 to 1950 broadened his knowledge and understanding in a way that books, broadcasts, lectures and conversations could not. He encountered important American and European masterpieces and sought out revered examples of American and South American Indigenous art. He was confronted with recent developments in contemporary art and encountered black and white illustration from a multitude of sources. McCulloch mixed socially with internationally renowned artists, writers, critics and performers, with some becoming lifelong friends and correspondents. He attended important art events, including the First International Congress of Art Critics in Paris in 1948, and published and exhibited his work widely. These three years instilled in him the visual literacy and necessary bravura to prepare him for longevity both as an artist and as a critic.

The seed of McCulloch's overseas sojourn was sown just a few days after he received the letter from the *Argus* outlining his termination. The proposed destination of his first trip abroad was not Europe—'the cradle of Western civilisation'—as might have been expected, but the United States and then South America.[1] McCulloch envisaged giving a lecture tour on Australian art and writing a series

of articles for Australian newspapers based on interviews with artists and impressions of galleries and cultural centres.

McCulloch approached the director-general of the Australian News and Information Bureau for assistance in arranging an illustrated lecture tour for the new year.[2] With the encouragement of the chief publicity officer of the Australian government's Department of Information,[3] he wrote letters of introduction to organisations such as the General Federation of Women's Clubs in Washington, DC and the Metropolitan Museum of Art, New York. McCulloch had capitalised on his friendship with the director of the National Gallery of Victoria, Daryl Lindsay, by writing in the third person to the director of the Met. He fulsomely extolled his virtues by suggesting that: 'In the event of an Australian present day art collection going to the States it would be most usefull [sic] to us to have Mr McCulloch on the spot to tour with it.'[4]

McCulloch's ambitious plan to leave Australia as an official foreign correspondent for the Melbourne *Herald* was dashed prior to leaving home. Keith Murdoch informed him at the last minute that he could never justify paying McCulloch £500 per year for a fortnightly column. Instead, Murdoch offered to 'take only a few articles' at £10 each. He did not share McCulloch's enthusiasm for the work of American artists; rather, he suggested focusing on 'American displays of art', including 'gallery buildings and design'. This instruction was in keeping with Murdoch's own interests and his ambitions for the NGV, of which he was now chairman.[5] Undeterred, McCulloch left Australia in early 1947, clutching a letter of recommendation and a handful of verbal introductions.

San Francisco and Los Angeles

With the sniff of the briny, McCulloch arrived in San Francisco on 2 May 1947. The weeks following (and much of the preceding eight-week boat trip from Auckland) were productively spent. He was kindly offered the run of a millionaire's estate in Ross, Marin County,

as his arrival coincided with the end of the university lecture season in the United States. From this luxurious bathhouse setting he set about completing a manuscript on the NGV collection that had been commissioned prior to his departure.[6] By the end of May, he happily conveyed to his mother, Annie, that he was 'at long last on the last stages of the book', which he had 'slogged away at ever since I had arrived'.[7]

Once freed from writing, McCulloch arranged introductions to artists, academics and museum directors and visited numerous galleries and museums. His experiences there and soon after in Los Angeles were to have a transformative effect. McCulloch wrote to Grace McCann Morley, director of the San Francisco Museum of Art, thanking her for her help in securing speaking engagements and recording his intoxication with what he had seen:

> The art world of San Francisco continues to be a fascinating experience for me: the very interesting American work in your museum, El Greco's wonderful 'Adoration of the Shepherd' (the most magnificent piece of painting I have ever seen), to say nothing of the marvellous Goya 'Bull Fight' (could anything be more purely impressionistic?) and the Titians and Tintorettos at the Legion! I doubt, if I had to lecture at this moment, whether I could utter one syllable.[8]

The revelations provided by European old masters, including an El Greco retrospective, were counterbalanced by seeing exhibitions of contemporary American, British and European paintings and drawings. Leaving San Francisco, McCulloch went to Los Angeles expressly to see the Edward G Robinson Collection from the Museum of Modern Art, New York, and to meet the Italian-American artist Rico Lebrun. While an appointment to see the Robinson collection was cancelled at the last minute, McCulloch did meet Lebrun, saw an exhibition of his drawings and was invited to attend classes conducted by him at the Jepson Art Institute in Los Angeles. Lebrun's direct, uncomplicated style of teaching and his understanding of, in McCulloch's words, 'the meaning of line' confirmed McCulloch's

admiration of him. Henceforth, McCulloch championed Lebrun as 'one of the two greatest draftsman [*sic*] in America [and] the greatest influence in my life since Dyson (that is in drawing)'.[9]

McCulloch approached potential publishers in San Francisco and Los Angeles to promote his caricatures and illustrated travelogues. Heartened by the response and the offers of work, he felt reassured that his style of line drawing and mastery of techniques would stand him in good stead for future assignments, both in California and later New York. He continued to sketch the people he met and the places he went. This included a caricature of the controversial and reclusive American author Henry Miller and his family, which was drawn at Miller's retreat at Big Sur. At that time Miller was being openly vilified by the newspaper chain controlled by Randolph Hearst for reputedly undermining the social fabric of American life.[10] One of McCulloch's drawings of Miller was eagerly sought by the *Monterey Peninsula Herald*, even though McCulloch was reliably advised by American artist-friends 'that it could have fetched up to $200 from the Hearst's!'[11]

McCulloch also successfully pursued his idea of presenting lectures in selected US cities. The chief publicity officer at the Department of Information in Canberra wrote to McCulloch in June 1947 to send images of Australian art as requested: 'It is good to know that you have settled down so comfortably in the United States and that John Hewitt has been so helpful. I hope that he and Gavin Casey are able to arrange for you a really effective lecture tour that will help put Australian art on the American map.'[12]

Hitchhiking south from San Francisco to Los Angeles via Monterey, McCulloch had reached a realisation that 'he now had something to write [and draw] about' and that he 'must start sending stuff to the *Herald*'. He reflected further on his chosen vocation when he wrote: 'As for me I have achieved a state of freedom which I never thought possible—my home is my jungle hammock, my living is my pen and a piece of paper.'[13] McCulloch understood that in the United States there was an understanding and empathy

for his work, and that a market existed for his style of drawing and travelogue writing.

Plans to hitchhike to New York during the heat of summer were sensibly replaced by the offer of a shared road trip. Returning to Marin County, McCulloch was joined by Kay Fawkes, an Australian consulate official, and Ellen Moscovitz (nee Bromley). Moscovitz was an Australian-born US citizen and an actress known for her role in an early Australian talkie, *Secret of the Skies* (1934), now working as a manager for the American cosmetic company Elizabeth Arden. Ellen had met Wilfred McCulloch in Melbourne and through him Alan. Ellen and Alan had worked at the Commonwealth Bank's city branch in the early 1940s, becoming close before meeting up again in America.[14] McCulloch was disappointed not to have stuck to the original plan to travel by foot across America; nonetheless, he reasoned that it was compensated by having an opportunity to visit the great museums of Chicago and Detroit. The three Australians set off from San Francisco in a Chevrolet that had been bought for the purpose. Fawkes only travelled as far as Reno, but McCulloch and Moscovitz made their way across the American heartland and eventually arrived in New York.

New York

The New York that greeted Alan McCulloch was abuzz with excitement and purpose. After the austerity of the war years, people were once again able to celebrate life and their new-found freedom. Art exhibitions, lectures, performances and concerts abounded. Artists from across the world gravitated to the United States, with many congregating in relatively cheap or abandoned warehouses and tenements in SoHo and across Manhattan.

McCulloch thrived within this highly competitive field. He set about making inroads into the seething cultural metropolis, first taking a small apartment on the Bowery—in a precinct that was then home to many Russian and Ukrainian immigrants—and after that

building burnt down, relocating to West 103rd Street. The mornings were spent writing, drawing and preparing radio broadcasts and lectures on Australian art. In the afternoon he attended lectures and exhibitions and hosted visits from friends. The nights were reserved for dinners at sidewalk cafes and going to clubs, the theatre and artists' studio parties. McCulloch wrote to his mother in August 1947: 'Twenty-four hours is not long enough for a day in this city, I make no appointments until 1 p.m. of any day—it's the only way I can get any work done.'[15]

McCulloch and Moscovitz became lifelong friends of Dorothy and Oscar Hammerstein, the celebrated lyricist and librettist, through Ellen's contacts. Through them, McCulloch entered the heady New York theatre and acting scene. His wide artistic and literary circle included artists Ben Shahn, Jack Levine and Saul Steinberg, *New York Times* cartoonist Al Hirschfeld, drama critic Brooks Atkinson and playwrights George Kaufman, Moss Hart and others. McCulloch was a keen chess player and one evening took on Marcel Duchamp at a New York nightclub. McCulloch later recalled commenting during the game that he now had a better understanding of Duchamp's seminal work *The Bride Stripped Bare by Her Bachelors, Even (The Large Glass)* (1915–23), though he chose not to elaborate on the insight he had gained.[16]

McCulloch sought out expatriate Australian artists and writers, something he was to do in most places he visited. In New York this included ex-Meldrumite Percy Leason, who had left Australia in some controversy and, according to McCulloch, was shy to the point of absurdity; art educator Mary Cecil Allen, with whom he continued to correspond once back in Australia; and the painter Philip Evergood, son of Australian-born Miles Evergood, whom he would paint with again in Italy. Such connections enabled McCulloch to keep abreast of the latest artistic developments and exhibitions in America when he eventually returned to Australia.

In one of her subsequent letters to McCulloch, Allen gave a humorous account of the emergence of the young New York School

action painters through her experience of Abstract Expressionist painter Hans Hofmann's summer school in Provincetown. As students experimented with gravity-fed painting techniques such as dripping and pouring paint directly from the tin, their actions were met by Hofmann's excited cries in broken English: 'What Spontinaety [sic]'.[17]

McCulloch used every opportunity to promote Australian artists and art abroad. On one occasion he lunched with the highly influential Alfred Barr Jr, director of New York's Museum of Modern Art. McCulloch gave him a copy of the lively (but soon to be short-lived) journal *Australian Artist* and an impressed Barr 'agreed to write a short piece' for a future edition. After completing a short art history course under academic and writer Bernard Myers at the Art Students League of New York, McCulloch wrote to the league's management to make the case for establishing a scholarship for Australian artists there.[18]

McCulloch had long been an admirer of expatriate Australian artist John Russell, believing that Russell's work and role in the Impressionist movement in France had been misunderstood and undervalued. Alan and Ella met with Russell's widow, Caroline, who lived in relative seclusion in a cottage on Long Island with her sister, surrounded by her late husband's art.

During this convivial visit, the pair were excited to 'hear at first hand from Madame Russell some of the conversations that John Russell had with Van Gogh, Manet, Monet, Tom Roberts and others of that great era'.[19] Madame Russell presented McCulloch with two John Russell watercolours—one of Portofino, Italy, and the other a late work of Sydney Harbour. This act of kindness was repaid by McCulloch many years later when he wrote an essay on Russell that sought to reinstate his reputation as, in McCulloch's words, 'the only true Impressionist that Australia has produced'.[20]

McCulloch also wrote to George Grosz in the hope of making contact, an exercise in which he was successful. Grosz, the celebrated Weimar Republic satirist, had emigrated to America in 1934 through the aegis of New York's Art Students League and had settled upstate with his wife in Huntington. McCulloch was advised by New York

contacts that Grosz had 'lost his edge', but the brief time they spent together made a profound and lasting impression.

McCulloch acknowledged that the influence on his work of Grosz and the artists associated with the graphic journal *Simplicissimus* was comparable to that of Dyson, praise of the highest order.[21] McCulloch's irreverent cartoons show a similar economy of line to Grosz. This includes the elimination of shading and bodily weight and a similar exaggeration of facial features. Grosz replied to McCulloch's letter of introduction by inviting him to visit for a 'little party' at his country cottage. Later, in April 1948, Grosz also responded favourably to an article on his drawing that McCulloch had written for the *Australian Artist*. Grosz remarked that the 'magazin [sic] looked good, if a little on the french side though'.[22]

In the same letter Grosz went on to allude to what would become a central theme of McCulloch's own writing: the unwelcome intrusions on art and social life by a world now driven by technology, machines and science. The elder artist ended with a pessimistic rejoinder that predicted the moral demise of Western civilisation: 'The other day I studied a map of Australia, what a continent I'd say … vast and tremendous, I wonder what kind of Art may "develop" there in the future, after Europa is dead.'[23] McCulloch had the opportunity to see a 1948 exhibition of Grosz's work at the Associated American Artists (AAA) gallery, New York. The resulting review was sent back to Len Annois to publish in the *Australian Artist* the following year, putting this firsthand knowledge to practical use.[24]

After his visit to Grosz, McCulloch returned to New York and busied himself with a cultural exposé of American life. By mid-August 1947 he had finished his first piece. It was intended for publication in the Melbourne *Herald* and was entitled 'Bohemia on the West Coast'.[25] The response to the illustrated essay in Australia was not encouraging. *Herald* editor RK Thomas regarded this first article as 'not suitable for a daily newspaper', complaining that it was written for 'well-informed art lovers' and not the general public.[26] The follow-up pieces were also rejected—a major disappointment for

McCulloch. He found solace in the fact that he was gaining kudos for his literary and graphic work across America, and wrote proudly that he had been welcomed with open arms by a group consisting of a former editor of *Life* magazine, 'an editor of *The New Yorker*, and the editor (before the Nazis) of "Simplicissimus" (who is now living in New York)'—men who praised his work as being in the 'same class as Gulbranson'.[27] Plans to launch a new magazine along the lines of *Simplicissimus* and *Vanity Fair* were unfortunately, for McCulloch, still twelve months off.

Alan McCulloch married Ellen Bromley Moscovitz on 18 September 1947, at a simple ceremony in New York's City Hall. A month earlier, McCulloch had entered the highly competitive world of joke-block illustration. Following meetings with the art editor of the *New Yorker*, he had been placed on their list of contributing artists.[28] The editor of the *Saturday Evening Post*, William J Bailey, following his acceptance of a drawing in December 1947, noted that: 'I will be happy to send you some more articles when some suitable ones come along.'[29] Three further drawings, illustrating war anecdotes, were commissioned, and two published with the corresponding stories in April 1948.[30]

Potentially even more lucrative was an assignment with *Holiday*. This publication was revered by McCulloch and others as the 'the finest magazine in America'. Where in Australia he had been constantly urged by the *Argus* and *Australasian Post* to emulate the artists of the *New Yorker*, he found that once in America all these artists craved work with *Holiday*. A contract was signed following a visit to the Curtis Publishing Company in Philadelphia (who also managed the *Saturday Evening Post*). The agreement was initially for two pages of drawings to cover the cost of the transcontinental trip.

McCulloch worked conscientiously on the drawings—in Ellen's estimation, redrawing and redrawing in pursuit of perfection—finally invoicing the Curtis Publishing Company US$500 in November 1947 for his first illustrated feature on San Francisco. This was followed by the promise of US$2500 for illustrations and text on Los Angeles, Reno, Salt Lake City, Chicago and New York.[31]

These were princely figures to be paid upon receipt of the articles, almost unthinkable for an Australian artist/travel correspondent and a measure of the regard in which he was now being held. McCulloch proudly recounted: 'They have told me that in the whole of America with its 200,000 artists that there are only two others Bennelmans and Steinberg (neither American born) who can write and draw up to my standard.'[32]

Despite his success in penetrating the American black and white scene (but in the hope of continuing as a contributor to *Holiday*), McCulloch informed the editor, James Yates, of his plans to leave New York for Europe. The proposed itinerary included a cycling tour with his new wife from Paris to Holland, then on to Sweden and Norway and across to the British Isles before heading back to Paris.[33] Ellen McCulloch wrote home to her new mother-in-law in Australia, explaining: 'Alan wants to paint and draw furiously all the time we are there, besides meeting artists, and visiting all the marvellous galleries he has always dreamed about, and I will be happy joining in all his adventures as I have in America.'[34] In a major blow, Jan Hine, the new editor of *Holiday*, informed McCulloch that she had 'finally decided against the material you sent me'. She left him with a more hopeful rejoinder regarding his newly proposed cycling travelogue project: 'Next time try a tandem.'[35]

The Australian Artist

Alan McCulloch worked hard to remain in contact with Australian artists and publishers while in America. There were outstanding projects and several promises to honour, as well his prearranged contributions to local art journals. The demise of *Art and Australia* during the war and a dearth of mainstream journals devoted to Australian art was a cause of concern for McCulloch and his contemporaries. Small magazines such as *Angry Penguins* and the Contemporary Art Society's *Broadsheet* had helped to launch modern art and artists in a local context; however, there was a perceived gap for artists associated

with other more mainstream arts organisations, such as the Victorian Artists Society (VAS), to promote their work.

McCulloch helped to launch the broadsheet *Genre* in May 1946, in association with artist-friend and fellow VAS member Len Annois. McCulloch contributed an essay, 'Popularity Is No Criterion', for the first issue. This was a provocative essay that admonished artists who accepted popularity and commercial gain as their chief criterion of success. An essay for the following issue was equally didactic, discrediting the idea of verisimilitude as an artist's overriding aim. McCulloch explained how works such as William Dobell's *Billy boy* (1943) awakened the viewer to 'a further consciousness of character', remarking that 'the emphasis is on a *felt* as well as a *seen* resemblance'.[36]

Genre was replaced by *The Australian Artist* in 1947. The new quarterly was essentially a VAS publication. It was to be edited by Richard Haughton James (an industrial designer who had recently moved to Melbourne from Sydney) and Len Annois, with production overseen by Percival Searle, Alan McCulloch and artists Nutter Buzzacott, Noel Counihan and Ian Bow. The editorial policy of this reincarnated VAS magazine focused initially on how it was to survive. Topical themes were subsequently adopted for each issue. The first, on drawing, was followed by 'Personality in art', and then in the third issue by 'What is art worth?' The editors hoped to broaden the audience for Australian and international art but to make the magazine commercially viable at the same time.

The first issue went to press in winter 1947. The ambitious nature of this magazine showed McCulloch's guiding hand, evident in the content of Annois' editorial notes, and in the foregrounding of drawing as its theme, with the lead article by McCulloch titled 'Reflections on the Meaning of Drawing'. The selection of a diverse range of writers included close friends and colleagues Adrian Lawlor, Noel Counihan and Joseph Burke OBE. Burke was a recently arrived English scholar whose appointment as inaugural Herald Chair of Fine Arts at the University of Melbourne had been championed by McCulloch, among others.

Following the publication of the first issue, Annois wrote to McCulloch in America advising him that the reception and sales had been good, notwithstanding 'the George Grosz illustration [in your] articles and the Matisse + Picasso drawings [that] brought forth yelps from the prurient minded and a long abusive letter from a Methodist Minister from Sale'.[37]

The entirety of the planning and production of the next few issues of the *Australian Artist* were completed while McCulloch was overseas. The second issue featured another of McCulloch's pet subjects— the importance of subjectivity in the creation of art—along with contributions from writers he admired, including veteran Sydney art critic Paul Haefliger. Haefliger's article on the development of personality in the art of Picasso, which according to Annois also stirred up 'some controversy', was very much in the McCulloch mould.[38] As previously discussed, McCulloch also supported the magazine by promoting it in New York, coaxing art-world luminaries such as Alfred Barr Jr to become a contributor and sending some of his own illustrations, such as his portrait of Cubist stalwart Georges Braque sketched on location in Paris.

In March 1948, James asked McCulloch to collect information on mural painting for the next issue, stating: 'We want to show some of the ways in which, given a modicum of support from an enthusiastic public, a great deal more paying work can be found for the artist, especially murals.'[39] Despite his contributions, McCulloch later expressed criticisms of the magazine's shortcomings in a letter to Annois.[40] Production of the magazine ended abruptly. In mid-1949, Annois reported that it was 'definitely finished—our last number will be published within a fortnight'.[41]

The *Australian Artist* was beset by external criticisms of active Communist Party member Noel Counihan being part of the editorial committee. Internal squabbling (including perceptions regarding the interference of Communist Party artists with the society exhibition program) were also rife: 'Haughton James [was] dismissed from Editorship, to enable the Society to publish the last number without

Haughton James' double page diatribe against the [editorial] Council.' McCulloch later reflected: 'The last great revolution in the VAS occurred in '46–47 when the "Australian Artist" was launched. The amateurs won in the end, but it was a memorable engagement.'[42]

Masterpieces of the National Gallery of Victoria

While he was living in the United States, McCulloch also spent much time writing and planning for the first major publication focused on the National Gallery of Victoria's collection. The tyranny of distance was sorely felt at times. After much toing and froing, the publication ended up being quite different from what was originally planned.

McCulloch was originally sent a draft agreement in October 1946, specifying that he was to co-produce the first comprehensive publication on the NGV's collection. Melbourne-based Cheshire was appointed as the publisher, with Andrew Fabinyi as its editor. In December 1946, Ursula Hoff, then the NGV's assistant keeper of prints and drawings, and McCulloch signed the contract. The two authors were each to receive a 5 per cent royalty on the proceeds from sales, with the contract countersigned by director Daryl Lindsay.[43] Hoff was asked to write on the fourteenth to eighteenth centuries, and McCulloch from the nineteenth century to contemporary times. Joan Lindsay, Daryl Lindsay's wife and a celebrated author in her own right, was employed to assist with editing and contributing some of the entries about sculpture.

The initial feedback that McCulloch received on his manuscript was positive. Hoff acknowledged the arrival of 'the book' on 30 June 1947, congratulating McCulloch on his foreword. She also thanked McCulloch for 'additions and corrections to my stuff and the compliment paid to my Rembrandt' and looked forward to 'commenting in more detail once she had read the rest in Daryl Lindsay's absence'.[44]

Lindsay, however, expressed disappointment—it was not what he expected or what was 'required for a book of this kind, which will be used by scholars all over the world'. His view was that the only

logical course of action was to rewrite the introductions to each entry by 'getting Hoff and Joan [Lindsay] to collaborate on rewriting the modern section'. Somewhat reluctantly, Joan Lindsay consented to the demand.[45] In a further blow, Lindsay's honorarium and payment for Hoff's extra work was to be extracted from McCulloch's share of the royalties.

Pressure was mounting internally to set the letterpress and commence printing so that the book could be available in early 1948. The deadline was conveyed by Hoff to McCulloch in November 1947. Hoff's letter also included mention of the 'ungrateful tasks ... that [have] fallen to our lot' as editor of McCulloch's texts, adding: 'I won't tamper with anything that can be safely left standing.' McCulloch wrote to Daryl Lindsay setting out his side of the story and making suggestions on how to move forward. The letter followed a phone call from McCulloch to Lindsay from New York that cost a princely US$75.[46]

Whereas Lindsay had been expecting, in his words, 'a short biographical note, some relative matter on the painter's place in art, and some descriptive matter on the picture produced to link it up',[47] McCulloch had provided text that was more discursive, or at the very least, highly opinionated. Some of his assessments of the work and careers of artists included in the book were not complimentary. His draft text on Donald Friend, for example, painted a picture of an artist that was 'too flashy' for his own good. According to McCulloch, 'He is like a singer who trills magnificently up and down the scales without having the slightest intention of engaging in a serious work.'[48] McCulloch's primary concern was how art could be a successful union between the artist's temperament and a suitably engineered plastic or visual equivalent. In his opinion, Friend didn't meet this criterion.

The publication date was delayed while Hoff and the Lindsays reworked the existing text and McCulloch worked on new material.[49] Fabinyi finally wrote to McCulloch in August 1949 to inform him that the 'Gallery book has at long last made its appearance. Last night

there was a very happy party in Mr Lindsay's office, and the first copy was handed by Mr Lindsay to Sir Keith Murdoch, and by him to the Premier.' He added: 'We were all tremendously pleased to have your mother with us on this occasion, and as you can well imagine she was your worthy and charming representative.'[50]

Fabinyi and McCulloch would work together again under better circumstances. In the short term, McCulloch was able to provide Fabinyi with introductions to George Grosz, Dorothy Hammerstein and George Kaufman during his visit to the United States.[51] The gesture helped to cement a professional relationship that was to extend well into the 1950s. Cheshire was a publishing venture with lofty ambitions, and it continued to grow in its aspiration to introduce and maintain new standards in the Australian publishing industry.

Paris to Positano

Departing New York on 15 May 1948, Alan and Ellen McCulloch arrived in Le Havre, France, on 24 June. They settled into a hotel on Paris's famous Left Bank and McCulloch happily immersed himself in the art and street culture of early summer. Like New York's residents, Parisians were happy to be released from war. Despite ongoing reconstruction of the city and a shortage of food and essential goods, most people went about their business unimpeded. As he had done in New York, McCulloch captured the vitality of the city and its gregarious people in the many pencil sketches he made at places that he and Ellen visited.

A contingent of Australian artists were also visiting or had settled in France in the late 1940s. McCulloch contacted some of those, including the painters Albert Tucker, Mitty Lee-Brown, Sam White and Sam Atyeo, who had left behind his early modernist experimentations in art to become a farmer and advisor to the Australian government in Paris. Robert Klippel, sculptor, later recalled in a letter to McCulloch: 'I don't know if you remember me in Paris when we went around some galleries together, that was 1949 or 50?'[52]

McCulloch saw his first major Impressionist exhibition and, in company with Albert Tucker, visited Chartres and took in other exhibitions of contemporary French and Italian artists. The artists sketched together, with McCulloch noting in Tucker's pencil studies the beginnings of a series devoted to psychological head studies.[53] McCulloch retained several of these (including an intense portrait of a seated man that he later sold at auction) and a portrait of himself that was later acquired by the Mornington Peninsula Regional Gallery, Victoria. In this intriguing portrait, McCulloch is depicted with one eye facing in and one out—a strong gesture that according to Tucker referred to McCulloch's dual life as an artist and a critic.[54]

McCulloch's entrée into the official Parisian art world was aided by introductions to artists' ateliers and galleries following his attendance as an unofficial delegate to the First International Congress of Art Critics held in the UNESCO pavilion in Paris, 1948.[55] The relevance and viability of the School of Paris, and abstract art, were being openly questioned by influential art critics, including Waldemar George. Writing from his new posting with the University of California, art historian Bernard Myers concurred with McCulloch that George's 'statement about the replacement of abstract art by realistic art' was undoubtedly true and that this had already happened in the United States—the increasingly 'moribund' nature of the School of Paris there, 'demonstrated by the 1947 exhibit at the Whitney, means that something must be done'.[56]

Alan and Ellen McCulloch purchased a tandem bicycle in preparation for their cross-country journey. On 2 August 1948 they left Paris bound for Positano, Italy. The subject of his second illustrated book, *Trial by Tandem*, as well as unpublished essays including 'An Artist of Positano',[57] the adventurous journey would take them across the South of France and into northern Italy before concluding on the Amalfi Coast. Staying in hostels along the way, they visited the Fontainebleau Forest and Lyon, and several places associated with the Barbizon School. They cycled through Van Gogh's Arles in Provence, following in the artist's footsteps to nearby Saint-Rémy.

Marseilles, Cannes and Monte Carlo were reached, with the intrepid cyclists eventually crossing the Alps into Italy.

In Italy, the McCullochs toured Genoa and Portofino and stayed at the villa of a vicomte and his Australian wife before arriving in Venice in time to witness the first post-war incarnation of its famous biennale. According to McCulloch, it was 'the greatest collection of contemporary art ever to be assembled in one place'.[58] Included in the program were solo exhibitions by Pablo Picasso, Oskar Kokoschka, Georges Braque, Marc Chagall, Georges Rouault and Henry Moore—McCulloch's artist-heroes. Venice was followed by Florence, Siena, Rome, Naples, Capri and Pompeii, with the newlyweds finally parking their tandem in Positano on southern Italy's Amalfi Coast. There they had the good fortune of meeting the Swiss sculptor Isolde Grishuna-Hetz, who invited them to move into her villa, also occupied by fellow Swiss expats Brunhilde (Damira) Smith-Kind and Ady Fogolin Kind.

The glistening waters of the Mediterranean and small clifftop villages formed the backdrop to a thriving community of artists, among them a German painter who was the former president of the Düsseldorf Academy. Artist-friends such as Oliffe Richmond came to visit, and he and McCulloch went sketching together at Amalfi and Ravello, prior to Richmond heading back to England to become Henry Moore's studio assistant. By far the greatest influence, though, was Grishuna-Hetz. McCulloch learnt much from her, particularly in the spiritual and psychological use of colour, noting: 'And [now] I had to feel the color, as well as to see it, before I set it down.'[59]

In retrospect, many of McCulloch's watercolours and gouache paintings from this period echo such sentiments through their bright colour palette, exuberant brushwork and intriguing bird's-eye perspectives. McCulloch recorded in his diary that their 'idyllic existence at Positano came to an end in the early spring' of 1949. Ellen was pregnant and the baby due in three months. He had also 'finished a good many paintings which [he] hoped to exhibit in London'.[60]

Exhibitions

From Positano, McCulloch had written to Gino Nibbi, asking for advice on the best way to secure an exhibition in Italy. An advocate for modern art, Nibbi was credited with bringing contemporary European art into Melbourne through his bookshop in the inner-city. He had subsequently returned to Italy, where he assisted other Australian artists, including Albert Tucker and Sidney Nolan, to secure exhibitions. Nibbi's suggestion to McCulloch was to consider holding an exhibition in Rome. He gave contact details for a Mr Gaspero Del Corso of 'The dell Obelisco', to whom Nibbi had recommended McCulloch. It was an act of blind faith and generosity, since Nibbi added that he was 'not acquainted with your [recent] creative work'.[61]

In early 1949, McCulloch followed up with a letter and photos of his work, and both Nibbi (and Del Corso) responded enthusiastically, with Nibbi writing:

> Personally, I like your work, and I feel certain that many people here in Rome would like it ... I am pleased to see that you have progressed so much since I saw your first sketches in Melbourne. What is important is not to see that pictures are cleverly conceived and executed, but that the approach is a personal one, where echoes and derivations are no longer detected.[62]

Del Corso's gallery was heavily booked until the summer, and Nibbi's own plans for a gallery bookshop were not far enough advanced for it to play a role as an alternative venue. He now suggested that McCulloch hold onto the pictures for exhibition at a later date. Nibbi wrote to McCulloch again in February 1949, relaying Del Corso's decision not to proceed with a show of his work, and to advise him that the timing was not good. His own building, earmarked for use as a gallery, had been reassigned by the Allied Control Commission. According to Nibbi, 'it is unlikely the burocracy [*sic*] will expedite things'.[63] Nibbi eventually established his gallery in Rome—and hosted a show for Grishuna-Hetz on McCulloch's

recommendation.[64] By this time, however, McCulloch had moved on and arranged a showing of his work in London.

In England, the McCullochs moved to a cottage outside London in Sidcup, Kent, for the summer months of 1949. With Ellen now heavily pregnant, Alan used the time to prepare for a show of his Italian works, continue his correspondence with artist-friends in Melbourne and undertake short trips. The latter included a visit to meet the McCulloch family relatives, who hailed from the Isle of Skye. He had been writing to Len Annois and Harald Vike sporadically, sharing his art experiences and conversely getting their reactions and updates on the local art scene. In reply to a letter the McCullochs had sent from Salermo, Vike commented,

> I am still very much Impressionist but am trying hard to add something more solid to it. I have been thinking a lot about your gouache paintings. It would be a very interesting medium … (and from reading a letter to Len) I was particularly interested to see what you said about Arles as I have been very interested in Van Gogh.[65]

Contact was re-established with Oliffe Richmond, who had returned from Positano via Orvieto and was now working with Henry Moore. In a mood of despair, Richmond had earlier reported to McCulloch that his attempts to gain a gallery showing of his work in London had not been successful: 'England is cold and grey, so are the English.' 'I have ordered stone and clay but so far am impoverished of ideas, having been idle for far too long,' he wrote.[66]

McCulloch settled in to painting and according to Ellen was 'working feverishly'. The challenging work paid dividends when, with the help of Australian critic Colin MacInnes, McCulloch was invited to exhibit six of his expressionist works in a summer show at St Georges Gallery in London in mid-1949. Although McCulloch was conscious that it was a summer show, which meant that many people would be away, it was the first 'serious' exhibition of his studies of Italian life. It was also the first that he had been offered since an invitation from Alan S Warren to participate in an exhibition

of contemporary Australian drawing at Myer Gallery, Melbourne, extended prior to McCulloch's leaving Australia in 1947.[67]

McCulloch would have been chuffed to learn that his highly keyed gouaches from Positano were to appear alongside a work by the European master Paul Klee, as well as works by renowned English artists including Ben Nicholson and Graham Sutherland. Reviewing his work in the *Sunday Times*, its resident critic Eric Newton noted that while McCulloch was 'a painter who sometimes lets his excitement run away with him, [he] is at least, excited, as though he [has] just discovered Siena or Positano or an old man in Capri …'[68]

McCulloch also busied himself with preparations for the Second International Congress of Art Critics to be held in Paris in 1949. This time McCulloch was designated as an official delegate and, along with Albert Tucker, was invited to deliver a keynote address. Tucker wrote to McCulloch in Sidcup, reporting that he was 'resuming his notes on the Congress'. 'I hope yours is on the way. I am continuing mine in the manner I outlined to you.'[69] For his lecture, McCulloch made the case for critics as 'guides for the uninitiated', open-minded and straightforward. In a sentence that was to inform the philosophy and trajectory of his writing upon his return to Australia, he ended with the statement: 'For simplicity is a cardinal virtue, and clarity is a voice that sings in heaven.'[70]

The McCullochs were to return to Australia in December 1949. Tucker's parting letter to Alan acknowledged his own dilemma and his isolation from his home country. He asked McCulloch to write to him about 'what it feels like to return'. 'I have the urge to go back occasionally myself,' he added, 'but then I'm sure I would miss Paris more from Australia than I miss Australia from Paris.' While McCulloch was bound for home, having achieved what he had set out to do, Tucker indicated that he himself was less satisfied. He was to stay on another year, 'then [go to] New York by hook or by crook'.[71]

CHAPTER 3

THE CRITIC RESPONDS

How did I become an art critic? Briefly, because one misguided day some 30 years ago I set pen to paper to try and inspire others to share my enthusiasm for a painting by an artist named Dobell.

Alan McCulloch, 1971[1]

FROM HIS RETURN to Australia in 1949 until the late 1960s, Alan McCulloch's work increasingly shifted from illustration and drawing towards writing, lecturing, advocacy and broadcasting. The change in emphasis stemmed from a dissatisfaction with what he and other like-minded art critics believed to be the paucity of art criticism in Australia during the 1940s and 1950s. McCulloch felt that a general lack of understanding and appreciation of contemporary art by the Australian public required immediate attention. The emergence of some critics whom he held little regard for, as well as the related lack of a firm foundation or organisation to support Australian art critics and artists, was also a primary motivator for McCulloch and other prominent Australian critics.

Arts writer Simon Plant used the phrase 'Patrolling the Frontiers' as the title of his 1995 thesis to describe McCulloch's role during these years.[2] It is an apt description. McCulloch hatched his most ambitious ideas from the relative security of the family home on the Mornington Peninsula, free from art world politics and machinations.

The calming environment of Shoreham and Western Port helped him to produce his most ambitious tomes. 'Whistlewood' became a haven for artists and arts professionals. It was close enough to Melbourne for them to visit, enjoy Alan and Ellen McCulloch's company and relax in their idyllic surroundings near the beach.

Return home

Alan McCulloch, Ellen and baby Susan departed England on 26 October 1949, aboard the *Strathmore*. Their arrival in Melbourne was acknowledged by the *Age* under the headline 'Artist and Wife Return Home'. This was followed by other newspaper articles of the same ilk and an interview with the legendary 3KZ broadcaster Norman Banks. According to Banks, McCulloch had returned to Melbourne after a 'successful London exhibition', with his wife, 'former actress, Ella Bromley'. At this stage, Ellen was possibly the better known of the two.[3]

The couple and their child stayed initially at the family home in suburban Glen Iris. Soon after, they purchased a cottage on 15 acres (6 hectares) at Shoreham, near Western Port, 90 kilometres south of Melbourne. The original weatherboard cottage had been built in 1870 by a son of Henry Tuck, one of the first white settlers in the area, who also hailed from the Isle of Skye. Sixty years later it passed into the hands of Charles Smart of Bates, Smart and McCutcheon architects, who added additional rooms to the front. 'Whistlewood' was a lengthy two-and-a-half-hour drive from Melbourne in the 1950s. McCulloch would spend Mondays and Tuesdays in the city visiting exhibitions and writing his weekly column. For the rest of the time, Alan, Ellen and Susan resided in a home that became a welcome respite for Australian and international artists, writers, critics and curators for the next forty years. Arthur Boyd designed and largely built Alan's studio adjacent to the house in 1951. It was there that McCulloch compiled and wrote his *Encyclopedia of Australian Art*, along with countless books and articles.

The Australia that McCulloch returned to at the end of 1949 was a different cultural and political landscape from that which he had left behind three years earlier. On 26 January 1949, the *Nationality and Citizenship Act 1948 (Cth)* had become law. This Act created the status of 'Australian citizen' for the first time—if you were white. Indigenous Australians were still precluded from basic rights, including citizenship and voting. Just weeks before the McCullochs disembarked at Station Pier, eight years of Labor Party rule had ended when the ALP, led by Ben Chifley, was defeated by Robert Menzies' Liberal Party in the federal election of 10 December. The change signalled underlying tensions had reached a boiling point following the national miners' strike earlier that year, a disquiet that continued to simmer into the 1950s. US–Soviet instability and the perceived threat of communist insurgency, both domestically and on the world stage, provided the backdrop for the period. At the same time, Australia was experiencing the beginnings of an era of unprecedented growth and economic prosperity, and with that came increased opportunity and new mindsets.

Professionally, McCulloch was still regarded first and foremost as an artist—which, given his not-so-distant experiences as a post-war art critic in Melbourne, was an idea he may have been happy to foster. Yet he also soon found that the critics and public had failed to warm to contemporary artists whom he regarded as the most promising and worthy of support.

Paintings and drawings from McCulloch's London group exhibition formed a representative showing of his recent work at Stanley Coe Gallery, Melbourne, from 28 August to 7 September 1951. These pictures represented a summation of McCulloch's interests and achievements during his time spent in Europe. Executed in vibrant expressionist colour and line, three were sold and favourable reviews were written by most Melbourne critics. The artist and critic Arnold Shore wrote approvingly: 'Modernism of the expressionist type clothes his natural sense of humour, literary ideas and love of drawing.' A more considered treatment in the *Age* followed, with

its unnamed critic expressing his appreciation for McCulloch's wit, his use of 'highly mobile colour to convey the emotional impact of the Italian life', and the extent to which his work had been imbued with 'a sense of urgency and the intense impact of a new visual experience'. While the oils were found to be a 'little too loose and occasionally slight', the same could not be said of the drawings: '*Positano*, and several drawings in the folio,' he stated, 'indicate a draftsman of distinctive quality whose sensitive line seeks the fundamental structure of a scene and evokes its spiritual essence with tense economy of means.'[4]

McCulloch approached the established Macquarie Galleries, Sydney, in 1953 with a proposal to mount a more ambitious group show. The idea was to include works by seven contemporary Melbourne artists: John Brack, Roger Kemp, Joseph Stanislaus (Stan) Ostoja-Kotkowski, Arthur Boyd, Charles Blackman, Leonard French and himself. Inadvertently, the group of seven became eight when Sydneysider Allen David was put forward by one of the gallery directors, Lucy Swanton.[5] When French then tried to pull out, citing that his works were too large for the gallery and that he would prefer a solo exhibition, McCulloch managed to convince him otherwise and he ended up recommitting to the show.[6]

The exhibition was opened by Russell Drysdale with several hundred people attending the opening. A few works were sold, including another of McCulloch's Positano landscapes; however, the exhibition failed to impress the Sydney media. Two of McCulloch's close friends wrote to him from Sydney suggesting that he would have been better off having a one- or two-man show, instead of the eight artists who were given short shrift by critics. They 'had "damned" the show with "faint praise"', wrote his friends, who continued, 'how can Gleeson say they "lack the urbanity and polish of their Sydney counterparts". It is so parochial! … Haefliger is better but he treats it as a "fling"'.[7]

Pictures from the exhibition were printed in the social pages of the *Sydney Morning Herald*'s women's section with the caption 'aggressive, primitive, lyrical expression'.[8] In light of this, one of the participating

artists, Ostoja-Kotkowski, remarked to McCulloch from his base in Leigh Creek, South Australia, that he was happy to join another Melbourne group showing but cheekily added: 'I will try to be more "sophisticated" the next time.'[9]

Despite the criticisms, the Sydney exhibition represented a strong selection of works by predominantly younger and mid-career Victorian artists. It aimed to give individual members greater exposure in Sydney and was one of the first of many exhibitions that this group would later show in together. Some of the participating artists made their prices deliberately high. This included John Brack, who wrote to McCulloch explaining: 'The astronomical prices are designed to prevent their sale, because my production is so small.'[10] For McCulloch, it was an opportunity to align his own work and ideas with an emerging group of modern Australian artists, whose roots lay closer to Europe and Paris rather than with the more conservative elements of prewar Australian and English art.

Trial by Tandem and *Highway Forty*

After McCulloch's return from England, his international reputation as a cartoonist and illustrator allowed him to seamlessly attract work from Melbourne's commercial agencies and newspapers. This included a two-month stint with the *Australian Journal*, where he was contracted to fill in for the well-known illustrator JB Priestley while he was on leave. Priestley's style was quite different from McCulloch's—but the latter managed to imbue the signature knockabout Australian larrikin character with suitable panache and style in the two submitted sets of illustrations.[11] Similarly, McCulloch's 1952 publication celebrating a Georges department store anniversary year was accurately described by expatriate Australian artist and educator Mary Cecil Allen as a 'bordy [*sic*], gay booklet'.[12] Such contracts, however, became fewer and fewer. McCulloch's next large assignment was not until 1958, when he received payments from Walker Advertising in Melbourne for a series of caricatures.[13]

The writing, illustration and publication of two travel journals based on his experiences abroad was also initiated by McCulloch on his return to Australia. *Trial by Tandem* (1950) and *Highway Forty* (1951) originated from a series of essays, articles and drawings that McCulloch had produced in America and Europe. To these he added a clutch of unpublished articles and handwritten notes. Letters that he had wisely posted to his mother in Melbourne, with instructions that he would collect them 'when he got back home', also featured largely in the resulting text.[14]

The two books emanated from a lucrative assignment with *Holiday* magazine. In 1949, the magazine had paid McCulloch in advance for a series of commissioned articles that were to chronicle his adventures and observations while travelling across America. The option to publish these was not taken up, for no apparent reason. Undeterred, McCulloch submitted more travelogues, such as 'The Devil's Diary', to *Colliers*, *Harper's Bazaar* and *Atlantic Monthly* in the United States and the *Strand Magazine* in the UK over 1949 and 1950. The assistant editor of the *Strand Magazine*, Richard Usborne, thanked McCulloch for his submission, adding 'it is right for the Strand'—however, several months later he was again contacted to pass on the news that the magazine had been forced to close.[15]

In another dispiriting turn of events, the initial enthusiasm shown by Jan Hine, who had left her position as editor of *Holiday* to become a literary agent, also gradually dissipated and then fell away altogether. Hine had negotiated through the well-known American commentator and broadcaster, William Winter, one of McCulloch's American friends, something quite large: 'I think about 50,000 [copies] should do the book, along with illustrations,' she wrote.[16] But when McCulloch arrived back in Australia he received a letter from Hine advising him that she was closing the agency and sending all his material back.[17]

Several of the individual travel pieces were printed in the Melbourne *Herald*. Sensing greater opportunity, McCulloch turned to local publisher Cheshire, with whom he had previously worked on

the publication about the National Gallery of Victoria's collection. In January 1950, Andrew Fabinyi, Cheshire's managing director, offered McCulloch advance payment for a book in lieu of royalties,[18] along with an agreement that a memorandum of understanding would be signed in early April. The emergence of Cheshire and their faith in McCulloch reflected the re-energising of the local publishing industry. Angus & Robertson, Georgian House and Melbourne University Press were all keen to rejuvenate the Australian publishing landscape, with Cheshire's local publications including numerous scholarly art books that had international reach.

Trial by Tandem, the first of McCulloch's two books, was published simultaneously in Australia and the United Kingdom by George Allen & Unwin. It featured a witty narrative and accompanying line drawings that showed McCulloch's economical style at its best. As intimated by the title, the book followed the adventures of Alan and Ellen in post-war Europe and specifically their ambitious tandem bicycle ride that took them from Paris through the Italian Alps to Positano on the Amalfi Coast. The jovial approach and youthful sense of adventure was picked up by the Australian press. Characteristic of these, John Hetherington, then a young journalist with the *Herald*, described the book as 'irresistible' and a 'magnificent frolic'.[19]

Highway Forty was published the following year, in December 1951, just in time for Christmas. This illustrated travelogue of McCulloch's time in America gained widespread national and international recognition: critics declared it even more successful than *Trial by Tandem*.[20] Typical of these was an article written by 'BG' for the *Age* in which he described the book as 'unpretentious' and 'well-written' with 'lively caricature', and the author as having an 'impressive facility for giving general appeal to personal experience'.[21] A script developed for a Radio Australia broadcast described the book as 'a tale told with verbal felicity, humour, and a stature strengthened by some excellent illustrations'. Ainslee Baker from the *Australian Women's Weekly* claimed: 'With an artist's eye McCulloch is an astute and refreshing observer.'[22]

Highway Forty was published and distributed in London by Angus & Robertson at the same time as its release in Australia. It received widespread praise there too, including a review by Andrew Porter in the prestigious *New Statesman* in which he described the book as 'gay and competent'.[23] Further attempts to attract a US publisher fell on deaf ears. Despite this, Andrew Fabinyi wrote to McCulloch in February 1953, bragging that 'he was now receiving royalties for three books, both in Australia and London'.[24]

The combination of image and text provided by the same person was still relatively new in Australian publishing circles. McCulloch's ability to traverse and bring together the two separate disciplines was something he also explored in his contemporaneous work for Australian magazines, including *Meanjin*.

Having developed a strong relationship with Fabinyi, McCulloch accepted an invitation to contribute an essay on modern trends in Australian art. This was commissioned specifically for an upcoming book with a proposed publication date of 1952. Although the book never eventuated, his essay 'Contemporary Art Trends' traced Australian art through its predominantly European influences. McCulloch postulated that the relationship was lopsided, arguing that it was 'too dependent on overseas sources'.[25] He was also in increasing demand as a writer and broadcaster. A series of art talks produced for the Victorian program of the Australian Broadcasting Commission (ABC) in April 1952 led ultimately to a series of television programs on Australian artists for the ABC's *Panorama* in 1962.[26]

The lectures, programs and specialised essays that McCulloch produced on his return to Australia served to circulate his ideas about Australian art, the national and international significance of chosen artists and the state of art criticism in Australia. Once he joined the Melbourne *Herald* as its national art critic, McCulloch's increased knowledge, experience and skills were called upon on a weekly basis. Henceforth, the mainstream press would become the primary means through which he engaged with the widest possible audience.

The Herald

Alan McCulloch's appointment at the *Herald* was announced on 3 February 1951. Employed principally to write a weekly art column—something he was to do pretty much unabated until his retirement three decades later—McCulloch's role and influence grew over time. The investment in art writing by daily newspapers such as the *Herald* had a longstanding tradition in Australia. Newspapers had the resources (and deadlines) that encouraged art journalists to respond to contemporary issues and events in a timely way. This was something simply not possible in more sporadic art writing for specialist and often short-lived broadsheets and journals. In the 1950s, the *Herald*'s investment in art commentary and stories was proportionate to a small but growing audience for art and art writing. McCulloch's role at the *Herald* developed in conjunction with the evolution of a more professionally run gallery system and the emergence of nationally touring blockbuster and state-sponsored exhibitions.

As the art critic for Victoria's arguably most famous and widely read family-run newspaper, McCulloch exercised considerable influence. He was often asked to comment on his role and the responsibilities of art critics, as well as the significance of artists and striking art projects and issues. McCulloch was quite clear that his aim was to identify the best and most interesting art being made at this time. He took the educational side of his role very seriously and developed a set of fundamental platforms and ideas that reached back to his time in Paris in 1948–49.

While McCulloch was often praised for his ability to write for a lay audience,[27] this did not stop him being pilloried by others for what they saw as obtuseness and overuse of jargon. One *Herald* reader wrote in 1951: 'I always strive to make out what Mr McCulloch is trying to say in his column, but so far it has always eluded me.'[28] McCulloch's editor during the 1950s, AK Thomas, regularly reminded his critic that he was writing for a popular daily newspaper and not an art magazine. A 1952 review was unceremoniously

returned to McCulloch accompanied by editorial notes that highlighted an inappropriate choice of words and pitch.[29] Conversely, Thomas commented in 1955: 'I thought the stuff you wrote on [Ivor] Hele's picture was the best stuff I have ever read from you. Probably because it was one of the occasions that I could understand it.'[30]

McCulloch sometimes despaired of this sort of treatment and the constraints and demands under which he worked. He valued his independence and fought for proper recognition of his worth as a nationally recognised art critic, requesting better salary and conditions to match the increased responsibilities and profile of the position.[31] When challenged by the *Herald* editors or managerial hierarchy, McCulloch would respond in kind. On one occasion, he was told without consultation that the weekly art reviews were to be changed to become more populist. He scrawled defiantly on the letter: 'I don't / think so / Resist this.'[32] The strong rebuke came on the heels of an editorial decree to McCulloch that 'when your attention is attracted to things in which the House has a particular interest we expect you to respond'.[33] Many years later, fellow artist and newspaper critic Ronald Millar wrote to McCulloch: 'I could fill several sheets with the unbelievable and deeply shocking examples of what you rightly term the bloody-mindedness of the *Herald* ... I wonder only at your fortitude and utterly untainted purity over so many years. How the hell did you do it?'[34]

He did it by determinedly sticking to a few fundamental ideas. McCulloch outlined the basis of his approach to art criticism in response to a letter in which he was chided for not being positive enough:

> Confronted with two personable people as Mr and Mrs Nance appeared to be on their brief acquaintance the temptation to any critic is to be kind; but I can assure you from long experience that in art above all things there is no ultimate cruelty like that of misguided critical kindness. And apart from that a critic cannot afford to consider anything but his allegiance to art itself. ... Your contention that constructive criticism is that which praises,

destructive the reverse, is a popular fallacy; criticism of any value at all aims at accurate analysis.[35]

What was at stake was not just reward for effort, but the need for informed and passionate criticism in Australia.

McCulloch countered the perceived favouritism he afforded selected artists and styles by pointing to the limitations of the arguments posed against him. Despite this, the perception that he supported modernist artists over more traditional or academic artists continued well into his first decade at the *Herald*. For his part, McCulloch did not see a need to dispel this inaccuracy, reflecting many years later:

> In the early days I drew favourable attention to the work of Godfrey Miller, Ian Fairweather, John Passmore, Arthur Boyd, Charles Blackman, Leonard French, Roger Kemp, John Brack, Albert Tucker, Sid Nolan, Dobell, Drysdale etc. ... I have since been accused of 'making' some of these artists, but no critic ever 'makes' an artist.[36]

Under public pressure, the *Herald* management eventually picked him up on the amount of column space he was giving to modern artists. No-one seemed to make the obvious connection that these were the artists most frequently featured in important exhibitions and also that McCulloch was often as critical of these so-called 'friends' as he was supportive.

McCulloch's letters to the artists he favoured as well as his reviews and articles reveal a highly developed sense of visual acumen and discrimination. The young but still shy artist Roger Kemp recognised as much when he wrote to McCulloch not long after the latter had joined the *Herald* as its critic. Kemp wrote approvingly of McCulloch's handling of a difficult job: 'I think here in Victoria too you *are* doing good work by sustaining your value of creative background with such fidelity which has no doubt given you the confidence to be consistent in building up + making the people generally more appreciative of that elusive but ultimately more significant quality.'[37]

Ironically, McCulloch was also singled out for criticism by contemporary artists associated with John and Sunday Reed and the Museum of Modern Art in Melbourne. 'Had a spot of bother at the M. of M.A. (of Australia) the other day,' McCulloch wrote to a friend. 'Ordered off the premises no less and of course refused to go. They started a magazine called 'Modern Art News' first number of which started with three attacks on me, no less ... Ah well ...'[38]

Meanjin Quarterly

In the same year McCulloch joined the *Herald*, he was invited to become a regular contributor and arts editor of the quarterly literary magazine *Meanjin*. The magazine had relocated from Brisbane to Melbourne in 1945, at the invitation of the University of Melbourne and under the editorship of its founder, Clem Christesen. Christesen was intent on raising the profile and maintaining the economic stability of the journal and the University of Melbourne offered his best hope. He also expressed the desire to expand its literary base to include more pieces about visual art. For McCulloch, it was a welcome change. It afforded him an opportunity to develop his ideas in more detail and for a more art-literate audience.

Meanjin changed to a new format in 1951, which included bigger pages, an enlarged art section and the appointment of six associate editors (McCulloch, Nettie Palmer, Arthur Phillips, Elizabeth Vassilieff, Bernard Smith and Dorothy Green). Such changes helped to make *Meanjin* Australia's pre-eminent art and literary quarterly, joining with *Overland* (est. 1954) and to a lesser degree *Southerly* (est. 1939) to give voice to avant-garde writing in Australia and shape intellectual debate during the Cold War years. Christesen remarked many years later that the art component seemed to be an afterthought.[39] However, these early appointments imbued the magazine with greater depth (and potential reach) and tied in with his vision of a left-leaning magazine with a democratic vision of Australian art and society. The appointment of McCulloch also set in train

a longstanding professional relationship and personal friendship between Clem and Nina Christesen (founder of the Department of Russian Language and Literature, Melbourne University) and Alan, Ellen and Susan McCulloch. A substantial corpus of letter writing was sustained between the two men for over forty years. In a rich trove of often feisty exchange, each writer shared their aspirations and frustrations concerning art, literature, bureaucracy and life.[40]

Alan McCulloch protested the federal government's decision to cancel its order of *Meanjin* in October 1950, just prior to him joining the magazine. His staunch support continued following his appointment as an editor. He judiciously used the pages of *Meanjin* to highlight inequalities or protest significant issues of the day, including widespread condemnation of the perceived government mismanagement of the handling of Danish architect Jørn Utzon's design for the Sydney Opera House. McCulloch highlighted the work of a variety of artists whom he felt were not getting the attention they warranted. This included Australian Aboriginal artists, emerging moderns and a wave of newly arrived immigrant artists from Europe, many of them talented artists and writers with strong reputations in their respective countries of origin.

McCulloch provided much-needed practical support for artists by commissioning drawings and cover illustrations (as well as producing several with his own hand) for *Meanjin*. Designed to encourage drawing and the graphic arts, and to provide material for feature essays on specific artists, the commissioned work should be seen as an extension of his previous initiatives at the *Australasian* in 1946–47. There he had hoped to nurture a new generation of artists and phase in Australian art and culture. One outcome of this focus at *Meanjin* was that he was able to foreground the work of hitherto little-known artists such as the Viennese-trained Louis Kahan, who had arrived in Melbourne in 1950. In 1955, McCulloch successfully canvassed Christesen for *Meanjin* to sponsor a major exhibition of migrant art to correspond with the 1956 Melbourne Olympics. McCulloch also designed a number of the journal's covers and contributed drawings

to illustrate the text. Like Kahan, he was invited by Christesen to produce a series of line drawings of Melbourne writers in 1959.[41]

McCulloch's first commissioned piece for *Meanjin* was a detailed assessment of the achievements of goldrush artist ST Gill, written in early 1951. McCulloch claimed Gill as an early radical, based on the latter's early, albeit rudimentary, explorations of the Australian landscape and psyche. He believed that Gill heralded the 'dawn of an Australian art'. This was followed by an essay highlighting the drawing style of Kahan, whom he believed had introduced 'to Australian contemporary art a note of sophistication that sprang straight from the boulevard cafes of Montparnasse', and a short exposé on two paintings by young Melbourne artist Roger Kemp.[42]

The endeavours of these artists signposted the three approaches that McCulloch most admired: the artist who had come to Australia prior to being trained or being fully formed (Gill); one who had brought with them the techniques, theories and subject matter of a parent country but was adapting these in response to their new surroundings and conditions (Kahan);[43] and the emerging artist (Kemp) who had responded to and adapted elements of the work of modern masters but to that technical structure had added 'the deep sincerity of an artist who is striving to articulate his own compelling emotional response to the world around him'.[44] Each approach signified for McCulloch how the best and most relevant artists of each generation developed and adapted their art to a particular place and time.

McCulloch responded to Christesen's open question, 'What have you planned for the Winter issue?' by submitting an essay on two younger Melbourne artists: Leonard French and Arthur Boyd.[45] McCulloch identified in both a concerted attempt to unify pictorial construction through form/technique (how you say it) and content/subject matter (what you have to say). French had recently returned from a short study tour in Ireland and McCulloch discerned a newfound ability to meld '*felt* influences' with the 'artist's own temperament'.

McCulloch sensed great ambition in Arthur Boyd, though he believed him to be still flawed in pictorial construction and technique. He thus could perceptively claim him as a 'rare creative spirit impatient to express itself'. McCulloch reasoned that Boyd's art had aligned itself with international standards and universal themes: 'And, if the vehicle used to express these ideas is as yet imperfect, the conception is at least a big conception, one which reveals the artist as a serious thinker.'[46] McCulloch was echoing Paul Haefliger's criticisms, which had featured in the *Sydney Morning Herald*, of Boyd's recent paintings. He was also consciously opening a gulf between his own lofty ambitions and those artists and critics content with their own stasis, who were embedded in or retreated into bygone styles and eras.

McCulloch's strong views on the status of Australia's emerging contemporary artists and critical writing, and their relationship with mainstream European aesthetic principles and art movements, became his signature. They also drew criticism from a range of people and positions—including the progressive art historian Bernard Smith, a fellow associate editor in the revamped *Meanjin*. Like McCulloch, Smith had recently returned from overseas, having received a scholarship to study at the prestigious Warburg Institute, London (1948–51). McCulloch and the younger-by-eight-years Smith maintained a cordial though strained relationship over their respective careers. McCulloch considered the author of the seminal left-wing Australian art book *Place, Taste and Tradition* as an art historian whose views on art and material circumstances would be increasingly shaped by academe.[47] Smith, as he intimated privately to friends and colleagues, did not think McCulloch was his intellectual equal.

Relations were strained over how each writer defined modern art styles and their Australian adherents. McCulloch objected to what he perceived as Smith's limited definition and use of the term 'expressionism'. He took the opportunity to advance his own thesis regarding Australian painters Russell Drysdale and William Dobell

in 1952. According to McCulloch, they were more classicist and romanticist than expressionist in conviction and style.[48] Although there was plenty to unite the two writers—Smith's valorisation of foreign art styles being adapted and transformed under Australian conditions, for example—the flexing of muscle by the elder critic and the younger historian and art educator and a desire for both to be heard and understood on their own terms is clearly apparent.

For McCulloch, the 'full tide of Expressionism' had yet to reach our shores. To speak of a successful adaptation was therefore premature. To designate Dobell or Drysdale as Australian Expressionists was, he wrote, more 'a reflection on Mr. Smith's capabilities as a critic of contemporary art'. From Smith's perspective, McCulloch had misrepresented his comments and taken unnecessary offence. The feisty public exchange ended with a conciliatory comeback from Smith: 'I'm sure we can be excellent friends really if you don't attempt to turn matters of opinion into matters of fact.'[49]

McCulloch's contribution to *Meanjin* ebbed and flowed over the 1950s and into the early 1960s; it depended upon his workload elsewhere and the level of drive and enthusiasm of its editor. Christesen would sometimes announce that he was going to reinvigorate the board and strengthen the art content after periods of slackness or time spent overseas.[50] He sometimes questioned the level of McCulloch's contribution. Once, in the face of McCulloch's increasing commitments to *Modern Art News*, Christesen internalised the issue by trying to agonisingly pinpoint where his magazine had faltered.[51]

The constant element in their letter writing was Christesen's never-ending battle to maintain editorial independence and to keep the magazine financially solvent. This included making sure that it remained linked to the University of Melbourne. Christesen shared his personal challenges and frustrations with McCulloch on a regular basis. In early 1956, he wrote in characteristic fashion:

> My publishing plans are in a hell of a mess, due to continued and increased humbug here. I might now be able to publish two issues

only during 1956—or throw the whole game away. From next month I will be doing some work that will provide me with an income and *Meanjin* will have to take its chance.[52]

As was so often the case, the aggrieved Christesen wore his publishing heart on his sleeve.

Writing matters

The Herald and *Meanjin* presented McCulloch with the opportunity to promulgate a variety of forthright views to different readerships. This ranged from questioning the relative merits of the acquisition of major international works by public institutions to critiquing institutional and corporate support for international touring exhibitions or drawing attention to the paucity of presentation of Australian art and artists abroad. McCulloch proved to be an early and vocal supporter of the second wave of Australian modernism and an important source of information about landmark exhibitions and publications.

McCulloch's sceptical response to the National Gallery of Victoria's purchase of a painting by Rembrandt exemplified his adoption of a policing role with regard to major acquisitions funded through the public purse. It appeared in one of his first *Herald* columns in February 1951.[53]

McCulloch proved far more welcoming of the landmark purchase of *Draped seated woman* (1958), by noted British sculptor Henry Moore, ten years later in 1960.[54] Moore's monumental sculpture cost the equivalent of three years' allowance for the purchase of contemporary art from the Felton Bequest. The acquisition was pilloried in some quarters for its cost, as well as for its prominent placement in the NGV forecourt. McCulloch countered the discontent by expressing unequivocal support for the work. It was, he rightly claimed, a major work by an acclaimed international artist: 'It is the first full-scale sculpture by an artist of world renown to be acquired by any Australian gallery,' McCulloch confidently declared. He then proceeded in a more conciliatory tone to respond to its detractors

and give a clear sense of the English artist's humanist philosophy and its underlying principle of fundamental forms. For McCulloch, this sculpture signalled 'the need to get back to the source of life, the ultimate simplicity ... Add to these the genius of a modern thinker and artist fully alive to the stresses and strains of his own time'.[55]

McCulloch's support for modernism can be further seen in his reactions to the winning entries of the annual Blake Prize in Sydney. The Blake Prize was an exhibition for art with a religious subject that had been introduced in 1949 to promote the development of art and faith. The prize polarised the Australian public, starting with the award of Justin O'Brien as the inaugural winner in 1951. McCulloch often found himself having to explain the rationale behind the shows and the selection of each year's prize winner.

In 1958, Rev. Dr Malcom Mackay (from the Scots Church, Sydney) thanked McCulloch for his article on modern art and the Blake Prize, and outlined his desire to encourage 'virile and strong artistic work in the artistic field' to counter the dismissive attitude towards 'local anaemic sentimental stained glass and other "works of art" which have nothing other than a mistaken sense of tradition to justify their perpetuation on the public'.[56] Elwyn Lynn's *Betrayal* (1957), a bold semi-abstract work that was purchased by the NGV directly from the exhibition, was a just winner in the same year. It exemplified the sort of art emphasised in Mackay's statement.

McCulloch was also supportive of the major international exhibitions that toured Australia's state galleries in the 1950s, including *French Painting Today* (1953) and *Italian Art of the Twentieth Century* and *French Tapestries* (1956). He was one of the first Australian art critics to engage more closely with Asia and press for greater cultural understanding and contact with our closest neighbours. In 1956, he proposed a pilot biennale as a follow-up to the Melbourne Olympic Games.[57] The idea was praised by Eric Westbrook, the recently appointed director of the NGV, who brought the idea before the gallery's trustees and gained their approval to investigate further. Six months later, McCulloch received advice regarding how to gain

support for such an idea at the highest possible government level.[58] Although this exhibition failed to eventuate, McCulloch's early interest in mixed exhibitions of contemporary Australian and Asian artists was finally realised with the Biennale of Sydney in 1973.

While Alan McCulloch is primarily identified with the emerging and established modernist art and artists of post-war Australia, there is another side to his long career that has largely gone unnoticed. McCulloch harboured a great interest in Aboriginal and Torres Strait Islander art and artefacts as well as the First Nations art and material culture of Australia's Pacific and Asian neighbours. In this respect, he was both a man of his times in some of the ideas and attitudes he held, and a forward thinker in others. His longstanding attempt to put traditional Australian Aboriginal and Asian art at the centre of Australian and international cultural circles could only be described as unrelenting. He was one of the first southerners to see and recognise the talents of the Central Desert artists and those of the Papunya School in 1972.

In 1967, McCulloch exclaimed to a senior government official that 'Australian Aboriginal bark painting in its primitive form ... represents our only great national art treasure'.[59] The context for his declaration lay with plans for the new Victorian art gallery nearing completion and his belief that Australian Aboriginal art should be premiered in the first exhibition. Although his call fell on deaf ears, the idea that Aboriginal art was worthy of such treatment, and that it was something all Australians could be proud of, predated the support for Australian Aboriginal art by most public galleries and museums for another twenty or so years.

McCulloch's high regard for Australian Aboriginal art can be traced to his boyhood fascination with the Baldwin Spencer Collection. Spencer was the first director of the National Museum of Victoria, as well as a collector and anthropologist of note. His collection of objects from Central Australia and Arnhem Land was the mainstay of the Victorian museum's Indigenous holdings and was later often called upon for loan to other institutions and exhibitions.

McCulloch had befriended Dr Leonhard Adam, from the Department of History, University of Melbourne, in the 1950s. Adam was to prove a strong ally as well as a fertile source of information. The Berlin-born Adam was the author of a widely read Pelican book titled *Primitive Art* (1940), which had been produced while he was a lecturer at the University of London following his escape from Nazi persecution in Germany. Ironically, Adam was despatched to Australia at the outbreak of war as an 'enemy alien'. Upon his release, he joined the University of Melbourne and established an important ethnological collection throughout the 1950s.

In 1951, Adam wrote to McCulloch to congratulate him on an article published in the *Herald* entitled 'Save Art from Aborigines'. In the article, McCulloch wrote that post-European contact had weakened and would ultimately lead to the destruction of a 'genuine' Aboriginal art and culture, rather than either enhancing, adding to or being assimilated into it.[60] Sensing a kindred soul, Adam invited McCulloch for a private viewing of the bark paintings that he had recently acquired for the university.[61] This was followed in 1954 by an invitation to visit the university to meet Aboriginal artists from Ernabella, South Australia, whom Adams claimed had 'developed a style consisting of totally abstract line designs on paper'.[62]

As their friendship grew, McCulloch became increasingly aware of the parlous state of Aboriginal art collections held in Australian museums and a lack of exhibition opportunities both here and abroad. Adam wrote to McCulloch again in 1955 asking for support for the creation of a museum dedicated solely to Aboriginal and Torres Strait Islander Australia. He reasoned that 'even apart from the National Gallery, that not one but two museums were needed—one for Natural History and one for Anthropology' (his own specialty was the University of Melbourne's ethnographical collection). Adam finished by drawing McCulloch's attention to the condition of the 'Sir Baldwin Spencer barks ... packed away all the time in the dark vaults of the building' and cajoled him to action, stating: 'You are the man who has got the power to get things done.'[63]

McCulloch's *Herald* column was the ideal way to transmit these strong views. Such a stance was bound to get a response—and it did. In March 1954, a writer from Eltham replied to McCulloch's suggestion of an exhibition of 'primitive art' by proposing that the works stored in the vaults beneath the museum be brought out.[64] McCulloch had responded to an earlier letter writer that he had 'not realised there was the wealth of material you mentioned stored in the vaults of the National Gallery ... I have always been worried about the fine collection of bark paintings [that have] been shown so indifferently in the anthropological museum.'[65] Sensing an opportunity, McCulloch wrote to Gordon Thomson, assistant and curator of the Art Museum, which was then adjacent to the National Museum in Swanston Street. Thomson replied, informing McCulloch of the NGV's plans to create an exhibition relating 'primitivism to modern art'.[66]

From these small beginnings, McCulloch made the establishment and development of museums devoted to Australian Aboriginal art and material culture a priority. His ultimate plan was for a museum of Indigenous art to be built in every state as well as the national capital. In 1962, he wrote to the town clerk in Darwin, asking for information about the art scene there and posing the question of whether the town would be interested in establishing a gallery of Aboriginal art.[67]

The primary difference between McCulloch and colleagues such as Adam was that he saw Australian Aboriginal material culture in terms of its artistic orientation rather than through the lens of anthropology or ethnography. But he also held other, more hampered views about what constituted Australian Aboriginal art. Like many of his generation, he held the opinion that Aboriginal Australia was a 'dying culture' that had become tainted by Western contact. He felt that the 1930s was the period in which 'authentic' Aboriginal art had become moribund, synonymous with the introduction of Western painting techniques into remote communities by Rex Battarbee, Violet Teague, Jessie Traill and John Gardner. McCulloch was speaking here very much as a man of his times.

In 1956, McCulloch declined an invitation to attend a special preview of the Commonwealth Bank of Australia's contribution to the city's Olympic decorations. His three-page reply to its chief manager, LJ Dooling, focused on the art he supported and that which he did not, detailing his disdain for 'Aranda [Arrernte] watercolours'.[68] Following this, in 1958 the Canadian *Family Herald* invited him to write an article on Joe (Alimindjin) Rootsey from Weipa and Albert Namatjira, who was a Western Arrernte man. McCulloch's initial response was that he could 'only write about N. etc as a study in psychology or as anthropology'.[69] This reply attracted the attention of the editor, H Gordon Green, who wrote: 'It is our opinion that the facts as you have set them down in your letter, would in themselves make a highly absorbing and moving article ... We would be prepared to run this under your own name, or pseudonym if you would prefer.'[70] The resulting article by McCulloch was a damning critique of what had happened to Albert Namatjira as a result of his artistic success and the double standards of white Australians. McCulloch recounts how Namatjira's relatives were painting works in his style and how some of these were being sold as being by him because of the high demand for his work. Moreover, the incarceration of Namatjira for supplying alcohol to his family even though he had been made an Australian citizen (and that under cultural obligations he could not refuse) effectively broke his spirit and pride leading to great shame and a premature death only a few months later in 1959.[71]

The Victorian Artists Society's *Antipodeans* exhibition of 1959 and the Tate exhibition *Australian Painting* that was shown in London in 1962–63 embroiled McCulloch in ongoing vitriol over how Australia's modernist artists were being represented both here and overseas. The first exhibition had famously brought together seven mid-career artists (Charles Blackman, Arthur Boyd, David Boyd, John Brack, Robert Dickerson, John Perceval and Clifton Pugh). Bernard Smith's *Antipodean Manifesto*, which featured in the exhibition, outlined a juncture between figurative and abstract art and is a landmark document in Australian art. McCulloch had supported

and indeed championed the participating artists as those who would bring Australia out of its current cultural malaise. The second of the two exhibitions showcased some of the same artists but, according to McCulloch and others, situated their work within a retrogressive overview of Australian painting. The fact that the exhibition had been organised and promoted by the Liberal government and its primary arts agency became a cause célèbre in some quarters.

McCulloch's review of the *Antipodeans* exhibition in the *Herald* was supportive and instructive. In contrast to the more dramatic headline, which read 'Battle Cry of Antipodeans', he focused on the visual strengths of the exhibition that he felt filled 'the VAS galleries with pictures big enough and strident enough to illuminate even the darkest corner'. He argued that the artists were simply repeating what they had said in previous shows and singled out Smith's text as being 'very well put together', representing 'a local gesture reflecting the world-wide nervousness of the more orthodox moderns at the growing popularity of tachists, action painters and the like'. However, McCulloch also reasoned in a characteristic rejoinder that 'the evidence of history is that art can weather any storm' and that (following the trajectory of the twentieth-century avant-garde) once it had made its contribution, tachisme 'would then dissolve, like the countless movements that preceded it'.[72]

Smith wrote to thank McCulloch for his 'temperate and well-balanced review of the Antipodean show and what they stand for', adding that they were not against abstract art—but were focused instead on the 'need to sharpen debate'.[73] For McCulloch, it was more about artists remaining true to their convictions and original impulses. His follow-up review of a 1959 solo show of Clifton Pugh at Australian Galleries made this position clear:

> A hearty sensuousness accompanies him in his attack upon the local landscape presenting it as we all too rarely see it—not sparse and dead as of the desert but as something exuberant and robust. Pugh thus has the good sense to be himself: never more so than in this exhibition.[74]

Pugh contacted McCulloch to outline his own thoughts in the lead-up to both exhibitions. Some of these observations may have informed McCulloch's writing as Pugh sought to stave off negative rumours circulating (possibly, he said, emanating from McCulloch himself) and clarify his involvement. Pugh was not 'anti' any form of art, he explained, as 'any form of art pursued with honesty has a positive validity'. Nor was anyone in the group '*against* Non-Objective painting'. Rather, they had come together out of mutual respect and through 'having an affinity with each other', in that 'we all believe in the image to be the way to fuller expression and more positive statement'.[75] Pugh's idea was that for art to be indigenous it had 'to come from and be conditioned by the environment' from whence it came, whether that be manufactured or natural. This was precisely the argument that McCulloch had been making over the preceding ten years.

Australian Painting: Colonial, Impressionist, Contemporary was the full title of the monumental exhibition organised for the Tate Gallery by the Commonwealth Art Advisory Board. It was initially shown in Adelaide and then London during 1962 and 1963. The official purpose of the exhibition was to present a story of Australia's development and show 'our' continued prosperity since white 'settlement'. The unofficial line was that it was to present Australia as a desirable destination for British emigration. As art historian Sarah Scott has observed, the exhibition was disjointed and flawed from the outset. It focused on paintings and only those with narrative content. No Australian Aboriginal art was included and there was a sizeable section devoted to colonial and Impressionist art that was situated alongside contemporary paintings.[76] As the exhibition lurched from one crisis to the next, it was nearly cancelled, both by the Tate and its Australian organisers.

McCulloch voiced his concerns in March 1962 regarding the proposed tour of this exhibition of Australian art to the Tate Gallery. In a letter to James (Jim) McCusker of the Prime Minister's Department, Canberra, whom he had met in Adelaide at the exhibition's premiere,

McCulloch stated his position clearly: 'From my point of view the only theme to be considered is to build the show around the artists who have placed Australian art in the position it enjoys in London today. The rest must surely be regarded as ornament.'[77]

McCulloch's review of the Adelaide show and a subsequent article titled 'Shake-Out Is Needed at the Tate Show' reaffirmed this position. He commented that the exhibition looked good at the recently refurbished Art Gallery of South Australia, but had been hastily conceived, lacked a clear focus, included inferior work and had left out artists who figured among the most interesting and deserving. Most concerningly for McCulloch, the exhibition was likely to put the cause of Australian art back many years, if not dramatically reconfigure it. 'To allow [the exhibition] to go to London in its present state', he lamented, 'would be to label us once more with the stigma of provincialism from which we have struggled so hard, for so long, to escape.'[78]

McCulloch received validation for his strong stance from a variety of unexpected quarters. Social realist artist Noel Counihan was encouraging: 'I am very glad you sharpened up your criticism of the show proposed for the Tate—it is a travesty of a show, i.e., for what? purpose.'[79] Daniel Thomas's catalogue introduction and comments on the contemporary artists it included brought a key element of the show—the interchange between figurative art and abstraction—back into more comfortable territory. Olsen's 'recent pictures', McCulloch wrote, 'are as Australianist in intention as anything the *Antipodean Manifesto* could wish for. They undoubtedly express his experience of his time and place—as a total environment.'[80]

On the opposite side, a fiery exchange of letters ensued between one of the selected artists, Dawn Sime, and McCulloch. Sime disputed McCulloch's summation that she 'was a comparative beginner' and didn't warrant being represented by three works.[81] If this comment further exemplifies what has been described more recently as the exhibition's celebration of the achievements of male Australian artists of the post-war generation, then this would have reflected, for both

McCulloch and Thomas, a contemporary reality rather than the relative merits of one gender over another.[82] The final word was reserved for artist Leonard French in a letter to McCulloch postmarked 5 January 1968, Highgate: 'The press are all lined up to tear it to pieces.'[83]

CHAPTER 4

GALVANISING THE CRITICS

SPECULATING ON THE life of the Australian art critic in the 1950s and 1960s, Alan McCulloch characterised a small group of passionate though geographically distant writers who fought tenaciously to have their qualifications and expertise recognised and to be properly compensated for their efforts. The Australian branch of the Association Internationale des Critiques d'Art (AICA), or International Association of Art Critics, became the primary organisation they chose to represent their aims. Like UNESCO, AICA was formed in the aftermath of World War II. Its primary objectives were to develop international cooperation in the arts, safeguard the prestige and professional interests of art critics, and facilitate international residencies and exchange. This platform was welcome and timely among Australia's fledging band of art critics. High on their agenda was presenting a united front. Through solidarity, they hoped to liberate themselves from excessive proprietorial control and develop new opportunities for artists and critics to travel and work both interstate and abroad.

International Association of Art Critics (Australian branch)

In 1948, Alan McCulloch attended the First International Congress of Art Critics, held in the UNESCO Pavilion in Paris, as an observer,

along with fellow Australians Albert Tucker and Peter Bellew. His mounting international reputation and contacts ensured that he was an invited delegate to the subsequent conference in 1949. McCulloch was therefore well versed in AICA'S role and that of UNESCO in raising the profile of the arts by the time he returned to Australia in late 1949. He harboured a desire to create a similar organisation or branch in Australia. Tucker wrote to McCulloch from Paris in 1951, updating him on his travels and recent painting, and to share the likelihood of him attending the upcoming art congress in Amsterdam. 'It's been on my mind since the last one,' he wrote, 'has anything happened at the Australian end? Did you form a National Council?'[1]

The impetus for forming an Australian division of AICA eventually came through the Australian National Advisory Committee for UNESCO. Its secretary had written to the University of Melbourne's Bernard Smith in June 1960 to gauge his interest. Smith, in turn, canvassed McCulloch (and presumably others) by asking him to read the association's statutes and to gain his 'opinion about the possibility and desirability of setting up an Australian branch'.[2] McCulloch wrote on an original copy of Smith's letter that he was 'all in favour', tacit support Smith reiterated to McCulloch in a follow-up letter: 'I see great advantages in an Australian critics' group.'[3]

A stated aim of the proposed constitution of AICA Australia was to facilitate 'international exchanges in the field of art'. This was a beacon for most critics, who recognised the dearth of opportunity facing progressive Australian artists. The secretary of the Australian UNESCO Committee for Visual Arts and Letters, HJ Russell, wrote to McCulloch and thirteen other Australian critics in December 1960 to explain the advantages of eligibility of Australians for National Guggenheim Art Awards. Later, in April 1962, McCulloch reported that following an informal meeting of critics at the Adelaide Festival of the Arts, 'W. Thornton (*SMH*) and Elizabeth Young (*Adelaide Advertiser*) ... decided to form the branch.'[4]

A provisional committee was formed with McCulloch elected president and Sydney critic Wallace Thornton as vice-president for 1962.

Office bearers were elected in May 1963 with McCulloch ratified as inaugural president, along with Daniel Thomas, the emerging Art Gallery of New South Wales curator, as his secretary. The secretary-general of the international branch, Simone Gille-Delafon, thanked McCulloch for forwarding the names of thirty-eight Australians, including those who would attend the upcoming general assembly in Venice in 1964. She recalled her personal pleasure at the prospect of '[seeing] you again after the years passed since the first Congress'.[5]

Concern over the international body's failure to properly administer and duly recognise the Australian representatives, and McCulloch's growing frustration over Daniel Thomas's apparent lack of conscientiousness, paled into comparison with the heat generated by the vehicle chosen by McCulloch to launch the association: providing judges for the inaugural Georges Art Prize in Melbourne. McCulloch had a long association with the Melbourne retail stalwart. The minutes of the first meeting, held in 1963, recorded 'doubt' that critics should be involved in art prizes at all, a position that Wallace Thornton made patently clear in a stinging rebuke to McCulloch.[6] McCulloch countered but Thornton continued on to question the theme of portraiture as a focus for the first prize. McCulloch once again returned missives with the argument that this presented a good chance to attract artists who 'have never entered [other] portrait prizes'.[7]

McCulloch saw the role of AICA in Australia as national and international in scope rather than regional in focus. Each annual conference was subsequently planned to coincide with major exhibitions in different states, as an additional enticement to bring Australia's leading critics together and selected critics from overseas. McCulloch 'found the expenses' to bring most of the interstate critics to Melbourne to attend the first meeting in 1963 through *Herald* connections. He also assisted in bringing the current international president, JJ Sweeney, to Australia the following year.[8] He lobbied the Department of External Affairs in Canberra on the importance of sending a delegate to Lahore, Pakistan, for the first seminar

conducted by AICA's Asian division. This was followed by a letter to artist and friend Guelda Pyke asking for additional financial support.[9]

Engaging in matters that he considered in the national interest was an important focus for McCulloch. He wrote to the editor of the influential English newspaper the *Spectator* following Charles Osborne's review of Bernard Smith's new survey monograph, *Australian Painting 1788–1960*. Whatever his personal views on Smith's book, McCulloch took umbrage at what he considered 'several grossly misleading statements' contained in the article that cast negative aspersions on Australian critics and art. He ended with the admonishment: 'Art criticism here is varied, extensive and at its best, constructive.'[10]

Unilateral support was also given by the Australian art critic to Danish architect Jørn Utzon and his 1957 competition-winning design for the Sydney Opera House. Like most of McCulloch's targets, he took aim at a pivotal time when the original building design and cost was increasingly under attack. In April 1966, McCulloch wrote to Bernard Smith stating that AICA could simply not afford to 'stay out of the Opera House argument'. He proposed a jointly signed letter to the *Sydney Morning Herald* and other major Australian newspapers.[11] According to McCulloch, Utzon had produced exactly what the brief had asked for: 'an original, world class design'. The statement was drafted and distributed by AICA secretary Barry Seidel in May 1966. McCulloch followed it up with an article written in support of Utzon for *Meanjin*'s spring issue the following year.[12]

Smith and McCulloch were also key lobbyists in the Australian push for access to an artists' studio/apartment initiative that formed part of the innovative Cité Internationale des Arts project in Paris. In July 1966, Smith had 'met the Grand Secretaire of the Cité Internationale des Arts to discuss the possibility of Australia obtaining a permanent studio in Paris'.[13] This was an idea that had been incubating for some time. Discussions were held between Smith and influential public servants including Herbert Cole (Nugget) Coombs, first governor of the Reserve Bank of Australia, at Australian Academy of Humanities meetings.[14] McCulloch, though, had become involved

slightly earlier, in 1965. He had been invited to Europe as a guest of the French and later Dutch governments. While there, he attended AICA's 1965 congress in Paris. As part of his report on the congress proceedings that he gave at the annual meeting of AICA in Adelaide on 12 and 13 March 1966, McCulloch brought up the question of possible Australian participation in the Cité Internationale des Arts, proposing a fuller discussion in the meeting scheduled for the following day.[15] A letter was subsequently drafted and distributed to members for comment, including the incoming president, Bernard Smith. Smith sent his letter of support directly to McCulloch for action.[16]

The advantages afforded Australian artists through access to an overseas residency were compelling. It would give them a chance to live and work on the world stage. One of the primary reasons for establishing AICA had been to promote Australian participation in overseas exhibitions and to become eligible for awards and residencies such as that offered at the Guggenheim.[17] The Cité Internationale des Arts, which was a series of studio apartments recently built and available for countries to rent or purchase, presented a much-needed opportunity. McCulloch had had to wait twenty years before getting his first opportunity to go abroad, and this would have no doubt influenced his thinking.

McCulloch was shown through the centre by its director during his visit to Paris in September 1965. The newly appointed living quarters provided accommodation not only for painters but also creative artists of all types. McCulloch was impressed. He wrote to Henri Souillac, French ambassador to Australia, who had helped him schedule his recent trip. The letter contained the AICA resolution to request that the Australian government participate in the project.[18] McCulloch pressed for three studios in his subsequent submission to the Prime Minister's Department. He highlighted the paucity of opportunities for Australia's best artists, which in 1966 consisted of the NGV Travelling Scholarship (a triennial award comprising $2000 to fund study in Paris for three years), and the Helena

Rubinstein Prize that awarded $2600 to the winner. He also advocated for a student to be selected annually by a specially formed committee that included a representative from AICA.[19]

McCulloch determinedly pursued the goal of acquiring the studio apartments over the next twelve months. He wrote to the influential artist Russell Drysdale, who had recently returned to Australia from London, requesting that he support the idea at an upcoming meeting of the Commonwealth Art Advisory Board (CAAB), of which Drysdale was a member. Drysdale responded to McCulloch by conveying unequivocal support for the idea. He too had been taken through the building while he was in Paris, and stated it is 'something which I want the Board to sponsor'.[20] McCulloch also wrote directly to the CAAB, as well as requesting support from Coombs. In the spirit of André Malraux, French novelist, art theorist and minister of cultural affairs (1959–69), he advocated for Australian artists such as Arthur Boyd or Sidney Nolan spending part of their time there painting the ceiling of the Bourges Theatre. There was a history to the request: it was the place where Australian playwright Alan Seymour's play *The One Day of the Year* had recently premiered.[21]

A personal letter was sent to Prime Minister Harold Holt, with copies sent to the relevant ministers for education, finance and housing in various states throughout 1966. McCulloch also approached prominent public figures and private organisations, including the Contemporary Art Society, Sydney, Helena Rubinstein Foundation, Aubrey Gibson Foundation, Sir Warwick Fairfax and the Myer Foundation.[22] A second round of letters and articles were published in a concerted and coordinated push.

By late 1967, McCulloch confided to AICA secretary Brian Seidel that after much correspondence the indications were that the Commonwealth and at least two state governments might participate in the Cité Internationale idea. This, he indicated, had involved 'a lot of work but [would be] well worth it if it comes off as it could change the whole of the Australian art scholarship set up!'[23] McCulloch had cause for optimism, given the purchase of twenty-two apartments

by the US Government. Bernard Smith expressed his support: 'Congratulations on your work in connection with the Victorian Government and an appointment at the Cite.'[24]

Like McCulloch, Smith had the advantage of firsthand experience of the Cité Internationale des Arts.[25] Following his appointment as inaugural director of the Power Institute of Fine Arts, University of Sydney, in 1967, Smith was able to take matters into his own hands. Eventually, in a lost opportunity, the only studio apartment purchased came through the aegis of Smith and Sydney University. Despite his best efforts over a two-year period, McCulloch had been unable to convince the state or federal governments to purchase one studio, let alone three, as he had hoped. However, his dedication to the task had had several positive outcomes. This included the pledge of increased state government support for the NGV Travelling Scholarship and consideration given to revising 'the amount of the scholarship to keep pace with living costs'.[26]

McCulloch's three-year tenure as president of AICA was due to expire in 1966. Fellow critic and AICA member Elwyn Lynn urged him to continue, complaining that he was too busy to take up the role, and 'Bernard Smith was off to Paris to study colour theory and practice in 19th century painting and Wallace Thornton should be sounded out'.[27] McCulloch indicated to Seidel that he 'hoped to be relieved of responsibility but find myself doing more AICA work than ever'. He also confided that he was involved in unwanted but necessary skirmishes such as the inappropriate and retrograde naming of the new cultural precinct as the 'National Gallery and Arts Centre of Victoria', which he considered carried colonialist connotations.[28]

McCulloch had also become publicly embroiled in a spirited defence of Lynn in July 1966. Lynn had recently resigned his role as art critic with the *Australian* newspaper. This was due to the appointment of artist Charles Bush as the newspaper's Melbourne correspondent. McCulloch wrote to the *Australian* arts editor, Walter I Kommer, in support of Lynn. He considered the appointment of Bush unethical, as according to McCulloch he was 'a painter with a

vested interest in a private commercial gallery'.[29] Kommer replied that he was 'deeply upset' that Lynn had resigned but that it was a question of establishing balance between Melbourne and Sydney writers. McCulloch retorted: 'Once dealers, no matter how reputable, start writing about art for newspapers then that, surely, is the beginning of the end of objective art criticism.'[30] Sensing a great loss, McCulloch also took the opportunity to write to Lynn urging him to reopen negotiations with management.[31]

The return of Smith from London meant that McCulloch could now ask him to lend his authority to the debate.[32] Despite misgivings expressed by some of the members, Smith was elected president of AICA following his six-month study tour to Europe and the United States. He used the opportunity to outline AICA's charter, which was 'to protect the moral and professional interests of art critics and collectively to uphold the rights of all its members'. Australian art critics had never had a such a strong and representative body. Smith set the tone: 'There is, however, no parallel, to my knowledge, of an Australian newspaper permanently employing a critic who is also the proprietor of a gallery.'[33]

Clement Greenberg sees Australia

Alan McCulloch combined forces with Bernard Smith once again to help bring Clement Greenberg, the American formalist art critic, to Australia for a series of lectures, functions and events. Just as Smith and McCulloch hoped to take Australian artists and critics to the world, so they conspired to bring internationally renowned art critics and historians to Australia. In September 1967, Smith proposed to McCulloch a possible joint sponsorship between Georges Ltd, the US consulate and the Power Institute. Smith was taken aback when he learnt that Greenberg 'charges $500 plus full expenses for an hour's talk'.[34]

McCulloch's suggestion to involve the *Herald* as a sponsor came to naught, despite his lofty recommendation that Greenberg was the

'most famous contemporary art critic in the USA' and the one 'more than any other ... responsible for the rise of the New York School and its "take over" as leader, from the School of Paris'.[35] He was, however, able to persuade Georges to host Greenberg's visit to Melbourne, on the proviso that the American judge the Georges Art Prize. Ultimately the trip was jointly funded by the Power Institute—for whom Greenberg was to deliver the first of the 'John Power Lectures in Contemporary Art'—and the Carnegie Corporation of New York, along with Georges.[36]

Smith turned his attention to the organisation of a 'Seminar on Criticism'. This was scheduled to be held in Sydney as a UNESCO event (rather than an event at the Adelaide Festival) and Greenberg was a designated keynote speaker. McCulloch took responsibility for the week-long Victorian leg of Greenberg's tour. Smith had written to McCulloch previously that Greenberg was keen to visit all Australian states and, as Greenberg put it, 'to see as much of the country as I can (and I hope that includes some of the backwoods)'.[37] McCulloch was able to facilitate this by arranging a weekend stopover for Greenberg with his friends Douglas and Margaret Carnegie at Kildrummie, their expansive cattle station at Holbrook, in New South Wales.[38]

McCulloch placed himself, along with Patrick McCaughey, at Greenberg's disposal while in Melbourne. The very full itinerary included judging the Georges Art Prize and announcing the winner; visits to Ballarat, the Victorian Arts Centre and the National Museum of Victoria to see the Baldwin Spencer Collection of Aboriginal bark paintings; an evening dinner organised by University of Melbourne lecturers McCaughey and Ruth McNichol, 'primarily to talk informally with young artists'; and time at the university's fine arts department.[39] McCulloch wrote to NGV director Eric Westbrook about the arrangements for Greenberg's visit and him seeing the new centre while he was in Melbourne: 'There have been a lot of requests for him to do various things, but since he's our guest (guest of the Carnegie Corp'n of N.Y., plus Power Institute, plus AICA) we are conscious not to kill him with work.'[40]

Although McCulloch and Greenberg may have appeared unusual bedfellows, the two critics became firm friends. McCulloch even became a staunch admirer of some of Greenberg's views. For his part, Greenberg wrote to McCulloch halfway through the trip, in Adelaide, recounting his trip to Tasmania and thanking Alan for his time in Melbourne. In tantalising fashion, he suggested that he was 'keeping ... for a later date' the highlights of the trip and his observations of Australia.[41]

Greenberg's visit to Australia in 1968 was viewed as a formalist cause célèbre. However, his subsequent pronouncements on Australian art and artists were a surprise. Many of the artists, academics and critics associated with 1968's *The Field* exhibition at the NGV and Central Street Gallery in Sydney believed that Greenberg stood for internationalism over regionalism and abstract over figurative art. In short, he was welcomed as a much-needed antidote to what younger, contemporary Australian artists regarded as an overemphasis on the *Antipodeans* exhibition artists and as a portent to generational change. However, in public pronouncements and in talks and seminars Greenberg took a contrary stance. Sydney critic and later gallery director Laurie Thomas postulated to McCulloch following the critic's departure that 'I, too, have enjoyed Greenberg's visit enormously—great man I think, and one [who] has thought his position through thoroughly from philosophy to practice.'[42]

In an unpublished essay, 'Clement Greenberg's Visit: The Unsure Audience', McCulloch found heart in Greenberg's words and the way he acquitted himself. He described a 'gentle, laconic manner [that] was extremely deceptive; beneath the friendly smile was a tough, hard-hitting critic who overlooked no detail of what was said and whose judgements had an edge ... made all the more sharper because invariably they emanated from unsuspecting quarters'.[43] McCulloch expanded upon these thoughts in 1974 when he challenged artist and critic Bernard Boles in his review of a show by Sydney Ball. 'In general,' McCulloch wrote in a letter to the editor, 'Australian paintings that most interested [Greenberg] were those by [the] "Antipodean

School" of painters, and the advice he offered us generally was that we should "celebrate its diversity".[44]

Regionalism and internationalism

The regionalist versus internationalist debates galvanised Australia's artists and critics throughout the 1950s and 1960s. The scene had been set with the 1959 *Antipodeans* exhibition. Debate broadened through reactions to subsequent touring international exhibitions, such as *Two Decades of American Painting* in 1967. John Olsen confided to McCulloch: 'My only comment is a lesson that I have learnt about the hoax of the great internationalism when I went abroad—+ how Aust. is still teaching me lessons.'[45]

McCulloch shared Olsen's misgivings and perceptions concerning the wholesale embrace of overseas trends. This position emerged strongly in a string of letters and articles published over 1968. The context was McCulloch's invitation by Clive Turnbull, a veteran *Herald* journalist and editor, to contribute a book chapter on 'Australian art today' for the publisher André Deutsch. Initially McCulloch rejected Turnbull's overtures, but changed his mind.[46] Turnbull posed the following question as the basis of the essay: 'Is there an *Australian* (regional) art; indeed, is there a regional culture anywhere now, or is the whole world swept by waves of international fashion?'[47]

McCulloch's faltering reply to Turnbull was symptomatic of his and other critics' grappling with an issue that seemed to defy easy answers:

> … the chapter has set me a lot of problems and I've made one or two abortive attempts to get into it: I am a slow and very uneasy writer and my theme needs to hit me pretty hard before I can really bring it off. Regional? International? It's a mighty confused issue and takes a lot of sorting out: I hope I can succeed.[48]

By 1971, he had found a wider audience for his thoughts on the centre–periphery debate.

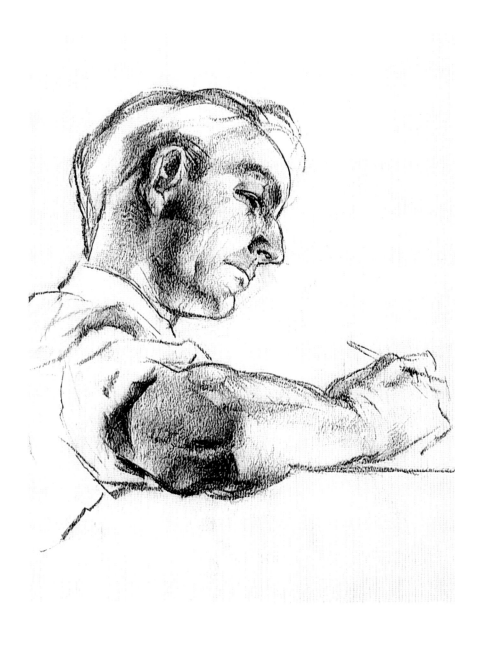

1. Wilfred McCulloch, *Portrait of Alan McCulloch* c. 1940
charcoal on paper
McCulloch collection

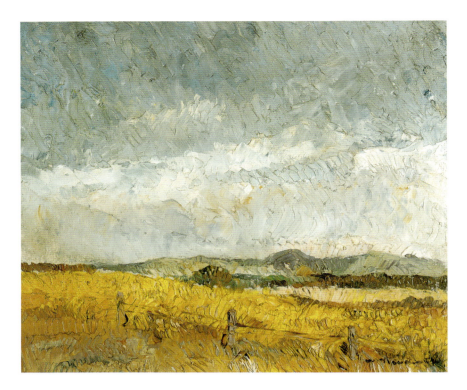

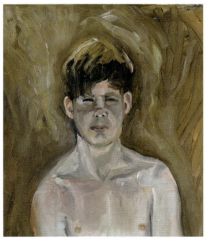

2. Wilfred McCulloch, *Heat Haze, Mornington Peninsula* c. 1938–40
oil on board
McCulloch collection

3. Wilfred McCulloch, *Arthur Boyd* c. 1937
oil on canvas
McCulloch collection

4. Alan McCulloch (top), Harold Beatty (rear), and Wilfred McCulloch in middle.
Artists' Camp: Gunnamatta, gelatin silver photograph
McCulloch collection

In the mid-to-late 1930s, the sand dunes behind Gunnamatta Ocean Beach on Victoria's Mornington Peninsula played host to a group of spirited young artists consisting of Alan and Wilfred McCulloch, Arthur Boyd, Harold Beatty, and National Gallery School student and poet, Donald Town. The artists' camp continued until 1941, until the makeshift shelter they had constructed fell into disrepair and ultimately became target practice for the Australian army.

5. Alan McCulloch, *Untitled (Gunnamatta Back Beach)* 1944
gouache on artist board
McCulloch collection

Cartoon historian Vane Lindesay points out in a 2014 tribute piece that McCulloch's drawing style for the 'Gulderbrandt' wartime series of cartoons such as that depicted above were drawn in an angular and geometric Art Deco style.

6. Alan McCulloch, *Death of Venus* 1940
etching
National Gallery of Australia, Canberra

7. Alan McCulloch, *[Neutrals]* 1940
pen and ink
Art Gallery of Ballarat, Victoria

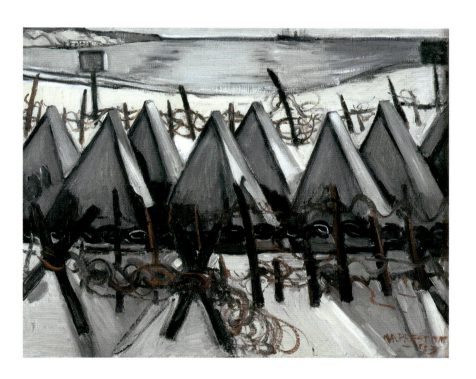

8. Margaret Preston, *Tank traps* 1943
oil on canvas
Mornington Peninsula Regional Gallery, Victoria

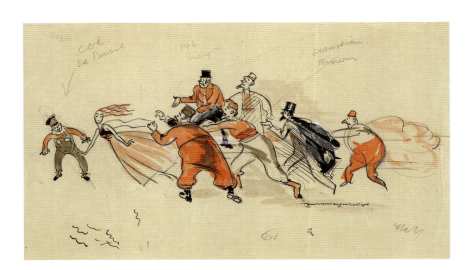

9. Alan McCulloch, *Pirouette des Pyjamas*
Henry Bucks catalogue 1938
McCulloch collection

10. Alan McCulloch, *Colonel de Basil* c. 1938
pen and ink
State Library Victoria, Melbourne

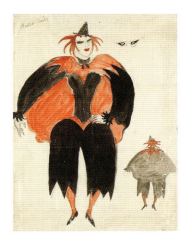
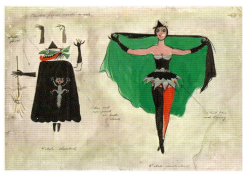
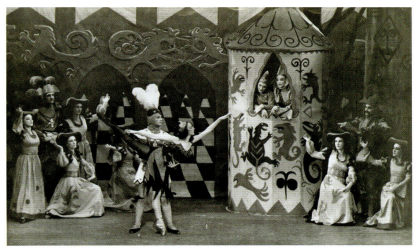

Contes Heraldiques, choreographed by Laurel Martyn, was first performed by the Melbourne Ballet Club, at the Repertory Theatre, Middle Park, on 5 November 1946, and again in 1959. *Contes Heraldiques*, or 'The Witch's Whim', was performed to a commissioned score by Dorian le Gallienne, with the costumes and set design by Alan McCulloch.

11. Alan McCulloch, *'Whimsical Witch' costume design for* Contes Heraldiques
Ballet Guild 1946
gouache and pencil on paper
State Library Victoria, Melbourne

12. Alan McCulloch, *Witch costume design for* Contes Heraldiques, 1959
gouache and pencil on paper
State Library Victoria, Melbourne

13. Jean Stewart, *Noel Murray as 'The Witch', Maxwell Collis as 'Sit Humbolt', Corrie Lodders and Grace McLean as 'Princess' in* Contes Heraldiques,
Victorian Ballet Guild 1947
Victorian Arts Centre Trust, Melbourne

14. Sybil Craig, *Opening of the Women Painter's exhibition by Alan McCulloch* c. 1947
oil on paper
State Library Victoria, Melbourne

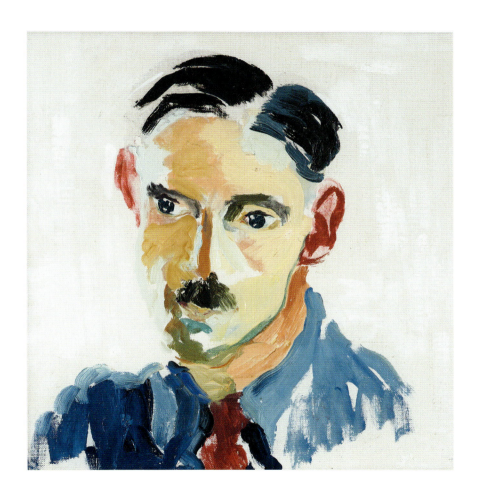

15. Lina Bryans, *Alan McCulloch* 1942
oil on canvas
Kerry Stokes collection, Perth

McCulloch carried a sketchbook wherever he went. In these small notepads he recorded his observations and experiences of people, places and events.

16. Alan McCulloch, *New York* 1947
pen and brown ink on spiral sketchpad
State Library Victoria, Melbourne

17. Alan McCulloch, *Caricatures* 1948
pen and brown ink on spiral sketchpad
State Library Victoria, Melbourne

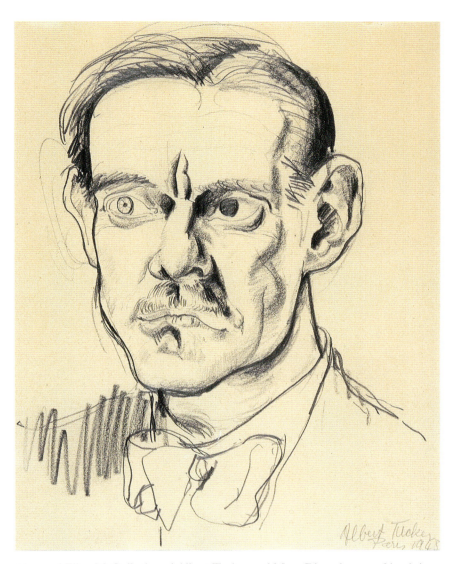

Alan and Ellen McCulloch and Albert Tucker and Mary Dixon became friends in Paris in 1948. This portrait of McCulloch depicts him with one eye facing in and one out—a strong gesture which, according to Tucker, referred to McCulloch's dual professional life as an artist and critic.

18. Albert Tucker, *Alan McCulloch* 1948
pencil on spiral sketchpad sheet
Mornington Peninsula Regional Gallery, Victoria

19. Alan and Ellen McCulloch in Paris 1948,
McCulloch collection

20. Alan and Ellen McCulloch at the
beginning of their adventurous tandem
bike trek across Europe
McCulloch collection

21. Alan McCulloch, *Positano* 1949
gouache, pencil and pastel on paper
Collection of Rene White

Alan McCulloch's French- and Italian-inspired pictures of European cities and landscape were exhibited in London in 1950 and again in Melbourne upon his return to Australia in 1951. Reviewing his work in London's *Sunday Times* the critic Eric Newton noted that while McCulloch was 'a painter who sometimes lets his excitement run away with him, [he] is at least, excited, as though he had just discovered Siena or Positano or an old man in Capri …'

22. Alan McCulloch, *Palio di Siena* 1948
gouache, pencil and pastel on paper
McCulloch collection

23. Allan, Ellen and Susan McCulloch, Melbourne 1950

24. Alan McCulloch outside the 'Whistlewood' studio he built in 1951, c. 1957

'Whistlewood' on Western Port Bay, Victoria was home for the McCulloch family from 1951. It became a haven for artists and their families. Visitors were expected to work for their keep as well as have time to relax.

25. Ellen and Alan McCulloch, and Albert Tucker, 'Whistlewood', Shoreham 1961
McCulloch Collection

26. Charles Blackman, *The swimmer* 1952
crayon and charcoal on tracing paper
National Gallery of Victoria, Melbourne

27. Charles Blackman, *Man floating* 1953
oil on composition board
Private collection

28. Danila Vassilieff, *Woman with monkey* 1950
Lilydale marble
Heide Museum of Modern Art, Melbourne

The uneasy relationship between McCulloch and the new generation of artists and critics who emerged in the early and mid 1960s culminated with his mostly negative response to the flagship exhibition designed to launch the newly completed National Gallery of Victoria building in August–September 1968. *The Field*, a transformational exhibition that was restaged by the NGV for its fiftieth anniversary in 2018, repositioned the state gallery away from the past and more towards current developments in art. According to McCulloch, however, *The Field* represented a lost opportunity to properly survey and promote what he considered the best in Australian art—modern, contemporary and Aboriginal art. This opportunity, he reasoned, had been cast aside in favour of a young and relatively untested group of artists whom he felt relied too much on fashionable overseas sources: in particular, American proponents of hard-edge abstraction.[49]

McCulloch wrote in disparaging terms to critic John Henshaw about the opening 'of the Westbrook Mahal' in the lead-up to the exhibition. The 'embarrassing part of the inaugural exhibition', he stated, 'is that it looks, on paper, like an all-time loser and I'll need to say so before rolling along to the opening. Ah well, what else are we critics for.'[50] Participating *Field* artist Dale Hickey wrote to the *Herald* editor in response to McCulloch's statement that what 'visiting art authorities want to see here is an art which is unmistakeably Australian and preferably figurative' to challenge this as a matter of fact.[51] McCulloch had laid down the gauntlet and he received as good as he got. John Reed, the director of Melbourne's Museum of Modern Art, suggested in a follow-up letter to the editor that McCulloch's comments in his review of the actual exhibition 'reveal an unfortunate lack of contact with an important section of the creative world'.[52]

Art International

In 1970, McCulloch cut back on writing and other commitments due to the sheer volume of work. The 62-year-old had a new monograph

in progress and had recently helped to establish a regional gallery on Victoria's Mornington Peninsula. This was in addition to the two days a week spent as *Herald* critic, regular contributions to a range of art journals and a publishing regime that included the *Encyclopedia of Australian Art*. He had been elected AICA's representative on the Australian National Advisory Committee for UNESCO in March 1969, and his role galvanising Australian art critics under the aegis of the association continued to take up valuable time and effort.[53]

Into this heady mix, McCulloch saw fit to take on an additional role in raising the profile of contemporary Australian art abroad. In 1969, he accepted an invitation from magazine editor and owner James Fitzsimmons to contribute a bi-monthly 'Letter from Australia' to the Swiss-based journal *Art International*. McCulloch had been recommended by a mutual friend, JJ Sweeney, director of the Museum of Fine Arts, Houston. McCulloch's brief was to report on 'the interesting things going on in Australia' and to help 'redress the imbalance of a magazine that purports to be international' by providing essays of between 3500 and 5000 words.[54]

McCulloch accepted the prestigious appointment quickly and with good grace. His offer to write the first piece on current trends and outstanding individual artists was accepted by Fitzsimmons, who then urged him to be more topical in future editions by dealing with current exhibitions in Sydney and Melbourne.[55] McCulloch provided an overview of the trajectory of Australian art up until the *Antipodeans* exhibition in 1959. In particular, he drew out the achievements of Arthur Boyd and Fred Williams as well as other independent artists such as Jan Senbergs, George Baldessin and Leonard French. His first essay was substantial and engaging, with some beautifully crafted lines and turns of phrase, and an additional note of caution. He was dismissive of artists coming after the Antipodean artists—he believed they would bring about the demise of Australian art—and warned of the wholesale embrace of the large scale and new techniques of American hard-edge and colour field abstraction. McCulloch felt that

slavish imitation was 'at the mercy of anyone armed with masking tape and a spray gun'.[56]

Fitzsimmons expressed pleasure in McCulloch's article,[57] but its deliberately provocative nature meant that it was destined to draw the ire of sections of the Australian art community. The 32-year-old Sydney-based sculptor Wendy Paramor, whose work had been included in *The Field*, wrote to Fitzsimmons in December 1969 to lodge the 'strongest possible protest'. She accused McCulloch of being unable to deal with non-figurative painting and sculpture and of a lack of factual detail. Worse was to follow. McCulloch was also to receive a lengthy open letter from art critic and historian Terry Smith and another artist, Paul McGillick, who, like Paramor, was an exhibitor at Central Street Gallery in Sydney.[58]

McCulloch's first article had been a 'lost opportunity', according to Terry Smith. There was, he contended, a lamentable emphasis on the Antipodeans and the 'gravest distortions of historical fact occur when he attempts to deal with local Colour-field, Hard-Edge and Geometric abstract art'. Smith pointed out that many of the Australian artists working in these modes had had firsthand contact with its source, with many having lived overseas throughout 1960–66. '*The Field* exhibition', he wrote, 'served not to begin a new movement but to fragment one that had been in existence for three years.'[59]

Smith was fundamentally correct, but McCulloch was nonetheless livid. The article appeared to attack his hard-earned sense of professionalism and he believed misrepresented what he had said. In McCulloch's estimation it was an 'amateurish and bad-mannered letter' that 'lacked sincerity'. Furthermore, he was happy to put his name next to the mature work of the Antipodeans over 'that of immature students'. McCulloch's three-page reply to Smith remained unsent.[60] Instead, he wrote to numerous colleagues seeking clarification and making his case. He wrote to Bernard Smith questioning whether Smith's letter had been sent with the 'official sanction of the Power Institute': Terry Smith was a tutor there and the letter had been sent on Power Institute letterhead.[61]

McCulloch turned to Sydney painter and art critic Elwyn Lynn, asking if the open letter was to be published in Sydney's Contemporary Art Society (CAS) *Broadsheet*: Terry Smith had offered McCulloch the chance to respond to him there. McCulloch took up the offer, though he refused to go into much detail due to, in his words, the 'foolish' argument, contradictions and 'extreme narrowness of the views expressed in it' by Smith. McCulloch countered the latter's argument that he was blinkered by 'well-known prejudices' and restated his case that he did not object to *The Field*, which he now characterised as 'quite a gay, bright show'. Rather, it was the lost opportunity in concert with the opening of such a prestigious gallery to 'consolidate the recent hard-won prestige of Australian art by placing before this audience a full-scale comprehensive exhibition of the finest contemporary art this country could produce'.[62] McCulloch, it now seemed, was arguing for these younger turks to pay their dues rather than miss out altogether.

Lynn informed McCulloch in July 1970 that a reply was no longer needed, as the letter that Smith claimed had been sent to the CAS was never received. He added: 'It is, of course, a campaign to discredit you with Mr Fitzsimmons and I consider it deplorable; it is part of a general take-over bid, a present aim to expand the B/S into a magazine with an editor or editors chosen to promulgate a Central Street ideology.'[63]

Following an unrelated period of ill health, including a stint McCulloch spent in hospital, Fitzsimmons felt compelled to advise him on how best to deal with his critics. This included the 'need to be vigilant about speculation' and keeping his 'keen' though 'faintly malicious' sense of humour under control. Fitzsimmons ended with the rejoinder: 'My way of disarming the connivers you mention is: be nice to them. Thus I've commissioned articles from some of them: this will serve to "balance" yours—ahem.'[64] McCulloch was grateful for the advice—bringing the perceived dissenters closer was something that he too had learnt. He chuckled in response to Terry Smith's subsequent essay on painter David Aspden that was

included in *Art International*: 'Well the policy of giving "connivers" plenty of rope by publishing them certainly proves effective in this instance.' In another letter, McCulloch observed that he had liked 'Patrick's [McCaughey] piece' although he 'would argue that he's elevated Meadmore a bit beyond his true status'.[65]

McCulloch's relationship with Fitzsimmons and *Art International* became increasingly strained over 1971–72. Changes to the brief that included giving the essays 'a larger bearing' had made the job more time-consuming and difficult for McCulloch. Several articles were rejected, including one on the art of New Guinea and a lively diatribe concerning the history of the Power Bequest. Fitzsimmons also resented McCulloch's support for Swiss curator and writer Harald Szeemann. Fitzsimmons characterised him as 'one of Europe's foremost champions of bullshit'.[66] McCulloch, he believed, had lumped conceptualist critics like Szeemann and formalists including Greenberg and Michael Fried into the same camp and wrongly blamed them for 'the death-of-art predictions'. McCulloch was magnanimous. As he explained to Fitzsimmons, 'Well, re-reading it I feel you are probably right; it doesn't take much to convince me about my own faults in writing and certainly the material was thin.'[67]

In Fitzsimmons' estimation, McCulloch had miscalculated when he used the opportunity to attack formalist and conceptual art critics. McCulloch was less intent on voicing his frustrations about Greenberg, Fried or Szeemann than about the inclinations and public pronouncements of local historians and critics such as Donald Brook, Ross Lansell and Terry Smith. According to McCulloch, 'All subscribe to the notion that the "idea" compounded in words (by themselves) is of more importance than any actual work of art … All three are haters and in fact two are real misanthropists who have done a lot of harm to art in Sydney.'[68]

McCulloch also took aim at Bernard Smith, who by this time was part of the Power Institute fraternity. In January 1971, McCulloch enclosed with his latest letter to *Art International* a heated discussion on the 'destructive influence' of that institution. He commented that

Smith, an art historian, was 'not the right man for the job'. 'They also needed firm ideals'—suggesting that Smith had moved on from the Communist Party of Australia leanings evident in his 1945 book *Place, Taste and Tradition*—'originally strong for social realism and figuration, he made a sudden switch to avant garde abstraction when he got the Power job. His greatest weakness, however, was [his] inability to pick the right staff', by which McCulloch clearly meant the South Australian Donald Brook.[69]

Fitzsimmons was not impressed. He wrote back two weeks later simply stating this 'would not do!' and he was not interested in the 'growing pains, intramural games and internecine squabbles of the local art institutions and establishment'. Instead, Fitzsimmons suggested that he send the new material to *Studio International*, 'who seem to love this sort of linen-washing-in-public thing'.[70]

Hurt and mystified at his colleague's reaction, McCulloch intimated a parting of ways. He submitted a revised manuscript on drawing and the 'non-controversial part of the rejected material'. In a more conciliatory tone, he provided a brief overview of University Galleries in Australia, the role of Elwyn Lynn as a curator and the pitfalls and perils of forging a contemporary art collection.[71] Fitzsimmons reassured McCulloch that he was not trying to 'out' him and thanked him for the letter which 'was much more to my liking'.[72] However, there could be no reparation of the relationship.

Critics/Historians

Alan McCulloch's relationship with other art critics during the 1960s and early 1970s provides a fascinating insight into Australian artworld politics and changes in style and method. James Fitzsimmon's aversion to 'washing dirty linen in public' was something that McCulloch felt compelled to broach, especially given what he saw as the negative impact of some art critics on Australian art and artists. He was loyal to those whom he regarded as like-minded or as important precursors and mentors but at the same time scathing of others

whom he disagreed with on principle or felt let down the practice of independent and informed art criticism in Australia.

One of his first and longest-standing confidants in this respect was not an Australian, but an American art historian and lecturer, Bernard Myers. McCulloch and Myers were the same age and had met in 1947: Myers was teaching at the Art Students League and McCulloch spent time there during his New York sojourn. In addition to his books on German expressionism and Mexican art, Myers had gone on to become editor-in-chief for art books at McGraw-Hill (1959–70). In partnership with his wife and fellow academic, Shirley D Myers, he edited the five-volume McGraw-Hill *Dictionary of Art*. He also served as a consulting editor for the massive 16-volume McGraw-Hill *Encyclopedia of World Art*.

The largesse of Myers' approach to art and his focus on a range of artists and styles endeared him to McCulloch. The two remained steadfast friends and were frequent letter writers. Myer was equally effusive towards McCulloch and his achievements. When thanking him for sending a copy of the 'charming and entertaining' *Highway Forty*, Myers reciprocated by sending the first of two German expressionist articles that he had written for the journal *American Artist*. He promised to send him the other when it was completed and the foreword that he was preparing for the Albright Art Gallery in Buffalo, which 'is doing Expressionism in U.S. Ptg. Show'.[73]

Myers wrote of his impending trip to Mexico on 'June 5 in search of fresh material for a survey of Mexican painting, 1922–1952' and of 'bringing the entire business up to date, from the point at which others left in 1941'. According to Myers: 'Lots has happened there: the work of [David Alfaro] Siqueiros especially significant, the last decade of [José Clemente] Orozco's work a climax of his previous efforts and the appearance of a number of new muralists as well as easel painters unknown in this and other countries.'[74] In 1954, Myers was able to update McCulloch on the progress of his *Art and Civilization*—it was now finished, and the German book and Mexican book were 'on the way'.[75] Through Myers, McCulloch stayed in

touch with recent developments in art scholarship worldwide and was introduced to the world of the art dictionary and encyclopedia, something which would have far-reaching effects on both McCulloch and Australian art.

McCulloch's earliest Australian mentors included Joseph Burke, whose appointment as inaugural professor at the University of Melbourne's art history department he applauded through articles in the *Argus*. Sydneysiders Laurie Thomas and influential immigrant artist and critic Paul Haefliger were also important precursors and contemporaries.

McCulloch argued in a 1952 *Meanjin* article that Haefliger had raised 'the whole standard of critical writing in Australia. [His writing was] based on a very thorough knowledge of the history, psychology and philosophy of art as well as its practice, a knowledge gained through intensive study'.[76] McCulloch followed these remarks with further analysis in a script for a 1962 ABC television series developed for the 'University of the Air'. Haefliger, McCulloch postulated, was the 'chief protagonist in the cause of this realist, romantic interlude in Sydney ... [while his] intellectual appraisals introduced new and much tougher standards, demanding "intelligence" as well as technique, and "feeling", in place of mere "effect".'[77]

Haefliger became increasingly disengaged from art criticism, effectively retiring from writing in 1957. Responding to an invitation to write for *Meanjin*, Haefliger responded: 'I should like to discuss the work of John Passmore who may yet become the best painter Australia has ever had. At present he is a mad eclectic who needs a swift kick in the pants.'[78] This passage could have been written by McCulloch. In the year before he left Australia, McCulloch commented admiringly, about a *Forum* radio broadcast in Sydney covering the Archibald and Wynne prizes for the *Herald*, that 'even Haefliger said I made some good original points'.[79]

Sydney critic, curator and journalist Laurie Thomas was another writer that McCulloch respected and looked to for guidance. McCulloch recognised in Thomas something of a kindred spirit:

a hard-hitting critic and trailblazing early supporter of Australian Aboriginal art—and someone who, he later wrote, was 'never willing to compromise in matters of conscience'.[80] One of Thomas's aversions was what he saw as the malaise besetting art criticism in New South Wales and the ongoing debate on the death of painting. This reached a crescendo in the early 1970s as conceptual art gained momentum in Australia. McCulloch aired his views on the state of art criticism in response to a letter from Thomas: 'I too opt for the "thing" + believe in its power to survive as already it has for 5,000 years.' Thomas replied in agreement to both points.[81]

McCulloch and artist, author and critic Elwyn Lynn, younger than McCulloch by a decade, often held opposing views based on their different interpretations of the trajectory of modern art in Australia. Lynn was more open than McCulloch to avant-garde practices and the emphasis on an idea-driven practice. However, they developed a friendship and harboured similar thoughts about some of Australia's other, better-known artists and critics.[82] The two sometimes conferred on the difficulties they were experiencing as critics and lent support to each other during difficult times. A fundamental difference of opinion emerged in 1964 after McCulloch had offered to write on the Helena Rubinstein and Blake prizes for *Art and Australia*. The journal's editor, Mervyn Horton, informed McCulloch that he had already commissioned Frank Cozzarelli to write on the former. McCulloch's submission was provocatively titled 'Popunjunk's Picnic' and, while it had arrived too late for the next issue, McCulloch emphatically rejected Horton's suggestion that it could be published in the issue after that with 'possibly one or two modifications'.[83] Horton then asked for an edited version 'to avoid giving the impression that we have no editorial policy at all—that we publish articles by Robert Hughes and Elwyn Lynn which we think worthwhile and then knock them down in later numbers'.[84]

John Olsen entered the debate from the perspective of his membership of the Art Advisory Board for *Art and Australia*. He began by citing the 'defence of art and importance of tradition'. Olsen wrote

to McCulloch in December 1964 and again in January 1965. In a beautifully eloquent and handwritten letter that ruminated on the nature of the avant-garde and the direction of art, Olsen spoke of the apparent willingness of some critics to jump onto the American bandwagon.[85] McCulloch finally had his way when in the June 1965 issue of *Art and Australia* he reviewed the exchanges over the judging of the Rubinstein prize and Lynn's involvement in it.[86] Lynn countered angrily with a personal letter to McCulloch, and in a more measured way then invited him to contribute a discursive piece on Australian art to *Quadrant* in the following year, explaining that 'as [McCulloch was] the longest-practising critic in Australia ... it would be a pity if some such observations (what it's about and how it's changed) were not recorded somewhere sometime'.[87]

Lynn's own misgivings about the state of Australian art criticism took a more resolute approach following his appointment as the first curator of the Power Bequest from 1969. He wrote to McCulloch about the provincialist squabble that McCulloch had drawn out in *Art International* and of the 'divisive influence' of Donald Brook and Terry Smith at the *Bulletin* and the Power Institute. He noted that Brook had recently 'challenged my authority so much that he wanted to have the Deputy Vice-Chancellor resolve matters. He did, in my favour. Bernard, of course, deplored all this.'[88] Four weeks later, in September 1970, Lynn followed with a letter that despaired of the triviality of contemporary art and the split manufactured by Central Street Gallery artists.[89]

Lynn further acknowledged the personal difficulties and the 'loneliness of the long-distance critic' in a heartfelt exchange of letters with McCulloch written in 1971, initiated primarily to gather information about holdings of Sidney Nolan in public galleries for a forthcoming book on the artist.[90] McCulloch replied in kind: 'Loneliness in art? Well, it catches up with all of us at times. But somehow I always come back to the thought that things don't just happen someone has to make them happen ...'[91]

In contrast to what McCulloch thought of the older guard represented by Haefliger and the slightly younger Thomas, he found much to dislike among an assortment of art critics and historians that emerged in the 1960s. McCulloch was often scathing of the efforts of the young Robert Hughes, for example. In 1964, he confided to a friend that the art critic turned historian showed 'Great brilliance, but needs to be treated with caution'.[92] Hughes, then a 25-year-old architecture graduate, had been writing for the London *Observer* and *Sunday Times* since 1959 and was contracted to write a history of Australian art. He famously went on to forge a long and illustrious international career as an author, critic and broadcaster. McCulloch, one suspects, particularly in the early to mid-1960s, found Hughes more brash than endearing.

Two art critics with whom McCulloch (and Thomas) frequently clashed in the late 1960s were Melbourne's Ross Lansell and Sydney-based critic and lecturer Donald Brook. They all possessed very different ideas about art, with McCulloch questioning at various times Lansell's and Brook's integrity, art-world allegiances and judging protocols for art competitions.

In January 1968, Lansell wrote to the *Herald* to protest McCulloch's criticism of his comments on the annual Archibald Prize in Sydney. Lansell claimed that McCulloch had unfairly singled him out as one of the 'new critics' whom the latter argued were contributing to the sensationalism of art prizes. McCulloch, Lansell continued, had misrepresented his primary intention, which was to weed out the mediocre works from the better ones.[93] This debate was followed soon after by a very public spat that again involved both McCulloch and Lansell, this time in regard to the latter's criticisms of prominent Sydney gallerist Rudy Komon and artist Andrew Sibley. McCulloch sided very strongly with Komon and Sibley. He reassured Komon that he too believed that Lansell was out of order and promised that he would strongly recommend to fellow AICA members that Lansell, who was also in the association, 'be asked

to resign immediately'.[94] Komon went even further by writing to Lansell's editor at the *Sunday Telegraph* to demand a public apology. Eventually, a letter was sent to Lansell's editor at *Nation* on AICA letterhead, advising that he was in fact no longer a member and 'would not be acceptable as such because of his apparent lack of ethical responsibility'.[95]

McCulloch could be equally outspoken when pressed on matters of the correct protocol and relevance of allegiances within art-world politics when key protagonists judge state and national art prizes. In November 1968, Donald Brook requested a public apology from McCulloch for insinuating that liberties had been taken in the awarding of the annual Transfield Art Prize, the richest award exhibition in Australia. In a letter he cc'd to Lansell (the fellow judge),[96] Brook challenged McCulloch's suggestion that the $2000 Alcorso-Sekers Award should be 'carefully fostered and not taken liberties with, as was the case with the recent highly valued Transfield Prize'.[97] Most of the artists singled out for commendation by the two judges of the Transfield Prize were new colour-field abstractionists, including Tony McGillick, Michael Johnson, Col Jordan, Dale Hickey, Robert Rooney and John Peart. Peart, a 23-year-old Brisbane artist, was the youngest-ever winner of the $5000 cheque, for a large painting he described as 'just an abstract'. Conferring the award on such a young and inexperienced painter would in his eyes prove counterproductive to the artist's progress, while the over-representation of artists associated with Central A Gallery in Sydney and Melbourne and a limited representation of artists with a figurative style was a further cause of concern. Elwyn Lynn retrospectively teased out the issues surrounding art prize awards and contemporary judging trends and protocols in an illuminating essay published in *Art and Australia* in 1969.[98]

McCulloch found common ground and interests with some young and/or emerging art critics, even where they held contrary views and philosophical positions—most notably, the flamboyant and erudite art critic, university lecturer and later director of the National Gallery

of Victoria, Patrick McCaughey. McCaughey was the youngest-ever art critic appointed to write for a major daily newspaper. He brought a new face and perspective to Australian art criticism, one that differed markedly from McCulloch's humanism, though this did not deter him from riding around the city with McCulloch, stopping for lunch together and reviewing the exhibitions in Melbourne for their weekly columns.

An early follower of Clement Greenberg and one who eschewed his formalist bent through writing and lectures, McCaughey once rebuked McCulloch for his response to *The Field*, claiming that he had written about the landmark exhibition without having seen it. McCaughey's support for the artists included in *The Field* and the idea of their different styles and approaches to art being wide in their respective levels of achievement and in transit was fully elucidated in his seminal essay on Australian art, 'The Significance of the Field', published in *Art and Australia* in December 1968. For McCaughey, the new abstractionists had rightly claimed their place in the hierarchy of Australian art and had initiated a new wave of art to come.

Not long after, in January 1969, McCulloch wrote to McCaughey to congratulate him on receiving the Harkness Fellowship, which would allow him to live and study for twelve months in the United States. McCulloch laid out the challenges he would face and offered advice on what he might find and how he could profit from the experience. He used the opportunity to communicate his ideas on regionalism and internationalism in art and the need for McCaughey to be vigilant.[99] McCaughey's response was equally staunch, agreeing with McCulloch's assessment regarding 'how important it is to assess the centre properly before working at the fringes and that's exactly what I want to do in NY'. His reply was also gracious. While the two often had disagreements, he suggested that he didn't let them interfere 'with my admiration for your commitment to a thoroughgoing humanist view of art; even when I thought it mistaken, it is always good to be reminded of the human source of all art'.[100]

The relationship between McCaughey and McCulloch oscillated between tongue-in-cheek rivalry, outright disdain and a genuine affection. McCaughey wrote to him in 1972: 'I see we reversed our roles this week. You going for the positive, me for the negative … I hope you didn't think my comments were too gentle?'[101]

CHAPTER 5

FRIENDS AND FOES

The real aesthetic status of any country depends in the end on the quality of its individual artists.

Alan McCulloch, 1969[1]

ALAN McCULLOCH WAS an art critic who regarded himself first and foremost as an artist. This meant that he was also naturally drawn to doers and makers. McCulloch enjoyed the advantages of having a wide circle of artist-friends, and as his sphere of influence grew so too did the length and breadth of his contact with artists, gallerists and arts patrons.

In the 1920s and 1930s, McCulloch gravitated towards established artist-heroes whom he believed had successfully crossed the divide between fine art and illustration. Will Dyson and George Grosz, among many others, helped him to form his own ideas about art. This included the importance of the drawn line as a significant form of self-expression with roots in democratic ideals and longstanding humanist traditions. With the emergence of a cluster of artists during and immediately following the tumultuous years of World War II, McCulloch gained new perspectives that broadened his understanding of art. His contact with a group of immigrant artists that (re)connected him with European traditions and contemporary

European art; the emergence of homegrown though predominantly figurative artists who were intricately linked to the reinvigoration of Australian art from the 1940s, and the next generation of younger artists who would later define themselves in opposition to the older and well-established Antipodeans—these were all part of McCulloch's journey as a critic.

Figuration and Australian Expressionists

McCulloch endeavoured to maintain a strong critical independence in his writing and be even-handed in his approach to art. Even so, the desire to present a balanced outlook was sometimes handled in clumsy ways. Writing in the foreword of the catalogue for the 1969 Georges Art Prize, he postulated that only a few good artists stood out in each generation and that his job as a critic was to sort out the wheat from the chaff.[2] This position inevitably caused friction in his relationships with artist-friends and colleagues. It alienated him from conservative artists who were producing hackneyed tonal paintings and put him at odds with a new generation of emerging artists and critics for whom such connoisseurship was an old-fashioned and increasingly moribund notion.

McCulloch coined the phrase 'The Heroic Years' to broadly encapsulate the coming together of a group of Australian modern artists from the 1940s to the mid-1960s. Primarily male, these artists had, according to McCulloch, changed the course of Australian art. He believed they had lifted it out of the dull morass of the academicians and conservatives who had dominated in the years preceding World War II. Not surprisingly, 'The Heroic Years' became the title of a major exhibition McCulloch curated for the Melbourne *Herald*, which toured eighteen venues across five Australian states throughout 1977–78. The artists he associated with that grouping, combined with Australian Aboriginal art, gave Australia its first sustained international profile.

The links between this otherwise diverse group of artists were outlined by McCulloch in a letter introducing Australian art to the senior editor of *World Book* (Australia) in 1986. 'If Drysdale supplied the classicism and Boyd and Nolan the primitivism to the Antipodean movement,' he reasoned, 'Albert Tucker supplies the savagery and cutting edge.'[3] McCulloch was friends with most of the Antipodean artists and admired their work, although this was not something that had happened overnight nor did it come without significant strains. McCulloch was one of the first critics to embrace, learn from and adapt his thinking to incorporate changing bodies of work, but he was also critical of new offerings when he felt it was required.

Arthur and Yvonne Boyd were lifelong friends of the McCulloch family. Arthur Boyd encapsulated many of the values and qualities of a progressive that McCulloch sought. They met through Alan's younger brother Wilfred in the mid-1930s. Arthur became a frequent visitor to the McCulloch's home in Malvern. Later, through Alan, he was introduced to Yvonne Lennie, a separate friend of McCullochs who was also studying art at night. In 1959, Arthur and Yvonne set sail for England. Boyd wrote from the ship, *Iberia*, thanking McCulloch for his kind letter, reflecting upon their shared past and concluding that 'the days I spent with Wilfred and you were some of the happiest of my life'.[4]

McCulloch painted with Boyd in the open air in the 1930s and early 1940s and openly admired his landscapes; however, his appreciation and understanding of Boyd's wider oeuvre of paintings and ceramic sculpture took more time. Writing in *Meanjin*'s winter 1951 issue, McCulloch recognised Boyd's genius but was ambivalent about what he saw as an unevenness in his work. This was evident in a perceived lack of cohesion between figures and ground, along with 'inconsistencies in the execution'.[5] While acknowledging Boyd's 'singularly rich and fertile imagination' in biblical paintings such as *Jacob's dream* (1947–49), McCulloch added that 'technically there are plenty of shortcomings'.[6]

McCulloch's review of Boyd's 1952 solo exhibition at Stanley Coe Gallery, Melbourne, and subsequent reviews in 1953 and 1954, continued in the same vein. Boyd's extended foray into ceramic sculpture and painted tiles did nothing to alleviate the problem. In McCulloch's view, Boyd's burgeoning talent, originality and expressive vigour needed to be counterbalanced by the discerning critic against the artist's technical deficiencies.

A 1954 review of Boyd's ceramic sculpture exhibition at Tye's Art Gallery, Melbourne brought a stinging rebuke from gallerist and patron John Reed. Reed wrote to Albert Tucker in December 1954 to say that 'McCulloch does his best but in doing so only shows his hopeless limitations. Instead of going straight to the point and telling people that they are confronted with masterpieces of contemporary art, he doodles around with words as though he were writing in a school magazine.'[7] Ironically, McCulloch's review drew an equally strong response from veteran Melbourne painter William Frater. Coming from the opposite position, he stated the need to 'redress the direction of art', commenting, 'Loneliness, fear, misery and death on earth, completely shadows any aesthetic worth', concluding that 'All great art is the result of research upon the Phenomena of nature'.[8]

While McCulloch singled out Arthur Boyd as 'probably the most *completely* Australian painter extant'[9] and by 1959 was happy to champion his work as the most resolved and original of all artists working in Australia, he did not warm to the work of Boyd's younger brother David. In 1956, David Boyd complained to McCulloch, vehemently objecting to the description of his Murrumbeena pottery as 'commercial', which he felt 'implies mass production and repetition'.[10] In another letter dated 10 December 1961, David Boyd challenged McCulloch's review of his Melbourne show, refuting the inference 'to link my interpretation of the desert and its people with Aboriginal art'.[11]

McCulloch also took time and effort to develop a fulsome appreciation of the work of Sidney Nolan. He first discounted Nolan's Wimmera paintings in the early 1940s. In a later recollection to

Elwyn Lynn, where he was asked to nominate writings on Nolan considered of importance, McCulloch gave the following assessment:

> By the way, I don't want to sail under any false colours regarding Syd. Both Reed and [Clive] Turnbull were always more enthusiastic than I was about his potential in those early days. I had a hangover from the Lambert era that took a lot of getting over and 'primitivism' had little appeal for me before 1946.[12]

McCulloch's 1953 review of Nolan's drought series, which included six large carcass paintings shown at Peter Bray Gallery, Melbourne, shows how far he came in less than a decade. Paintings such as *Carcass* (1953), now in the National Gallery of Victoria collection, were to prove difficult for the public and potential buyers. None of the works were sold during the exhibition. Yet, like James Gleeson in Sydney, McCulloch saw the exhibition as 'extending the national visual vocabulary'[13] and as his 'most impressive to date'. The 'skeletonised cattle of the drought lands', he wrote in elegant fashion, 'are here stated in terms of large simple shapes whose dramatic force makes them true, tragic symbols of the less attractive aspects of life in central Australia'.[14]

McCulloch had limited further opportunity to review Nolan's works with the departure of Sidney and Cynthia Nolan for Europe in October 1953. However, his summation of Nolan's contribution, made several decades later, confirms how he had changed his position when he stated: 'If modern Australian painting has impinged iteself [*sic*] on the consciousness of the international art world, much of the credit for this must go to Sidney Nolan.'[15]

Albert Tucker was also absent from Australia for a decade, from 1947 to 1957. During this time, McCulloch endeavoured to keep Tucker's work in the public domain. He had employed the artist as a freelance contributor to the *Australasian* in 1945, but it wasn't until they were both working in Paris in 1949 that they became firm friends. Tucker was living in a caravan on the banks of the Seine while Alan and Ellen were living in slightly more agreeable circumstances in a one-bedroom flat. The McCullochs shared their meagre

rations with the struggling artist, including hard-to-come-by portions of butter and eggs.[16]

Tucker's published letters to fellow expatriate Nolan give an insight into the physical conditions he endured and the internal battles he fought while living as a fringe-dwelling Australian artist in Europe.[17] Exhibitions were difficult to secure and positive critical response to his work was almost non-existent. McCulloch was one of the few critics to discern the strengths in Tucker's art and offer him both personal and professional support. One of the first reviews of Tucker's European work was written by McCulloch and published in French in a Parisian magazine called *Prism* in 1956. Tucker commented approvingly: 'I hope Mary's [version] re-translated back into English still has a semblance to what you originally wrote. A timely and necessary piece by the way.'[18]

Tucker continued to write intermittently to McCulloch prior to and following his return to Australia. These letters express the convictions of an artist searching for a personal voice and his attempts to make sense of his position in the art world. In May 1954, Tucker wrote to McCulloch apologetically, explaining that all his time had been taken up with looking after Nolan, who was staying with Tucker and Mary Dixon, and they were also 'up to our ears preparing a show for the Foreign Press Club' to be held in Italy. Tucker proceeded to give a sense of the direction his work was heading: 'All the human tragedy of course, but with some curious meeting of Pacific totem forms with elements of the Christian myth.'[19]

Tucker later ruminated on a new world order, his continuing self-imposed exile from Australia and the need to go to America. Whatever difficulties he faced, he cited the experience of living in France and Italy as having given rise to a more profound sense of what it meant to be Australian. This consciousness had severed him and his generation from a distinctly British ethos and engendered a deliberate rawness in his art:

> I'm working pretty hard now, and my present burst of work has convinced me of one thing—that Australia no longer has any real or

dependent connection with the Greco-Roman tradition of Europe. The images I am pulling out are definitely Australian-Pacific in their basic impulse; the imagery has little or nothing to do with Europe and what is not specifically Australian is more the diffused urban-technilogical [sic] imagery of emerging world culture.[20]

The rough, pitted surfaces and expressionist forms alluded to by Tucker have a visual counterpart in the *Antipodean Head* series dating from 1957 and his aptly titled *Lunar landscape* (1957), the first work by Tucker to be acquired by a public museum. These works represented the crystallisation of Tucker's ideas and were his most original works to date—Australian in origin but universal in their scope. They also helped to launch a more financially successful period in his career.

Tucker returned to Australia from the United States in 1960, and continued to find a valuable ally and friend in McCulloch. He visited the McCullochs at Whistlewood and stayed with some of their close friends in Perth, while his first return show, organised by John Reed, was held at the Museum of Modern Art of Australia—the goings-on in the lively art scene described by a friend as 'dashing hither and yon to parties, talks, his opening (very gala, my word)'. A monograph on Tucker's work was also in preparation.[21]

Tucker had been largely inconspicuous to the Victorian public during the late 1940s and throughout the 1950s because of his self-imposed exile in Europe. However, the same could not be said of Joy Hester, a former partner of his. The three solo exhibitions and numerous group exhibitions she appeared in (while she endured a debilitating long-term illness leading to her early death in 1960, aged forty) were either ignored or lambasted by Melbourne critics. It was left to avid supporters such as John Reed and friends from the Heide circle of artists and writers to champion her work—they recognised early on her unique style and vision. Her supportive husband, Gray Smith, expressed it best: 'Apart from a select few the world wasn't ready for her.'[22]

Reviews of an exhibition of expressionist artworks and accompanying poems by Hester held at the Melbourne Book Club Gallery

in February 1950 were symptomatic of the negative criticisms. An unnamed *Age* art critic claimed the drawings to be 'so personal in style and form that their meaning is lost in the obscurity'.[23] In the *Herald*, Laurie Thomas's response took a similar path. Although Thomas found the poems to 'well out' of 'a deep intensity of feeling', the visual representations fell short because he felt that they lacked an appropriately concentrated form with which to express such deep emotions. According to Thomas: 'A great effort of sympathy is needed to see beyond the amateurish drawing to the private feeling that hosted it.'[24]

Hester's second solo exhibition, held at Mirka Café in July–August 1955, was reviewed in a far more engaged way by McCulloch, who by this time had replaced Thomas as *Herald* art critic. Where Thomas had seen a profound lack of formal substance, McCulloch discerned a 'striking ... originality' built upon 'the unusual presentation, in large, flat areas of black and white, of the human physiognomy'.[25] Hester exemplified McCulloch's theories surrounding the perfect union of the emotions and drawing as an outwardly visible persona or form. In the same year, McCulloch included three of Hester's drawings in the second *Herald* outdoor art show and continued to make mention of her work up until her death, such as the pieces included in the Contemporary Art Society's annual exhibitions.

By the time the extensive *Joy Hester: Commemorative Exhibition of Her Drawings* was shown, McCulloch was well placed to eulogise about her work. Organised by the Museum of Modern Art and Design and held at Georges Gallery, Melbourne, in September 1963, the posthumous exhibition was credited with 'marking her first serious acknowledgement' and the gradual turn of critical opinion in Hester's favour.[26] His lead article included a large reproduction of one of Hester's head studies included in the exhibition, which McCulloch claimed had attained 'surprising and rich variety'. He wrote in an equally moving way:

> A desperate sense of longing, a yearning for life is tragically expressed in these withered waxen faces ... *La fleur de mal* endows

them with a strangely haunting beauty, as though the artist, aware always of her own destiny, had been endowed by fate with special gifts of penetration which enabled her to see beneath the surface.[27]

Painter Charles Blackman and poet Barbara Blackman also became longstanding friends and correspondents of the McCullochs. Alan McCulloch was in the unique position of seeing Blackman's work develop from its beginnings. Their correspondence began following Blackman's relocation to Melbourne from Brisbane in 1951. Younger than McCulloch by twenty years, Blackman looked to him for guidance and support. In turn, McCulloch warmed to the spontaneity of Blackman's personality, the exuberance of his work and the compelling nature of his artistic vision. Blackman's letters show a young man finding his way, open to new experiences and ideas.

Charles Blackman wrote to McCulloch in early February 1952 inviting him to his first studio exhibition in Christobel Crescent, Hawthorn.[28] McCulloch reciprocated by reviewing the young artist's Melbourne showing in the pages of the *Herald* and in an article for *Meanjin*. In both, McCulloch developed the idea of Blackman's convincing psychological impulses and fresh approach.[29] Soon after, McCulloch invited Blackman to co-exhibit in a show of Victorian artists that he was developing for Macquarie Galleries, Sydney.[30]

McCulloch was initially encouraged to organise this after seeing Blackman's rapid evolution, as well as the exhibitions of Roger Kemp and Leonard French at Peter Bray Gallery, Melbourne, in February 1952. McCulloch acknowledged the work of these still little-known artists as showing as much talent as that produced by any artist in the state. On that basis he recognised 'momentous things are stirring without having arrived as yet at their most satisfactory expressive form'. Singling out the youngest of the three, McCulloch noted: 'Blackman's work certainly has a power that carries the spectator right into the picture. His *Man floating* has been apprehended in the very act of floating and we are right beside the *School girl*, walking with her in that lonely lane.'[31]

Writing from Brisbane, to where he had temporarily returned from Melbourne, Blackman 'thought the *Meanjin* article pretty true' and shared a wistful familiarity with the ambient surroundings of his native suburban Brisbane as well as some of his working methods, including the use of coal tar pigments.[32]

McCulloch's support for Blackman's expressionism and the idea that 'art takes something from life and replaces it with something new' was soon tested by his *Herald* readers. In his review of the Dunlop competition entries at Tye's Art Gallery in May 1953, he had commented that most of the artists had 'literally nothing to say'. McCulloch contrasted this against Blackman's paintings of schoolgirls, which he felt were at the other end of the spectrum: 'They speak rather aggressively, perhaps, but with undeniable power and artistry', matching the 'degree of inspiration' he had arrested in his drawings.

The work reproduced to accompany the article, *The swimmer* (1952), drew the greatest ire from *Herald* readership.[33] There were inevitable comparisons with third-grade art and with the inept manipulation of human form. McCulloch countered this view strongly in a follow-up article. There, he adroitly compared the distortions to the psychological equivalent of humans caught out of their depth:

> ... one is made aware of a futile energy; energy generated by man's eternal fear of the sea, and the ego that drives him always to demonstrate his superiority ... Blackman's figure has ventured beyond the limits of safety—his features are presented in their most expressive aspects, the distortion carried logically into every department of the picture, underlying the general feeling.[34]

A recurrent theme in the Blackmans' letters to McCulloch was the need for an autobiographical element in their art and to feel well acquainted with their surroundings to produce their best work. After a weekend spent at Whistlewood, and in the month after the furore generated by Blackman's *Schoolgirls* exhibition, Barbara Blackman wrote to Alan and Ellen describing how it had been 'most refreshing to both of us, Charles came back and launched out on an intensive painting session with much vigour which involves getting up at

dawn + new brushes + my being left downstairs with the sounds of foot stepping, thumping, whistling + [illeg.] for company'.[35]

Later, when the Blackmans had gone to live in Avonsleigh, near Macclesfield, Victoria, in 1954, Blackman recorded: 'We are staying up in the country for a while, it's a lovely spot. Am managing to do a bit of painting a lot of walking.'[36] And sometime in 1970 he wrote a note informing McCulloch of his plans to live in Paris for the next twelve months with his family: 'I love Sydney', he wrote, 'and never tire of its physical beauty, but all Australians should travel more', noting the importance of Paris: 'I've always been affected by their levels of understanding things and their sense of analysis of life (with passion).'[37]

Barbara Blackman acknowledged McCulloch's longstanding support of Charles' work by thanking him for his foreword in the publication accompanying an Adelaide show in 1974: 'We both want to congratulate you on a superb piece of writing and understanding and thank you. It means a great deal to Charles that you have consistently over the years come to a viewing of his work with such sensitivity.'[38]

The role of setting artists off on a steady path and watching them progress was played out time and again in McCulloch's career. Clifton Pugh was another of the artists who exhibited in the 1959 *Antipodeans* exhibition. Writing from his property and artist's retreat, 'Dunmoochin', at Cottles Bridge outside Melbourne, Pugh thanked McCulloch (for himself and on behalf of others):

> You have been very helpful and I must admit I was very thrilled— this show has been a great stimulation ... I'm learning a lot by my paintings being hung with the others. They are helping to give me the courage to break out—I've been trying for several years but after this show I know at last I can start to do so.[39]

Leonard French benefited from McCulloch's support in their formative years, with McCulloch becoming a sympathetic sounding board for French's ideas. In 1958, the younger man confided in McCulloch what he felt it was to be an artist. French was by now

well established but continued to feel intense self-doubt. 'Sometimes my spirits sink when I think of the immensity of the unknown and the smaller immensity of the known, and how little I know and have done ... Deep inside me is a dissatisfaction which eats and nags away continually,' he wrote.[40] Prominent art patron Margaret Carnegie was another supporter of French. In 1963, she wrote to McCulloch seeking help to promote French's work following his relocation from Melbourne to London: 'Would you advise sending over 2 or 3 of Len's paintings to London + could we get Brian Robertson or someone interested. Sir Kenneth Clark? or a gallery?' This act of generosity by Carnegie was accompanied with a letter of reference for French.[41]

McCulloch readily showed his support and loyalty to artists he admired; however, he was equally swift to resist pressure to support the work of artists whom he felt did not warrant praise. Had he not progressed through incremental steps? McCulloch's expectation was that others would tread the same path. He was happy to reconsider or explain his views about a given artist when he felt it was necessary. Elizabeth Vassilieff's indignant response to McCulloch's review of a Danila Vassilieff show held at the Museum of Modern Art in Melbourne in late 1958 was noted by McCulloch. A subsequent letter, written following Danila's death in 1959, expressed her appreciation of McCulloch's review of her late husband's memorial exhibition of paintings and sculptures—including his candid admission that he had not given him 'full credit' in his lifetime.[42]

McCulloch's supposed allegiances with contemporary Melbourne artists were also challenged for a perceived lack of understanding and empathy. In March 1952, Lesbia Thorpe wrote to the *Herald* chiding McCulloch for characterising her as a 'young artist' and 'all that that implies'. McCulloch responded with a personal two-page reply.[43] A series of letters between Noel Counihan and McCulloch in 1955 following the latter's review of a Romanian art show was a curt reminder of how friendships could easily be overridden by heated political rhetoric.[44]

In 1963, his friend Louis Kahan remonstrated with McCulloch for what he took to be a prolonged attack on his integrity as an artist. Lily, Louis's wife, subsequently reported that her husband had been lying on his back for the previous ten days, thinking about 'all the things left undone'.[45]

Sydney moderns

Alan McCulloch was attracted to individuals who set themselves apart, who were part of a *zeitgeist*—the spirit of their times—but who also worked outside of conventional paradigms. These artists encapsulated McCulloch's romantic theories regarding the artist as outsider: one who delivered art from deeply based feelings and strong, personal convictions. This was epitomised in the life and art of the brilliant itinerant artist Ian Fairweather, whose work McCulloch followed from the early 1950s.[46] It also applied to other art world veterans, including Desiderius Orban, who wrote to McCulloch in 1957 to thank him for a positive *Herald* write-up on his recently published book, *A Layman's Guide to Creative Art*. Orban acknowledged McCulloch as one of a few 'who really understand what I am talking about'.[47]

McCulloch reached out to other Sydney-based modernists, notably John Passmore and Godfrey Miller, teachers at the National Art School in Sydney. Both artists were talented; both were highly strung. They used letter writing as a way of explaining themselves and asserting their independence. Passmore wrote to McCulloch in 1962: 'I am sorry that I cannot help with the other photographs you ask for. I am sick and doing these things is a strain that I must say no to—my nerves are ragged and my heart needs mending.'[48]

Godfrey Miller was the more prolific letter writer of the two. If he was alive today Miller might have had mixed feelings about social media and its capacity to deliver messages at any time of day, on whatever subject, and to whomever he chose. The forty or so letters preserved provide an engaging snapshot of his disposition—tense

and cryptic (with letters often penned in the form of a story or fable). Their correspondence indicated a topsy-turvy relationship set among passages of mutual admiration.

The relationship between McCulloch and Miller was established not long after McCulloch had returned from Europe. It continued until Miller's death in 1964. Fittingly, McCulloch provided a eulogy that was published in *Art and Australia*. The two had been introduced in 1953, by Hal Missingham, director of the Art Gallery of New South Wales, when a plan was hatched to bring down works for an exhibition in Melbourne. McCulloch invited Miller to come and stay at Shoreham in the early summer of 1954, in the lead-up to the exhibition. Upon his return to Sydney, Miller wrote to thank Alan and Ellen for the 'happy time … The afternoon tea. The wandering around, chance to talk a bit, the pines and lovely countryside.'[49]

Miller proceeded to share many of his innermost thoughts with McCulloch over the following years. These often revolved around the tortuous path of him being an artist and the inexorable progress of the creative process. In 1955, Miller famously wrote: 'My drawing is disintegrated. But I am bringing a terrible will into it. And those two things have as a rule, presaged a new step and a further stage. Never really seen the figure yet.'[50] A disastrous trip to Europe, where he was run over by a car and ended up in hospital, lost drawings he had already donated, and had difficulty managing sales of his art and finishing works were all covered by Miller in follow-up letters to McCulloch. However, the primary focus of their correspondence was the planning and build-up to an exhibition of his work at the National Gallery of Victoria that had been organised for 1959.

In March 1957, Miller proposed a small show in Melbourne 'with 7 paintings; 4 being large, 3 small, putting say 4 up for sale'. This was followed in June 1958 with a note to the effect that 'I too have a feeling I should hold a little exhibition in Melbourne. Sydney must be tired of me. It would not be a big show.'[51] Despite indicating his acceptance of McCulloch's plans for the exhibition at the NGV, things quickly went awry. The 'small' exhibition he had hoped for

had ended up being badged as a 'Godfrey Miller Retrospective'. Twenty-two works were selected, mostly from his collection, and fleshed out by a work each from the NGV, Art Gallery of South Australia and Art Gallery of Western Australia.

Miller expressed his dissatisfaction to McCulloch that it had grown so large.[52] At the same time he railed against the idea of the catalogue being progressively reduced in scale so that in the end there was no room for his writing. Miller urged McCulloch to be brief, and base his comment on text that Miller had himself sent him. Miller proposed using a piece he had already prepared, 'dealing with intuitive understanding in days of our present logic and science'. He said, 'All my life I have written and no one ever paid heed … Why see my paintings when everyone hates what I think?' Upon hearing that the exhibition catalogue was to be pared back, he exhorted: 'The catalogue is very important. It was the ground that supported my little writing. This writing is—as I say—70 years of existence.'[53]

Despite the withdrawal of Miller's support, the exhibition went ahead, with McCulloch providing a glowing review in June 1959. The show, displayed in the NGV's main exhibition hall, was described by McCulloch as a portent of good things to come (with a new NGV director on board and plans for a new gallery to be built on prime land south of the Yarra) and an honour for an artist mid-career, rather than a climax for one whose status had already been established. McCulloch's well-expressed description of the paintings, including *Nude and the moon* (1954–59) from the Art Gallery of New South Wales collection, reveals a clear sense of Miller's achievements:

> Beneath the surface of the thinly applied paint is a complex structure of fine pen lines. The lines fix the focal points and control the rhythms. They establish the mood of the pictures and define the boundaries of colours and tones. These in turn define the objects and set up a constant shimmering movement across the whole surface.

The ultimate result was: 'A poetic unity of dissolving forms, a constant flow of movement in space, and a serene yet vibrant picture structure'.[54] It was another example of how well McCulloch could

write when engaged and well informed: Diderot-like, with occasional touches of panache and grace.

Despite his fine words, relations between the two men deteriorated even further after the exhibition. Miller started writing hostile letters and McCulloch received equally bad reports from friends and colleagues in Sydney on his state of mind. McCulloch wrote placatingly to Miller in July 1960: 'I assure you Godfrey that all the angels in heaven could not have got the contents of that unopened envelope printed in that catalogue even if it was written by Shakespeare. Then what happened? You refused to co-operate, even refused to have anything to do with the show.'[55] Miller responded with a terse rejoinder: 'That little writing for my catalogue was what I directed my life to acquire ... something which our world needs and wanted.'[56] This was followed by instructions from Miller for McCulloch not to include him in the forthcoming *Encyclopedia of Australian Art* based 'on religious grounds and on aesthetic grounds'.[57]

What had started out simply enough as an opportunity for Miller to gain a wider audience for his art in Victoria ended in bitter acrimony. Miller only produced about forty paintings in his lifetime, published a pamphlet (1959) elaborating the philosophical stance reflected in his paintings, and produced a book, *40 Drawings by Godfrey Miller* (Sydney, 1962). He died two years later in May 1964. McCulloch noted, 'I have never met a man whose work was so completely integrated with his personality.'[58] This was the highest of praise that McCulloch could offer given the sorts of personal difficulties the two had endured. Artist Ken Whisson wrote to McCulloch to congratulate him on his tribute piece to Godfrey Miller published in the *Herald*.[59]

Young Melbourne painters

Melbourne-based artist Ken Whisson, known for his whimsical line, political subjects and lyrical semi-abstractions, was a similarly likeminded artist. Like Miller, he represented the epitome of the creative

soul who plumbed the depths of their personality in the service of art. His was a constant search to refine how this sensibility would be or could be expressed.

McCulloch first encountered Whisson in 1945. His first sustained review of his work, however, was not until an exhibition held at Kozminsky Galleries, Melbourne, in 1952. The artist was then in his mid-twenties and McCulloch recognised a talent that was, in his opinion, excessively one-paced: '… one is tempted to spin around on one's heel and make for the exit. His watercolours have the unnerving quality of an impotent scream of protest.'[60] Whisson immediately responded to the critique by posting a letter to the *Herald* editor. He claimed that McCulloch had written 'so vigorous a criticism after what necessarily [can] be only a brief look at my work'.[61]

Rather than taking umbrage or withdrawing, McCulloch took the time to type a two-page letter addressed to the artist. In it he intimated that 'unlike other letters of a similar kind it merits an answer because I think you can be taken seriously as an artist'. McCulloch justified his working methods and reiterated that Whisson's strengths as an artist would develop quicker with a less impetuous approach. Whisson, he claimed, had been done a favour in the review because McCulloch had not buttered him up, for 'nothing is crueller to the student than flattery'. This process followed a familiar pattern in McCulloch's approach to being a critic. Tellingly, Whisson obliged with a more conciliatory letter in which he changed course and wrote 'your vigorous reaction to the pictures … pleased me'.[62]

McCulloch's growing regard for Whisson and especially his drawing was cemented by a subsequent exhibition (with fellow Melbourne artist Stella Dilger) the following year at Kosminsky's lower gallery. McCulloch believed that Whisson now had something to say but just lacked the polish or means to convey it in a wholly convincing fashion: '… for all the crudeness of its general presentation—it is endowed with an inner truth expressed at one and the same time lyrically, expressionistically, and with much of the ingeniousness of child-art,' he suggested.[63]

Encouraging Whisson to develop the means to most effectively convey his private world became typical of McCulloch's reviews of the Melbourne artist's work across the next decade. While other critics of Whisson only gradually warmed to his intentional simplicity and apparent spontaneity, McCulloch was one of the earliest to embrace it (with caution). Whisson, in turn, welcomed McCulloch's criticisms and would sometimes write to him to clarify points of mutual interest. One such occasion was on the cusp of Whisson's departure for overseas in April 1968. Whisson saw fit to correct what he saw as a small though common misconception of his work so that it might not gain further traction, as he planned to be away for an extended period: 'I thought it might be worthwhile to point out that my drawings are not done at full speed ... but with an intense concentration of faculties, and with deliberate bursts and brief stops.'[64] McCulloch later wrote in a letter of support for Whisson's application for a Visual Arts Board grant in 1973: 'I have known his work since 1945 and have always believed it to be the work of an artist of singular talent and dedicated purpose.'[65]

McCulloch was a critic who, due to the longevity of his career, straddled four generations of artists. Alongside his early predilection for artists such as George Lambert and his support of the Antipodean artists, he also saw and participated in the emergence of successive groups of artists whose work and careers he followed. Sometimes the relationship was mutually beneficial: McCulloch could learn as much from them as they from him. Sometimes what started off as a verbal stoush could develop into greater understanding, a shared respect and in some cases friendship. Occasionally, the gap was simply too wide to bridge.

This emerging pattern can be seen in relationship to McCulloch's reviews of exhibitions held at the short-lived Richman Gallery in Little Lonsdale Street, Melbourne. Between 1958 and 1960, the gallery provided a launching pad for many artists, most of whom were still students, with a select few going on to make significant

inroads into the Australian and international landscape over the next four and five decades. Jan Senbergs, Gareth Sansom and to a lesser extent Robert Rooney were three such artists.

Alan McCulloch's relationship with Sansom started positively enough. McCulloch reviewed the 20-year-old Sansom's first solo exhibition at Richman Gallery. What Sansom later described as Leonard French–inspired enamel paintings were characterised by McCulloch as promising but brash. He concluded: 'What makes him more promising than others is that he has a painter's feeling for paint and enough intelligence to recognise the virtues of economy of form and colour.'[66] The exhibition was towards the end of the first year Sansom had enrolled in painting at the Royal Melbourne Institute of Technology. Sansom had requested Arthur Boyd open the exhibition and despite a reluctance to speak in public Boyd agreed and purchased a painting from the show.[67]

A follow-up exhibition of new works, held jointly with Chris Wallace-Crabbe at the Argus Gallery in May 1963, was also reviewed favourably by McCulloch. This prompted Sansom to write directly to McCulloch in January 1964 requesting an answer as to why he (and other young painters including Senbergs, Rooney and Wallace-Crabbe) had not been invited to submit an entry for the newly instated Georges Art Prize. Sansom claimed: 'I frankly feel that I should have been one of these, because, quite frankly, I feel that I could win the £50 prize.' Once again McCulloch took the time to write to the artist and set things straight. Sansom replied with an apology of sorts, explaining that when he heard who had been invited, he 'became somewhat "hot-headed" and quickly scrawled that outlet for my emotions'.[68]

McCulloch might have taken heed of the admonishment, for a work by Sansom was included in the 1965 prize. This time it was the artist who retrospectively showed misgivings, specifically about the quality of his own entry: 'When I entered last year's prize, I did with some confidence until I saw my work on the walls. I made

all the usual mistakes + didn't fare very well at all.' Despite these doubts, Sansom wrote again to pontificate on who had and who had not been selected for the 1966 award, including himself.[69]

By this time Sansom was enjoying national recognition as one of the most interesting younger artists in Australia.[70] His reputation and his notoriety had been enhanced by two exhibitions, one held at South Yarra Gallery in 1965—from which the National Gallery of Victoria purchased the work *He sees himself* (1964)—and the other at the newly launched Gallery A in 1966—from which the Australian National Gallery purchased *Leaving that well known void* (c. 1965).[71] Inspired by Hitchcock's classic film *Psycho*, this work shows Sansom exploring the idea of dangerous liaison or identity, paralleled by his investigations into the work of English artist Francis Bacon and his radical approach to the human figure. Sansom wanted to be abrasive and sensationalist but not in the way some critics chose to view the work.

Sansom saw fit to attack McCulloch personally regarding his review, characterising it as 'sheer crap', explaining that his works were 'examples of a painter's crush on a beautiful film' and castigating McCulloch for overplaying his campaign against the supposed influence of international magazines on Australian art. He followed this with a letter in which he apologised to McCulloch for phoning him as a 'protest concerning recent reviews' on behalf of a group of young artists at a 'recent high-spirited party'. The flurry of letters and indignation was capped off in his letter of 26 October in which Sansom took umbrage at McCulloch's review of an unrelated artist, in particular the implication that he was feminine—even threatening legal action if the artist did not receive a public apology.[72]

Sansom wrote to McCulloch in 1970, paying tribute to him and in an extraordinary admission laying out his profound self-doubts and the difficulties he was facing, ending with the wistful declaration: 'I had such grand notions that I was a born painter.'[73] This was followed in May 1971 with Sansom applauding McCulloch's review of an exhibition by Ian Burn and Mel Ramsden at Pinacotheca Gallery

at which they were showing books of their own writing on the subject of conceptual art. 'Pleased to see that somebody is not afraid to be honest about "CONCEPTUAL ART"', Sansom wrote, ending with the rejoinder, 'can "ART" be that selfish'. By late 1976, the tables had fully turned. Sansom wrote to request McCulloch act as a referee for a position that he was applying for at the Victorian College of the Arts, stating: 'I would really appreciate having someone who understands my work.'[74] McCulloch consented and Sansom was ultimately successful, becoming head of painting from 1977 to 1985 and then dean from 1986 to 1991.

Ivan Durrant was another among a younger brigade of artists with whom McCulloch developed an ambivalent relationship. Durrant had appeared on the art scene in 1969–70 when his first exhibition of folk-inspired paintings of animals and farms was successfully sold out by Georges and Mirka Mora at their Tolarno Galleries in the beachside suburb of St Kilda. McCulloch warmed to these early exhibitions by Durrant and, having got to know him personally, wrote in 1973 in support of his application to become an occupant of the Cité Internationale des Arts, explaining that he would 'be a very worthwhile tenant and a credit to his country'.[75]

Durrant's 1974–75 photorealist paintings of movie stars, jockeys and the racetrack brought him wider recognition, but his 'performance piece' that culminated in the slaughter and dumping of a cow on the forecourt of the NGV on 26 May 1975 tested the resolve of art critics and public alike. Although conceived as a protest against the hypocritical response of people to death and dying, the performance piece was more commonly portrayed in the media as a stunt by a young and attention-seeking artist.[76]

McCulloch and Durrant found themselves at odds over the decision in February 1976 to revoke the award of Sydney's annual Archibald Prize to John Bloomfield for a large photorealist portrait of the film director Tim Burstall. The debate erupted because the work was deemed to have contravened the rules of the prize. McCulloch voiced his concerns from Melbourne, calling for the judging process

to be restaged. His contention was that the work had not been done from life but from a photograph, and was therefore ineligible under the original terms of the prize. Durrant challenged him, with McCulloch replying in disparaging terms that Durrant had misread the terms of the award and that in 'any event a Chuck Close did not come close to Rembrandt'.[77]

In late 1969, Christo and Jeanne-Claude's monumental *Wrapped coast* at Sydney's Little Bay afforded McCulloch an opportunity to expand upon his usual frames of reference and show how he reached out and embraced new art and art forms. He had written to Claudio Alcorso (founder of the Alcorso-Sekers Travelling Scholarship) in September of that year, advising that he had written an advance notice of Christo's event and would like to cover it more fully—adding 'congratulations on having organised this visit—the first by any internationally-known sculptor since [Henry] Moore was here at British Council invitation in the very early 50s'.[78] He followed this with an equally enthusiastic letter to the event organiser, John Kaldor, in October 1969. McCulloch notified Kaldor that he was coming to Sydney to look at Christo's project, review it for the *Herald* and give a full report in an upcoming *Art International* column. He indicated that he was keen to spend time with the artist, even requesting to stay in the same hotel.[79]

Photographs taken of the development of the landmark installation, possibly by artist Stanislav Rapotec, feature in the double-page spread of McCulloch's November 1969 *Herald* article.[80] According to McCulloch, Christo had made himself the most talked-about artist in Australia, 'And because of him an Australian art event has received world press coverage for the first time in history.' While McCulloch identified his personal struggle to come up with a precise term of reference for the art piece, he wrote enthusiastically about its form and the response it elicited: 'Christo has revived and brought a partly dead piece of nature back to life again. Every breath of wind stirs the skin to ripples or gently billowing curves. It's a monumental, environmental art of enormous dimensions and one can't help feeling involved.'

These sentiments were further developed in his column 'Letter from Australia', where McCulloch ruminated on the state of contemporary art—and the emphasis on the idea rather than the successful realisation of form and intent, as in Christo's giant wrapping. Having been made aware of McCulloch's regular column for *Art International*, Kaldor was keen to share his idea of bringing more overseas artists to Australia to 'execute some exceptional paintings or sculptures'. He wrote to McCulloch seeking advice on a suitable name for his new venture. In reply, Alan raised some of the issues related to bringing artists to Australia and offered as an idea the 'Kaldor Art Foundation'.[81]

Gallerists and patrons

The late 1950s and early 1960s witnessed the emergence of a new breed of Australian commercial gallery directors and dealers. Rudy Komon in Sydney, Brian and Marjorie Johnstone in Brisbane, Kym Bonython in Adelaide, Rose and Joe Skinner in Perth and Thomas (Tam) and Anne Purves in Melbourne, along with John Reed and the newly instituted and branded Gallery of Contemporary Art, led the way in bringing a more entrepreneurial spirit to the display and sale of contemporary Australian art. Alan McCulloch played an important if largely unrecognised role in supporting the establishment of these galleries, both publicly through his reviews and notices and privately as a friend, advisor and confidant. In part, this stemmed from a desire to increase opportunities for exhibiting artists and practical demonstrations, including the creation of the *Herald Outdoor Art Show* in May 1953.

The *Herald Outdoor Art Show* quickly established itself as an annual event and played a cameo role in providing artists with alternative sources of income and introducing a new clientele to buying art outside of the city's commercial art galleries. Reflecting on its success and the dearth of opportunities to buy, sell and exhibit contemporary Australian art in Melbourne in the 1950s, longstanding

Australian Galleries co-director Anne Purves commented later that 'I could see that there was just nowhere for young artists to show their art regularly.'[82] Purves was herself an exhibitor in the *Herald Outdoor Art Show* (and those of the Victorian Artists Society), with her paintings selected for the first and third exhibitions, in 1953 and 1955 respectively.[83]

Australian Galleries opened in June 1956 in a converted space that was originally the Purveses' pattern manufacturing business at 35–37 Derby Street, Collingwood. It quickly set about fulfilling its remit of supplying an exhibition space for serious artists and acquainting a new generation of potential buyers with contemporary art. Co-director Tam Purves had written in advance to invite McCulloch to the opening and to introduce the new Australian Galleries program and approach that had been set out in a three-page brochure.[84] McCulloch duly announced the coming of the new gallery (and the soon-to-be-opened Gallery of Contemporary Art) in the *Herald* and welcomed it as 'a further indication of the sudden rise in the social scale of the Carlton–Collingwood area'.[85]

The notice was followed a fortnight later with a more thorough review of the opening exhibitions of both galleries, including the suggestion that even though Australian Galleries was a commercial gallery it 'could be of great service to artist and public alike'. The '200-odd pictures on display indicate[d]', for McCulloch, 'a healthy catholicity of taste'. 'Perhaps its most important function', he went on to reason, was 'the avowed objective of introducing the artists of Australia to the many potential buyers who never ordinarily visit an art gallery.' 'The atmosphere of cosiness, which is one of the gallery's most attractive features, should go far towards achieving this,' he duly noted.[86]

McCulloch supported the new gallery and its aims in very practical ways, such as speaking at prearranged functions. On 14 November 1956, Tam Purves thanked McCulloch for 'explaining some of the aspects of modern paintings to our businessmen guests at Monday's coffee session' and expressed the joy that he and Anne had got from

reading his article on Australian Galleries and its John Perceval exhibition: 'Your article has refreshed both Anne and myself, as you have just put into words for thousands to read just exactly the things we are trying to do.' Specifically, McCulloch had praised the gallery for its focus on attracting a new breed of businessmen and -women to art, whom he thought were its logical patrons, and for its new exhibition of John Perceval's Williamstown paintings, programming that signalled a distinct shift, along with its 'more modern interior and specially designed gallery furniture'.[87] The gallery had extended into the building's designated factory area to accommodate the exhibition of thirty large paintings of Williamstown and Gaffney's Creek by Perceval, and from this time on the building would be solely dedicated to art.[88]

McCulloch was also invited to contribute to the gallery's exhibition program with *A Critic's Choice*, a show he curated to open the 1958 season. Opportunistically, he reviewed the show in the *Herald*, explaining that the 'critic as curator' model was a common practice in the United Kingdom but was for the first time being tried locally. He was also keen to point out that the exhibition was a self-acknowledged selection based on personal taste rather than a rigorous survey of Australian art. Either way, he was continuing the tradition of *Herald* art critics, notably Basil Burdett, who saw no harm in curating exhibitions and then publicising them through an associated media outlet.

The Australian Galleries exhibition included thirty-six artists, 'all with widely divergent viewpoints', drawn both from the gallery's stock and borrowed in for the occasion:

> Beginning with a modest though promising representation from young artists like Coburn, Lyn [*sic*], Gleghorn, Laycock, Williams and others, the show enters pure abstraction, psychology, dynamics, classic mythology and various others ... [and] arrives at its climax in John Passmore's *Boy and pear tree* (41), and an old favourite, Godfrey Miller's *Still life with fruit* (34).[89]

Quite amazingly, given the purpose, the latter painting had been loaned from the National Gallery of Victoria. McCulloch

had taken the work of promising young figurative painters from Melbourne to Sydney for a Macquarie Galleries show in 1953. In this exhibition he was strategically introducing emerging abstract and figurative painters, primarily represented by Clunes Gallery in Sydney, to Melbourne.

McCulloch's relationship with John Reed, president of the Contemporary Art Society (CAS) and founder of the associated Gallery of Contemporary Art (1956–58)—and its non-commercial antecedent, the Museum of Modern Art of Australia (1958–66)—was more fraught. Letters and conversations between the two provide an insight into the operations of both galleries and the role McCulloch took on in order to monitor their progress. The frosty exchanges between McCulloch and some of the artists associated with the galleries was in some ways an extension of his relationship with Reed. Their work was increasingly also antipathetic to the sort of values and modes of excellence to which McCulloch subscribed.

In May 1956, just prior to the opening of the Gallery of Contemporary Art in Tavistock Place, Melbourne, Reed wrote to McCulloch asking if he had given any more thought to his suggestion for a pilot biennale exhibition for December. McCulloch's handwritten response was to 'forget the "Pilot" idea for the time being'.[90] The constructive nature of the exchange was echoed in McCulloch's initial public remarks regarding the look of the museum and the make-up of its inaugural exhibition in June of the same year. According to McCulloch, 'Carefully designed artificial lighting, an original colour scheme and a hanging arrangement of wire mesh against a white stone wall, are interesting features of the new gallery, for which artists had been asked to donate "a major work"—a cause established mainly for the purpose of helping artists to help themselves.'[91]

These promising beginnings changed when McCulloch began to review some of the individual and group showings and to leave others out. Among the positive reviews of solo exhibitions by Charles Blackman and Robert Dickerson was a review of a state-wide CAS exhibition in July 1956. McCulloch recorded that what looked

stimulating at first glance, upon reflection 'suffers from inbreeding'.[92] The critic saw his role as monitoring a semi-public institution and he held the Gallery of Contemporary Art to its open gambit claim of supporting contemporary art Australia-wide. When the art didn't measure up either, he was quick to intervene.

In June 1957, John Reed felt compelled to write to McCulloch and break his self-imposed silence on responding to critics' reviews. Reed did this by flagging his duty as the gallery's director to protest the absence of any review at all—in this case with the current exhibition of Peter Burns. McCulloch's response to Reed was perfunctory but consistent with earlier views—the exhibition had been mentioned and non-communication between gallerists and critics was a 'highly proper attitude' that 'enables critics and gallery directors to operate amicably in separate roles'.[93] McCulloch and Burns had been previously embroiled in an altercation when, in his role as secretary of the Contemporary Art Society, Burns had chided McCulloch for not mentioning the CAS involvement in a graphic arts exhibition in Melbourne.[94] When McCulloch did come to review Burns' paintings and lithographs the following year the reason for his silence may have become clearer when he noted: 'We find complex intentions which on investigation add up to very little.'[95]

The short-lived Gallery of Contemporary Art was set up by Reed to meet the exhibition needs of CAS members. It was funded primarily by artists. Reed's next project, the non-commercial Museum of Modern Art of Australia (later MONAD), followed an even more ambitious path. Among its fourfold charter, it was 'to serve as an educational centre in the field of modern art' and 'to foster and stimulate the experimental and the new in the realm of art and design'. Founded in April 1958, it was to 'be an independent body that would be funded largely through its own activities, including public subscription and private sponsorship'.[96]

McCulloch greeted news of the new museum with a glowing review of the first exhibition held there in June 1958, one by Leonard French. He also commended its organisation and governance

by an industry-based board but placed a question mark over the 'appropriation' of a name that he felt was too close to that 'owned' by other more deserving and prestigious art museums, notably New York's MoMA. Eleanor Margaret Baker, public relations officer with Geiger Holdings—sponsors of the inaugural (and only) £1000 grant for paying the costs of invitee artists from overseas—wrote to thank McCulloch for his *Herald* article, exclaiming: 'Everyone was thrilled and John Reed was literally bewildered. You certainly have upset all his deep founded conceptions of you.'[97]

Once again Reed broke his silence, feeling compelled to write to McCulloch explaining how and when the gallery had come into existence and responding to aspects of his report. The name change, he submitted, was 'neither premature or pretentious, but rather, I think, the only one that is applicable'. Reed reiterated the aim of the museum was to show new and experimental art as well 'as do my best to build up a permanent collection, which I agree is something that must be done'.[98] Reed's alignment of MOMAD with MoMA in New York was unrealistic given the differences in scale and resources. However, the gradual development of his and Sunday Reed's mid-twentieth-century Australian art collection did lay the basis for what would eventually become today's Heide Museum of Modern Art.

A burst of letters between McCulloch, John Reed and artist Ian Sime, with the *Herald* editor brokering as an intermediary, ensued not long after in mid-1959. This followed McCulloch's response to a letter from Reed, in which he had refuted McCulloch's criticism of the Museum of Modern Art of Australia on the grounds that it was not carrying out its avowed aim or responsibility. For McCulloch, 'giving repeated annual exhibitions to individual local artists is scarcely in accordance with its aim'.[99] If it was not published, McCulloch asked his editor that his reply to Reed at least be placed on file 'just in case there are any later repercussions'.[100] Some five weeks later, Sime continued the ongoing battle in a letter addressed to Sir John Williams, managing director of the Herald and Weekly Times. He had written specifically to request that McCulloch not be sent to review his

exhibition at MOMA Australia since McCulloch was not, in Sime's words, 'emotionally or intellectually equipped or competent to assess the work of artists whose problems, needs and ways of expression are almost totally outside his experience or knowledge'.[101]

Opening slightly later than Australian Galleries, Perth's Skinner Galleries was active from October 1958 through to about 1974. According to McCulloch it was 'during its 16 years of operation ... the centre of Perth's art life'.[102] McCulloch first met Joe and Rose Skinner in 1953, when he had gone to Perth to review an exhibition at the Art Gallery of Western Australia. One of the participating artists, Grey Guy-Smith, wrote to McCulloch to thank him for taking an interest in his work and to describe his interest in the Western Australian landscape.[103] Rose Skinner had not yet opened a gallery but along with her husband was well known there as a patron and supporter of the arts. She also had a personal association with the artist and took the time to thank McCulloch for the 'very friendly helping hand you have extended to Grey Guy-Smith'.[104]

The relationship between McCulloch and the Skinners was a longstanding one. There was an open invitation for the McCullochs to stay with them in their hometown of Perth as well as to use their Melbourne flat. In February 1958, after having visited Melbourne, Rose Skinner wrote to Ellen and Alan McCulloch to announce her ambitious new plans to build and operate an art gallery in the centre of Perth. She had also written to 'enlist [their] help' and 'advice': the gallery, an extension to the Skinner's residence in 40 Mount Street, Perth, was to be purpose-built and feature a large open space, pristine white walls and 'full glass on the 40 feet facing South over a garden area which will be developed for display of the odd piece of sculpture'.[105]

Although there aren't copies of the McCullochs' letters, it is possible to reconstruct a sequence of events which led to the formation of the gallery, its first exhibitions and the important role that McCulloch played. This included suggesting and encouraging artists to exhibit there as well as promoting contemporary Western Australian art

through his articles in the *Herald*. Following their initial correspondence, Rose Skinner wrote to thank the McCullochs for their 'most generous and ready response to my letter' and to inform them that she would heed their sound advice. One such recommendation involved contacting Rupert Murdoch, 'owner of the Perth *Sunday Times* and *Adelaide News Limited*, asking him to contribute a substantial monetary prize for the best painting by an Australian artist ... for our opening in mid-September'. Skinner went on to prevail on McCulloch further 'to interest well-known painters and sculptors in the venture'.[106]

Perhaps capitalising on the success of Australian Galleries, Rose Skinner wrote to the McCullochs, in May 1958, to float the idea of affiliating with the Melbourne gallery. This would have effectively enabled them to promote a wider range of new artists. Apart from an exhibition of the Australian Galleries stable—including John Perceval—this grander idea didn't eventuate. Skinner was, however, able to share the good news that:

> Your brilliant suggestion about a local newspaper magnate has borne fruit. Rupert Murdoch ... has generously donated a yearly prize of £250, to be divided into two sections—one by the best painting of an Australian or overseas artist and £50 for the best West Australian contribution ... [and that] we could implement your idea about a non-objective competition early next year—with success. I am sure.[107]

McCulloch's notice in the *Herald* encouraging artists from all over Australia to participate in the first competition was again met with thanks from the Skinners. Rose exclaimed: 'I was puzzled at first by the steady flow from Victoria of requests for entry forms re the Murdoch prize, but I now know their beneficent source.'[108] Skinner again turned to McCulloch regarding advice on the format and publicity of the program, with his return suggestion of making the Murdoch-sponsored exhibition a drawing prize one that she considered 'positively wizard'.[109] Unfortunately, this was to be the last of the prize exhibitions, even though Skinner Galleries continued to prosper.

Rudy Komon was another of Australia's leading commercial gallery directors who emerged in the 1950s and early 1960s and benefited directly from McCulloch's involvement. Komon was a Czechoslovakian journalist who had emigrated to Sydney and opened an antique store. The gallery was converted from a wine shop and opened in 1959. According to Komon's biographer, 'His instinct for European marketing techniques was a revelation and a gift to Australian artists. Through promoting their work, he significantly influenced the careers of several generations of painters, including John Brack, Jon Molvig, John Olsen, Fred Williams, William Dobell, Russell Drysdale, Sidney Nolan, Arthur Boyd and Brett Whiteley.'[110]

Alan McCulloch recalled his first meeting with Komon taking place in the 'mid-fifties, in company with Michael Kmit, the 1953 Blake Prize winner, and Stanislaus Rapotec'.[111] The two became longstanding friends, with Rudy and his wife, Ruth, staying at the McCullochs' house at Shoreham when they came to Melbourne and McCulloch visiting his Woollahra-based gallery on most of his visits to Sydney. McCulloch and Komon wrote and conversed regularly but it is generally not known how influential McCulloch's early involvement with him was or came to be.

Komon told him of his plans to open an art gallery in Sydney at that first meeting. He asked McCulloch if he would supply a list of artists, for which in return he would 'make their fortunes'. McCulloch was at first reluctant but once back in Melbourne changed his mind. The list was sent and when Komon did establish his gallery some six years later McCulloch's faith was vindicated. According to McCulloch, the list 'changed the fortunes of half the artists of the Heroic Years (1940–65)',[112] a claim that may be true but is difficult to quantify given the advice Komon was receiving from a variety of sources around the same time.

Throughout the 1960s and 1970s, the relationship certainly proved mutually beneficial. In 1968, Komon was a trusted advisor for McCulloch on his upcoming and first solo exhibition since 1951. For his part, McCulloch was able to direct some business

opportunities Komon's way. This included correspondence in 1963 from McCulloch seeking an artist who could be commissioned to paint three portraits in Melbourne, including one of a mayor as well as 'a football club president and an important businessman'. McCulloch's first preference was William Dobell, but Dobell declined because it had taken eighteen months to only partially complete his last portrait. Komon thought Queenslander Jon Molvig a better choice.[113]

McCulloch was often called upon to offer practical assistance to a new crop of gallerists in the 1960s and early 1970s. In a sense, this was repeating the pattern of a previous generation. One example was his support of Sweeney Reed, the adopted son of John and Sunday, who had started his own gallery, called Strines Gallery, in 1966. Sweeney wrote to McCulloch in early 1967, thanking him for the 'valuable assistance you have rendered in giving evidence in support of their defence to the police prosecution'—he had been charged with obscenity at the opening of the gallery's first exhibition in October 1966. The offending drawing by Ronald Upton, *Oops* (1966), was eventually withdrawn and the charges against Reed and the artist dropped.[114] William Lasica was the solicitor acting on behalf of Reed and Upton. He duly acknowledged McCulloch's role in the case: 'I appreciate your effort in going to the trouble of giving a clear interpretation of the drawing', with a subsequent letter notifying him that 'charges had been dismissed and drawing returned to owner'.[115]

CHAPTER 6

BIG IDEAS

SOME GO AFTER big projects; others are consumed by them. Ambitious ideas and the pursuit of big projects formed a major part of Alan McCulloch's life. Not content with working as an artist and art critic, McCulloch became a nationally and internationally recognised curator, author, encyclopedist, broadcaster and lecturer from 1951 through to his retirement in 1991.

Part of McCulloch's motivation as an art writer, curator and administrator was the compulsion to respond to new opportunities and problems as they arose. He loathed to let things go. Bugbears that irked him were swiftly dealt with and obstructions that stood in the way of important decisions or ideas were faced head-on. Although this pattern of direct engagement did not always achieve the desired results, it did galvanise his supporters and provoke strong reactions from critics. McCulloch privately acknowledged the folly of his commitment to impossibly large projects, but he also believed that the time and energy that he spent on these was for a greater good.

Herald arts patronage

Alan McCulloch's ambition can be gauged from the few, though singularly high-powered, positions that he applied for from the 1930s to the 1960s. As a 32-year-old, and without formal qualifications, he brashly applied for the position of curator of the Art Museum of

Victoria in 1939. Unsurprisingly, he missed out. Later, in the 1960s, he was proactive in imagining and creating his 'plum' appointment. In 1966, he wrote to the vice-chancellor of Sydney University, Sir Stephen Roberts, to present a case for himself to be considered for the post of director/professor at the prestigious Power Institute of Fine Arts.[1] The position was eventually taken by Bernard Smith, with Gordon Thomson, the deputy director of the National Gallery of Victoria, appointed the first curator of the Power Gallery of Contemporary Art at Sydney University and Elwyn Lynn appointed the first curator of the Power Bequest.

Part of the rationale underlying McCulloch's attempt to secure these prestigious appointments was a fervent desire make his imprint on Australian art—to be in positions that would contribute to and shape contemporary Australian art and criticism from the highest level. Yet, despite its many frustrations and restrictions, McCulloch's appointment to the *Herald* in 1951 and his thirty-year tenure allowed him to do just that. It was a position that gained him points of entry to major exhibitions and national competitions and provided leverage to work simultaneously on a variety of roles.

The Herald and Weekly Times had a history of supporting ambitious and forward-looking art projects as a patron of the arts. This reached back to the art exhibitions it organised in the 1930s but it was also a sign of the interests and influence of the paper's proprietor, Sir Keith Murdoch, and a protégé, the forward-looking art critic Basil Burdett. The infamous 1939 *Herald Exhibition of French and British Contemporary Art* that toured Australia in various iterations between 1939 and 1945 spearheaded the list of exhibitions the *Herald* sponsored during the 1930s and 1940s. The establishment of the Herald Chair of Fine Arts in 1947 was another important undertaking. It had been created by Murdoch, possibly against the wishes of his fellow directors, through a major endowment 'for teaching the understanding and appreciation of the Fine Arts and the application of their principles and practice to the life of the community'.[2]

McCulloch was well aware of the *Herald*'s pedigree and had himself been sought out and backed as an art critic by Murdoch. McCulloch was able to capitalise on this association in positive ways. In an undated memo from the early 1950s, for example, he argued for the establishment of its very own Herald Arts Foundation.[3] Following Murdoch's death in 1952, McCulloch pressed *Herald* management to develop or co-sponsor large national and international touring exhibitions in the manner of those before him. This included the co-sponsored *Italian Art of the 20th Century* of 1956 that was jointly organised by the Art Gallery of New South Wales and the National Gallery of Victoria. The *Herald* press release for the touring show was written by McCulloch, who extolled 'the opportunity of seeing, for the first time, a vital contemporary art in all its stages of development'.[4] In the same year, McCulloch tried to organise a large exhibition under the aegis of the *Herald* to be called 'Contemporary Art in Australia', although it did not go ahead.

McCulloch sought to ignite *Herald* interest in other national and international art projects into the 1960s, among them a series of festivals that were being planned to demonstrate the way of life in Commonwealth countries. The festival was planned to coincide with the completion of the Southbank Centre in London in September 1964. The Australian media had picked up on the Festival of Arts in January 1961 and McCulloch raised the idea with *Herald* management of the possibility and benefits of being practically involved in the event.

McCulloch's draft notes included an estimate of costs dated 6 July 1961, and he subsequently made a strong pitch. 'Contemporary a.a. has', he argued,

> not been seen abroad at top level—and it has not even been seen in Australia. Several attempts have been made to show a.a. as such in Europe both at the Venice Biennale. The first comprised work of about 6 painters and the second the work of 2 (Arthur Boyd and the late Sir Arthur Streeton).

'Neither of these', McCulloch went on to argue, 'was either representative or important. The field is wide-open for a first-class promotion and would I feel sure arouse first a nation-wide interest and when shown abroad, international interest.'[5]

McCulloch wrote to Lord Balfour of Inchrye, Chairman of the Executive Committee. In the letter, he flagged the *Herald*'s interest 'in helping to sponsor a full-scale exhibition of Australian contemporary painting if there was sufficient incentive to do so'. He then went on in full conversation mode: 'For your information the Melbourne *Herald* is traditionally known as the principal patron of contemporary art in Australia', and that furthermore as their national art critic he would be happy to be the organiser.[6] On 13 September McCulloch received a reply from Ian Hunter, Director-General, advising that Lord Balfour would be visiting Commonwealth countries to discuss ways in which they might want to participate.[7]

Follow-up attempts by McCulloch and the *Herald* to organise large exhibitions of Australian and international art were equally ambitious. In 1967, the *Herald* agreed to sponsor at McCulloch's request 'an exhibition of two cities'. McCulloch confided to his well-connected colleague and friend JJ Sweeney, director of the Museum of Fine Arts, Houston, that he was soliciting advice on the availability of Picasso's *Guernica*, and a great Chagall and that: 'We've never seen a big Pollock, or de Kooning or Gorky etc.'[8] Unfortunately nothing came of the idea but Australians were at least introduced to Jackson Pollock and his contemporaries for the first time through *Two Decades of American Painting*, an exhibition organised by Waldo Rasmussen for MoMA, New York, that toured Australia over 1967.

In the wake of the exhibition's success, McCulloch lobbied *Herald* chiefs (and others) by proposing grand schemes for the inaugural exhibition at the Victorian Arts Centre, which was scheduled to be opened the following year. McCulloch's idea was to emulate the 1939 *Herald* art show.[9] A four-page submission on the 'Herald Exhibition of Great Masterpieces of Painting' and a 'Herald Exhibition of Modern Painting from Two Great Cities', conceived as a competition

for ascendency between two cities, was put forward. Realising the 'too formidable' nature of his proposals, he submitted a third based on one of his other great loves: 'international drawing'.[10]

Although these and other grand ideas rarely came to fruition, McCulloch's determination and enthusiasm were paramount. He was sometimes ahead of his time—the blockbuster exhibition of international art was not to take off until the 1970s. Similarly, the first major exhibition of Australian Aboriginal art did not leave Australia's shores until the early 1960s. McCulloch was, however, able to realise his desire to promote Australian art nationally and internationally through a series of exhibitions and art events that he helped to initiate and develop.

The *Herald Outdoor Art Show*

The *Herald Outdoor Art Show* (*HOAS*) was held for the first time in Melbourne's Treasury Gardens from 8 to 14 December 1953. Melbourne film director Tim Burstall recollected that 'it was conceived as a democratic event, with no restrictions on entry and no fees, commissions or rents. There were separate sections for amateur and professional exhibitors, a number of practising artists were invited to display their works in the latter category.'[11] Scheduled to coincide with the Moomba Festival in March, the second exhibition in 1955 and subsequent art shows became a feature of Moomba celebrations and a special event in Melbourne's social calendar for over twenty years, making it one of the world's longest-running outdoor art events.

McCulloch was one of the instigators, along with artist Charles Blackman, as well as its main organiser and publicist. During a trip to the United States, *Herald* editor Archer Thomas had visited the Washington Square open-air exhibition in New York and 'toyed with the idea of having his own newspaper attempt something along similar lines'. Back in Melbourne, he discussed the possibilities with McCulloch, who urged him to 'press ahead with the venture and suggested basic guidelines'.[12]

Charles Blackman had also mooted the exhibition idea in discussions with McCulloch. Blackman saw the outdoor exhibition as a way for contemporary artists to sell their work outside of the small commercial gallery market in Melbourne.[13] McCulloch was well placed to take up the idea and turn it into reality. The famous open-air art displays in New York and on the Left Bank in Paris had captivated his interest when he lived in those two cities over 1947–48. There was also a precursor in Melbourne, the 'May Day Art Prize', a labour movement initiative founded in 1952. Artist Noel Counihan commented to McCulloch that 'the pictures were hung [for some years] on the Railway fence on the Yarra Bank during the big rally which always climaxes the actual march'.[14] So while the idea of holding open-air exhibitions was not new, the *HOAS* was conceived as an additional avenue for sales for contemporary artists, many of whom were starved of opportunity at that time. Predicated upon a democratic and inclusive policy of being open to both amateur and professional artists and showing work in a range of mediums, the exhibition was championed as a way of bridging the divide between contemporary art and the wider viewing public.

At the first formal meeting of the *HOAS* committee held in the *Herald* offices in August 1953, McCulloch was appointed chairman and a report was tabled in which he urged for greater attention to be given to sculptors based on the example of other outdoor art shows, such as in Hobart.[15] In the transcript of a radio broadcast, McCulloch went on to outline the aims and objectives of the exhibition, singling out its inclusive character and promoting it as a chance to discover unknown artists.[16] The aim was 'to encourage people generally in the practice of art', with his role as the *Herald* art critic 'to separate wheat from chaff'.[17]

The dissemination of knowledge and the educational value of contemporary art was cited by McCulloch as one of its primary goals. The educational value was also extolled by Joseph Burke, the first Herald Chair of Fine Arts, University of Melbourne, in his accompanying catalogue note. This didactic aspect is apparent in

Charles Blackman's undated sketch of a nude woman set within a modern urban backdrop. As one critic has commented, 'His almost surreal image is presumably intended to epitomise modernity in art.' Blackman took a leading role in the first *HOAS*. In June 1953 he had visited McCulloch at his Shoreham home and together they had discussed the outdoor art exhibition in detail. Blackman subsequently helped to sort, hang and guard the exhibits for some years and his foundation ideas held strong, at least for the first decade.[18]

Although not without its detractors, the popularity of the open-air exhibition and its success in introducing a wider public to contemporary art in Melbourne was profound. In the lead-up to the first exhibition, the *Herald* was peppered with promotional stories and advertisements promoting the event and encouraging artists to submit work. The opening was postponed for four days due to inclement weather, but the exhibition eventually attracted over 200 000 visitors and many thousands of pounds in sales, with over 10 000 people visiting on its final day.

The 94-page catalogue produced for the inaugural 1953 event was illustrated by McCulloch and detailed around two thousand exhibits. These were from a diverse range of artists and included major works by emerging and established modernists, among them Charles Blackman, Arthur Boyd, John Brack, Ola Cohn, Dorothy Braund, Ken Whisson, Sybil Craig, Leonard French and Danila Vassilieff. Works by emerging artists such as Dale Hickey and Donald Laycock, as well as the whole group of Centre Five sculptors, were included. McCulloch had written to many of them personally to invite them to participate. One of the more surprising entries over the 1950s included a shoescape assemblage by University of Melbourne student and Dadaist Barry Humphries.

Some of the reasons offered by artists as to why they could not participate were often as compelling as the reasons given by those who took part. Although he thought it a 'wonderful idea', John Perceval gracefully declined the offer to submit a work for the first exhibition, explaining: 'It gives me more satisfaction to keep my

own store of personal ideas for another time.' Perceval, who had recently returned to painting after a long period of ceramics, further elaborated in maternal phraseology: 'When so many are chasing everything they have to offer I feel secure to contemplate unborn paintings as they might be to look on the finished product. To show anything now would spoil the pleasant feeling of expecting.'[19]

Contrarily to Perceval, Melbourne artist Sybil Craig saw her participation in the first *Herald* show as a source of validation and inspiration. Writing in January 1954, Craig expressed her appreciation for having three pictures chosen and 'well hung in the stimulating *Herald Outdoor Art Show* last December. I was very pleased to have had the opportunity of showing work in such circumstances + received it at the end of the exhibition without any damage at all to either pictures or frames.'[20]

Despite its popularity, the art critic Arnold Shore wrote disparagingly of the exhibition, claiming in the rival *Age* newspaper that 'no budding or blooming genius was discovered' here. He questioned the relevance of the open-air exhibition for Melbourne.[21] But McCulloch believed in its potential and worked steadfastly to make sure it would continue to be a success. Continuing support from the *Herald*, the festival-like atmosphere that for many was like a breath of fresh air in post-war Melbourne, and strong sales figures gave optimism that it was the beginnings of something quite promising.

For the second exhibition in 1955, rescheduled to coincide with Moomba, McCulloch expanded the representation of professional artists. He now invited selected interstate artists to join, making it, in his words, a 'strong [local] representation of progressive art'.[22] The expansion was met with a mixed response. Joseph Stanislaus (Stan) Ostoja-Kotkowski wrote from Royston Park, South Australia, to advise he would be sending two paintings. More reluctantly, Jim Sharp wrote from Forestville, New South Wales, to explain that despite his misgivings he would submit some works along with four others by Desiderius Orban's students: 'I think I said to you that I am

not in favour of showing paintings in the open air + when Sue and I looked at our work before parcelling it up, that feeling was again very strong.'[23] For the 1956 exhibition John Olsen sent down one of his abstract paintings, and Stanislaus Rapotec and Janet Dawson provided works in this style as well.

With additional prompting by *Herald* management in 1955, the support of affiliate newspapers throughout Australia and the participation of the lord mayor and Victorian governor, the *HOAS* steadily grew.[24] In an open letter to Melbourne's art community written in 1955, McCulloch cited the phenomenal success of the first *Herald*-sponsored show, in which 'some £4000 in sales' had been netted, 'a quarter of a million people' attended and 'worldwide publicity' had been gained.[25]

For some invited artists, the problem was now not whether they would commit but lay with finding suitable works. John Brack complained in April 1955 that the build-up to his first solo show, scheduled for Peter Bray Gallery (and on at the same time as the *Herald* exhibition), had left him with 'barely enough paintings to fill it'. He did eventually find a work that he could include: 'There is a painting here, called *The Little Boy Lost* [1947], the best one I did before 1952.'[26]

Charles Blackman submitted a painting from his well-known and respected 1954 series *Hoardings* and Leonard French contributed the enamel painting *Death of a warrior* (1952), while Arthur Boyd included the large ceramic sculpture *Judas kissing Christ* (1952–53). Each of these were bold works made from resilient materials and both were later acquired by state institutions. Future curators would have been aghast at some of the more fragile works that were exhibited. This included Fred Williams' three gouache works on paper (listed as not for sale); while Joy Hester, who had not exhibited in the first exhibition, submitted three ink drawings, entitled *Faces I, II* and *III* (c. 1955). Writer and friend Barrett Reid conveyed his admiration of Hester's works as well as the difficulties of exhibiting in the open air:

Your drawings in the *Herald show* are so lovely, the loveliest of them all. Not only were they the loveliest, but they also shone out. Most drawings would be lost in the open air among all the colours and the hard wire netting and the crowds, but these don't; the black which holds the heads like a pillow is so deep and black, soft and resonant—the faces come through the crowds like stars.[27]

As part of the inaugural presentation of Moomba, arts institutions began to initiate their own affiliated exhibitions that made Melbourne a focus for contemporary art and artists. The National Gallery of Victoria mounted an exhibition of Australian painting to mark the occasion. According to McCulloch, it presented 'an excellent cross-section of what is being done in this country at present'.[28] The reclusive Sydney artist Godfrey Miller was one of those who participated in both exhibitions. In the lead-up to these early public showings in Melbourne, McCulloch and Miller corresponded regarding which works he should exhibit at the *HOAS*, settling on *Building and trees* (c. 1952–53).[29] In provocative fashion Miller recounted to McCulloch that there was not one but two versions of the same picture:

> Going back to painting 'Building and Trees', did I ever tell you this. The picture 'Building and Trees' was stolen and, after I could see the police could not or just would not do anything, I got to work, and hurriedly ran off another ... This copy or hurried one I put into exhibitions. By that I identified the painting idea as mine ... Now that I have the 'copy' on exhibition that thief has a task to explain as to how he has a picture of G.M.[30]

What Miller had clearly forgotten was that the original picture had been acquired by the Art Gallery of New South Wales in 1953.

The success of the first two *HOAS* was noticed far afield. McCulloch was repeatedly prevailed upon to advise other cities intent on setting up similar ventures, including Adelaide and Perth, while various regional centres, including Geelong, developed smaller equivalents. Laurie Thomas, director of the Art Gallery of Western Australia, wrote to McCulloch soliciting advice on setting up an open-air art show in Perth: 'The young Rupert Murdoch has bought

the controlling interest in the *Sunday Times* here. He wants to emulate his father's activities here, at least in so far as they can be made to serve a useful end.'[31]

For the 1956 *HOAS*, only one work by each of the 1150 artists who entered could now be accommodated in the exhibition. An additional 250 pictures were selected by McCulloch for 'their special interest or contribution to a balanced show'.[32] Artist Isabel Huntington expressed her excitement when she was thrilled to 'discover you had noticed my work and placed a sticker on it', a method used by McCulloch to guide people towards 'works of outstanding interest or quality in their respective sections'.[33]

By 1957, there were 5000 entries in the *HOAS*. This included 1600 open entries, with up to three works now allowed from artists chosen by McCulloch, with all sculpture submissions selected. However, despite the impressive numbers, there was a sense in which the best of the exhibition's more progressive origins was already on the wane—even though paintings would be purchased from the show by the National Gallery of Victoria in 1957 and 1958. The number of professionally run galleries in Melbourne and Sydney was rising, and increasing opportunities for artists meant that exhibiting in the *HOAS* became more and more the preserve of amateurs and other less established artists.

Questions regarding the quality of the exhibits increasingly dogged the organisers of the show. The specially constructed wire fences from which hung a multitude of works by artists proved difficult to 'curate', and the selection and placement of three-dimensional works also proved to be an issue. In a 1961 memo, *HOAS* director FH Moloney requested action and a response from McCulloch to his proposal to restrict 'sculpture entries to 10 invited artists' claiming: 'It is urgent, however, that we clean out the appalling rubbish that has been in our sculpture selection recently.' Written over the top of a follow-up letter from Moloney in which he detailed the negative responses by sculptors to his idea, McCulloch scrawled in pen: 'Decided to leave as was and create sculpture gallery. A.'[34] By 1967,

a *Herald* staff journalist was exhorting change by drawing attention to McCulloch's repeated calls for quality—some 'artists [have been] recommended by the *Herald* art critic, Mr Alan McCulloch, because he considered their work would lend strength to the show ...'[35] Susan McCulloch, who worked on the exhibition as one of the band of student installers, later wrote of her father's involvement: 'It was one of those things that Alan was proudest of achieving and one he came to cringe about most!'[36]

The final exhibitions

The time that Alan McCulloch spent in Paris with prominent French art critic Waldemar George in 1965 validated his interest in Asian and Pacific culture and a long-held belief that this was as important to the development of a modern Australian culture as the championing of Aboriginal art. According to McCulloch, 'The first question he asked me was how were Australian artists responding to the approaching world of S.E. Asia? I didn't mention my attempts of course but with my fish [a motif selected by McCulloch in his latest paintings] etc., it seems I'm not far away from what the French think Australians ought to produce.'[37]

McCulloch's support of homegrown and touring Asian art exhibitions was one way in which he sought to help strengthen ties within our region. The watershed Sydney Biennale held in 1973 was one of the first to realise McCulloch's dream of combining Australian and Asian artists in an intelligent and sympathetic way. He wrote to the organisers to express his approval and was duly thanked in return.[38] McCulloch followed this by writing to the *Herald*'s chairman of directors, PF Jones, in the same year, requesting that they join with other newspapers to 'bring the Chinese show to Australia when London has finished with it? It could be the biggest show ever at the National Gallery of Vic. And the new Art Gallery of New South Wales ... Any chance?'[39] The reply was an emphatic 'no' from management. Victorians had to travel to New South Wales to see the magnificent

death suit of the Chinese Queen Tou that comprised 2162 tablets of jade sewn together with gold thread.[40]

McCulloch's interest in the art of the Asia-Pacific region intersected with his art practice during the late 1960s. His first solo exhibition had been held in 1951. The second was seventeen years later, at Georges Gallery, Melbourne, between 5 and 17 August 1968. This survey of paintings produced over the preceding four years represented a significant departure for McCulloch. The emphasis on creating a fusion between Asian, Pacific and Western art had resulted in a series of large paintings with tropical motifs, including brightly coloured fish and birds, and ultimately in the production of a large tapestry that was widely exhibited and publicised.

In the lead-up to the show, McCulloch wrote to Sydney gallerist Rudy Komon for advice and support as his dealer. McCulloch provided him with catalogue information, a $1000 price tag for each large work and details on how he wanted the exhibition to be set out. An old friend and colleague, Alan Forbes, had agreed to open the show at Georges Gallery. In the absence of a reply from John Olsen, McCulloch had requested academic Franz Philipp write a review for the *Herald*.[41] He was more than a little concerned about the sort of critical response he might get. It was a brave move for an art critic to hold his own show, particularly after so long. He wrote to Komon again, including notes on each painting so that, in his words, 'now you are armed to the teeth to defend them, if you feel like it, from the many misinterpretations which will undoubtedly be placed on them'. According to McCulloch, the exhibition encapsulated ideas that he had been toying with since viewing two El Greco paintings in Rome in 1948—ideas about how to create a 'surface equally alive, as moving, various and vital as the surfaces in these masterpieces'— and since an epiphany in 1953 that 'Australia was moving from European to an Asian theatre of influence'.[42]

Hearing about McCulloch's upcoming show, the printmaker Franz Kempf wrote an unsentimental appraisal from his home in South Australia: 'I am sure that whatever the work looks like it will

be picked to pieces. It is hard enough for a painter to be viewed objectively, but a critic who puts his head out after a number of years is really looking for it.'[43] Despite these words of foreboding, the exhibition was generally well received. It consisted of eight big paintings (around 2 × 1.5 metres), seven smaller studies and one drawing. Each of the studies was sold during the first hour at the opening. The first of the paintings also attracted a great deal of interest but according to McCulloch was not for sale because he had promised it to his wife, Ellen. Entitled *Archipelago*, it had taken McCulloch three years to complete from 1963 to 1966, mainly because he had used fine sable brushes and then overpainted it.[44]

McCulloch intimated to a friend in the aftermath of the exhibition that he was satisfied that he had opened 'a window on the new world of colour presented to Australian painters through our involvement with Asia'. According to McCulloch, Arthur Boyd responded most enthusiastically among the local artists, returning to see the works on separate occasions.[45] Melbourne art critics including Alan Warren and Ronald Millar were also complimentary, although Patrick McCaughey felt the work too 'literary'.[46] McCulloch explained the show, his motivations and the reactions, in a heartfelt letter to American art critic Clement Greenberg. 'I feel', he wrote, 'like having a quiet chat with someone and to whom should I turn but you, seeing that a few at least of our ideas have not proved antipathetic.' Greenberg's response was less taciturn but nonetheless interesting: 'Myself, I tend to suspect the notion that Australia has entered an Asian sphere of influence. I fail to see that in either the Australian way of life or in her culture.' Despite McCulloch's stated intentions, the style of works such as *Kokomos II* reminded Greenberg 'very much of an early phase of Pollock's all-over style—which means, not that it's derivative, but that it's still very much Western art'.[47]

In his commissioned review for the *Herald*, Franz Philipp was ebullient in his praise, referring to the exhibition as 'youthful and mature, joyous and disciplined and free of the shibboleths of the

"New" and "Old" academies'. Philipp also intimated towards the end of his piece that several of the paintings would 'translate very effectively into larger scale tapestries'.[48] This suggestion seems to have taken root (or reinforced an existing desire), as it formed McCulloch's next big project.

McCulloch's interest in tapestry dated back to the period he spent in Europe in 1948–49 where he had developed a love of French and Spanish modern art and design. He had offered glowing endorsement of the Aubusson tapestry show that was held at the National Gallery of Victoria in 1958, the first of its kind in Australia, and assisted in the purchase of a large tapestry for the Women's College, University of Melbourne, in 1966. McCulloch noted the ripple effects of increased tapestry production among Australian artists, including Arthur Boyd, John Perceval, Leonard French and John Olsen, whose tapestry *Nude and clock* (1966) had been exhibited at South Yarra Galleries in July 1967.

Boyd wrote to McCulloch in July 1969 to congratulate him on his plans to produce the work and to offer some contacts for its production: 'Great news about your tapestry commission. I think I could recommend the Portuguese tapestry manager who has done them for me via Frank McDonald in Sydney.'[49] McCulloch had visited Aubusson in 1965 while in Paris and toured the facility. He had also visited a major retrospective exhibition of the work of Jean René Bazaine that was held at the Musée National d'Art Moderne, Paris, from 22 October to 31 December 1965. The bright, exuberant colours and dynamic semi-abstract designs left an indelible impression and seem to have informed his tapestries as well.

In a letter to *Art International* editor James Fitzsimmons penned in March 1970, McCulloch explained, 'I'm looking forward to a slight spell from writing while I draw up the cartoon for the picture to be made into a tapestry. It's called *Fight of the Kokomos*: maybe a few too many curves in the design but with as much rich colour as I can pack into it.'[50]

Production of the tapestry began two months later. McCulloch had engaged the services of noted Melbourne weaver Karen Wigan and was keeping track of her progress:

> It's not all that big (5′ × 7.6′) but it is the biggest that's ever been done by a local weaver. Working flat out she weaves about two inches a week. For the rest, well, the lot of the painter-critic continues its hazardous path ... the critics never forgive you for being a painter and the painters ... [illeg.][51]

McCulloch tried to find a suitable venue in which to display his new opus. Powell Street Gallery in Melbourne and Rudy Komon in Sydney were two of the venues he initially thought of;[52] however, by choice or otherwise, he eventually settled on Manyung Gallery in Mt Eliza on Victoria's Mornington Peninsula. Manyung was a new gallery that had been set up in a prominent location on a highway, next to a house and on land owned by Betty Meagher, a gallery director and art collector. McCulloch used the opportunity to extend the exhibition by including other tapestries borrowed from a multitude of sources.

McCulloch wrote to Komon in February 1971 to say that he might get a call from Meagher to see if they could borrow a Tamara Island tapestry 'to make a general tapestry exhibition', adding, 'There would possibly be one or two other tapestries as well as my tapestry with cartoon.' Unfortunately for McCulloch, he was subsequently advised by Komon's secretary that four of the five had already been sold and last one was with Skinner Galleries in Perth.[53] Meagher also wrote to Anne Purves at Australian Galleries to request the loan of 'two or three tapestries to hang during an exhibition of tapestry by Alan McCulloch and Karen Wigan'.[54]

Later the same year, McCulloch exhibited his tapestry at Manyung. He was excited by the response that it had generated and said it had made him 'one of the most astonished artists in Victoria'.[55] The works were featured in an *Australian Women's Weekly* article, complete with a double-page spread of colour pictures of the tapestry in situ and Meagher's fashionable, newly designed home that featured an eclectic

collection of commissioned and acquired artworks and furnishings.[56] From LR Killeen, whom McCulloch had met through his work with the National Capital Development Commission in Canberra, came high praise: 'You have been modest about your tapestry designs! That photograph in the *Woman's Weekly* caused a lot of interest here. I like the "bird" theme.'[57]

On the strength of these favourable reviews and critiques, McCulloch intended to continue with the medium and themes. This included an idea for 'a 30-foot-long tapestry woven at Aubusson or Portugal'.[58] However, McCulloch's enthusiasm for this or any other similar ideas was soured by the theft of the tapestry after it had been loaned to the Hilton Hotel in Melbourne. His subsequent attempts to receive compensation from the gallery's new director amounted to little. Eventually, McCulloch received a $500 insurance payout for *Flight of the Kokomo birds*, a paltry sum given the hours of work and grand hopes he and others had invested in it.[59] It was to be the last exhibition of his work. In retrospect, his last-exhibited paintings and drawings hold less interest, as the relevance of McCulloch's theories on the meeting of east and west were most successfully explored in the tapestry. For McCulloch's part, he was already involved in other projects, including the production of two monographs for the newly announced Lansdowne Australian Art Library.

The Heroic Years of Australian Painting 1940–1965

> *Lift up your heart brother and let*
> *the whole world be but for you*
> *a reflection of your own heroic spirit*
>
> Don Quixote[60]

Alan McCulloch's dreams of organising a major exhibition of Australian art were realised through *The Heroic Years of Australian Painting 1940–1965*. Curated and managed by McCulloch and financed and promoted by the *Herald*, this landmark exhibition

toured nationally over a two-year period and was seen by well over 100 000 people.

The idea of sponsoring a 'top exhibition of Australian art to tour Victoria's 16 regional galleries' was put to *Herald* editor John Fitzgerald in March 1975. McCulloch saw it as being formed along the lines of 'the Tate Gallery exhibition of Australian Art that put us on the map in London 15 years ago'.[61] For McCulloch, it represented a unique opportunity to give his perspective on the art of the period—to bring together the works of those whom he felt had been the most productive and engaging. The exhibition was also built upon his popularist philosophy of taking only the very best art to regional audiences and venues. The original suggestion was for the exhibition to go to eighteen centres over the course of a year, not including town halls, which McCulloch regarded as inappropriate venues.[62] The idea of adding town halls onto the end of the tour was mooted by *Herald* management, who were keen to find the widest public possible and help defray the already significant costs.[63]

Just as the *Herald Outdoor Art Show* had been given a distinctly Parisian theme in the 1950s, a connection between this exhibition and the 1939 *Herald Exhibition of French and British Contemporary Art* was made explicit in a general letter sent out to potential venues. The exhibition, it claimed, was 'the first full-scale exhibition of its kind sponsored by an Australian newspaper since the heroic *Herald* Exhibition from 1939–40'.[64] *Herald* marketing director Fred Flowers wrote to Melbourne's lord mayor requesting the Town Hall as an appropriate venue to launch the exhibition, given its historical connection with the 1939 show.[65] In a similar vein, Herald and Weekly Times CEO KD MacPherson boldly stated: 'There [has] not been a better collection of artwork relevant to Australia since the pre-war modern art tour.'[66]

Not all were so enthusiastic or uncritical. Mervyn Horton, editor of *Art and Australia*, exhorted McCulloch to convince those in charge to remove the *Herald* prefix from both the 1939 exhibition and the present show and stop propagating what he believed was a false

connection.⁶⁷ Graeme Sturgeon, art critic for the *Australian*, challenged the claim that it was one of the most important exhibitions to be held in this country and criticised the use of the digger's slouch hat and rising-sun motif on the catalogue and promotional literature, claiming it made a false bid 'to equate the advancement of these years with that of the Heidelberg School'.⁶⁸

An exhibition of the scale and complexity imagined by McCulloch did, however, require unilateral agreement and support. At the *Herald*'s prompting, McCulloch wrote to Victorian premier Rupert Hamer requesting state government assistance.⁶⁹ Hamer, who 'was delighted to receive [McCulloch's] letter' and learn about the 'generous gesture' by *Herald* management, subsequently signalled his support—and a web of communications between McCulloch, Hamer and an enthusiastic Eric Westbrook, now director of the Ministry of the Arts, followed.⁷⁰

The resulting roundtable discussion at Parliament House involved a high-level contingent of Herald and Weekly Times staff, including the newly appointed Macpherson, along with Lyle Turnbull, managing editor, and RH Sampson, executive director. In the lead-up to the meeting, McCulloch was keen to claim territory, signalling to his colleagues that contrary to the badging of the invitation that he had received, 'this is our, *Herald* show—[and] not to be taken over by the Ministry of Arts', a fact that needed to be made 'quite clear' at the luncheon.⁷¹ Westbrook and McCulloch later combined to jointly travel to each of the sixteen regional galleries.

McCulloch's initial wish list for the exhibition contained many iconic works of the era. This included long-time personal favourites such as Godfrey Miller's *Nude and the moon* (1954–59) and *Monastery* (1961) by Ian Fairweather. Many of these paintings were too fragile to travel, required elsewhere or simply withheld by their respective owners. NGV deputy director Kenneth Hood wrote that he was prepared to recommend only six of the seventeen paintings that McCulloch had requested.⁷² Nevertheless, the final list of seventy-three paintings (reduced to seventy-two) represented a formidable

entrée into post-war Australian art from the 1940s until the mid-1960s. Most of all, the exhibition gave a compelling insight into the art and artists that McCulloch had most strongly supported during the period.

The Heroic Years opened to the public at the Lower Town Hall, Melbourne in April 1977. For the *Herald*, it was billed as front-page news: the 'greatest exhibition of modern Australian painting ever assembled'.[73] Full-page advertisements were given over to the show, again reminiscent of the 1939 exhibition. McCulloch was more circumspect than the *Herald* publicity machine. He recognised the difficulty of successfully applying for the loan of key works: for example, William Dobell's *The Cypriot* (1940) from the Queensland Art Gallery and *Billy boy* (1943) from the Australian War Memorial. Another important work by Dobell that was included, *Joshua Smith* (1943), had recently returned from London where it had been sent by Adelaide businessman Sir Edward Hayward. The painting had undergone two years' treatment for fire damage and was, McCulloch felt, 'only a reminder of what it once was. Much of the colour and the life has gone.'[74]

McCulloch explained that the exhibition was not intended as a comprehensive survey but as a 'summation of outstanding work done during the most creative period of Australian painting in living memory'.[75] Interestingly, he refined his position over the course of the exhibition. This change came about through the recognition that it was not so much a reflection of individuals as heroes—shifting from his romantic conception of artists as outsiders, in which 'poverty put steel into the artists of the Heroic Years'—but more the style of the period that marked the rise to eminence of a new generation of artists who had discovered French modernism and challenged the cultural conservatism of the prewar period.[76] The distinction was crucial, as McCulloch believed the stylistic innovations had changed the trajectory of Australian art.

Presented in association with the Victorian Ministry of the Arts and the Department of Education, who co-produced a 20-minute

documentary featuring McCulloch as narrator, *The Heroic Years* ended up being seen by 170 000 visitors, possibly setting a new benchmark for exhibitions of Australian art. In addition to the Lower Town Hall venue and all sixteen Victorian regional galleries—something not attempted since—the exhibition toured to Newcastle; the Art Gallery of South Australia, where it was sponsored by the Adelaide *Advertiser*; and on to the Art Gallery of Western Australia, where it was given an extended season.[77] Gallerist Joe Skinner dutifully reported on the success of the exhibition in Perth, relating that the gallery was 'packed to suffocation': 'Nearly 1600 people attended on Sunday, bringing total attendance to 3718 since it opened last Wednesday', only four days prior.[78]

Melbourne art critics were generally favourable in their assessments but, not surprisingly, pointed to the limitations of the show. Writing for the *Age*, Maureen McGilchrist noted some inclusions as disappointing: the work of John Passmore, the lack of a mature work to represent John Olsen and the inclusion of a minor figure such as Ivor Hele.[79] Anne Purves wrote on behalf of Jeffrey Smart to convey his 'upset' at not being included.[80] Jeffrey Makin, art critic for the *Sun*, pointed out that it was a show of Melbourne art comprised of old favourites with subjects of a figurative and Australiana bent. Echoing McCulloch's own sentiments, he added that it was 'an extremely personal account of the sort of cultural consciousness that existed in Melbourne in 1940–65' but that 'Alan McCulloch's choice of examples is both scholarly and impeccable, as [is] to be expected from an art connoisseur and art critic who not only lived through it but was and is a trusted confidante of the artists who made it.'[81]

Personal letters between McCulloch and Patrick McCaughey highlighted their generational differences and McCaughey's formalist bent. McCulloch reiterated in a feisty response to McCaughey that the exhibition was his take on the artists that he knew who had made their reputation in the years covered by the show.[82]

Following its opening at the Art Gallery of South Australia, *Advertiser* critic David Dolan focused on the debate that had sprung

up around the exhibition rather than on the content of the show. Scathing of each position, Dolan pronounced it a battle between provincialism and internationalism.[83] Incensed, McCulloch wrote to the chief of staff, John Satelly, challenging Dolan's interpretation of the so-called 'bitter public debate'—acknowledging the argument on philosophical grounds, but objecting, as always, 'in an atmosphere of mutual regard and respect'.[84]

The Heroic Years was selective, and did lack proper representation of some artists, but McCulloch's wish list of fifty practitioners said a lot about his appreciation and championing of these people. Although it included only three women at a time when the women's rights movement was gaining strong momentum, it was an exhibition that in its scale, focus and length of time on the road was unique and unlikely to be repeated again.

CHAPTER 7

EXHIBITING AUSTRALIAN ABORIGINAL ART

Australian Aboriginal bark painting in its primitive form ... represents our only great national art treasure.

Alan McCulloch, 1967[1]

The opening of the new [Victorian] arts centre provides an opportunity for a special magnificent premiere [of Indigenous Australian art] ... All that is needed is a little imagination and proper co-operation between Museum and Arts Centre authorities ... At the same time a long overdue tribute will have been paid to the life's work of a truly great Australian.

Alan McCulloch, 1968[2]

IN HIS FAMOUS 1968 Boyer lecture series highlighting the paucity of coverage given to Aboriginal peoples in mainstream Australian historical writing, anthropologist WEH Stanner singled out Alan McCulloch as the only one of ten contributors to have 'anything to say about the Aborigines'. McCulloch, wrote Stanner, had bucked the deplorable silence in WV Aughterson's *Taking Stock: Aspects of Mid-Century Life in Australia* (1953) by making 'passing but perceptive observations of their art'.[3]

At first glance, McCulloch may be considered an unlikely commentator on Australian Aboriginal art. However, his writings for

the *Herald* and *Meanjin* from 1951 show that he was among the first of the modernist critics to consistently address the position of Aboriginal art in the panoply of Australian art. He argued for and applauded stand-alone as well as mixed exhibitions featuring Aboriginal artists, and made the case for professional curators to be appointed to properly care for and administer Aboriginal collections.[4] He pressed for the establishment of a 'Museum of Primitive Art' to showcase collections of Aboriginal art drawn from across Australia.[5] McCulloch championed Aboriginal art as a unique and vital tradition, albeit one that he believed should be cushioned from the worst excesses of Western culture and the destabilising influence of European art and its own culturally specific visual traditions.[6]

The Spencer Collection

Alan McCulloch's most sustained and vociferous support was directed towards the well-being and promotion of a vast collection of Aboriginal art and artefacts assembled by pioneering National Museum of Victoria (now Museums Victoria) director, anthropologist, artist and art collector Sir Walter Baldwin Spencer. The Spencer Collection featured in major exhibitions held at the museum in 1929 and 1943,[7] and parts of the 170-strong bark collection had been on display in the museum's ethnographic galleries since the 1920s. McCulloch believed that the Spencer Collection had been both under-utilised and ill-cared for: his concern for the treatment of the collection led to him visiting the museum's storage vaults in the early 1950s and subsequently proposing that its objects be brought out on display.

How he eventually came to curate an exhibition from the NMV's collection of Spencer bark paintings and organise a tour to the Museum of Fine Arts, Houston in 1965 is a remarkable story. Between 1963 and 1965, McCulloch drew together and became the centre of a dynamic tryst that spanned three continents and as many museums. This included the legendary James Johnson Sweeney, who

had been appointed director of Houston in 1961. Sweeney curated the hitherto largest exhibition of African art held in America for the Museum of Modern Art, New York, in 1935, and was known throughout the Western world for having excavated and transported a 16-ton (14.5-tonne) Olmec head to Houston for an exhibition he had arranged of Mexican art. Along with his exhibitions, Sweeney embarked on an acquisition policy for Houston that embraced both New Guinea and Australia, purchasing the museum's first group of bark paintings from the Musée Ethnographique in Basel, Switzerland in 1962 and following this with the purchase of a bark from the Australian Aboriginal Trust via the Art Gallery of New South Wales in the spring of 1964.[8]

Important also was the highly respected Karel Kupka, the Czech-born artist who had made his name as a curator, writer and collector specialising in Indigenous cultures. Prior to the Houston exhibition in 1965, Kupka had already visited Australia on four occasions, primarily to research and collect Aboriginal art and artefacts from Arnhem Land on behalf of the Basel Ethnographical Museum and later the Musée des Arts Africains et d'Océaniens (Musée du Quai Branly), where he held the position of *Charge dé Mission*. Having met McCulloch in Paris and worked together on the Houston show in 1965, Kupka attempted to persuade Musée des Arts officials to ask the MFA if the landmark exhibition could come to Paris following Houston.

The extensive correspondence between McCulloch, Sweeney and Kupka over the 1963–65 period reveals a mutual interest in the art and Aboriginal communities of Arnhem Land, but also the lengths that each of these men went to to secure the exhibition of Spencer bark paintings for their respective museums.

The development of the 1965 exhibition also had much wider implications, raising issues and concerns about how Indigenous collections in Australia were formed, cared for, interpreted and displayed. Though not privy to internal efforts by the NMV to gain greater international exposure for its Aboriginal art collections from

the 1940s,[9] McCulloch's *Aboriginal Bark Paintings from Australia* was effectively the first exhibition of Aboriginal art from the museum to tour internationally.

Following on from the example of the UNESCO-sponsored exhibition *Australian Aboriginal Culture 1948–55* which toured to fourteen venues in North America, then Canada and Australia between 1953 and 1955,[10] *Aboriginal Bark Paintings from Australia* was also at the vanguard of a cluster of 1960s Aboriginal art exhibitions developed by Australian state galleries and museums that promoted Aboriginal art and culture on a world stage.[11] Each of these exhibitions highlighted a longstanding debate in Australia between the aesthetic value of Aboriginal art and its ethnographic significance. In putting Indigenous art within a fine art context, there were to be important ramifications for both Australian museology and the reception of Aboriginal art abroad.

Sweeney's introduction to the NMV Aboriginal bark collection was in 1964. In his capacity as director of the prestigious Museum of Fine Arts, Houston in Texas and president of the International Association of Art Critics (AICA), he had been invited to Australia to mark the occasion of the newly formed Australian division of the AICA (1962) and to officiate at the second Georges Art Prize.[12] In his role as inaugural AICA president in Australia, Alan McCulloch was entrusted with looking after Sweeney while in Melbourne and took him on a whirlwind tour of the city's artists' studios, galleries and museums.

The museum's bark collection was at that time held in vaults underneath the combined museum, gallery and library complex. In company with John McNally, recently appointed NMV director, McCulloch, his daughter Susan and Sweeney were both excited and appalled by what they saw. Rows of bark paintings were stacked on one another, stored in cellophane bags and on 'improvised racks'. When McNally started to dust one of the barks, McCulloch and Sweeney implored him to stop in unison, 'as they watched a work being wiped clean of its pigment'.[13]

Before leaving Melbourne, Sweeney raised the possibility of a special loan exhibition of the barks being made available for Houston, and on his return to the United States was quick to remind McCulloch of their discussions and resolutions: 'I wonder what further you have heard about the "missing" bark drawings. I have not forgotten your promise to do "everything possible" to help me have a group for exhibit here in Houston of the Baldwin Spencer barks we saw framed and glazed in the Museum.'[14]

Negotiations

Over the next eighteen months, McCulloch and Sweeney remained in steady contact. Their correspondence reveals the friendship and trust that developed between them and the obstacles they had to surmount. By 31 July 1964, McCulloch reported that he had initiated contact, including speaking to

> members of the government and also the director of the Nat'l Museum of Vic. All seem sympathetic to the idea so far. McNally, the director asked me to get an official letter from you setting out details (especially the costs as the Museum has no funds). He said that before anything could be done they would need the services of a trained anthropologist etc., for purposes of documentation, catalogue etc., but as I am sure that this would be the last thing you would want (and seems to me arrant nonsense). I tactfully suggested that I would manage to provide what was necessary.[15]

Sweeney's hectic schedule precluded his immediate focus on the idea of an American showing of the Spencer Collection. From his second home in Ireland, en route from the Venice Biennale to a Miro exhibition at the Tate Gallery in London, Sweeney fondly reminisced about his time spent with the McCullochs in Australia, noting: 'I know how much I must have missed simply on the basis of what I enjoyed in those few crowded days.' Sweeney's appreciation of McCulloch's efforts and the 'trouble to which you have gone in regard to the Bark Paintings and the suggestions you have given

me' was followed soon after by a loan request for his comment and revision.

At McCulloch's suggestion, Sweeney's formal letter to the NMV chairman of the board of trustees dated 31 August 1964 requested an exhibition of bark paintings from the Spencer Collection for a major showing in the 'coming season', including the 'ones we saw glazed', and a dozen or so others 'to give a wider representation'.[16] Such an open request would not have endeared itself to either the museum or the curator-in-charge. Nonetheless, McCulloch quickly followed Sweeney's formal request with his own letter of support and was duly advised that the matter would be put to the 7 October meeting of the board.

When the answer did come it was a resounding no. Though the trustees signalled their appreciation of the 'mutual advantages which could result from such an exhibition' the proposal was regretfully declined, citing the age and fragility of the barks, their 'great ethnological value' and the risk of damage caused by overseas transport.[17]

McCulloch was first to receive notification of the decision. Forwarding the letter to Sweeney, he expressed his outrage: 'I would much rather not have enclosed such a stupid letter; it is most embarrassing to be saddled with this kind of idiotic bureaucratic administration of so valuable a trust.' Frustration turned to defiance as McCulloch plotted a course of action aimed at overturning the decision:

> But please don't think this is the end of it; it is only the beginning. Having done the correct thing I will now take the matter direct to the government suitably armed with the copy of your original request and all the facts concerning the shameful neglect of the Spencer collection since it fell into Nat'l Museum hands.[18]

Sweeney's response was more taciturn, sharing Alan's disappointment in the decision and thanking Alan for being such a 'sympathetic ambassador'.[19] His international stature as a curator, author and inaugural director of MoMA, New York, carried some weight with museum officials. However, it was McCulloch who was in the better

position to take up the cause, immediately writing to Victorian politicians, including friends such as Labor leader of the Upper House Jack Galbally, as well as Eric Westbrook, director of the National Gallery of Victoria, for their support.[20]

McCulloch's blunt request for 'official intervention' on the part of the Liberal government to help reverse the decision was sent to Sir Arthur Rylah, chief secretary and deputy premier of Victoria. Rylah's portfolio included the museum and the letter to him was accompanied by a damning report on the background to the collection, its perceived (mis)administration over the years, the lack of public display, absence of proper curatorial records and the continuing risk of insect damage, mishandling and improper storage. In response to the museum's stated concerns, McCulloch pointed to Sweeney's professionalism (considered 'the most important American art authority to have visited Australia') and his growing stature as a world authority on primitive art.[21]

McCulloch conveyed the feelings of Spencer's daughter Alice Rowan and her bitterness over 'the treatment of the collection [and delight] at the loan exhibition idea, especially since some new editions of her father's famous books are soon to be published in Europe'.[22] He also had the precedent to draw upon of the bark paintings from the Spencer Collection that had been loaned and returned without incident from an exhibition of Aboriginal art toured nationally under the auspices of the Art Gallery of New South Wales in 1960–61.

While McCulloch signalled his intent to Westbrook 'to fight this decision to the last ditch',[23] for his part, Sweeney confided to McCulloch: 'I would be the last person to want any damage to come to those pieces through a loan to us', adding, 'if I am not mistaken several of them were once loaned to the Museum of Modern Art in New York and I did not hear that they suffered on that trip.'[24] Sweeney subsequently wrote to McCulloch on 29 October 1964 thanking him for 'taking up the fight' and proposing to draft a letter in reply to offer the trustees a 'face-saver'.[25]

A solution to the impasse

A softening approach was to follow. Early in January 1965, Deputy Premier Rylah wrote to McCulloch informing him regretfully that, while the trustees had reiterated their earlier decision that the Spencer barks should not be sent overseas, although there were staffing difficulties they had conceded to maintain a representative selection 'on display in Spencer Hall' and to 'increase and improve display when circumstances permit'. Rylah left the door slightly ajar, conveying to McCulloch his request to the trustees that they 'further examine their position with a view to making available certain less valuable bark paintings'.[26]

The latter course of action was reiterated in a letter from Victorian government parliamentary secretary James MacDonald as he announced a better financial deal for the museum and advised that, following his meeting with Professor Hills, chairman of the National Museum of Victoria trustees, the board of trustees would consider the idea mooted by Rylah when they came together in February 1965: 'If you have achieved nothing else, Alan, I am sure you have stirred a number of people into focussing light upon the many difficulties under which our Trustees are working and the importance of raising the whole institution to a higher level.'[27]

With the spotlight now firmly upon them, the NMV finally gave ground. In April 1965, McCulloch reported to Sweeney that

> an unconditional surrender on the part of Museum trustees was in sight when unfortunately they discovered Sir Baldwin Spencer's original legal agreement concerning the collection ... there in black and white was a clause which stated that no item collected and presented by Spencer should ever, at any time, leave the possession of the National Museum.[28]

Fortunately, as McCulloch went on to note, a way around the impasse presented itself with works not collected by Spencer himself being made available for loan. Ironically, this included, as McCulloch wrote, many of the barks he had previously selected because they

had been collected not by Spencer but on his behalf. It was a fine but important point of difference.

McCulloch was able to ponder the exhibition once again and what form it might take. Following a series of visits to the NMV, he confirmed the museum's about-face in a letter to Sweeney: 'At last, after a whole year of intermittent warfare, the issue regarding the bark paintings has been resolved, at least partly to our satisfaction', indicating that his selection of 'about 21 barks and one 9′ crocodile from communities in Arnhem Land' had received tacit approval from NMV director John McNally. McCulloch put the final decision back onto Sweeney, conceding that that he might not want even to go ahead given how things had gone.

By this stage there was an added sense of urgency as McCulloch pondered the likely implications of key works from the NMV being made available for other exhibitions being developed for international venues. Wrongly, as it turned out, McCulloch believed that Tony Tuckson, organiser of the successful 1960–61 exhibition *Australian Aboriginal Art* that toured Australia and then a selection of which went on to the Bienal de São Paolo, Brazil, was working on another:

> I'm a little nervous about the rival exhibition being put together by Tuckson, Sydney, for the Commonwealth Arts Festival, London; scheduled time for this is October this year ... I'd hate to think that having at long last opened up the doors of the National Museum of Victoria, someone else marched in and collected the spoils.[29]

A telegram sent from Sweeney three days later confirmed his interest and allayed McCulloch's fears: 'Delighted to hear of your success with bark drawings anxious to have exhibition please nail it down for us. Do not let it get away.' Moreover, rather than seeing any parallel exhibition being organised in Australia as a potential rival or competitor for loans, in his characteristically ambitious fashion Sweeney gave McCulloch permission to broaden his selection of works from the NMV to include works from other collections, and specifically two Melville Island barks that had been shown to

McCulloch by the then director of the South Australian Museum, Norman Tindale, in 1964.[30]

The final twenty-four works chosen by McCulloch represented a small though cohesive selection of works from three collections drawn from different regions of Arnhem Land: Oenpelli (now Gunbalanya) on the western border closest to Darwin, Yirrkala in Eastern Arnhem Land, and Cape Don on the Cobourg Peninsula, the northernmost tip. By concentrating his efforts on the first of these two places, McCulloch sought to introduce an international audience, presumably with little knowledge of Australian Aboriginal art, to some of its regional stylistic differences, including the naturalistic, x-ray style art of Oenpelli and the use of cross-hatching infill (rrark) to delineate form and space that we most closely identify with the art of Yirrkala.

The dominant group came from Oenpelli and consisted of fourteen works depicting stencilled hands and feet and representations of spirit figures and single animals—including the largest known spontaneously made bark painting in existence, measuring 294 × 103 centimetres—which were attributed in the catalogue as belonging to the 'Cahill collection'.[31] Precluded from this were thirty-eight paintings collected in 1912 from the Alligator, East Alligator and South Alligator rivers,[32] where Baldwin Spencer famously spent two months with the buffalo hunter and pastoralist Paddy Cahill and his wife and her sister, who had taken up residency there in the early 1900s. The works acquired at this time were clearly what the NMV meant when it referred to the Spencer Collection proper, while works believed to have been collected by Cahill in subsequent years, between 1914 and 1922, were considered as falling outside these parameters.

A second group consisting of seven composite paintings of marine life and animals was collected by Wilbur S Chaseling, who in 1935 set out following his ordination as a minister to establish a new mission between the existing Methodist stations at Milingimbi and Groote Eylandt. He settled on a creek roughly halfway in between, after which Yirrkala was named. A third group of three works from

the Cobourg Peninsula had been collected by William Austin Horn in 1922 and were sparingly described in the catalogue's list of works as male and female figures, 'probably Iwatya tribe'.

On the water

Notwithstanding McCulloch's efforts to expand the exhibition by including several Tiwi barks, his focus shifted in August 1965 from exhibition content to more practical considerations such as how the works could be best prepared for travel and display. The framing of barks from the Spencer/Cahill Collection for the Australian tour in 1960–61 provided a sympathetic model for how they might be displayed and protected at the same time. As with the Houston exhibition, individual glass cases emphasised the unique quality of each work and represented a dramatic change from the classification systems and methodology of collection and display of Aboriginal art that characterised Australian museums and galleries from the late nineteenth century.

New box frames were built consisting of a heavy glass casing and plywood backing with mitred corners secured by long coach screws. Using McCulloch's contacts at the National Gallery of Victoria, notably a craftsman named Les Hawkins who had been recommended by NGV exhibition officer and artist Leonard French, the legacy of nail holes and splitting left by previous attempts to frame and/or exhibit the works was attended to and a new way of mounting the works was utilised that was more in keeping with their age and condition.[33] The work was not without its own drama, as an alternative studio workshop had to be found at short notice. McCulloch reported: 'The barks were being framed as the building was being gutted around them; I'd never have exposed them to this risk in hands other than French–Hawkins who watched the barks like babies.'[34]

McCulloch was justifiably proud of their collective achievements. He wrote to McNally confirming that all the frames and mounting

'had been completed to his satisfaction'; there were twenty-four barks in twenty-three frames, with the twenty-fifth returned; and 'I feel sure you'll agree that it's a show to be proud of.'[35] By this stage he had secured the full support of McNally, including the provision of information relating to each work, which McCulloch duly checked off against Spencer's and Cahill's notes. He wryly noted in a letter to Sweeney: 'The Nat'l Museum trustees are now very proud of "their show" and one at least is visiting Houston to see it there.'[36]

Having personally overseen the conservation and framing of the works, McCulloch expressed confidence in the exhibition as it now stood, 'a truly magnificent one' drawn from a single museum collection. Counselling Sweeney against the need to look elsewhere for supplementary works—in particular from the South Australian Museum—he wrote: 'My own feeling however is that our show is complete in itself and needs no addition.'[37] Documentation was subsequently prepared and sent on, including a draft of McCulloch's foreword and negatives of the twenty-four photographed works. The frames were fitted and crated with the consignment readied to leave Melbourne on 14 September 1965 on the *Montreal Star*, scheduled to reach the Port of Houston on 30 October. The day after they set sail, McCulloch notified Sweeney that the barks were 'on the water'.[38]

McCulloch travelled in the opposite direction courtesy of the French government, which had invited him to visit France as a representative of Australian art and 'as their official guest to look over improvements wrought by André Malraux'. He wrote: 'I jump for joy to be restored, for two whole months to my first love—the beautiful world of *drawing* … I won't be really peaceful in my mind till the day they [the barks] are *on that ship*.'[39]

McCulloch left Australia with a letter of introduction to Karel Kupka. Kupka's seminal text on Aboriginal art had been translated from the French into English in 1965: quite naturally it figured among McCulloch's list of catalogue references. At their first meeting, Kupka perused the documentation that McCulloch had brought with him requesting copies of his 'excellent comments and the photographs

of all the barks [he] might have', asking McCulloch to pass on his best wishes to Sweeney 'and to assure him that I would be glad to give him some additional information for his excellent collection of aboriginal arts'.[40]

McCulloch ended up spending several sessions with Kupka, prompting the former to write urgently to Sweeney asking him to 'hold the catalogue' so that a revised version could be sent.[41] Following their final session, McCulloch 'finally arrived at ... [an] amended and corrected version' and openly acknowledged the contribution of the French curator: 'Kupka has been of very great help: I don't pretend to be an anthropologist and I am very grateful to him for having saved me from error.'[42] Moreover, Kupka 'immediately wanted to know if he could have the show for Paris'.[43]

The language employed in the extended entries accompanying the list of works certainly points to the involvement of a third person.[44] Drawing upon his own artistic background and interests as well as his work as a curator of anthropology, Kupka's commentary ranged between a discussion of some of the artistic or formal qualities of works included in the exhibition, an outline of their possible symbolic meanings, and observations regarding the impact of European civilisation on Aboriginal art.

Karel Kupka shared in the mid-twentieth-century belief in a primitive psychological experience, which could 'shed light on the universal origins of the aesthetic impulse in mankind'.[45] Aligning himself with the influential writings of French structural anthropologist Claude Lévi-Strauss, Kupka argued, moreover, that Aboriginal culture was inherently susceptible to the destabilising influence of other cultures. In Arnhem Land he believed that he had found a relatively uncontaminated culture, and all care had to be taken to keep it thus. Kupka's views struck a responsive chord with both Sweeney and McCulloch. All three argued in their respective catalogue texts for the desirability of an Indigenous art unsullied by the destructive forces of Western imposition. Not surprisingly, the same protective impulse posited by Kupka had motivated Baldwin Spencer and

Wilbur S Chaseling in the development of their own collections of Arnhem Land art.[46]

Arrival and launch

Concerns over whether the barks had arrived safely in Houston led to sleepless nights, underscored by McCulloch's frustrations at not being able to make firsthand contact with Sweeney from Paris. Sticking to his original plans to go to Holland and then on to London and home via New York, he finally received good news in a cable from Sweeney on the day before his departure. Sweeney reassured him that the barks had arrived safely and without incident.

Plans to put the opening back a week to 16 December and for McCulloch to be there for it were met with an enthusiastic response from the Australian:

> If you could manage this for me all would be well. I would certainly love to attend the opening of the barks. Kupka is very anxious for the show to come to Paris and I'm having difficulty getting my set of photographs back from him: I'd be delighted of course but I have too many complicated commitments to do any more work on it. I'll try to give a talk to the Nat'l Museum trustees when I get back; I think their whole attitude is now sympathetic but one never knows ...[47]

McCulloch arrived in Houston via New York on 10 December, where he was 'royally received by Sweeney and saw his beautiful gallery'. Reeling in shock, McCulloch learnt that Sweeney 'had sent out invitations for the opening of the show and *a lecture the following evening by me*', remarking: 'Only an Irishman like Sweeney or a Scot like McCulloch takes the law into their own hands like this and only an Irishman like Sweeney gets away with it.'[48]

Following a few relaxing days spent with his old friend, broadcaster and political commentator William Winter, McCulloch returned to Houston to see the exhibition fully installed. Nothing could have prepared him (or his contemporaries) for what lay before them.

The twenty-four barks had been taken out of their glass cases and frames and expertly housed, suspended and set against the towering white walls of the Mies van der Rohe–designed Cullinan Hall.

The change did not alarm McCulloch. Rather, the striking minimalism of the hang was duly noted in an approving letter to his wife, Ellen: 'The barks look beautiful against the white walls of the Museum of Fine Arts.'[49] McCulloch was certainly aware of the space and its generous proportions and the system of suspending panels from the ceiling—he had been sent a series of photographs and a catalogue of an earlier exhibition held in 1963—but the display was 'signature Sweeney'. At MoMA and later at the Guggenheim, Sweeney had forged a reputation based on uncluttered exhibition design where architectural elements were stripped back to reveal only essentials and screens were suspended from the ceiling in a dramatic intersection of space. It was a method of display that McCulloch was to later adapt to great effect in exhibitions he organised back in Australia.

In the open, cavernous space measuring close to 100 feet (30 metres) wide, 95 feet (29 metres) deep and 30 feet (9 metres) high, the bold patterning, striking lines and resonant pigmentation of the barks meant that the works floated as though in space, casting shimmering effects off the walls and polished travertine floor in a way that was foreign to most Australian galleries and museums of the time. The clean lines and generous exhibition space and hang were matched by the handsome catalogue design in which bold, black type was superimposed over a section of a lightning figure that in turn floated on an orange wraparound cover. All twenty-four works were illustrated, one to a page with no borders or background colours or design elements, with the catalogue printed in black and white. Corresponding text had been relegated to the back page. Clearly the catalogue reader was being encouraged to view each work for its artistic qualities alone and, in this respect, the modestly scaled catalogue joined other notable examples in setting new standards for Australian Aboriginal art publications.[50]

'On the art map of the world'

The response to the well-attended exhibition, both in Houston and further afield, indicated that the show was as popular commercially as it was a critical success. Houston's major daily newspapers each carried prominent exhibition notices and reviews.[51] Though the responses of writers were informed by popular tropes of the day—marvelling that such things could be produced by so 'primitive' a people—Marguerite Johnston in particular wrote with sensitivity about the development of Aboriginal culture and art, 'which required imagination, invention, patience, painstaking effort'.

McCulloch expressed his deep appreciation of the exhibition and catalogue in a letter written to Sweeney following his return to Australia in January 1966:

> Just a note to thank you for all your wonderful hospitality to me during my stay at Houston ... I thought the Museum was truly beautiful with its Mies van der Rohe facade ... The bark paintings couldn't have looked better than they did so attractively mounted in that egg-white setting; I forget now whether or not I specially thanked Herbert Matter for his catalogue design—I can't think of any detail that might have improved the catalogue unless it was in the writing of the foreword.[52]

Notwithstanding the unnecessary downgrading of his catalogue contribution, McCulloch joined with Sweeney again to explore ways to broaden visitation to the exhibition. Both men recognised the need to get full value from a collection that had travelled halfway around the world and would be unlikely to tour again. While nothing had come of Kupka's request for the exhibition to go to Paris, Sweeney was contacted by several leading museums in the United States during the period in which it was on display, and he wrote to McCulloch now back in Melbourne:

> You ask what will happen to the exhibition after it closes here. We have extended it for a week because of the interest in it. Chicago's Museum of Natural History wrote some weeks ago about it.

I would like to see it go there but I have been waiting to hear further before writing Melbourne. Rene d'Harnoncourt [Director, Museum of Modern Art, New York] also expressed an interest in it through the catalogue and wrote me he planned to put the question to his board.[53]

Soon after, McCulloch raised the possibility of the exhibition going to Chicago and New York with NMV director John McNally;[54] however, the idea was rejected by McNally and the trustees, as was a counterproposal from McCulloch that the barks be displayed at the Argus Gallery in Melbourne for two weeks in June 1966, 'fresh from their USA triumphs'.[55] This was despite the fact that the 'the barks had weathered the trip to Houston and back in fine style' and that 'our old friend McNally was all enthusiasm ... [but] the Trustees declined and I gave it away in disgust'.[56]

McCulloch's note was tempered by obvious disappointment, though he and Sweeney recognised in subsequent letters the positive outcomes that the exhibition had brought about, both for the Spencer Collection and the NMV.[57] For his role in this, McCulloch received numerous notes of congratulation, including the personal thanks of Alice Rowan.[58] Parliamentary Secretary James MacDonald claimed the whole exhibition as 'a credit to Australia ... [and] To you personally I extend my congratulations, as without your drive and enthusiasm this event would never have taken place, and I believe your efforts are a great contribution to the preservation of the bark paintings which will be held, at our own National Museum.'[59]

McCulloch was left to ruminate on what he perceived to be a lost opportunity to frame, document and exhibit the NMV's entire bark collection at no cost and resulting publicity 'that would have put them on the art map of the world'.[60] His advocacy of a specialist 'Museum of Primitive Art' or, short of that, stand-alone collections developed and displayed in each of the state galleries was once again flagged, as he proclaimed in a letter to MacDonald: 'What is needed in Australia is a proper museum of Primitive Arts. And why shouldn't it be in Melbourne, as part of the Nat'l Museum of Victoria?'

Plans to rehouse the National Gallery of Victoria in a purpose-built Roy Grounds design on St Kilda Road in 1968 were seen by Liberal state ministers and key officials as a partial solution to the Museum of Victoria's problems with space, and over 1967 and 1968, McCulloch entered a new debate. Using his position as *Herald* art critic, he argued that the opening of the new Victorian Arts Centre provided an ideal platform to launch 'a comprehensive display of indigenous primitive art of Australian aboriginals'—the neglected Spencer Collection—alongside the attraction of the architectural merits of the new building and 'a collection of the finest contemporary Australian art'.[61] Roundly criticised by Melbourne artists and critics for what they perceived to be his reactionary position on contemporary Australian art, McCulloch was instead lamenting a wasted chance to celebrate Australian art and culture in a more expansive and inclusive mode. As he underlined in a letter to artist and critic Elwyn Lynn: 'It was not the exhibition that I deplored [*The Field*] but the tragic waste of a great opportunity.'[62]

In late 1967, McCulloch conveyed his hopes and concerns for the Spencer Collection in a series of letters and meetings between himself and JV Dillon, under secretary, chief secretariat office, Treasury; minister for labour and industry John F Rossiter; and Rupert Hamer, minister for local government, during which time he also pressed for the creation of a statutory body 'empowered to deal with matters affecting various arts developments within each state'.[63] McCulloch urged both Rossiter and Hamer to consider an international showing, claiming that 'the entire collection should be sent on an American–European tour'.[64] He refuted the reply from Dillon that 'many, if not all, of the problems which you mentioned are obviously due to lack of space at the Museum ... which will be solved for the foreseeable future ... once the Gallery relocates', advocating instead building a separate museum to honour Baldwin Spencer and his collection.[65] 'The opportunity exists for the establishment of a truly magnificent "Museum of Primitive Art",' McCulloch wrote, 'one that could complement the collections of the new Victorian

Arts Centre and help make Melbourne the art centre of the entire South Pacific area.'66

Twenty-five of the Spencer barks, the majority bearing their Houston frames, were brought out on display for a dinner organised at the NMV for the Australian visit of Prince Phillip in 1968.67 Though McCulloch was by now adopting a more conciliatory attitude towards the museum, the director and the trustees, and giving recognition to the work that was at last being undertaken, he had the last word: namely, a call for a museum to honour Baldwin Spencer and his remarkable collection of Aboriginal art, which had first brought to notice the art of western Arnhem Land. In reply to a letter from the recently knighted Australian actor Sir Robert Helpmann, McCulloch declared: 'The entire collection should be publicly displayed either permanently or in a series of constantly changing exhibitions expertly mounted, and selections from it should be used for travelling exhibitions initiated from Australia in exchange for important exhibitions abroad.'68

His pleas were not to be acted upon immediately; McCulloch's views were, in a sense, before their time. Still to come was advocacy for properly funded and administered state and federal museums capable of delivering adequate storage, display and interpretation of Australia's Indigenous collections; for Australians to value their country's Indigenous heritage at a level that would rival that which McCulloch had personally encountered in overseas museums; and for the initiation of 'blockbuster' touring exhibitions of Indigenous art. In addition to these, McCulloch's proposal to cover the Jolimont rail yards in Melbourne and build a gallery of Aboriginal and Oceanic arts (anticipating recent calls for the creation of such an annexe on that site by over four decades) reveals a man passionately and intelligently engaging with the art of his time. Though it went largely unrecognised at the time in his own country, his vision and commitment to take the Spencer Collection of bark paintings to a world audience in 1965 was a measure of the significance of Baldwin Spencer's unique collection, and McCulloch's and JJ Sweeney's passion for Aboriginal art.

CHAPTER 8

AN ENCYCLOPEDIA OF AUSTRALIAN ART

In January 1962, Alan McCulloch pronounced the future of Australian art publishing as 'exceptionally bright'. In contrast to the literary landscape of the 1950s, he could now cite the strong interest in publishing the work of contemporary Australian artists in England (with a Nolan publication and another on Boyd to follow) and a recent bevy of commissions and announcements. These included Penguin Books, London, who had commissioned Robert Hughes to write a book on Australian art; the long-awaited and imminent appearance of Bernard Smith's *Australian Art*, to be published by Oxford University Press towards the end of 1962; a series of monographs on Australian artists edited by Smith, forthcoming from Georgian House; and Longmans, Green & Co.'s entry into the market with the brochures 'The Arts in Australia'. The announcement by Sydney publisher Ure Smith of a new art quarterly—*Art and Australia*—and a *Survey of Australian Art since 1940* by critic James Gleeson were also on the cusp of publication.[1]

McCulloch could have also mentioned his own projects—including the monumental task of preparing the first authoritative dictionary of Australian art. This culminated in the research and publication of the various editions of the *Encyclopedia of Australian Art* that ultimately became McCulloch's finest contribution to Australian art scholarship.

The encyclopedia takes shape

McCulloch had earlier recognised the need for extended biographical entries on Australian artists, in the 1940s. Hampered by the dearth of general reference books on Australian art and frustrated by the lack of easily accessible and verifiable information, he began to record information on a handwritten card system. Although not without limitations, these card entries could be endlessly expanded and rearranged to suit. They would prove invaluable to his role as *Herald* art critic, and in particular the frequent requests from readers for detailed biographical information on individual artists. From around 1958, and with the 'Antipodean invasion' of London and 'climate propitious for an approach to a London publisher', McCulloch recorded that he 'began to order the notes I had collected over the years and set to work in earnest to fill in the gaps'.[2]

On top of his weekly reviews and frequent essays and lectures, McCulloch was increasingly called upon to contribute specialist essays and short biographical entries on Australian artists to international art dictionaries and encyclopedias during the 1950s. This need followed the post-war boom in educational literature, which gathered momentum in the 1950s and reached a peak in the following decade. Long before Wikipedia and the internet had been thought of, printed and bound encyclopedias and dictionaries offered the most comprehensive (and sometimes only) way of learning about both historical and contemporary art and artists.

On 6 January 1961, McCulloch outlined his draft vision for a dictionary of Australian art in a letter to Len Voss Smith, a consultant to Christie's and the general manager of Hutchinson's Australasian publishing group. He proposed one thousand entries in two volumes (1788–1936 and 1939–61), along with 200 black and white and fifty colour plates and a 'practical format' similar to that of Methuen's dictionaries.[3] McCulloch felt sure of its success even though the plan was hugely ambitious. He reasoned that since 'there is not material at present available on the subject, very little planned ... the field is

consequently wide open'. Two days later he followed with a request to the Hutchinson Publishing Group in London to pay him the £750 owing upon signing of the contract.[4] Although Voss Smith needed to travel to London to present his case, McCulloch's demand was an act of supreme confidence. It would be another seven years before the book was published. It was to prove a test in patience and endurance for writer, editor and publisher alike.

Hutchinson's director, Geoffrey Howard, bluntly assessed the initial projected sales target of 6000 copies in Australia and New Zealand in two years as overly optimistic. At the same time, that amount of copies was deemed necessary to recover costs for what promised to be 'a *heavy* investment under present circumstances and we must be sure of our ground'. In addition to his fee, McCulloch was granted 10 per cent royalty of the published price in Australia and overseas. As was (and still is) the custom, expenses incurred in gathering visual material were considered solely the 'author's concern'.[5]

In December 1961, the dictionary project was handed over to Hutchinson's Edith M Horsley to manage. Horsley was an outspoken editor and writer who was well qualified to take on the job. She was in the process of publishing a revised dictionary of superstitions (first published 1948) and a dictionary of English art. At the same time, she was also working on her own magnum opus (later published as an encyclopedia of nineteenth-century British history). To her credit, Horsley was to stay with and oversee McCulloch's book until the end, despite her own heavy workload.

In an introductory letter to Voss Smith, Horsley developed a contract that stipulated a book of 512 pages at 500 words per page, with publication to be ready at 'as early a date as the author can manage it'. Horsley had been impressed by McCulloch's perceptive and accessible style of writing—in her estimation a rare combination—having been sent a recent *Meanjin* article: she was, however, to prove an empathetic if sometimes testing ally.[6] Refusing McCulloch's request for an increased royalty, she also refused to announce the dictionary of Australian art to the Australian press. She was concerned that such

a move would 'alert Penguin Books into pushing forward their own book by Robert Hughes'.[7]

According to McCulloch, the initial planning for the dictionary of Australian art was undertaken during a hiatus period in Australian publishing. He made a case for it in a letter to Sidney Nolan in 1962:

> I feel more than a little nervous about the general exodus of Australian artists who seem bent on cashing in on 'the London success'. The situation seems quite badly in need on [sic] consolidation with the degree of emphasis placed correctly in its right perspective: this is the idea behind my Dictionary whose emphasis, despite that, the book is also a complete work of historical reference, will be on contemporary Australian art.[8]

In spite of the changes in the Australian publishing landscape during the early 1960s, McCulloch remained unequivocal regarding the dictionary's style and intention. It was not an art history but 'intended as a compendium of facts from which the reader may draw his own conclusions and make his own analysis. To provide a framework ... obviously indebted to the historical surveys of William Moore and Dr Bernard Smith the only comprehensive studies before this volume.'[9] Questions were later asked as to whether this was the right approach—McCulloch's more polemical writing style in his *Herald* and other articles was seen as livelier and more engaging—but he remained steadfast in the belief that this was what was required.

With little in the way of reliable and up-to-date information, the dictionary was to be situated between Moore's 'chatty history', published in 1934, and Smith's more robust single-volume study of Australian art, *Place, Taste and Tradition*, written in the climate of World War II and from the author's avowed left-wing perspective. McCulloch believed his contribution would become the essential reference book for Australasian art. To this end, he recommended to Edith Horsley that she refer to Michel Seuphor's dictionaries of abstract painting and modern sculpture as guides—Seuphor being one of McCulloch's favourite writers. She responded that she 'thought it resembled Lake? and Maillard's *Dictionary of Modern Painting*',

which had disadvantages to it. She also wanted to limit entries for contemporary artists to those represented in state galleries.[10]

Once the contract was in place, McCulloch set about the huge task of compiling biographical entries on every artist of note in Australia since European settlement. He frequently recorded his frustrations at being almost a lone hand, compiling most of the entries in the 250 000-plus words from scratch or from information provided to him. Without adequate research or administrative support, much of the unsolicited information had to go unchecked. Added to that was the high cost of securing Ektachrome slides for photographic reproductions and the stringent protocols regarding word usage and titles.

Getting correct information on Australia's white history proved difficult enough, but gaining specialist information on Australian Aboriginal art and artists proved even more elusive. McCulloch noted some of his frustrations and the lack of consensus regarding place names, which intensified as the process of editing gained traction: 'There is no written Aboriginal language', he explained to his English publishers,

> and Yirkalla is spelt Yirrkala, Yirrakalla by [FD] McCarthy and [Ronald M] Berndt. I have taken [Charles P] Mountford's spelling as in his UNESCO book and we might as well keep it. Rafferty's rules prevail, I fear, in this case, but Mountford is as good an authority as the others … Yes, use official Northern Territory, but not 'Dead Heart'. Much better to use 'Great Central Desert' as used by Spencer.[11]

Competing titles and other challenges

There was also the matter of other publications rising to usurp his opus. A cutting in McCulloch's archive includes a 1962 letter to the editor of the *Sydney Morning Herald* by Colin Roderick, then director of Angus & Robertson. The letter mentions a comprehensive dictionary of Australian art that is already in preparation and to be authored by James Gleeson for Angus & Robertson.[12] McCulloch

and Hutchinson's representatives were also aware of the precocious art critic Robert Hughes and his contract to produce a book on Australian art. The Gleeson dictionary failed to materialise in the timeframe and form it was first thought, and the Hughes book, when it did come, did not cause McCulloch much consternation due to what he perceived as the number of mistakes and poor-quality printing.

Bernard Smith's now classic *Australian Painting*, first published in 1962, was also a cause of concern but, in a handwritten note to Horsley dated 12 December that year, McCulloch wrote: 'The Bernard Smith book is out. *Australian Painting 1788–1960*. Text is alright but colour plates nothing.'[13] McCulloch was more gracious in public. He recognised Smith's achievement—to which Smith replied, 'Thank you for your kind remarks about my book'[14]—but he did not see *Australian Painting* as a direct competitor to or replacement for his own more comprehensive encyclopedia.

Progress on the dictionary was slower than anticipated. Efforts to gain financial assistance had not been successful. In March 1962, McCulloch had requested help from the Australian government. Stating that his only regular source of income was from the *Herald*, he forlornly appealed by explaining that all other writing, drawing and lecturing engagements had been forgone 'so that I could devote the necessary time to the book'. He may have been partially undermined in his application by the uncompromising tone of his letter, in which he asserted his critical independence and integrity, which he would not be willing to override 'for the sake of a grant'.[15]

Throughout 1963, both author and publisher faced unavoidable distractions. McCulloch was busily producing a new television series for the Australian Broadcasting Commission. He noted in a subsequent letter to his English editor the sort of practical problems he faced. For instance, securing good reproductions was a difficult process, and there was also the constant issue of maintaining 'up-to-dateness', especially in relation to annual art prizes, for which the information was constantly changing.[16] The addition of a Mornington Peninsula local, Judy Blythe, as a typist and administration assistant

in 1962 went some way towards re-energising the process as well as providing a valuable ally.[17]

Most artists responded positively to McCulloch's research enquiries. Some used the opportunity to pen precise and extended treatises on their own work and the organisations they were attached to, while others questioned why they were considered worthy of inclusion.

John Passmore and Alan McCulloch launched into an extended correspondence that covered everything from Passmore's stated desire for artists to be left alone to detailed diatribes concerning his current state of mind. In 1962 he wrote: 'I would like to be more of an artist and have nothing to do with these things but from experience I know something will be done regardless of the artist's wish and done worser [sic]—if there was only the work and nothing else.'[18] Passmore followed this with the admission that 'I do not feel that I have achieved anything yet, but the hope that I might keeps me going'. In July came a litany of excuses for not getting material off, ending with a plea that his 'nerves are ragged and my heart needs mending—a serious breakdown otherwise'.[19]

By 1963, Passmore was still yet to send the information McCulloch had requested. On 3 April 1963 he wrote to explain his delayed response, dramatically stating: 'I am on the edge of a precipice if not in the abyss where the mind rejects all the wrong.' Yet two days later he wrote to thank McCulloch for including him in the encyclopedia and included a cryptic message and diagram.[20]

For McCulloch, research on the dictionary of art was a chance to renew old friendships and make new acquaintances among Australian artists who were now scattered around the globe. Robert Klippel, whom he had met in Paris around 1949, wrote from New York in July 1962 to outline his plans for an exhibition of sculptures in Sydney, recounting the difficulty of getting '18 pieces of sculpture' through customs.[21]

Erica McGilchrist provided many varied and interesting comments throughout 1962, often in relation to her anxiety and the

contradictions she faced in her work. Writing from a base in Neufarn near Munich, she responded to McCulloch's requests with one of her own, asking him for a personal reference to help get a show in Germany.[22] Reference received, McGilchrist revealed her resolve that it should be 'put into service if necessary, in spite of your advice to retain a little originality and NOT exhibit'.[23] She chided McCulloch for referring to her as a 'woman painter as though my sex makes a difference to the quality of my work ... Oddly enough in spite of all the doubts about whether I am a real painter or not, I do feel sure that I have something to say.' McCulloch was made to understand that suffering for the cause was something that transcended age and gender. Once the groundwork had been laid, their further correspondence demonstrated a strong bond. McGilchrist continued to provide McCulloch with long discussions on the German art scene, her humanistic philosophies and future plans.[24]

Although a dictionary of this kind was long overdue and would have a positive impact on artists and galleries, some artists made strong statements by refusing to be included. Richard Larter declined, in protest over the Australian government's continued deployment of troops to Vietnam.[25] The eccentric Godfrey Miller instructed McCulloch not to include him in the forthcoming encyclopedia based 'on religious grounds and on aesthetic grounds'.[26] Taking a humble tack, Gordon Thomson, deputy director, National Gallery of Victoria, asserted that 'the only thing about myself worthy of recording [is] perhaps that one of my hobbies is privacy ...'[27]

In July 1964, two-and-a-half years after commencement, McCulloch triumphantly handed in the completed draft copy for the biographical dictionary of Australian art. He noted: 'As for the body of the MSS I feel that I have done my best and my reader here, [Max] Dimmack, tells me it's a very valuable work (his words).' He added, 'The departure of the MSS leaves me with a feeling of exhilaration mixed with a sense of bereavement: I know I could have worked on it, improving all the time, for several years more; but had I succumbed to temptation it could have gone on forever.'[28]

A protracted process of revising the format, procuring illustrations, checking layout and myriad other details followed, including making provision for new art-prize winners, that had taken place over 1964, 1965 and 1966. The manuscript finally went into production in May 1966. Trying to keep track of all these changes, Horsley noted dryly: 'I am beginning to think the easiest way of earning a living in the world must be as an artist in Australia: the country must be knee deep in prize money.'[29]

McCulloch learnt that Penguin had withdrawn their book by Robert Hughes two weeks from release in February 1966 because, in his words, 'the standard of the production was not up to Penguin requirements'. Hughes had announced from Siena in Tuscany that he was bringing the book up to date.[30] This left the field open. However, the constant revision meant that McCulloch's dictionary was also in danger of being out of date before it was published. McCulloch acknowledged this dilemma in a candid letter to Daniel Thomas. Alterations and additions were inevitable as new information became available—such as information 'formerly inaccessible in the vaults of the State Library of Victoria ... being unearthed daily by a staff of industrious research workers owing to the sudden generosity of an industrious millionairess to the new La Trobe Library'[31] and a 'good deal of specialist research being done in Australia now owing to a vast number of university graduates majoring in such subjects ... This situation didn't exist when the body of our Encyclopedia was complete.'[32]

By early 1967, the main text was complete but the introduction had been rewritten to provide a more detailed historical overview and a fuller provision of information about schools of art. To accommodate the changes, an almost complete set of new galleys had to be printed, with McCulloch bearing a percentage of the cost. He bemoaned the fact that he had effectively not earnt any income from his work for six years and that along with this came the responsibility and realisation that 'my work won't really ever be finished because I must at once establish a system that keeps a constant *file* of new material'.[33]

Uncorrected proof copies were finally delivered and the single-volume *Encyclopedia of Australian Art* went to press soon after. Ambitions to have the first copies of *EAA* available at the Victorian Arts Centre opening in mid-1968 did not eventuate, but the book was belatedly sent to McCulloch on 12 August. The situation in publishing had changed dramatically by this time. 'You cannot imagine', McCulloch wrote to Judy Blythe,

> what has happened here when I say that *not one book* appeared on Australian art from 1945–60. Fifteen years of absolute silence except for a few sparse magazine articles and ordinary newspaper critiques. Then Wham! A constant flow of literature started up three years ago and has gained steadily in volume making things interesting but damned difficult for the misguided writer of the *Encyclopaedia of Australian Art*.[34]

Launch and critical reception

McCulloch provided a valuable firsthand account of the official launch, which was at the exclusive Windsor Hotel, Melbourne on 24 October 1968.[35] As befitting a publication of this nature, the critical response to the first *EAA* was extensive and widespread. Veteran academic Joseph Burke called it a 'remarkable achievement'. Elsewhere it was labelled indispensable, while Laurie Thomas, director of the Art Gallery of Western Australia, ruminated in the *Australian*: 'In its 688 pages it tackles so much that one wonders how on earth McCulloch had the courage to take it on in the first place and then had the tenacity to see it thorough ... having seen it once, you wonder how you got on before without it.'[36] Responding to Patrick McCaughey's review in the *Age*, McCulloch described it more as a labour of love than a 'loveless, thankless task'.[37]

Terrified that he had left out important artists—as he nearly did with Sidney Nolan and Thea Proctor, over which he later remonstrated with himself—McCulloch was relieved to have the encyclopedia out at last and in the public domain. But this did not stop the criticism that inevitably followed. It ranged from the

petty—an aggrieved Ross Lansell, whose credentials as an art critic McCulloch had previously challenged, questioned why McCulloch had included fellow art critic Patrick McCaughey but not him[38]—to more fundamental issues and concerns. Many of these McCulloch had himself debated over the seven years of writing and production. Chief among them was the charge that it was already out of date, with most entries finishing in 1964. Some questioned whether it was more dictionary than encyclopedia (because it favoured information about dates and events rather than offering interpretation), or pointed to the provision of incorrect information, questions of accuracy and attribution, and the use of legal rather than working names, such as Dawn Frances Westbrook rather than Dawn Sime. Others believed that minor artists were given equal prominence with better-known artists, and that there was a bias towards McCulloch's hometown of Melbourne.[39]

McCulloch accepted most of the criticism in good grace. He wrote to each of his fellow critics individually or in the form of a reply to their editors. He accepted calls of omissions and asked the writers to update him as new information came to hand. McCulloch thanked Daniel Thomas for his 'sympathetic review', agreeing with him that it tapered off after 1965 and remarking that it would need updating every five years. Thomas requested his own personal copy so that he could make annotations for future editions.[40] To Elwyn Lynn, who had challenged the criteria for selection of artists, claiming there was not much chance for the 'anti-prize artist and loner', McCulloch replied in his letter to the editor of the *Bulletin* that you 'need a criteria and once decided, [it] needs to be upheld'.[41]

The review that would have upset him the most was by Joseph Burke. Writing for McCulloch's newspaper, the *Herald*, possibly at McCulloch's own recommendation, Burke questioned the fairness of the book and some of its observable omissions. 'In noting those value judgements that are expressed by the comparative length of articles, the judgement of McCulloch the encyclopedist has sometimes

been influenced by the sympathies of McCulloch the critic with romantic and expressionist art, as well as coloured by his residence in Melbourne,' he ended. Burke recanted some of this in response to a personal letter from McCulloch with an acknowledgement of the book as a 'true labour of Hercules' and that 'I sounded a note of warning because I believed that many people would only read their own interests, and there is no pleasing the vain.'[42]

McCulloch's awareness of potential omissions, possible misinformation and the likelihood of mistakes was conveyed to *Meanjin*'s editor, Clem Christesen, in February 1969:

> The art critics of Australia are one and all little reservoirs of specialised information; each one knows a few things relevant to Australian Art that nobody else knows and they like to keep it like that. So a book of this kind gives them a heaven-sent chance to air this knowledge. I'm not complaining. But it would be nice if someone did a review that looked at the whole thing in its proper perspective. e.g. as a necessary pioneer work.[43]

Artists were equally forthcoming as critics and once again the reaction was bittersweet. Alun Leach-Jones wrote that he ought to take responsibility for keeping McCulloch up to date, conceding that 'I feel that all the work should not be left up to you'.[44] One unnamed artist thanked him 'for taking 3 years off my age', exhorting 'I *feel* that *much* younger.'[45] In a personal valediction, artist Mirka Mora wrote in a beautifully illustrated letter: 'Dear Alan—thank you for the pleasure your large book has given me and will give me in the years to come. Much love Mirka.'[46]

These criticisms notwithstanding and the 'totally unexpected disaster' that many of the undistributed copies had to be recalled due to a fault with the binding,[47] McCulloch had already begun planning for future editions and changes. He raised the idea with Hutchinson of initiating a loose-leaf binder service for 'which schools, universities, societies, artists and public subscribers would pay an annual fee'. This, he felt, would keep the information up to date, deterring

would-be dictionaries from being written in competition and thus representing a 'better return for my work'.[48]

Edith Horsley discounted McCulloch's loose-leaf binder scheme but not the idea of regular supplements, adding:

> It was, I know, a conscious decision on your part to omit the kind of criticism which made your *Herald* articles popular, and I hope you will forgive me if I say that I think it was a mistake. If we could build up material of this kind in the supplements, it will make a revision of this major work easier when it [comes], as well as more saleable to the public ...[49]

The reprint of the *Encyclopedia of Australian Art*

Throughout the 1970s, Lansdowne showed their interest in taking over the rights of the *Encyclopedia of Australian Art* by publishing a new and revised edition. McCulloch had resisted this, noting the determination of Hutchinson (Australia) to eventually do the same thing themselves.[50] It was, however, the parent company of Hutchinson based in London that ultimately held sway. In June 1973, McCulloch wrote to Sir Robert Lusty, general manager of Hutchinson, to argue the case for a reprint of the first edition with corrections. He also took the opportunity to lobby for a new, revised edition that would include much new material and give a different treatment to the individual biographical sketches of the first, as well as short, specialised articles on architecture and mediums such as ceramics and tapestry, 300 pages of new and adjusted biographies and double the number of colour plates for the period from 1967 to 1977.

McCulloch reasoned that if Hutchinson was not interested, then it should 'permit me to find an Australian publisher':

> Understandably there is a strong feeling within Australia that an *Encyclopaedia of Australian Art* should be published in Australia. And while I would be reluctant to sever my connections with Hutchinson it is true that the publishing situation in Australia has changed so radically as the art scene and everyone is now aware of Australian book publishing as a highly competitive business.[51]

The corrected and partially revised *Encyclopedia of Australian Art* was eventually reprinted in 1978, ten years after the first—although it would not be until 1984, and again in 1994, that McCulloch would get his wish for a new and substantially revised edition. For him, the first *EAA* had been a 'labour of love which took fifteen years', and from which he had earnt nothing. For the proposed reprint in 1978 and revised second edition in 1984, McCulloch sought help from a range of sources and wanted to commission specialist writers to add diversity and depth.

In his capacity as acting director of the Visual Arts Board of the Australia Council, Patrick McCaughey was empathetic towards McCulloch's efforts to apply for financial assistance in May 1973.[52] In a follow-up memorandum to the board, McCaughey presented a solid case to provide $5000 to 'allay costs' and 'improve the accuracy of the Encyclopedia and increase photographic representations of artists on a more equitable system than the original illustrations were compiled'.[53] Upon receipt of his successful application, McCulloch thankfully acknowledged that the money would help ease the burden as well as make it possible to attain 'a higher standard of accomplishment than was achieved in the original book'.[54]

McCulloch often despaired regarding the quantity of information and the lack of adequate financial support. Responding to a request by the VAB for an update on the progress of the encyclopedia, he declared in 1975: 'Publication date will probably be 1978, ten years after the first book appeared, which seems fair enough. With any luck I'll be dead before a third edition looms on the horizon.'[55] McCulloch was unsuccessful in his efforts to secure a second grant from the VAB fund in 1977, principally to fund a research assistant for eighteen months to help him meet his contractual obligation to complete the revised edition by the end of the following year.[56]

Passing the encyclopedia to Hutchinson (Australia) in the mid-1970s was presaged by the need to resolve outstanding problems, such as recompense for the remaindered copies still held by the parent company in London, which had led to reduced royalty payments to

McCulloch and the potential for cheaper copies flooding the local market. Hutchinson's Australian accountant, Peter Pulbrook, eventually settled with McCulloch in June 1976, gently reminding him of the benefits of being with them: 'As you are aware it is our present intention to reprint a quantity of the *Encyclopedia of Australian Art*, from which you will benefit considerably directly from Hutchinson's Australia, as it will be our book and royalties will be payable direct from ourselves.'[57]

There was also the issue of how the reprint would differ from the proposed revised edition that they promised would soon follow. In McCulloch's estimation, 'By my reckoning it will be necessary for readers to have both books so naturally the contracts should be identical.'[58] In a commercial decision, the newly instated managing director, Elizabeth Douglas, replied:

> It is strongly felt that this reprint must not be substantially different from the revised edition otherwise it cannot be properly represented as a reprint and will be confused with the completely new and revised edition we propose to publish in the future. In practice, this means that only blatant errors, such as incorrect dates and the merging of artists into one (as in the case of Gray), should be corrected. No other alterations, such as the inclusion of artists previously omitted, should be made.[59]

The release of the 1977 reprint rightly met with derision in some quarters. It had been ten years since the first *EAA* had been printed and the art community, not privy to the ongoing discussion, had naturally expected more substantive change. Writing for the *National Times*, journalist Chris Berkman was strong in his criticism: he derided the book as dated, 'and its failures of scholarship and archival responsibility, and its sexism, make it less than a bargain'.[60] McCulloch and Douglas tried to placate the writer in their replies, claiming that they had tried to introduce as many corrections as possible 'without resetting each page'. They claimed, furthermore, that the author of the review had mistaken the 1977 reprint with corrections for the updated edition not yet out, 'a "relief" edition

published to relieve the pressure on the author and save seekers for the original the work the necessity of having to pay up to $200 per second hand copy!'[61]

Recognising the pressing need to publish a fully revised edition, McCulloch confided in Susan McCulloch, that he had asked for financial assistance to pay Charles Nodrum, who 'has generously offered his services (for research and general compilation work) free—known to you as Christies' rep in Melbourne'.[62] Christie's had suspended operations in Australia in July 1978 due to an economic downturn and Nodrum was available to provide his expertise. Credited as a research assistant for the 1984 edition, Nodrum rewrote essays and provided new material and research.[63]

Recognising the encyclopedia's importance for all Australians interested in the arts, Hendrik Kolenberg, Curator of Prints and Drawings at the Art Gallery of Western Australia, in October 1978 also advocated on McCulloch's behalf. Kolenberg ventured that the VAB should employ

> a good research student for the next year or two and have a small committee of curators from all State Galleries assist you with advice and up to date details so that the next edition is the best and most definitive possible. Why don't you try to put forward such a proposal? The AGDC [Australian Gallery Directors Council] could perhaps coordinate a Curatorial Committee. This is what these do anywhere else in the world. After all who *doesn't* use your encyclopedia?![64]

McCulloch ended the 1970s knowing that he was still a fair way off finishing the revised encyclopedia. In thanking author Murray Bail for sending him information and corrections to the Fairweather entry:

> I hope to finish the book this year with the able assistance of Charles Nodrum, late of Christies, but there's a vast pile of material to wade through. I blush when confronted with those early mistakes. My excuse? No precedent. Since I was a lone worker I had to take catalogues, newspaper cuts, *Art and Australia* bits, Moore

and other writers as correct. The Australian art world was still a small one in 1965, albeit largely unexplored and undocumented. Haefliger and I made the first speeches to start the first University Chair of Fine Arts c.1945/6, little knowing what we'd started under the aegis of K Murdoch and the *Herald*.[65]

Other organisations and publishers had by this time taken on board similar projects. The Power Institute announced the beginnings of its own dictionary of Australian artists, architects, sculptors, craftsmen, critics and major collectors with a completion date of three to five years. What had begun as a competition with Bernard Smith in the early 1960s had now come full circle.

The recent appointment of Smith to head the Power Institute put the organisation in a unique position to develop a major project that undermined or replaced McCulloch's opus. A direct commercial competitor had also emerged with the publication of Max Germaine's *Artists and Galleries of Australia and New Zealand* in 1979. Lansdowne had finally got the book it wanted, one that ironically incorporated McCulloch's earlier suggestion of a combined Australian and New Zealand art book, with the two reviewed the following year by Elwyn Lynn in *Quadrant*.[66] It did not escape McCulloch's notice that a bevy of new books, including two dedicated to Australian sculpture—a general history by Graeme Sturgeon, *The Development of Australian Sculpture 1788–1975* (1978) and Ken Scarlett's large single volume, *Australian Sculptors*, had been released within eighteen months of each other. Perhaps protecting his hard-won investment, McCulloch had uncharitably suggested that Scarlett's opus, the largest book on Australian art to date, had come 'hard on the heels' of the former.[67] The original encyclopedia and its subsequent rewrite and extension persists as a vital resource to this day, outperforming most other new and revised forms of Australian art biography, including that freely available and on subscription online.

CHAPTER 9

WRITING AND PUBLISHING

ALAN McCULLOCH HAD entertained the idea of producing a specialist book on Australian art and, more specifically, on contemporary Australian painters, in the early 1950s. These years were marked by fits and starts and more than a share of disappointments; however, during this time McCulloch was able to better understand the sort of book it needed to be.

He had held high hopes that his work for the 1949 publication on the National Gallery of Victoria collection would lead to more substantial writing and editing assignments. This was the impression passed on by Len Annois, his friend and NGV members' secretary. Annois informed McCulloch in 1948 that the NGV was embarking upon an ambitious publishing regime and that, with his imminent return to Australia, he was in line to become a key contributor on the art of his contemporaries.[1]

Despite the confidence shown by Annois, nothing major eventuated from these discussions. Instead, in early 1952 McCulloch was excited to announce that he had been approached to work on the revised version of *The Modern World Encyclopedia*. Donald Kingsley Thomson, editor of Colour Gravure Publications, a subsidiary of the Herald and Weekly Times, expressed the company's intention to publish this as soon as they could, and requested McCulloch to act as 'Editor and Chief Contributor in respect of art'. According

to Thomson, McCulloch was the right person to do that 'especially in view of high recommendations of your qualifications which I have'.[2]

On top of an already tight schedule, the publishing date was brought forward, and McCulloch was asked to provide a copy of whatever he had written.[3] McCulloch gave an insight into what this meant in a heartfelt letter to his brother Henry, dated 14 April 1953: 'I am writing the art section of a *Herald Encyclopedia* (in 5 volumes) 25,000 words being devoted to art … The things one does to earn a living!'[4] The book was published to deadline in 1954.

By this time, McCulloch had also begun to field requests to contribute short biographical entries on Australian artists for new encyclopedias being published internationally. In 1954, Bernard Myers invited him to forward a proposal on Australian art and artists to the 'World Encyclopedia of Painting'.[5] With the help of his wife and fellow academic, Shirley D Myers, Myers later edited the five-volume McGraw-Hill *Dictionary of Art* and was the consulting editor on a 16-volume *Encyclopedia of Painters and Painting of the World from Prehistoric Times to the Present Day*, also published by McGraw-Hill.

Once he became editor-in-chief of art books at McGraw-Hill, Myers continued to include McCulloch as one of his writers and throughout 1961 the two corresponded regularly regarding his contributions. McCulloch began by providing a list of Australian artists in order of relative importance, commencing with Tom Roberts and the Heidelberg School at the pinnacle. Already, he had elevated Nolan, Tucker and Boyd to the upper echelon, with Myers suggesting that he give the three artists preferential treatment 'since you seem to think that these are so important'.[6] In 1966, and with the encyclopedia still not gone to press, Myers wrote to McCulloch inviting him to review his contributions on artists with more current bibliographical details. McCulloch's response was to plug his own encyclopedia, which was 'scheduled to appear in Feb 1967'.[7]

The two men developed a special, long-distance relationship—offering each other support and sharing publishing ideas over the ensuing years, especially as their careers and interests coalesced and

developed. In 1952, Myers had responded positively to McCulloch's idea of writing a book on Mexican art (an ambition which he also harboured). At the same time, Myers updated McCulloch on his own efforts to find a publisher for what would eventually become the standard English post-war reference on German art. 'The idea of a book on Mexico is very sound, I think, and I imagine that very little has been done by Australian writers in this area. Actually, I myself have such a project in view, as a history of the Modern Mexican Movement,' he wrote, at the same time informing McCulloch that his German book was finished and he was now looking for a publisher.[8]

When McCulloch informed Myers that he was producing a book on the 'contemporary art of Australia' two years later, Myers added encouragingly: 'It might be possible to have this coincide with an exhibition of contemporary Australian painting perhaps with the cooperation of the Smithsonian Institute in Washington ...'[9] And the following year, in 1955, Myers again consoled McCulloch, suggesting that the 'hulabaloo about your "monster exhibition"' demonstrated how opposition to such shows formed part of 'the development of modern art'.[10]

Contemporary painting in Australia

McCulloch's *Contemporary Painting in Australia* was commissioned by Cheshire with a proposed publication date of 1954. McCulloch had previously worked with Cheshire's Andrew Fabinyi on *Masterpieces from the National Gallery of Victoria Collection*. The two had developed a good rapport throughout that process. McCulloch produced a table of contents, introduction and section pieces that set out his methodology and his grounding in mid-twentieth-century Australian art. It seemed to follow his earlier NGV book in style and form, but it was also linked to the biographies he was working on for the various encyclopedias.

McCulloch's draft outline was very much rooted in its time— demonstrably a Cold War piece. 'The atom bomb', he wrote, 'will

finally determine the issue.' He acknowledged the debt of Australian art to the School of Paris, though 'at its best, flavoured by its own climatic surroundings'. He also advanced his thesis regarding Australian Aboriginal art as an essentially static entity, which he also saw as of its times. 'Aboriginal art', he suggested, is 'emblematic as it is of the tribal culture of a people so primitive that they have never been known to till the land [and] is as foreign to the European-Australian as would have been the Chinese to an Italian painter of the quattrocentos.' Tellingly, he went on to differentiate between early European modernists and their study of African art—which he saw as a 'matter of direct intellectual appropriation'—and their Australian counterparts' study of Australian Aboriginal art—which was 'concerned with infiltration, the gradual assimilation of one culture into another'.[11]

While the book didn't go ahead as planned, McCulloch condensed his writing into a series of chapters that were published in several other publications. These included a small booklet, *Australia: Art*, published in 1954 by the Australian News and Information Bureau, Department of Interior, Canberra. He also began to collate material gleaned directly from artists, which was to lay the groundwork for the encyclopedia of Australian art.

Throughout 1953 and into 1954, artists and art officials around Australia responded to McCulloch's written questionnaire. Many were matter-of-fact responses such as that received from Russell Drysdale, who indicated a preference for reproducing one work over another.[12] Other artists warmed to the task of re-telling their life story, often using the opportunity to ruminate on their practice and more broadly on the current state of art in Australia.

John Passmore exclaimed: 'I am not interested in Australiana in art. In the world of ideas I am only a student. What might be accomplished in Art is the only reason of Art to me. Art is always only at the beginning and we all want to show beef steak like Brancusi.'[13] Some artists were less grandiose in their self-assessment. The most pitiful reply came from Hal Missingham, then director of the Art

Gallery of New South Wales, who wrote: 'Thanks for your note + detailed criticism but I feel you have wasted a whole lot of time and thought on a subject not worthy of such serious consideration ... I am now a Sunday dilettante painter, and professionally a Gallery Director and Secretary.'[14]

McCulloch set his sights high based on the strength of his research into individual artists. He contacted Professor Nikolaus Pevsner, an esteemed art historian from the University of London, in 1958. Presumably, this concerned McCulloch contributing to the *Pelican Companion of Art*, as Pevsner wrote back explaining that as the series editor he couldn't do what McCulloch requested as he only had at his disposal 'one volume in the Pelican History of Art which deals with painting and sculpture between 1800 and the present day in all countries ... If you remember this I am sure you will understand that it would be utterly out of proportion to follow your suggestion'.[15] Undeterred, McCulloch wrote to his brother Henry on 23 March 1960: 'I feel very neglectful that I have not written lately but same old excuse.—too much writing. I have been flat out on my book to the tune of about 2,000 words a day which *is* hard work.'[16]

Albert Tucker

Strangely, McCulloch passed on to others publishing opportunities that were offered to him. His decisions were usually based on either inappropriate timing or because of a self-perceived conflict of interest, like the invitation to write the first monograph on the work of Albert Tucker. In late 1960, Bernard Smith, now with the Fine Arts department, University of Melbourne, had recently been appointed general editor of a proposed new series of books on contemporary Australian artists to be published by Georgian Press. He invited McCulloch to contribute a monograph on Tucker. In the lively exchange that followed, Smith wrestled with the reasons McCulloch gave to decline the offer—he cited a conflict of interest and furthermore advised Smith on the proper sequence of such a list of books.[17]

McCulloch was the logical person to provide the text. He had known Tucker since the 1940s and had written on his work previously. As part of McCulloch's research into the proposed book on Australian artists, Tucker had willingly responded to his request for photographs and biographical information in May 1954.[18] However, at this point, McCulloch felt that newspaper critics shouldn't write monographs on single artists as it could signal a sense of favouritism. Smith's long and articulate reply was that contrary to it being a conflict of interest, such projects provided critics beset by weekly deadlines and space restrictions with far more amenable conditions in which to write. McCulloch, he pointed out, had also misunderstood—it was not to be a piece of biography but rather one of extended critical writing.[19]

McCulloch recanted somewhat on his original position, since the following April 1961, Smith wrote to him to enquire about the state of play with introductory text for the Albert Tucker book. A Clifton Pugh manuscript had been completed, he advised, and 'Mr Harris of Georgian Press is anxious to publish two or three of the monographs this year—AT amongst them.'[20] A manuscript was duly prepared, sent to Smith the following year and returned with 'no substantial alteration'. Smith promised to press on without delay but ended with the rejoinder: 'How art critics must long for the coming of Xmas. O for the sweet peace of January! Down with Archibald!'[21]

McCulloch's book on Tucker did not reach fruition. Smith had written to Tucker privately to express his conviction that he did not think very highly of what McCulloch had written.[22] A revised version supplied by McCulloch in 1963 also sat dormant. It also did not measure up to the brief of providing the first extended critical writing on Tucker's work. By the time Elwyn Lynn wrote to McCulloch in April 1968 it was too late: 'Nelson's have asked me to scout about for possible authors for a new series of books on Australian Art and I recollect that you had begun a book on Albert Tucker for Georgian House.' McCulloch's reply was that he was simply 'too flat out with present commitments' and 'that I can't possibly undertake

anything more at the present time, or even in the foreseeable future'.[23] Christopher Uhl eventually wrote the book. He had written to McCulloch earlier that same year requesting help and advice on his preparation of a thesis on Tucker at the University of Melbourne. It was this research that ultimately led to the first monograph published on Albert Tucker's work, appearing finally in 1969.[24]

The Golden Age of Australian Painting

The Golden Age of Australian Painting: Impressionism and the Heidelberg School (1969) was Alan McCulloch's first monograph on Australian art and part of the resurgence of Australian art publishing during the 1960s. Georgian House and Grayflower Publications had initiated a new phase of Australian art publishing in the early years of the decade. Thames & Hudson had followed suit with commissioned monographs on Sidney Nolan, William Dobell and Russell Drysdale. In mid-1966, the publishing house announced that it was also producing a large monograph on Arthur Boyd, to be written by University of Melbourne academic Franz Philipp.

The Golden Age of Australian Painting was part of an ambitious series of new art scholarship commissioned by the Australian-based publisher Lansdowne, which it had similarly launched in the mid-1960s. Its aim was to lay claim to the mantle of premier publisher of quality Australian art books. McCulloch was initially approached by John Henshaw, the general editor of Lansdowne's Australian Art Library from 1966 to 1970. Henshaw was himself an artist and writer of note, having produced a book on Godfrey Miller (1965) and an earlier volume on Miller's drawings (1962). Miller wrote to McCulloch in February 1968: 'I am pleased to hear from you + your decision to do "Masterpieces".'[25]

By this time, based on previous discussions with Lansdowne, McCulloch had prepared a list of chapter headings and potential artists for inclusion in what would have been one of the first Australian monographs on the work of contemporary Australian

artists. Broadly grouped under titles such as 'Erotic symbolism and pop' (Whiteley), 'Texturology' (Lynn, Clark, Marmol) and 'Optical and Environmental' (Ostoja-Kotkowski, Bilu, Jacks, Jordan, Partos and Dawson),[26] the list would have refuted the perception of McCulloch as bound to the artists and styles of his own generation. However, he changed his mind and requested that he instead write a book on Australia's Impressionists, followed by one on the colonial artist ST Gill.

McCulloch indicated to Henshaw that he had already been approached by a London publisher to produce a book on the Heidelberg School. This factor aside, McCulloch's primary reason for making the change was that for him it made more sense to begin the series with Australian Impressionism, and it was not possible to do 'Masterpieces'—'the word "Masterpieces" sticks in my gizzard', he exclaimed—in the time allocated. Henshaw agreed to the change and McCulloch set about getting 'straight into the job', adding: 'I own a Russell watercolour of "Portofino" which is almost pure Monet which we could use.'[27]

Henshaw contended with the trials of getting good-quality photographs taken of key Australian Impressionist works over March and April 1968. He noted that the competition building between publishers and authors, especially in relation to ST Gill, was also consuming his thoughts. McCulloch busied himself with the writing, suggesting to Henshaw's approval that he could bring it up to date by covering '"Impressionistic" elements in Boyd, Miller and maybe even Passmore in his Cézanne period. I'm with Greenberg in discarding the theory that Impressionism was "formless" incidentally,' he wrote.[28]

With writing well underway, McCulloch was invited to the official launch of the new Australian Art Library series at the Melbourne Ritz, in June 1968. 'This $1,250,000 project', claimed Lloyd O'Neil, chairman of Lansdowne Press, 'will be both the largest venture in Australian book publishing and, we hope, a significant event in the cultural life of Australia.'[29] Lansdowne had moved quickly to

secure other writers. In addition to McCulloch, by July Henshaw noted that two promising young art historians from the University of Melbourne had also been contracted. Ann Galbally was working on Arthur Streeton and Virginia Spate on Tom Roberts.[30] Margaret Plant (nee Garlic) was also reworking her University of Melbourne thesis into the first monograph on painter John Perceval. Plant's book was published in 1971, Galbally's not until 1979, while Spate's book on Roberts was taken over by Georgian House and published in 1972.

Lansdowne's offer of $1500 plus a share of the royalties if sales exceeded 4000 copies was a fair price for the period.[31] In addition to the writer's fee, Lansdowne offered practical assistance with travel expenses, and administrative help sourcing images for the publication. McCulloch was in a much better position now to get greater reward for effort. He turned to a trusted ally, Ursula Hoff, for her comments and corrections on his first draft. McCulloch and Hoff had worked together many years previously, with Hoff since forging an impressive list of publications on Australian and international art.[32]

Possibly at the behest of professional colleagues, and encouraged by Ellen and Susan, McCulloch had engaged the services of a literary agent in mid-1970 to represent his interests.[33] Despite this groundwork, there was increasing concern over the quality of his planned publication as McCulloch grew more and more conscious of the need to ensure the quality of print production and to make sure his work didn't overlap with that of other books already in production.

Following the launch of *The Golden Age of Australian Painting* at the NGV on 14 November 1969, McCulloch wrote:

> Now that I have had time to study my book and have a cursory look at the others and think about them I am increasingly conscious of the faults in production ... [*Art International* editor James] Fitzsimmons is an expert, a specialist in colour reproduction and very much a perfectionist ... His practised eye would pick up all the faults at once.[34]

After the publication of James Gleeson's *Impressionist Painters 1881–1930* in 1971, also for Lansdowne, McCulloch was moved to comment

on the 'terrible brown-red that runs through both books like a dye [ruining] some of the plates—*Shearing the Rams* is a disaster—and gives the cases an unnecessarily cheap look'. In addition to this, he observed: 'My plates and the plates in Gleeson's book overlap quite badly: my wife counted 25 identical plates in the two books.'[35] These were both hard-won lessons that would inform the approach to his next two publications.

Misgivings aside, *The Golden Age of Australian Painting* was an ambitious undertaking and still stands as an important early survey of Australian Impressionism. Although not the first stand-alone publication, it was by far the most comprehensive to date. It took over from Bernard Smith's account in *Australian Painting* (1962) and a small monograph, *Australian Impressionists*, which had been produced by NGV Curator of Australian Art Brian Finemore, as part of an Art and Australia series in 1967. Ninety-four colour plates were included in the publication, many of them full-page inserts, along with thirty-eight supporting illustrations. The text consisted of a substantial lead essay, followed by chapter biographies on each of the ten artists whom McCulloch had singled out as the most important Australian Impressionists.

If the structure of the book was very McCulloch, the content showed a more mature writer with strongly articulated ideas. He continued to add to a greater understanding of each artist in the biographies, rearranging known facts of their lives with new information in an accessible and readerly way. The essay showcased his strengths as a writer and included finely tuned and evocative descriptions of some of the works. The general thesis positioned the work of Australian Impressionists in an intelligent and well-reasoned way. As McCulloch noted:

> Plein air Impressionism reached Australia long after it had been accepted by painters in France and England … [but it arrived] at a crucial moment in colonial aesthetic history, when the first stirrings of informed public interest were beginning to support new ideas about the indigenous life of the community and its environment.[36]

Its major failing—the scant attention paid to the contribution of women artists Jane Sutherland, Janet Price, Clara Southern and others, who received far too little recognition—would have to wait again until later.[37]

Artists of the Australian Gold Rush

Artists of the Australian Gold Rush (1977) was McCulloch's second and final book for Lansdowne. It began as a companion to a more thoroughgoing investigation into the life and art of colonial artist ST Gill, who had documented life on the Victorian goldfields in the 1850s. The publication of Keith McCrae Bowden's biography of Gill in 1971 may have, in part, put paid to that notion.[38] McCulloch, however, had a personal connection to the goldfields—his maternal grandfather was James Johnson McLeod of Glendale, Skye. 'He migrated to Victoria in c.1850 and settled at Beaufort, or rather at Main Lead, where the store built by him is still standing though spoiled somewhat, by a new façade'.[39] McCulloch was keen to explore this aspect at the same time as expand his professional connections with goldfields centres such as Ballarat, Bendigo and Castlemaine. According to McCulloch, it 'took about seven years to complete and my greatest reward so far is the Australian history I learned from the research.'[40]

Lansdowne's initial offer in early 1970 of $1000 for the script and $500 in expenses for a 40 000–70 000-word manuscript matched the offer for his first book, *Golden Age*—though did not include provision for royalties, which they reasoned was unviable due to the cost of securing and printing images.[41] In spite of this, it was not until early the following year, following the appointment of John Ross, formerly editor of *Walkabout* magazine, to publishing manager at Lansdowne that McCulloch confirmed an agreement to write the book. This was only after copyright ownership of the text (a relatively new concept in Australia) had been changed in his favour with Lansdowne retaining publication rights.[42]

During the early days of McCulloch's association with Lansdowne, he worked diligently to ensure the quality of the publication as well as maintaining his rights as author in these fledging years of Australian publishing. Writing to Ross in February 1972, he noted: '[Gil] Docking's book on New Zealand painting has set a standard which should be the minimum standard aimed for. I just can't afford to have my name on a book that doesn't aim at top quality production …[I would] (rather not do it.)'[43] McCulloch was also aware of changes to copyright laws in Australia, including the introduction of Public Lending Rights to authors, instigated by the Australian Society of Authors. He was not prepared to relinquish royalties on sales and sought legal advice to this effect from the firm Herbert, Turner & Davis, which examined his contract with Lansdowne, and later John A Guthrie, who scrutinised all aspects of his relationship with Lansdowne.[44]

Artists of the Australian Gold Rush was finally released in 1977. According to McCulloch, the first edition 'sold out very quickly', as did the deluxe leather-bound edition—its 100 copies each sold for the princely sum of $150. In what had been a hectic time for the author, coinciding with the launch of *Heroic Years of Australian Painting* at Bendigo Art Gallery, McCulloch noted the flow-on effect between sales of the reprinted *Encyclopedia of Australian Art* and the new book.[45] As in *The Golden Age of Australian Art*, biographical vignettes on each of the main players were inserted into chapters describing how the works of relative newcomers to Australian soil had managed to integrate its look and feel into their work.

The unofficial goldfields historian Frank Cusack wrote a glowing tribute, claiming it as a 'fine achievement' which 'bring[s] into focus a terrific amount of material that gives a new perspective to goldfield's art'.[46] Former Labor prime minister Gough Whitlam was also effusive in his praise. McCulloch had assisted Whitlam during his research to establish the politician's family connections to the goldfields. In 1977, Whitlam thanked McCulloch for a copy of the book and the

'generous inscription it contained' and congratulated him on his fine achievement:

> I remember unveiling the [Eureka] flag in December 1973, at a time when its social significance and contemporary symbolism were yet to manifest themselves as they have since done. It may well be that in years to come I will look back on that ceremony in Ballarat as the most important and prophetic event in my public career.[47]

Other writers were more critical. Brian Hoad, the ABC's *24 Hours* arts journalist, wrote a disparaging review that provoked McCulloch's indignation. He countered Hoad's criticism over the choice of Julian Ashton's image for the dust jacket by suggesting he send back his faulty copy for a replacement.[48]

Author and journalist Peter Quartermaine, writing in the *Times Literary Supplement*, was also negative in tone. McCulloch went on the counterattack, challenging Quartermaine's reading as 'patchy' and lacking in understanding 'of the subject, place, period and the author's intention'.[49] Despite these isolated criticisms, *Artists of the Australian Gold Rush* and its predecessor *The Golden Age of Australian Painting* added to a growing canon of specialist Australian art writing. Despite their limitations and McCulloch's overtly biographical style, they stand as important additions to the literature on Australian art and artists.

CHAPTER 10

HOME ON THE RANGE

ALAN McCULLOCH'S INTERESTS took him to far-flung places and introduced him to a wide and eclectic range of people. It is not surprising, therefore, that he and Ellen McCulloch engaged with state, national and international issues as well as with more local concerns. The McCullochs were fully aware of the destructive potential of modern warfare and the threat posed by nuclear proliferation. They supported free speech during the Cold War in the 1950s and early 1960s and vehemently resisted Australia's military involvement in Vietnam in the 1960s and early 1970s. Both were passionate about the environment but at the same time interested in how architecture and urban planning could advance the quality of people's lives. During a period in which Australia's Aboriginal and Torres Strait Islander peoples were not considered citizens and newly arriving Asians and Europeans were treated badly, McCulloch supported Aboriginal rights and the transition of Australia from an insular nation to one composed of more tolerant multicultural and multiracial communities.

Art in the wider arena

The catchphrase 'think global, act local' epitomised the McCullochs' approach to the natural and built environment long before it became popularised. This basic philosophy underpinned Alan and Ellen's

vocal opinions, which ranged from tackling local environmental issues through to opposition to uranium mining and nuclear power. Influenced by the European tradition of academics being relevant to both their peers and a wider public, McCulloch used his position to engage, critique and shape important aspects of Australian life. McCulloch's weekly newspaper column, frequent letters to the editor and radio and television engagements, as well as regular functions, lectures and meetings, meant that he was able to use a variety of forums to get his message across.

Following the move to Western Port in 1951, McCulloch took a keen interest in maintaining the integrity and amenity of the surrounding coastal environment. In 1959, he railed against calls for the subdivision of land stretching from the seaside village of Balnarring to the coastal town of Flinders. He spoke out against the newly arrived land speculators who had their eyes fixed on nearby Cape Schanck. According to McCulloch, this was the most fragile and least accommodating of all the coastal tracts of land to be found on the Mornington Peninsula. As he bluntly explained in a letter to the *Peninsula Post*, the proposed subdivisions 'offered not land at all but so many cubic yards of shifting sand fronting the most deceptive and dangerous beach in the whole of Victoria'.[1] Following twenty years of local environmental activism, McCulloch wrote an impassioned plea in 1979 to the convenor of 'Vegetation and Tree Areas' for the Mornington Peninsula Association to protest the bulldozing and burning of the last remaining vestiges of indigenous trees and shrubs that once proliferated on the south-west slope of Arthur's Seat. 'To see a "garden" of grass trees growing out of a floor of sand is to experience a marvellous moment of time that recalls primitive Australia before the white man came,' he wrote.[2]

Alongside these local issues, McCulloch was a signatory to anti-bomb petitions in the 1950s and part of a groundswell of popular opinion that rallied against nuclear weapons and the arms race. His public opposition to nuclear testing continued well into his later years. In a statement issued in response to French nuclear testing in

the Pacific Ocean during the early 1970s, McCulloch made known his views on the subject to friends and *Herald* readers.[3] A former *Argus* colleague, Greeba Hoskin (nee Jamison), wrote in response to McCulloch's *Herald* article 'A New Guernica in the Pacific':

> You have summed up what lies deep in the hearts and minds of so many people who once loved France and all it stood for aesthetically; those who love the Pacific Islands and the artists who found their dayspring there; and those who love Picasso and the Spain that produced him! I hope your piece will be distributed through the agencies all over the world. It speaks, I think, far more potently than dry evidence before the International Court of Justice.[4]

McCulloch and his family also protested vehemently against Australia's involvement in the Vietnam War, until the final withdrawal of Australian troops in June 1973. In 1968, McCulloch's old American friend Bill Winter wrote to update him on his new job as news director at a public radio station. Winter's passionate diatribe against US involvement in the Vietnam War inculcated McCulloch's own views, which were heated and equally passionate: 'I'm extremely glad you are with us, against this obscene war', he observed approvingly.[5] 'The Vietnam war', McCulloch wrote to another international friend and colleague, 'is becoming more and more a burning issue here; it seems likely to split the country.'[6] Opposition to Australia's role in that conflict and the Cold War ran deep in the family.[7] Susan McCulloch discontinued her music studies at the Conservatorium of Music, University of Melbourne to work in the anti-war movement. According to Alan, planning for Susan's wedding at Shoreham in 1972 was overshadowed by her involvement as an organiser with the Congress for International Co-operation and Disarmament (1969–72) and anti-Vietnam protests, 'including a stint [spent] in gaol on [her] 23rd birthday'.[8]

Freedom of speech was a separate though still related issue that motivated McCulloch and that both he and Ellen passed down to Susan. He was vitriolic when it came to attempts to shackle the free speech or cut the budget of the Australian Broadcasting Commission.

As the one media outlet with a brief to maintain independent reportage and analysis, he challenged potential incursions into its independence and resourcing. In an open letter to Prime Minister John Gorton, written in June 1970, McCulloch maintained the need for 'total autonomy for the ABC'. This, he argued, was 'crucial to the interests of continued democratic government in Australia'. Leader of the Opposition the Hon. Gough Whitlam followed up with a quick reply to McCulloch, expressing his support for the latter's strong stand.[9]

McCulloch publicly supported the ABC by participating in programs on talkback radio and writing letters to management. In a letter to the ABC's general manager in 1977, he criticised the decision to remove broadcaster Terry Lane's talkback radio program on the grounds that it provided 'the expression of widely differing points of view'.[10] This was followed by a more personal letter to the now ex-prime minister Whitlam, on what he presumed to be the 'gagging' of the outspoken broadcaster.[11] Having experienced the vitriol of the editor's pen and seen the gradual erosion of civil liberties in Australia and overseas, McCulloch was quick to challenge any institution or individuals who denied the right to free speech, and pressed for the need for strong and divergent views to be openly expressed.

Government support for the arts

Despite his political pronouncements and allegiances, McCulloch maintained cordial relationships with politicians on both sides of parliament. These connections allowed him unparalleled access to those who could provide support for important art projects. Although his own politics was more in tune with the left, the reality was that for much of his professional life conservative Liberal parties were in office at state and federal levels. McCulloch cultivated long-term friendships and professional relationships with politicians of all persuasions, including prime ministers and their respective departments. These relationships were to serve him well. The positive role government could play in the arts and the need for arts professionals

to guide government decision-making was an important belief that motivated these connections.

The Hon. Rupert Hamer served as the thirty-ninth premier of Victoria from 1972 to 1981 and was a blue-blood Liberal. For many years he also resided at Mt Eliza on the Mornington Peninsula, not far from where McCulloch lived and close to the Mornington Peninsula Arts Centre, which was set up during the same period. McCulloch wrote to Hamer in April 1973, in his capacity as premier and minister for the arts, with a submission on the forthcoming appointment of the director for the newly formed Ministry for the Arts. This was such an important position that McCulloch felt it required five or six specialised appointees, plus a chairman and secretary. He reasoned that the role was too big for one person.[12]

McCulloch also developed some intriguing friendships and relationships at a federal level, including with Whitlam. Their relationship stemmed initially from their joint research into family connections with the Victorian goldfields. It blossomed into support for each other during times of crisis. McCulloch wrote to express his support for the former prime minister in the wake of the 1974 dissolution, his subsequent sacking and his tenuous fight for power in the 1975 election: 'I'm delighted to see that the artists are with you. So are the art critics (see attached). So we should be of course. We're a pretty small group but we're vocal. And I'd like to think that every little bit counts.'[13] On the day after the ALP 1977 election loss and Whitlam's final removal from office, McCulloch wrote equally prophetically, mourning the politician's demise and celebrating his dignity in defeat, signing his letter: 'In the electorate of Phillip Lynch, God help him 11 December 1977.'[14]

Australian Council for the Arts

The paucity of government-backed travelling art scholarships had long been a source of frustration for McCulloch and his contemporaries. Added to this was a perceived lack of a coordinated approach

to arts policy and funding across state and federal governments. In the 1950s, public discussion turned to how the arts could best progress and how this might involve government support and programs. In 1959, McCulloch was invited to put forward his ideas on these issues. Along with other prominent Australians, including Len Crawford, Andrew Fabinyi and Eric Westbrook, and with architect Robin Boyd as the primary signatory, McCulloch prepared and sent a statement to the Australia Arts Inquiry.[15] This preliminary incursion into federal government support for the arts was a precursor to the formation of the Australia Council for the Arts in 1975 and later the Visual Arts Board. McCulloch played a small though significant advisory role in the formation of both agencies.

In August 1966, McCulloch had written to the Australian prime minister, Harold Holt, advocating for a '*national* policy for the arts fully capable of correlating activities in the various art fields in Australia, and of projecting an Australian "culture image" overseas'.[16] This was followed by an article in *Meanjin* and a subsequent letter nearly twelve months later in which he reiterated the same points. In McCulloch's view, and that of his colleagues, 'a comprehensive National arts body is now a vital necessity'.[17] McCulloch used the opportunity to raise the issue at state level as well. He requested through the powerful JV Dillon, Under Secretary, Chief Secretariat Office, Victorian Treasury, that there be one statutory body 'empowered to deal with matters affecting various art developments within each state'. Dillon responded positively by saying that 'consideration would be given to such a State Arts Body'.[18]

The Australian Council for the Arts was established in 1968 as the primary arts organisation to administer federal arts funds and programs. A pool of $1.66 million in 1968 increased significantly to $4.5 million in 1971. The establishment of Visual Arts Board direct assistance grants was a much-needed instrument to support artists with travel and related projects, as was the Australian contemporary art acquisition program that subsidised the purchase of contemporary art by regional and state galleries.[19]

McCulloch used both grant programs to his advantage, such as successfully advocating for important acquisitions for the fledgling Mornington Peninsula Arts Centre (later Mornington Peninsula Regional Gallery) and offering his support to artists. He was frequently called upon to act as referee or to write on behalf of a diverse range of artists in their Australian Council grant submissions. These included Judith Alexandrovics, Kevin Mortensen, Daniel Moynihan, Frank Hodgkinson, David Fitts, Petr Herel, Andrew Sibley and Ken Whisson.[20]

Proving once again that he was willing to set aside personal preferences in the service of art and artists, McCulloch wrote about the sculptor Kevin Mortensen:

> Mr Mortensen's avant-garde sculpture is often contrary to what I have always believed sculpture to be, but in it there is a demonstrable command of modern techniques and plenty of evidence to show that he is an artist of considerable talent and promise ... In view of his attitude and versatile gifts it gives me great pleasure to warmly endorse his application for a grant.[21]

This was in sharp contradistinction to his response to a request that the one-time engineer and now full-time artist Edwin Tanner be considered for a government grant. McCulloch penned in the margins of one letter: 'Tanner obviously suffering persecution mania and some of his statements (i.e. about his dealer) are libellous.'[22]

McCulloch continued to offer advice on the increasing role of the Australian Council for the Arts once it was established. In a letter to artist and associate Clifton Pugh, who was serving on the board, McCulloch commented: 'I promised to let you have my views on possible projects that might be undertaken by the Council for the Arts at national level so here goes.' These included the establishment of national art centres, Australian embassies, an international sculpture exhibition and a festival of the arts for Canberra.[23]

Yet McCulloch was inherently aware of the danger of having too much government funding available as well. Reflecting on his upbringing and training during the Depression years, he believed that

it was possible to have too much access to government funds. In June 1973, he wrote to *Art International* editor James Fitzsimmons, explaining: 'There has been a revolution in official art affairs here with the new Whitlam Government and government support for the arts has vastly increased at both Commonwealth and state levels. Very interesting. I only hope we get good people in the administrative posts.' This was followed by a letter one month later in which he stated: 'Point is the Australian Government has suddenly jumped from the bottom to the top of the official art sponsors. What people like me are scared of is that they might suffer from excessive enthusiasm and go too far! How's that for a reversal of form?'[24] Fitzsimmons' response was measured. He simply requested McCulloch to go ahead and research an article on government patronage, agreeing that 'excessive enthusiasm' can have a damaging effect and that government program administrators should be 'critical and demanding'.[25]

Central to McCulloch's lobbying of government was soliciting support for regional art galleries and arts programs. In 1980, he wrote to the Hon. Bill Hayden, leader of the Labor Party Opposition, to recommend a policy of support for regional art development in regard to an upcoming federal election.[26] Susan Ryan (shadow minister for the arts) subsequently invited McCulloch to comment on her recently released paper on the arts and flagged her support for regional arts development and how it could be encouraged. McCulloch took a while to respond to Ryan but when he did was characteristically full of barbs, such as details about the effectiveness of the Australian Council and Commonwealth Art Advisory Board schemes to support artists and regional galleries: 'Aboriginal Arts. A tragic and difficult area. Nobody really knows what to do with it and already it's been mercilessly exploited—often inadvertently.'[27]

McCulloch also kept to his promise of 'writing any views I might have that may be useful in formulating ALP policy for the Arts', stating time and time again that he supported a 'decentralised art movement similar to that of [François] Mitterrand Government's policy of cultural decentralisation of Paris'.[28] By 1979, his concerns

about over-patronage and the centralisation of tastemaking organisations led to a shift in his thinking. He now began to argue that incumbent funding mechanisms needed to be redressed. 'I am a bit concerned over the growth of the bureaucracies—Visual Arts Board and AGDC (Australian Gallery Directors Council),' he wrote.

> We're all members of the latter and in two weeks' time 53 Aust. Gallery directors, including all Regional Gallery directors such as me, will assemble in Sydney at the AGNSW for the first ever full annual meeting. The AGDC has taken over from the Australian Arts Foundation, is substantially funded and has its executive office in Sydney … Why am I worried? Well these two bodies seem to me to have assumed the role of tastemakers. Anyway I'm making a speech about it at the Sydney meeting—hoping not to get thrown out for my pains.'[29]

In 1981 the AGDC was dissolved.

Shaping Melbourne's civic spine

Architecture and in particular the (re)shaping of his beloved hometown of Melbourne through support for new public spaces and/or the reinvigoration of old ones was an important focus for Alan McCulloch. It also brought him directly into the ambit of government and other leading bureaucrats. During the 1960s and 1970s, he played an important subsidiary role in publicising the development of Melbourne and the formation of a new, modern identity for the nineteenth-century goldrush-built city. Once again this engagement was driven by a healthy respect for the past, as well as an understanding of and engagement with the demands of new needs and changing circumstances. McCulloch's ability to communicate effectively with government and leading officials was to prove effective in this regard.

On one level this was because McCulloch was often the first called upon to recommend artists, sculptors and architects for public commissions. Importantly, his suggestions and recommendations were frequently adopted, as was his suggestion to use Leonard French

to decorate the Melbourne University Physical Education Centre in 1955. RA Eggleston from the firm Eggleston, Macdonald and Secomb wrote to McCulloch informing him: 'I thought that you would be interested to know that we have asked Leonard French to submit a sketch for the Beaurepaire Building—He is also working on the glass ceramic panels on the exterior of the building.'[30] This was followed by a letter in 1957 in which a Rod Macdonald updated McCulloch on the intended opening of the building and his desire for McCulloch to write about the mural.[31]

McCulloch also took on the role of supporting artists and architects to achieve their respective plans and vision for Melbourne. Often this meant advocating on behalf of others so that they would be duly compensated for their work. Maurice A Nathan responded to a McCulloch letter of 14 November 1956 that sought extra funding for 'Arthur Boyd's symbolic work outside the Olympic Pool'. 'What would you expect the Olympic Park Board of Management to do in this matter?' Nathan replied.[32] McCulloch castigated himself when he felt that he should have spoken out on behalf of Arthur's cousin, the architect Robin Boyd, and his landmark post–World War II work on small homes that McCulloch felt had received insufficient support among some of his contemporaries.

McCulloch's attempts to save heritage buildings and precincts are also clear from his involvement in the campaign to protect the Capitol Theatre (1924). Located in the Melbourne CBD, this landmark example of American architects Walter Burley Griffin and Marion Mahony's organic and crystalline formed interiors had fallen into neglect and disrepair. Academic Harold Spencer wrote to McCulloch from the Australian National University advising him of his impending visit and of his attempts to save it, including letters to the *Age* and *Australian*.[33] Similarly, McCulloch's successful advocacy for the relocation of the nineteenth-century Burke and Wills commemorative sculpture from an out-of-the-way location to Melbourne's newly designed city square in the early 1970s exemplified his desire to accommodate old and new. McCulloch's love of European cities and

the way they were formed and maintained ensured that he would not favour one at the expense of the other.

The NGV and cultural centre

Melbourne's CBD area was one of its most contested sites during the 1960s. Civic leaders looked for ways to bring the city up to date and make their mark. The building of a separate arts centre, including a new purpose-built home for the National Gallery of Victoria and its relocation to a more suitable site, was an issue that galvanised supporters and critics. One of the primary movers behind the drive to establish a purpose-built state gallery and arts complex was Keith Murdoch. The respected owner and chief editor of the *Herald* and trustee of the gallery, Murdoch pushed to reserve the Wirth's Park area just south of the Yarra River at the entrance to the city as a site for a new national gallery and cultural centre. Legislation was passed in 1946 for this purpose, though Murdoch would not live to see the work begin.

As reported in the *Herald* in 1950, the Victorian premier, John McDonald, was to lead a delegation representing the gallery who 'are interested in the erection of the National Gallery on the site over Princes Bridge, now occupied by Wirth's Circus'. However, with a budget deficit, it was reported that practical politics would have to take precedence.[34] In his capacity as the newly appointed art critic for the *Herald*, McCulloch was drawn into the ensuing debate. At a meeting convened at the *Herald* offices in April 1955, he proposed to the editor, Sir Jack Williams, that the best way forward was to draw together a suitably representative planning group and convince the state government that 'it is a matter of National importance (as it certainly is) in which they are privileged to participate'.[35]

Later, following an invitation from the premier in early 1961, McCulloch joined the general committee for the National Art Gallery and Cultural Centre Appeal and agreed to act as a speaker at planned functions.[36] To coincide with the display of architect Roy Grounds'

29. Joy Hester, *Lovers [II]* 1956
ink and wash
National Gallery of Australia, Canberra

30. Elwyn Lynn, *Betrayal* 1957
oil on composition board
National Gallery of Victoria, Melbourne

The rough, pitted surfaces and expressionist forms alluded to by Tucker in his letters to Alan McCulloch have a visual counterpart in the 'Antipodean Head' series dating from 1957. The aptly titled *Lunar landscape* was the first major work by Tucker to be acquired by a public art museum. It represents the crystallisation of Tucker's ideas about what it meant to be an Australian, living and working from afar.

31. Albert Tucker, *Lunar landscape* 1958
synthetic polymer paint on composition board
Museum of Modern Art, New York

Alan McCulloch was a driving force behind the *Herald* Outdoor Art Show that was based on Paris's Left Bank and New York's open air art exhibitions. McCulloch enterprisingly invited numerous young and mid-career professional artists to exhibit. Over 200,000 people attended the first exhibition in 1954.

32. Mirka Mora, *Self-portraits* (also known as *People*) 1960
enamel and oil on composition board
Private collection

33. Mirka Mora and Maurice Chevalier at the *Herald* Outdoor Art Show, 1960
William Mora Galleries, Melbourne

34. Henry Moore, *Draped seated woman* 1958
bronze
National Gallery of Victoria, Melbourne

35. Godfrey Miller, *Nude and the moon* 1954–59
oil, pen and black ink on canvas
Art Gallery of New South Wales, Sydney

36. Gareth Sansom, *He sees himself* 1964
oil and enamel paint, pencil, crayon, polyvinyl acetate
chalk and gelatin silver photograph on composition board
National Gallery of Victoria, Melbourne

37. Richard Larter, *First Hand Panorama Way* 1970
oil on board
Art Gallery of Ballarat, Victoria

38. Richard Larter, letter to Alan McCulloch, 1967
McCulloch Manuscripts, State Library Victoria

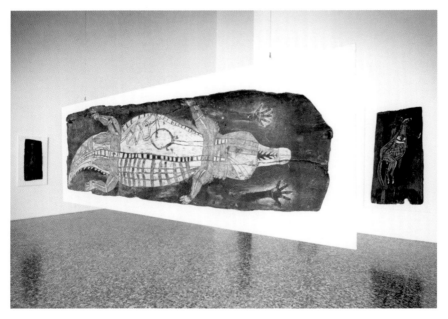

Showing an ochre painting by Mr Majumbu, *Arnhem Land of Kinga* c. 1912

39. Aboriginal bark paintings from the Cahill and Chaseling Collection,
National Museum of Victoria, Australia
17 December 1965 – 30 January 1966,
Museum of Fine Arts, Houston
Photographs by Hickey & Robertson

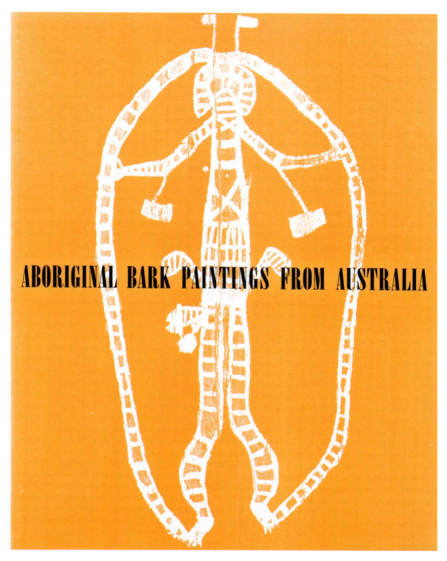

'Your catalogue is a first-rate job—and I mean that.'
Clement Greenberg to Alan McCulloch, 13 July 1968

40. Catalogue cover, Aboriginal Bark Paintings from Australia
Cahill and Chaseling collection, 1965

Alan McCulloch was one of the first critics to recognise the importance of the modern sculptors who were to make-up Centre Five. In 1969 Allan and Ellen McCulloch travelled to Canberra with Norma Redpath to witness the unveiling of two large sculptures that she had been commissioned to produce for the National Capital Development Commission.

41. Treasury Fountain installation 1965–69
State Library Victoria, Melbourne

42. Norma Redpath, *Treasury Fountain*,
Parkes ACT Canberra 1965–69
National Capital Authority, Canberra

In the 1970s and 1980s Alan McCulloch was a passionate contributor to the shaping of Melbourne's spine including the development of the Arts Centre, the City Square and the Capitol Cinema in Swanston Street.

43. Ron Robertson-Swann, *Vault* 1980
steel, paint
Commissioned by the City of Melbourne

44. Ron Robertson-Swann, *Sydney Summer* 1969
acrylic on canvas
Transfield Collection, Sydney

45. Donald Laycock, *Wings* 1971
oil on canvas
Private collection, courtesy of Charles Nodrum Gallery, Melbourne

Winner of the 1972 Alice Art Prize, judged by Alan McCulloch.

46. Sandra Leveson, *Series D –2D Optics* 1972
oil on canvas
Araluen Art Collection, Alice Springs

47. Fred Williams, *Upwey Landscape* 1965–66
etching and aquatint
Mornington Peninsula Regional Gallery, Victoria

48. Jenny Watson, *Portrait for Nick* 1977
gouache and coloured pencils on paper
Mornington Peninsula Regional Gallery, Victoria

49. Jan Senbergs, *Port Liardet* 1982
pastel and acrylic on paper
Gippsland Art Gallery, Sale

Chilean-born Australian artist Juan Davila presented *Bretonism* to Mornington Peninsula Regional Gallery in 1997. The gift was to show his gratitude twenty years after Alan McCulloch had written on his behalf to the Australian Immigration Department seeking permanent residency for Davila.

50. Juan Davila, *Bretonism* 1989
colour screenprint
Mornington Peninsula Regional Gallery, Victoria

Alan McCulloch travelled to Arthur and Yvonne Boyd's Shoalhaven property, 'Bundanon', in NSW, to spend time with Arthur and paint together one last time, in 1988.

Thanks to Arthur and Yvonne Boyd's generosity, McCulloch returned with two major paintings from Boyd's Mornington Peninsula years, the complete set of *Lysistrata* etchings and a host of other drawings for the Mornington Peninsula Regional Gallery collection.

51. Arthur Boyd, *Shoalhaven* n.d.
oil on board
Private collection

plans, including Michael Shannon's cause célèbre painting of the Arts Centre towers, McCulloch reported on the originality of the design, which he argued 'brings to Melbourne a vibrant note of much needed character'. The copper sphere was characterised as 'a graceful addition to the city skyline' while its functionality and use of bluestone walls were 'in complete harmony with its garden setting'.[37]

While McCulloch lobbied for Grounds' state gallery design, some details—including Grounds' plan to introduce a five-foot (1.5-metre) gap between the floor and some walls to assist in the lighting and security of works—drew his indignation. In recognising the divisive cracks that it was causing among detractors, McCulloch took his concerns directly to NGV director Eric Westbrook, who was overseeing the project: 'There is already, in those drawings of the courtyards, the slight feeling of a prison yard ... Point is that psychologically The Gap could turn your beautiful galleries into dunjons [sic].' Westbrook was anything but amenable in his reply: 'As an Art Gallery man first and foremost I will make the arguments as I think fit, and this I assure you will not be done lightly.'[38]

Despite such protestations, McCulloch's concerns had the desired effect. By June 1961, Professor Bernard Smith, who was also on the committee, passed on a letter he had received from the CEO of the building committee, JD Rogers. It stated: 'It is quite clear that Mr Grounds has now abandoned the "five-foot gap" and the "ten-foot ceiling" in his revised plan for the interior of the Gallery.' In response to an invitation to go to Grounds' home and discuss things further, McCulloch's handwritten response on Smith's letter stated that he had seen the advanced drawings and was 'now satisfied ... in the gap and the ceiling height'.[39]

Though seemingly only a small detail, the debates on the spatial dynamics of the NGV and the choice of artists to embellish its interiors were considered important enough for McCulloch to raise it in a cross-section of public forums. This included the national art journal *Art and Australia*. Its editor, Mervyn Horton, wrote to McCulloch in 1968 and thanked him for his two articles, 'especially

[the] one on the [Leonard French] ceiling': 'As people become more used to the grandness of the idea of the centre (and its being finished—stage 1 anyhow) so they are starting to speak of it more critically and your piece about the ceiling should stimulate interest at the same time [as] providing valuable information.'[40]

The City Square

Equally as significant for McCulloch and his contemporaries was what they perceived as Melbourne's lack of a symbolic heart— a suitably placed and well-appointed civic square. The aim to create a public place where people could gather, socialise and identify as Melbourne's centre was something that McCulloch felt very strongly about. Again, groundwork had been made in this regard before he became involved. Towards the end of the 1950s, a position for the city square was identified between St Paul's Cathedral and the Town Hall in Swanston Street. In 1961, a proposal was put forward by Councillor Sir Bernard Evans for a paved square fronted by six colonnaded buildings running along the eastern edge.[41] During this time, Melbourne City Council progressively bought back properties but, as described in a history of the project, 'it wasn't until the buildings on this site were demolished from 1966 onwards that plans could begin to make the square a reality. In early 1972 the council established the Civic Square Project (Special) Committee and then, at the end of 1975, organised a nation-wide competition for the design.'[42]

McCulloch took a leading role in the square's development, with his involvement spanning the next decade. Following Melbourne City Council's purchase of land situated between the Town Hall and St Paul's Cathedral, McCulloch led his *Herald* column in February 1967 with a congratulatory plea for an 'enterprising and imaginative plan' to match that united both landmark buildings.[43] The *Age* newspaper became involved in 1969, under the auspices of Peter McIntyre, the noted Melbourne architect and president of the Victorian chapter of the RAIA. They oversaw a competition 'to produce ideas and

rouse public interest in the possibilities of Melbourne's proposed new civic square'.[44] Twelve designs were put on public display, with one singled out as a firm favourite. According to the organisers: 'It features a vibrant, living square centred on a high canopy mounted on four pillars, which would allow sunlight to filter through and keep off the rain.'[45]

Perceiving basic flaws in each of the designs, McCulloch commented on them in private to *Herald* management. The most obvious problem, as he saw it, was that the proposed plan had overcomplicated a simple need. He considered the addition of the proposed roof too gimmicky and believed it would be susceptible to Melbourne's increasing smog. He was unable to make his case publicly—*Herald* editor Stuart Brown stopped him short by couching his decision in terms of newspaper rivalry: 'We feel it is more dignified for us to stay aloof and say nothing.'[46] McCulloch turned instead to Melbourne's town clerk, arguing for four main requirements: the incorporation of the largest possible amount of flat, open space to allow the city to 'breathe'; the alignment of levels with the street to allow for future development; a building that stylistically linked the Town Hall and St Paul's; and plenty of facilities for restaurants and boulevard cafes along the east side.[47]

McCulloch's vision echoed his love of Parisian street culture but also gave credence to Melbourne's social requirements and history. In a separate but related document he advocated the relocation of Charles Summers' historically important Burke and Wills statue (the first bronze cast in Victoria) from what he believed was its current compromised location, outside the Princess Theatre, to the more prominent western side of the square. At the same time, he called for the relocation of the Matthew Flinders statue from its location at St Paul's to the western side of the proposed square as well, and the placement of the two fountains in the centre.[48]

While it is difficult to quantify how many of McCulloch's ideas were directly taken on board and to what extent, those that he did entertain and propagate were in accord with many other leading

critics, architects and politicians of the day. Close to a decade of indecision and inactivity finally ended in May 1976 with the appointment of the emerging Melbourne architectural firm Denton, Corker, Kelly, Marshall (DCKM) to design the square. Their winning submission featured a centrally placed 'major sculpture'—a Caro-esque steel construction that would be designed and placed to act as a focal point and soften the bluestone walls and paving. This ushered in a whole new set of issues and concerns.

Initially, DCKM sought advice on the choice of a sculptor from Eric Westbrook. He responded with a list of potential artists that included the name of the eventual winner, Ron Robertson-Swann. In May 1977, the architects, having decided upon an Australian artist 'representative of the 1970s', approached art critics Alan McCulloch and Jeffrey Makin, along with National Gallery of Australia director James Mollison, for further advice. Both Makin and McCulloch included Robertson-Swann on their lists of 'more avant-garde, younger artists'. McCulloch used the opportunity to again recommend that Summers' Burke and Wills statue (then in Carlton) be moved there as well: 'Placed in the square it would unify St Paul's and the Town Hall buildings and give the entire area a badly needed character and a sense of history,' he stated.[49] Despite opposition to the idea in some quarters, and later criticism that its inclusion represented a draw between the 'moderns' and the 'conservatives', the relocation was eventually carried out in 1979.[50]

The polarised and in turn vitriolic debate that beset the selection of Robertson-Swann's *Vault*—a yellow-painted fabricated steel construction—and its ultimate removal to another part of the city is now part of Melbourne's folklore. Early critiques questioned the potential of the sculpture to meaningfully function within a community space.[51] However, following the public announcement (kept back until Melbourne City Council's December meeting of 1978), a wave of dissent took place within the council, in the art world and in the public domain. Unusually, Melbourne's press agreed with Patrick McCaughey (a selector) from the *Age*, Jeffrey Makin

of the *Sun* and McCulloch in his *Herald* articles. Some journalists favoured the synchronicity of the clean lines and unencumbered planes of the sculpture and the surrounding buildings and its vibrant colour, which 'illuminates and warms the heart of the Square' at night. However, for McCulloch, in an abridged and embarrassingly titled *Herald* article, this was also a sign of the weakness of the final square design. For *Vault* to be fully appreciated, all the competing levels, hard corner seating and edges and copious bluestone paving and blocks had to be eliminated from view.[52]

Ultimately, Robertson-Swann's work was removed to Melbourne's Batman Park and following that the forecourt of the Australian Centre for Contemporary Art in South Melbourne. Its commissioning and placement underpin a dramatic polarisation in Melbourne life in the 1970s, where lines were drawn between formalist sculpture and public art and amenity.

An international sculpture exhibition for Canberra

Throughout the 1960s and 1970s, McCulloch increasingly imagined the interaction of art and the public domain on a larger scale. In mid-1969, he and Ellen visited Canberra, along with their friend, Melbourne sculptor Norma Redpath. The purpose was to see Redpath's 'magnificent' bronze fountain, which had been recently installed at the front of the new Treasury Building. Inspired by Canberra's natural surrounds and news of the soon-to-be-opened Hakone Open-Air Museum in Japan that he had written about in the *Herald*, McCulloch ruminated upon Canberra's natural proclivity for public art. He seized the opportunity to propose and develop an international sculpture exhibition for the ACT.[53]

Under the direction of architect Sir John Overall, who had taken up the role of commissioner of the National Capital Development Commission (NCDC) in 1958,[54] Canberra had undergone a program of unprecedented growth and change. Returning to the spirit of Walter Burley Griffin's original designs, the central lake plan

was completed and filled in during 1963–64, large areas of public space were created, and the city's Y-plan of decentralised centres was designed and gradually implemented to accommodate the growing numbers of relocated public servants and their families in self-contained, semi-bushland settings.

McCulloch wrote to Overall in June 1969, suggesting Canberra as a site for a major international sculpture exhibition comparable with that of Hakone—'the first of its kind in this part of the southern hemisphere', which would bring 'international prestige of a kind unlikely to be gained by any other means'.[55] Following an 'all-too-brief' visit to Canberra as a guest of the NCDC in September 1969, McCulloch indicated that the best way to get 'effective action' was to write directly to the prime minister and 'to all heads of relevant Depts'.[56] Overall lent enthusiastic support, suggesting that McCulloch make contact with Sir James Plimsoll, Head of External Affairs;[57] McCulloch met to discuss the idea with Plimsoll while he was in Canberra in early October. He followed the meeting with a letter to the newly elected prime minister, John Gorton.

McCulloch's plan was grand. It was for an 'International Competitive Festival for Sculpture and Drawing' spread across Canberra and planned to coincide with the opening of the proposed National Gallery of Australia in 1972. To 'attract the world's best in monumental sculpture', the prize money was to be 'not less than $15,000 with around 30 leading artists and up to $2,000 for drawing'. JJ Sweeney, whose name had been linked with the inaugural directorship of the NGA, was put forward as a possible judge.[58] The scale and complexity of what McCulloch proposed was enormous but commensurate with trends in the international arena (Hakone had forty-eight artists and offered $12 650 as a first prize). Importantly, it also represented for McCulloch a way of aligning Australia's interests with Asia and the rest of the world. Prime Minister Gorton responded enthusiastically: 'This is a very interesting suggestion and I shall arrange for it to be examined.'[59]

Less ambitiously than he would have liked but of import nonetheless, McCulloch was commissioned in 1969 to write an updated version of the NCDC guide to public sculptures. Following on from these tentative beginnings, in 1971 he was invited to become an advisor on the acquisition of sculptures and other art forms to be placed in schools in Canberra for a 12-month period. Initial suggestions for a water dial sculpture by Keith Davidson and kinetic reliefs by Robert Owen did not get the enthusiastic support he had hoped for—school authorities and public officers preferred static works of art—but the committee was increasingly appreciative of his efforts:

> Clifford Last's carving *Monument to a fading love* was purchased for placement in a high school library, and approval is expected to be obtained shortly for a sculpture by David Wilson. Your suggestion about primitive art works have met with an enthusiastic response, and arrangements are in hand for the purchase of a New Hebridean carved tom-tom and for the commissioning of a traditional Maori carving. Enquiries are still being pursued about an Aboriginal artwork.[60]

By the time McCulloch's short tenure with the NCDC came to an end in mid-1973, his input had been collectively felt: 'The considerable number of acquisitions that have been made, or that are in the process of being made, as a consequence of your suggestions, is itself eloquent evidence of the value placed by the Commission on your advice.'[61] It also dovetailed with McCulloch's interest in the role of public sculpture in regional centres and his involvement with places such as Mildura.

The era of the art prize

The 1960s and 1970s were the heyday of art prizes and the development of corporate art collections and exhibition sponsorship in Australia. Prestigious and lucrative art prizes emerged where before only a handful had existed. With these corporate art prizes came

the need for greater openness, more rigorous decision-making and a pool of eager arts professionals willing to act as advisors, judges and opening speakers.

McCulloch, along with other members of the International Association of Art Critics, was uniquely placed to fulfil this role. He judged most of the major art prizes in Australia and was frequently called upon to speak and debate the inevitable controversy that surrounded the selection of a winner or an acquired work. A dearth of suitable candidates was felt more acutely in regional centres. This was damningly outlined by artist Kathleen O'Connor in a letter to McCulloch in which she expressed her pleasure at the availability of a 'well-known critic coming over to Perth to judge the Perth Prize Competition'. 'The ones they elect here', she claimed, 'are inclined to be sentimental and believe that the Prizes should be given to an artist who needs the money for one reason or another.'[62]

Along with the award selection and prizes, McCulloch was called upon to offer advice on the potential inclusion of artists in corporate collections, especially those with an international background. In March 1961, for example, he was requested to give advice on adding to the Atlantic Art Collection (the Atlantic Union Oil Company incorporates Esso) by identifying leading artists in Victoria, especially 'younger artists worth watching'.[63] The demand for this sort of advisory role increased over the 1970s and 1980s until it became commonplace in Australian art circles.

The Georges Art Prize

The Georges Invitation Art Prize was established under the auspices of the prestigious Melbourne retailer of the same name in 1963. It became a significant part of Melbourne's cultural life and continued for twenty years, until the mid-1980s.[64] The art prize was organised and judged by McCulloch for most of this time, with his legacy being that many of the award-winning artists entered the collections of Victorian regional galleries.

McCulloch later contended that the Georges Art Prize had been convened 'to overcorrect the big national prizes which were judged by (mostly Sydney) State Gallery Directors'. He claimed, 'One director gave no fewer than seventeen prizes to the same artist'.[65] The Georges Art Prize was also an important part of the fabric of Victorian cultural life. Even towards its end, McCulloch proclaimed it a key contributor to the Melbourne arts scene. The prize, he stated, 'remains an outstanding survivor of the period, now identified as "the era of great national art prizes" when these prizes represented a "vital source of patronage", since taken over by state and federal governments'.[66]

The format of the Georges prize underwent a full gamut of changes and permutations in its lifetime. Its origins, however, can be traced to a 1962 request in which McCulloch was asked for his opinion on the viability of establishing an annual art competition on its vacant third floor and to advise on a suitable framework. McCulloch embraced the idea, stating: 'There is certainly a specific field which could benefit greatly from a competition instituted by Georges.' He proposed the idea of a portraiture exhibition to fill the gap left by the *Women's Weekly* portrait prize, with the winning pictures being offered as donations to the collections of new art galleries.[67]

McCulloch's idea was taken up for the inaugural prize exhibition in 1962, as was his suggestion that the newly formed AICA would select the artist and provide judges.[68] Georges management's concerns that portraiture might prove a little too narrow and 'discourage ... some of Australia leading artists from entering' was met with a convincing counterargument from McCulloch, who reasoned that 'one of the objectives was to encourage artists who would not otherwise paint portraits to experiment a little by entering the competition and elevating the standards of portraiture'.[69]

The format decided in March 1963 was for a joint Georges/AICA prize comprising 1000 guineas. It was hoped that the creation of a well-endowed and well-supported exhibition would hopefully one day rival Sydney's annual Archibald Prize. The first year was designated for figurative painting, followed by portrait and then

non-figurative art in subsequent years. Five judges would be drawn from AICA members. In 1964 the submission process was changed to include open entry, while in 1965 judging was undertaken by three AICA members and two previous winning artists with McCulloch as chairman.

Following the model of the *Herald Outdoor Art Show*, artists were for the most part pleased to be invited to take part as it gave them much-needed exposure and the chance to earn additional income from sales and, if they were lucky enough, award money. For the first show, John Olsen expressed his approval, stating: 'Naturally Alan I am very honoured you would select me.'[70] And later, from his country property 'Tullydea' in Yarramalong, New South Wales, he wrote: 'I enjoyed my recent visit to Melbourne … I have sent an entry form in for the Georges Prize. I hope I am doing the right thing putting in for the figurative prize—though I regard myself as a figurative painter (God these terminologies) it's not always a point of agreement.'[71]

The 1962 show was well received in the press. Critic Alan Warren described it as 'the most provocative exhibition of present-day Australian art Melbourne has seen in years.'[72] In his *Herald* column, McCulloch was, as would be expected, even more effusive. He claimed it as Australia's most valuable art prize, with artists representing every state. It was not without detractors. These came mostly from conservative elements, but there were also well-respected and more liberal dissenters. In 1964, Max Harris threatened to resign from AICA if it was to continue its association with a commercial organisation.[73] In private, AICA secretary Daniel Thomas, curator at the Art Gallery of New South Wales, recalled his consternation that McCulloch wouldn't award Fred Williams the prize in the first year and how disparaging the critic was towards 'flat field and scrawls of paint'.[74] But Williams' work was awarded second prize in 1963 and, in McCulloch's defence, it was illustrated along with the winning entry *Trees of Life* in his *Herald* feature.[75]

The follow-up exhibition in 1964 was again well attended, with 5000 people making their way to the third floor of Georges'

Melbourne store. The high attendance figures had been stimulated, according to Georges' organisers, by the 'time-honoured visit' of 'James Johnson Sweeney, Esq.', director of the Museum of Fine Arts, Houston, who had missed the first but eventually made it to Australia to open the second show.[76] For his part, McCulloch was appreciative of the work of Thomas, who had looked after Sweeney to such an extent that 'it restores my faith in the capacity for at least a few amongst us to look after genuinely distinguished guests'.[77]

In 1966, discussion turned to the conditions of entry—one painting and one drawing—while in 1967 only one woman was included (Anne Hall) alongside twenty-nine males. In his catalogue introduction to the 1967 show, McCulloch asserted the importance of the prize 'in building the character of the art of a nation'—only the strong will survive—and in a familiar tone reiterating the need to 'resist being swamped by overseas fashion'. To issues of gender inequity came the generational divide. Patrick McCaughey saw this differently, claiming: 'The already patronised were given patronage and those who needed patronage were ignored.'[78] McCulloch responded the very next day when in a letter to the editor he outlined the selection process and his role as chairman of the selection panel.[79] Catching wind of the perceived bias towards established artists, Charles Blackman, in thanking Georges for the winner's cheque in 1967, suggested reserving each alternate year of the prize for artists under thirty, along the lines of the Biennale des Jeunes, held in France.[80]

McCulloch's response to criticisms took a familiar path. He invited dissenters the chance to air their views by bringing them in closer. His initial list for the 1965 exhibition included a host of emerging artists of all different styles and persuasions: Mike Brown, Asher Bilu, Dale Hickey, Michael Kitching, Robert Rooney and Gareth Sansom.[81] These were not conservative choices by any stretch, although still biased towards males. His correspondence with Melbourne artist Sansom between 1964 and 1966 provides an insight into the intrigue that surrounded the annual selection process. Sansom wrote initially in 1964 to ask why others were included in the inaugural show over

him. Once selected in 1965, Sansom followed with a letter in 1966 that made a case for the inclusion of others and gave a disparaging assessment of his own work that had been included in 1965.[82]

Despite earlier misgivings, AICA member Max Harris accepted that being part of the 1965 judging panel 'could be quite good fun, although [admitting] mine will be a small reticent voice amongst the bigger critical wheels'.[83] Among the invited judges for the 1968 prize was another dissenter, Patrick McCaughey (along with John Henshaw and the young sculpture critic Patrick Hutchings), with American critic Clement Greenberg brought in as 'advisor to the judging panel'. In accepting the role, McCaughey suggested that he and McCulloch talk about the drawing and painting prize and dutifully enclosed a list of forty painters arranged in a rough order of preference, stating: 'Whew! What a scandal if this lot was published.'[84]

The shifts in the type and range of artists included in the 1968 show was in turn echoed by McCulloch in his foreword to its catalogue, where he noted the shift of the international art centre from Paris to New York, though being careful to reassert the importance of drawing to the prize and to keeping connections with valuable traditions.[85] It was as if the 1968 Georges Art Prize was anticipating the arrival of Greenberg to Australian shores. The 1969 prize had Bernard Smith as one of the judges, chosen at a time when McCulloch was in bitter and acrimonious combat with the Power Institute, now presided over by Smith himself.

By 1970, changes were in the air with a desire to give the Georges Art Prize a fresh look. McCulloch commented in a letter to Elwyn Lynn that this involved 'concentrating on the young and promising'.[86] In 1971, West German art critic Harald Szeemann was invited to attend as an advisor, although McCulloch later noted in a letter to Daniel Thomas, now director of Newcastle Art Gallery, New South Wales, that he would never again 'make the mistake of asking an overseas judge to judge an Australian prize'.[87] He further explained that the real reason for Szeemann being invited was so that members of the committee would have a chance to talk to him; he was linked

to John Kaldor, who had brought the 37-year-old director of the Kassel *Documenta* to Australia.[88]

A series of new changes were also introduced for the tenth year of the art prize in 1972, with works now purchased and donated by ballot to Victorian regional galleries. McCulloch had recently gained tenure as foundation director at the Mornington Peninsula Arts Centre and through this important gesture was able to bring important works into the collection, including a major work on paper by respected Queensland artist Gordon Shepherdson.[89] In 1981, after the prize had become a biennial event, this initiative was followed by the establishment of an endowment of $10 000 to buy works 'which will be presented by ballot to member galleries of the Victorian Regional Galleries network' and 'will be given for "works on paper" exclusive of prints and photographs or any works that might be issued in editions'.[90] The change in format could not have been more quintessentially McCulloch, in that it promoted Australian works on paper and assisted artists and public galleries alike.

Corporate support for the arts

Alongside his work with Georges, McCulloch forged connections with a range of international companies and their managers. In the 1960s, many of these had signalled their interest in supporting the arts and involving their companies in Australian art and life. This was to have both immediate and far-reaching implications.

Cigarette companies positioned themselves as key arts sponsors in the 1960s and 1970s. They had the capital and market reach to provide new sources of funds for artists and large art projects and the idea of sponsorship of contemporary art supported their desired image as 'young, groovy, hip' or, alternatively, as good corporate citizens. McCulloch congratulated the Peter Stuyvesant Trust on bringing out the Rodin exhibition to Australia in 1967. Never one to miss an opportunity, he also raised the possibility of bringing a Marc Chagall exhibition to Australia. The reply was positive: 'We are

quite interested in arranging a really good Chagall exhibition—if it is possible to obtain some of his great works on loan for exhibition—and I hope you will be pleased to know that we are pursuing the subject with Michael Scott (from Newman College, University of Melbourne).'[91] Although the Chagall exhibition did not eventuate, the Peter Stuyvesant Trust did bring to Australia an Aubusson tapestry exhibition that toured to Mildura in 1967, among many other major touring exhibitions between 1963 and 1981.

McCulloch also supported the more innovative Comalco Invitation Award for Sculpture. In 1971, he submitted six names for their exhibition, most of whom were subsequently invited to participate.[92] This was followed by an attempt to guide the Philip Morris Foundation with their plans to purchase contemporary art from 1973. After the official announcement, McCulloch wrote to Comalco management to explain that no-one liked the works being selected for them and that isolating artists under thirty was 'plagued with problems and risks'. As an alternative, he suggested that Comalco invite public galleries to 'apply for an acquisition grant to be spent solely at the discretion of the gallery director or his nominee on the purchase of works by living Australian artists'.[93] This major initiative, comprising a $100 000 fund spread over five years, eventually enabled the acquisition of works by 'bold and innovative' artists to be exhibited in public galleries throughout Australia.[94] It was a magnanimous act that culminated in the 1982 National Gallery of Australia exhibition *The Philip Morris Arts Grant: Australian Art of the Last Ten Years* and the donation of the many iconic works to the Canberra gallery.

The Travelodge chain of hotels had also begun to build its collection in 1969. Through an art prize planned and executed from 1970 to 1973, the company aimed to develop a cross-section of Australian-themed works for its collection and to display across Australia and overseas. The first display was a lacklustre affair, made up of twenty predominantly conservative painters interspersed with works by Sidney Nolan, Michael Shannon and the Archibald Prize winner for

1969, Ray Crooke.[95] It had been organised by a Commander Michael Parker, who had joined Travelodge as a director in December 1968.[96]

Parker wisely sought art-world counsel for the second exhibition, with six of the twelve artists included in the 1970 show coming from recommendations made by McCulloch. The winner of the $7500 prize was Melbourne artist Donald Laycock, with a work described in McCulloch's notes as 'Glowing, incandescent colour. Semi-abstract.' The painting had impressed James Fitzsimmons during his visit to Australia, McCulloch noted approvingly.[97] The selection was another of the many acquisitions and awards that McCulloch made or gave that vociferated against the notion that he was out of touch—generationally stunted—as did his recommendation of new abstractionists: Dale Hickey, George Johnson and Guy Stuart. Instead, McCulloch believed his suggestions 'could provide a dynamic, impactful but balanced exhibition—the kind that might succeed as a travelling exhibition in other countries', adding in a by now familiar tone: 'What is needed is art that reflects something of the soul, spirit, and life of the country and yet in tune with the great traditions.'[98]

On the strength of the 1970 recommendations, McCulloch was subsequently invited to submit artists for the 1971 prize. His advice was once again well received, with eight of his suggestions out of a possible fifteen adopted. His stated desire to compose 'a carefully balanced list that could provide an extremely exciting show'[99] and an accompanying form guide provided a unique insight into his attitude on both established (some would say over-exposed) artists and those who were newly emerging, such as Col Jordan and Dick Watkins. McCulloch's final suggestion of including the reclusive Ian Fairweather paid dividends for that artist: 'You never know. He might just accept and produce a masterpiece.' Two works were ultimately submitted by the latter, including *Two Heads II* (1967–68), a work produced on Bribie Island.

The exhibition was reviewed by Patrick McCaughey in the *Age*. He saw it as a transitional exhibition in which corporate collections were taking over from private collectors (the larger size of the works

being indicative of this) but also as an attempt to close the widening gap between 'haves and have-nots, the emerged and emerging' in Australian art. The 'prematurely canonised' works of Dobell and Drysdale were counterbalanced by the inclusion of large works by Donald Laycock and the recently acquired Peter Powditch.[100] McCulloch's review in the *Herald* took the opposite view, stating that the winning entry, '[John] Brack's comparatively small "Three Pairs", signified a rare step-up for understatement in painting as opposed to the kind of overstatement implicit in ordinary prize-winning impact pictures.' He later mused: 'The collection looks damn good at the National Gallery', which, he wrote, was 'one of the few shows that can cope with those execrable silver walls'. He followed this private observation with the suggestion to Parker that the show be taken on a tour to Adelaide or Surfers Paradise. 'I've got plenty of ideas. They land me in some strange places sometimes.'[101]

In 1969, Transfield extended its promotion of the arts in Australia with an annual art prize, announced in press releases as Australia's richest at $5000. It opened at Bonython Art Gallery in Paddington and, corresponding to its national significance, art critic and publisher James Fitzsimmons was invited to be the judge—the first international critic to be used to judge the prize. Fitzsimmons selected a work by Ron Robertson-Swann, the 28-year-old painter and sculptor who had been included in *The Field* and had recently held a one-man show at Rudy Komon Gallery, Sydney. McCulloch warmed to the work, and Fitzsimmons was quoted in the accompanying press release as saying that it had been selected 'because it had for me a certain radiance ... It was a painting in which I felt the artist had carried his feeling, his concept through fully, there were no hesitations.'[102]

The Alice Prize

As well as being a participant in these major urban art prizes and awards, Alan McCulloch was a major supporter of regional public arts events and galleries. This did often land him in some strange,

or at least out-of-the-way, places. Asked to nominate possible judges for the 1971 Northern Territory Art Show in Darwin, he wrote back to recommend himself for the job. He went so far as to suggest that he be brought up early so that he could 'improve the installation'.[103]

Alice Springs was another regional centre squarely in the category of places where exciting things were happening, far away from metropolitan Melbourne, Sydney and Brisbane. Its Alice Prize was established by the Alice Springs Art Foundation in its inaugural year of 1970. Sir Paul Hasluck, Australia's governor-general, was its chair and patron and Ansett owner Sir Reg Ansett a major supporter.

Following his involvement in the Northern Territory Art Show, McCulloch was invited to judge the third Alice Prize in 1972. This was to have wide-ranging ramifications for both judge and judged. The winning entry was an abstract painting entitled *Series D – 2D Optics* (1972) by Melbourne artist Sandra Leveson. McCulloch described the painting in his *Herald* column as: 'Immaculately crafted ... a subtle interpretation in square, honeycombed, shifting patterns of deep blue-green tinged with red, of the philosophy of French-Hungarian inventor of Op, Victor Vasarely.' Its selection proved 'unpopular' with the Alice Springs public and some officials who voiced their desire to return to a more conservative approach in the following year. This was reflected in the appointment of the ageing academic artist Sir William Dargie as judge for 1973.[104] For McCulloch, the choice of an abstract painting, by a southerner and by a woman, was a further vindication of his growing support for some forms of abstract art.

Of great import too was the presence of 'a very exciting group of works from the Walpiri and Pintubi aboriginal tribesman working at Papunya'. Through his involvement in judging the Alice Prize, McCulloch had been awakened to the 'newly emerging' art of Central Australia.[105] In the tiny settlement of Papunya, aided by teacher Geoffrey Bardon, Western Desert artists were recording traditional sand painting designs using modern materials, including acrylic paint on boards. While in Alice Springs, McCulloch spent

time with one of these artists, George Gorey, learning at first hand about the latter's former life as a stockman and his experiences as an Aboriginal man living on the fringes of a small (and predominantly white) town community.[106] It was Gorey's work, not Leveson's, that was reproduced in McCulloch's *Herald* article. McCulloch wrote the article on location and was clearly moved by what he had seen. The stunning circular design rendered in feathers, ochre and blood left a lasting impression on him due to its 'strikingly dramatic design', and created 'a strong focal point for the entire display'.[107]

McCulloch was one of a select few interstate art critics to see the new work being produced in Central Australia, along with Elwyn Lynn, who had judged the same art prize in 1971. He was also in the unique position to be able to promote it nationally. In the earliest public recognition of a Papunya painting, Kaapa Tjampitjinpa had been co-winner of the 1971 Alice Springs Caltex Art Award (with Sydney abstract artist David Aspden).[108] But it was not until later that the works of the Papunya artists began to be acquired for the collections of the Museum and Art Gallery of the Northern Territory and South Australian Museum. Tjampitjinpa was Papunya Tula Artists' first chairman and principal artist for the collaborative creation of the famous honey ant mural at the Papunya School. McCulloch canvassed for the Alice Prize's judge for 1973 (William Dargie, whom he had known since the 1930s and who was involved in art acquisitions for the new Australian National Gallery) to be alerted to the exciting new work being done. McCulloch's enthusiasm for Aboriginal art was still couched in his use of old terminology and archaic concepts, as well as being wrong about the continued viability and vitality of contemporary Indigenous art. He did, however, plant the seed for a purpose-built art centre for Alice Springs:[109]

> Knowing Sir William Dargie's great interest in primitive arts it may well be worthwhile to bring to his notice the work being done at Papunya, Northern Territory. The Papunya aboriginal artists have been given modern materials by which they can give permanence to their traditional sand paintings. The result has been remarkable and

I know of no other instance of primitive artists having been able to convert from old to modern materials without violent disruption of style, totemic symbolism, etc. I saw some of their work during my Alice Springs visit. It was most impressive although, sad to relate, I can't see it lasting for more than say another two years. As the old artists die out there are none to take their place.[110]

In his final report on the judging, McCulloch wrote to Sir Thomas Wardle, who had put up the $2000 acquisitive first prize. Wardle was a noted philanthropist and lord mayor of Perth (1967–72), as well as managing director of supermarket chain Tom the Cheap. 'The entire exhibition', McCulloch wrote,

> created great interest and I had the impression that the competition may be the precursor of an even more important enterprise—the building of a fine public art museum or art centre to service the needs of a fast-developing community. I left the town fully confident of the ultimate implementation of this idea and also with very warm memories of Alice hospitality.[111]

Wardle's response was encouraging: 'The building of an arts centre at Alice is an excellent idea and I will support it strongly.'[112]

These letters of recommendation were circulated to Alice Springs MLA and businessman Bernie Kilgariff and the Alice Springs Art Foundation with a request for McCulloch to outline his thoughts in greater detail.[113] From humble beginnings, with the first exhibition held in a corrugated iron shed coated in hundreds of metres of hessian,[114] the Alice Prize grew and ten years later, in 1984, the Araluen Arts and Entertainment Centre was born. It owes its existence to these small seeds, with the Alice Prize growing in tandem with the impressive new building.

CHAPTER 11

THE AUSTRALIAN PUBLIC GALLERY MOVEMENT

P<small>UBLIC ART GALLERIES</small> formed a vital part of Alan McCulloch's personal and professional life. As an advocate, mediator, critic and advisor, McCulloch played a key role in promoting and publicising the strengths (and perceived weaknesses or limitations) of, in his words, the burgeoning Australian public gallery movement. He was sought out by government and private benefactors for advice and contributed widely to the development of Australian galleries and their collections and programs in the second part of the twentieth century. By far his greatest support and energy was directed towards the Victorian public gallery network and its regional galleries, in the belief that this was where the excitement *was*.

McCulloch's belief in the valuable role played by regional galleries was underpinned by a strong philosophical basis. He delivered a keynote address entitled 'The provincial art gallery as a cultural influence in the community' at a Victorian Public Galleries Group conference held at the National Gallery of Victoria in May 1961. The elevated sense of the social and educational role of the provincial or regional museum he expounded was emphatically set out in his later 1978 declaration that 'they represent a general, nation-wide movement towards the decentralisation of culture through the healthy growth of locally established bodies'.[1] In these and similarly

styled pronouncements, McCulloch was anticipating how well-run art galleries and well-financed exhibitions—such as those seen at Bendigo Art Gallery throughout the 2010s, for example—could contribute to the social, cultural and economic well-being and growth of regional communities and economies.

The importance of developing free and accessible public institutions to stimulate intellectual growth and bind communities had been significant in his own upbringing. He had spent countless hours in the Victorian state library, museum and gallery—but this principle was also something he had learnt from post-war French culture. McCulloch's contact with the prominent intellectual and French minister for the arts André Malraux was influential. Malraux's work resulted in the creation of many new and exciting public art ventures in Paris, as well as in outlying centres. McCulloch was keenly interested in these and other developments throughout Europe and the United States—with regional centres home to many of his most treasured gallery experiences, such as the Louisiana Museum of Modern Art, Denmark, the Kröller-Müller, Netherlands, and the Fondation Maeght, Vence, in the south of France.

An exhibition of architectural photographs and McCulloch's plans for a 'Proposed Victorian Decentralised Galleries Exhibition' to be held in Melbourne in 1966 came to naught, despite the impressive list of supporters.[2] He subsequently tried to enlist the aid of the *Herald*—proposing that the Herald and Weekly Times establish a regional arts foundation that would operate through the Regional Galleries Association of Victoria.[3] McCulloch advocated for the involvement of both the media and industry in the public gallery network. He believed that business had an important role to play.

McCulloch was by then also acting unashamedly as a champion of the regional gallery network and as the foundation director of the Mornington Peninsula Arts Centre (MPAC). This would be a position he held for twenty years through to his retirement in 1990, aged eighty-two. The Mornington centre was a local investment founded on worldly principles. At MPAC McCulloch sought to distil the best

of what he had encountered overseas, adapting it to a semi-rural and regional environment and drawing on well-connected men and women from the business world with strong interests in the arts.

National and state institutions

The greater the size and funding of the institution, the larger the responsibility and the opportunity—at least this was what McCulloch believed. Consequently, he often raised the hackles of key NGV trustees and staff. Sometimes, his consternation stemmed from the purchase of major works that he felt lacked importance or integrity. It could also result from the list of possible names touted—most of which he abhorred—and the look and feel of the newly designed gallery south of the Yarra. But McCulloch wasn't all doom and gloom. He contributed in a positive way to NGV programming, through exhibitions and illustrated lectures. For instance, he was appointed in 1959 to head a curatorial team to 'guide an exhibition on Australian graphic trends'[4] and, as we have seen, curated a survey exhibition on Sydney artist Godfrey Miller in 1958.

Part of McCulloch's topsy-turvy relationship with the NGV stemmed from his changing relationships with successive directorships. He was an affable colleague of Daryl Lindsay in the 1940s and 1950s, even though they had personal and professional differences. He had less affinity with Lindsay's successor, the New Zealand–born arts administrator Eric Westbrook. McCulloch wrote to the AICA secretary, Brian Seidel, in August 1966:

> Another most ungodly matter has arisen here; the planners of the great Melbourne centre have announced the new name 'National Gallery and Arts Centre of Victoria'. Have you ever heard worse? 'National' that old colonial relic ... Anyway, I've gone to war to eliminate the word 'national' and there's quite a stink cooking.[5]

In the following month, he wrote to the then-longest serving Victorian state premier, Sir Henry Bolte, forwarding suggestions for the naming of the new arts centre complex and outlining his reasons for not using

the word 'national'. His preference was the equally inelegant though more practical 'State Arts Centre of Victoria'.[6]

McCulloch wrote to Westbrook requesting information for his encyclopedia entry. Using the occasion, he could not help but give his own (now prophetic) suggestions:

> THAT NAME! When the Jolimont [sic] Yards are roofed as they undoubtedly will be, my tip is that the whole of that area will be named 'New Melbourne' (what other name could it possibly have?) and that nearby business houses will be tripping over themselves to add the 'New' to their Melbourne addresses. Melbourne has always sounded stuffy, but New Melbourne? That's different. It would have the prestige value of [London's] SE2. So why not NEW MELBOURNE GALLERY AND ART MUSEUM?[7]

Throughout the 1970s, McCulloch also continued to castigate the NGV over its exhibitions and acquisitions, as he had done from the outset of his appointment as *Herald* art critic in 1951. Following a talk he gave to the National Gallery Society of Victoria in 1973, he critiqued what he described as 'money culture' purchases by the gallery and their lack of support for Indigenous art and the Aboriginal collection. He pointed to Tony Tuckson's legacy at the Art Gallery of New South Wales, created during his time as deputy director, as an example of what could be achieved.[8] McCulloch anticipated the NGV's strong support of regional programs by advocating in the early 1970s that the gallery should be proactive in lending exhibitions and select works from its collection to regional audiences.[9] His idea for a stand-alone gallery of Australian art was later vindicated with the creation of the Ian Potter Centre: NGV Australia at Federation Square.

Australian National Gallery

McCulloch always considered the Australian National Gallery (as it was first known) as a regional gallery due to its geographical positioning in a land-locked capital. He maintained an equally strong stance

when it came to the ANG's policies and acquisitions. In 1965, the Prime Minister's Department invited him to assist with the work of the ANG Art Committee. Due to an impending trip to France, he couldn't contribute until the following February, which by his own estimation would be 'impractically late'.[10] This did not stop McCulloch from becoming involved in other ways.

Initially, this concerned the appointment of the inaugural director. 'We've had a hell of a political row here about the director-to-be of the new National Gallery at Canberra,' he wrote to *Art International* editor James Fitzsimmons, continuing, 'It was climaxed by the Prime Minister inviting JJ Sweeney to accept the job. But then the Prime Minister was disposed [of] about a week later and now nobody quite knows what the situation is. Ah well. That's the art political world that I like to keep out of.'[11]

McCulloch subsequently wrote to the frontrunner for the inaugural directorship, James Mollison, offering support and advising him to accept the prime minister's offer to become director of the ANG.[12] In private, he was far less complimentary, particularly following the purchase of Jackson Pollock's *Blue poles* (1952). Writing to his former secretary and trusted friend Judy Blythe, McCulloch stated in October 1974: 'Nor would I have made it to the [*Herald*'s] front page had it not been for the egg-headed, fiscal adventures of the benighted James Mollison, A.N.G. Director by default, J. Gorton having refused the CAAB's nomination of the late Laurie Thomas.'[13]

McCulloch was referring obliquely to the controversy over the 1973 acquisition of *Blue poles*. Purchased for the princely sum of $1.3 million (but now worth several hundred million), this work polarised the Australian art world and wider community unlike any other artwork before. McCulloch wrote an acerbic six-page letter to Prime Minister Whitlam in November 1973, outlining his disappointment with current government arts policy, and specifically with the purchase of *Blue poles*. This first unsent letter was replaced by one the following day in which he reined in its excesses. McCulloch followed

it up in person, having a conversation with Whitlam on the same topic at the 1973 Sydney Biennale.[14]

McCulloch also expressed his ire to friends and colleagues. He wrote to Len Voss Smith, who was still working with Christie's in London, giving a rundown on the Australian art scene including the purchase of *Blue poles* and JMW Turner's *Val d'Aosta* (c. 1845) by the NGV. McCulloch considered this to be 'an apology for a Turner painting for which the National Gallery of Victoria has paid $475,000'. Voss Smith supported McCulloch's response to the purchase of *Blue poles*, stating: 'I think this is the highest price ever paid at auction' but turned down his request to do some additional 'sleuthing' on the Turner.[15] Although ultimately proven wrong in his assessment of both the Turner and Pollock, McCulloch at the time had many vocal supporters in his opposition to the purchase of *Blue poles*, including that of ex-NGV director Daryl Lindsay.[16]

As he later related to a colleague, McCulloch was eventually refused 'back door entry to see *Blue poles* when it was put on display at the NGV in 1974'.[17] Following this personal snub, he used the re-election of the Fraser Liberal government in 1975 as an opportunity to comment on Fraser's preference for homegrown exhibitions and purchases: 'PM Fraser's remarks about his government's support of Australian art', as opposed to the 'former policy of buying international masterpieces' was outlined in a letter to Earle Hackett, Chair of Trustees, Art Gallery of South Australia, in May 1976.[18] In like manner, McCulloch commented on the proposed ANG Statement of Acquisition policy that had been circulated for comment in a four-page document submitted to the minister for the Capital Territory, Tony Staley. Staley later thanked him, saying, 'Your comments will be a great help to us.'[19]

Despite these controversies, McCulloch was supportive of his many state gallery colleagues. After his trip to see the recently acquired French pictures at the Queensland Art Gallery in 1960, McCulloch waxed lyrical about the incumbent director's high reputation and the

way Robert Haines had secured and put together a collection that was 'second to none [compared to] any public collection in Australia'. According to McCulloch, Haines had 'put the QG not only on the Australian map but on the map of the entire Western art world'. Although an overstatement, particularly at this stage in the gallery's development, McCulloch was offering his weight to a colleague under pressure. In a letter to the *Courier-Mail* editor, McCulloch registered

> the strongest possible protest against the State Government's acceptance of the resignation of the Director of the Queensland Art Gallery. That he does not want to see the collections which he has so carefully and industriously built over the years playing second fiddle to untried aspects of culture and inadequate housing is a matter of plain common sense.[20]

Assisting regional galleries

Alan McCulloch also took a leading hand in the establishment and development of regional galleries in each state and territory in the 1960s and 1970s. A good deal of this involvement had gone unnoticed until the recent publication of a history of the regional gallery movement in Victoria by Don Edgar. Edgar refers to McCulloch as a 'doyen of Australian art criticism and art history'[21] and as I show, he was a key player in the establishment of the McClelland Gallery and Mornington Peninsula Arts Centre, among others.

In 1970, for example, McCulloch was sought out by the director of the fledging Gold Coast City Gallery for advice and support for their new art prize. He was advised that the gallery intended to hold it again in the following year. In a six-page typed response, McCulloch put forward a compelling case: he used the opportunity to define how 'kitsch' or 'technologically driven art had come to dominate art prizes and our consciousness'.[22] The next year he offered follow-up advice on the new building development at the Gold Coast gallery as well as commentary around the difficulty of bringing such plans to fruition.[23] In the 1980s, McCulloch also advocated for the establishment of a

regional gallery at Cairns and was thanked for advice that had helped towards setting up a regional gallery in Far North Queensland.[24]

As he did in Queensland, McCulloch performed a behind-the-scenes role in the establishment of regional galleries in country South Australia and the Northern Territory. In 1973, he wrote to John Baily, the newly incumbent chair of the Visual Arts Board, Australian Council for the Arts, to congratulate him on his appointment and provide information on regional gallery developments in Australia and the potential for further growth. Baily answered by saying that he would welcome 'any more comments you can give me now on the means that might be employed in setting up a regional gallery (thinking about one in the Riverland district of SA)'. Buoyed by the response, McCulloch replied with his idea of a whole regional gallery network, including the 'establishment of an Arts Centre at Alice'. McCulloch's ideas took root and Baily responded: 'The Visual Arts Board discussed the idea of our having a feasibility study made towards the establishment of an art centre for Alice Springs'—a good idea but one carrying the need to 'proceed slowly'.[25]

McCulloch reserved his greatest attention for regional venues in his home state. When he first entered the art world as a critic in the 1940s and then again in the 1950s, Victoria's public galleries were in a parlous state. Low attendances, shoestring budgets, lack of professional staff, poor remuneration, deteriorating buildings and an inability to conserve or preserve collections adequately (as well as scant support across all levels of government) meant that the four long-established provincial galleries at Ballarat (1884), Bendigo (1887), Geelong (1896) and Castlemaine (1913) were struggling to survive, let alone maintain appropriate museum standards. The fifth, Warrnambool (1886), was, according to McCulloch, effectively no longer operating. Along with regional gallery representatives and the NGV directors Daryl Lindsay and Eric Westbrook, he was to take the lead in the revitalisation and expansion of what was to become by 1976 an incorporated body of sixteen public galleries spread across the state.

As early as 1944 or 1945, McCulloch had made his first moves in the regional gallery sector. He later detailed the resolutions of a meeting held around that time—initiated by the influential Lindsay, and attended by himself (then the *Argus* art critic) and Clive Turnbull (art critic for the *Herald*)—in which Lindsay outlined the dire situation facing provincial galleries and their unanimous desire to 'try and restore the situation'.[26] Almost a decade on, through the impetus of Westbrook, the NGV's new director, the Victorian Public Galleries Group was formed, later developing into the expanded Regional Galleries Association of Victoria (and now known as the Public Galleries Association of Victoria).[27] Donald Webb, its inaugural secretary and then executive officer, was widely credited by McCulloch for taking an active role in building the 'entire regional gallery movement in Australia' into a lively and flourishing entity up until his retirement in 1976.[28] Fittingly, McCulloch later recommended Webb for state honours.[29]

McCulloch was especially critical of public collections growing without the necessary means to provide reasonable care. To change this situation, he garnered the support of numerous high-profile sympathisers and supporters. Among these was the prominent collector Aubrey Gibson. Gibson wrote a colourful and punchy response to McCulloch's views in January 1956 in which he concurred with the need to make provision for 'reasonable storage, + manual staff, materials for display + technical staff for research, curator's work, cataloguing and what have you'.[30] Around the same time, McCulloch was discussing with Ross Shelmerdine, of the Myer Emporium, ideas to support the maintenance of buildings and collections—with a rescue scheme planned to address this.[31] He also enlisted the aid of philanthropist Neilma Gantner, second child of Sidney Myer, the Bendigo and Melbourne retailer and Myer family patriarch.

By the early 1970s, McCulloch recognised that Victorian public galleries were ripe for expansion, citing recent developments in New South Wales: 'There is now a strong move to follow the RGAV [Regional Galleries Association of Victoria] lead in NSW and an

association has already been formed under the leadership of the director of the Newcastle City Art Gallery, David Thomas.'[32] He later blamed the initiation of the Regional Galleries Association of New South Wales in 1972 for the brain-drain in Victoria: 'The Victorian Regionals have now lost 11 directors in 12 months,' he lamented.

The dire financial situation facing most regional galleries waxed and waned. In an open letter circulated by McCulloch in 1980, he detailed the crisis facing the Geelong Gallery, and declared the gallery would have no money 'to cover its operation costs from October 1980'.[33] The director at Ballarat, Ron Radford, voiced his dismay at the inability of regional galleries to properly care for or conserve their collection by curating an exhibition at the gallery in 1976 provocatively titled: *Attention Your Collection Is Rotting*.[34] This exhibition strategically predated the establishment of what would become the Conservation Centre of the Regional Galleries Association of Victoria in Ballarat in 1979.

The 1960s and 1970s stand out as a watershed in the development of Victoria's regional gallery network. The relocation of the NGV to new premises on St Kilda Road in 1968, major extensions to Geelong, and the emergence of new dynamic directors such as James Mollison (1967–70), Ron Radford (1973–80) and then Margaret Rich (1980–2003) at Ballarat ensured that things would and did improve. These developments included the introduction of new funding models and agencies within the Australian Council in 1972 and Victorian Ministry of the Arts (now Creative Victoria) in 1974. Until the Australian Gallery Directors Council was dissolved in 1981, it ensured the training of professional staff and the interests of museums were well represented.

Retiring RGAV chairman Eric Rowlinson remarked in 1979, 'we have now entered a Golden Age of official art gallery sponsorship', something that McCulloch welcomed but realised came at a cost.[35] Writing from his position as director of the Mornington Peninsula Arts Centre, he expressed in handwritten notes a more cautious response: 'We are delighted of course/ but/ Top heavy with art bureaucracies?'[36]

The number of public galleries in Victoria had by this time grown to seventeen. Over the space of two decades a revolution had taken place. This included the establishment of Mildura (1956); Hamilton (1957); Latrobe (1961); Sale (1965); Shepparton (established 1936 with a purpose-built gallery completed in 1965); Swan Hill (1965); Ararat (1968); Horsham (1968); Benalla (1968, with a stunning Munro and Sargeant–designed gallery built on the lake in 1975); McClelland (1971, also Munro and Sargeant); and Mornington, which began operations in Vancouver Street, Mornington, in 1970.[37]

These new galleries were largely an expression of civic pride, funded through the benefaction and enterprise of local collectors and supporters. Each went on to develop unique exhibitions, collections and buildings, often based on the interests of newly appointed directors. For Ararat it was textiles, while for Mildura sculpture. In his role as *Herald* art critic and as someone with political connections, McCulloch was frequently called upon to advise, petition and lobby on behalf of both the established and the newly formed galleries. After he became involved with the development of the McClelland Gallery in 1965 and foundation director of MPAC, his voice was augmented by an insider's view. Throughout all of his communications, his message was consistent and clear—regional galleries represented a new movement, full of potential.[38]

In the early 1960s, he had questioned the Ballarat City Council takeover of the gallery and what he took as its short-sighted attitude towards the promotion of its key assets, notably the Eureka flag. In a follow-up letter to the Warrnambool town clerk, McCulloch sought information for the upcoming dictionary of art and requested information in relation to the building's 'state of disrepair', asking if he could confirm: '1. What has been done with the building. 2. The State of the collection and what it contains. 3. Future plans'. 'I might add that the whole key to the success of provincial gallery development (as proven in the cases of Hamilton, Mildura, and of course, the provincial galleries of America) is the appointment of a highly qualified and energetic director.'[39]

The nurturing of professionally trained staff needed to develop in tandem with the increase in building meterage. Reflecting on the appointment of the enthusiastic schoolmaster Tom McCullough to the Mildura directorship, one city leader wrote prophetically: 'McCullough is very interested in sculpture—I think it is his main interest and [he] will certainly try very hard.'[40] Not surprisingly, Tom McCullough later turned to McCulloch for advice and support. He wrote requesting advice on plans for revamping the sculpture prize into a by-invitation triennial exhibition, from which works would be purchased for the centre's permanent collection and major new commissions for Mildura would be planned.[41] McCulloch's generous reply included advice for sponsorship, publicity and contacts. He wisely suggested Comalco as a major sponsor, expressing his support for their idea of an 'Aluminium tower and pool' commissioned for the centre of town: 'The thing that will interest people most in the idea of going to Mildura is the image of a well-watered oasis in the middle of the desert.'[42]

McCulloch continued his support for Mildura and its triennial sculpture exhibitions through his articles in the *Herald*, a catalogue essay and in 1972 by presenting a lecture on patronage and the arts at Mildura Arts Centre. He wrote to Premier Rupert Hamer requesting financial support for the gallery, citing its need for assistance as due to its decentralisation, education and tourism potential, 'and the provision of standards that offer permanent stimulus to the network of regional galleries in Australia'.[43] At the same time, McCulloch also urged the National Capital Development Commission, which he had been working for, to support the upcoming triennial with its new by-invitation focus: 'one of the best proving grounds for sculpture'.[44] In a welcome turn of events, three of the six works that he recommended as having merit were subsequently purchased for Canberra.[45]

When Tom McCullough offered his resignation in 1978, McCulloch noted his regret and the difficulties of keeping great ideas like the sculpture triennial going. As was his usual recourse, he generously offered to 'support him in any way'.[46] McCulloch was

subsequently invited to assist Mildura Council with the 'appointment of a new director'.[47] Along with his proposed structure and staffing model, he stated bluntly to the town clerk: 'It is important that Mildura gets a top professional director.'[48]

Through instances such as the advice he provided to Mildura, McCulloch contributed to Victorian regional galleries in very tangible ways, sometimes by simply offering his support and encouragement to a hardy band of individuals who felt isolated or out of touch. He lauded the achievements of Keith Rogers on his retirement from the directorship of the Shepparton Art Gallery in 1973, noting that he had started the process of 'creating something, quite unique'—not enough regional galleries, he added, 'were professionally run'.[49]

In 1974, McCulloch wrote to Rodney Davidson, Chairman, National Trust of Australia, to give a rundown of the Warrnambool Gallery and the dilemmas it was facing, including the prospect of it being 'razed to make way for new Civic Centre'.[50] Benalla Art Gallery—relaunched in its new building in 1975 with a dynamic director, Pamela Gullifer—appealed to McCulloch as an example of how a good purpose-built structure in the right setting could activate the community and give the arts increased relevance. 'They've vindicated my faith in them, Munro and Sargeant (the young architects I launched into the gallery building business with at the McClelland Gallery, Langwarrin),' he wrote.[51]

McClelland Sculpture Park and Gallery

The Victorian bayside suburbs of the Mornington Peninsula, stretching from Frankston and Mt Eliza to Portsea and Sorrento at its tip, have mostly benefited from their proximity to Melbourne. In the 1950s and 1960s this was certainly the case. Many of the state's most prominent arts managers and supporters, as well as industrialists, politicians and other powerbrokers, called the peninsula home or maintained properties there. Its commuter culture and its promise of sprawling ranch-style homes on large blocks within easy reach of

the city—with obvious exceptions such as Dame Elisabeth Murdoch, who lived permanently at Cruden Farm, Langwarrin, and Daryl and Joan Lindsay at Mulberry Hill, Baxter—meant that its residents often had closer links and alliances with Melbourne's more dynamic cultural centre than the denizens of other regional centres.

McCulloch's high standing in the art world meant that he would become a key spokesperson for the region. In the same month as he moved to Shoreham in 1951, he was invited to the first meeting of the Peninsula Arts Society. Daryl Lindsay, in his capacity as director of the NGV, took on the role of chairman, and local artist Maidie McGowan that of secretary.[52]

The first (and in the end, thankless) project he became involved in was the formation of a vision and design for what would become the McClelland Sculpture Park and Gallery at Langwarrin. His work in the gallery's early development constitutes a regrettable episode in mismanagement and led to bitter acrimony on both sides.

McCulloch had recognised the need for a regional gallery on the Mornington Peninsula as early as the 1950s. He was acutely aware of the distance to major cultural facilities in Melbourne. He was also aware of a growing network of artists, arts professionals and noted Melbourne-based philanthropists with links to the peninsula. Seizing one opportunity, he clearly articulated this need in 1962 when, offered £200 by Neilma Gantner to help set up an annual art scholarship, he suggested that 'it could be [better] put to a use far in excess of its value as money', stating: 'What we need on the Peninsula is a Provincial Gallery.'[53]

The primary impetus for the formation for an arts centre at Langwarrin was Annie May (Nan) McClelland. In honour of her brother Harry, she left $200 000 and 20 acres (8 hectares, which included Harry McClelland's 'country' studio) on her death in 1961 to build a public art gallery and cultural centre. Thanks to the cultivation of their bohemian disposition and artistic bent (Annie was a poet and Harry a painter and arts patron/dilettante), the McClelland family cut a striking presence in conservative Frankston from 1912,

establishing a house and studio on the beach at Long Island, where they lived permanently from the 1920s.

Four trustees were appointed to administer the will: William Harrison, Molly and James Graham and Dr Stewart Preston. Following Nan's death, advice was sought from Daryl Lindsay, Eric Westbrook and McCulloch in conjunction with the selected members of the McClelland Gallery Group.[54] This group, of which the McClellands had been foundation members, was made up of Peninsula Arts Society members.[55]

McCulloch was initially approached informally through artist John Rowell, a member of the McClelland Gallery Group. He detailed his suggestions to Rowell in a six-page report in which he tendered his name as a potential advisor, recommended a site and suggested ways to move forward. In March 1965, honorary secretary Maidie McGowan advised McCulloch that the report 'regarding plans for the McClelland Cultural Centre at Langwarrin, has been submitted to the Trustees and approved'. McGowan proceeded to ask if he was willing to be 'co-opted' onto the planning committee.[56]

Although the gallery was to be situated between the outer Melbourne bayside suburb of Frankston and the sand-belt area of Skye, Langwarrin and Cranbourne, McCulloch clearly saw the proposed development as a Mornington Peninsula entity. The idea of this regional gallery excited him because it was within reach of where he lived and was also close to other arts patrons who had forged strong relationships with the McClelland Gallery Group. Responding to a request by two potential donors (Myra Beale and Neilma Gantner), McCulloch presented his views at the April meeting of the gallery group, where he was requested to seek recommendations for potential architects from Melbourne University's professor of architecture, Brian Lewis. Lewis, explained McCulloch, was 'an old friend of mine'.[57]

Keen to capitalise on the level of interest and formally cement his own involvement, McCulloch moved quickly. In June 1965, he attended the inaugural meeting of the Australian Art Galleries Association in Sydney as a McClelland-funded observer.[58] He

recommended Colin Munro as architect at the McClelland Gallery Group's June meeting,[59] and submitted a plan for a five-year contract with an option of a three-year extension and 'properly constructed' board of trustees at a meeting convened at the trustees' solicitors.[60]

McCulloch's list of director's duties and responsibilities—in which he would assume sole responsibility for acquisitions and 'all matters pertaining to the conduct of the gallery, hall and staff'—was his way of dealing with other more parochial interests. However, the strongly worded document would not and did not endear him to at least one member of the original board of trustees. In his own typed press release published in the *Southern Peninsula Gazette*, McCulloch pre-emptively announced his appointment as the new director.[61] The vision outlined in his statement included the choice of an exceptional site, with natural amenities and careful landscaping—equivalent to what the newspaper editor mistakenly attributed as the 'beautifully converted villa "Louisiana" in Sweden [*sic*]'.

McCulloch's commitment to establishing the new gallery was given added impetus by a trip he had already been planning to France, England and America in 1965. The French ambassador to Australia, Henri Souillac, confirmed in September an invitation from the French government for McCulloch to spend two months in France as a '*personnalité invitee*', with the return airfare paid and an 'indemnity of 1500NF [francs]' awarded per month.[62] This was followed by an offer from the Dutch government to visit the Netherlands for a short period as their guest. The trip was also tied to work on the encyclopedia he planned to do in London, and an invitation from JJ Sweeney to help set up the Aboriginal bark exhibition he had curated for the Museum of Fine Arts, Houston.

Following an initial meeting in Melbourne, McCulloch wrote candidly to Souillac about his new role and what he hoped to achieve in France: 'I have been appointed Director of a new public gallery in the Peninsula … The enterprise, a rural gallery in a park-like setting, is quite new to Australia and gives me added incentive to see the new enterprises with which France is so richly endowed.'[63]

Departing Sydney on 29 September aboard an Air France flight, McCulloch was not disappointed with what he saw when he arrived in France. He recorded in heartfelt letters to Ellen the feast of art and architecture that he had seen in Paris and especially in provincial France: 'The galleries', he wrote, 'so many and so wonderful that I can't absorb then all. Matisse chapel at Vence, Cocteau Chapel at Villa France, Leger Musée, Maeght Foundation (makes anything we could possibly do at McClelland look sick), Valauris, Vence, St Paul de Vence, Biote etc ...'[64] He was equally impressed (though somewhat scarred by a harrowing journey) to regional galleries in the Netherlands. He wrote to a local Frankston artist on his plans for McClelland: 'What I would like to see created there would be an Australian equivalent to the Kröller Müller, at Otterlo.'[65]

Despite these promising beginnings and McCulloch being armed with a wealth of knowledge and ideas, things soon turned sour. While travelling overseas, he finally received notification from the Grahams wishing him well and advising that Munro had signed an agreement to begin work on the plans: 'Colin Munro has the key to Studio Park. This enables him to come and go without any hindrance, we have no doubt, he is the "man for the job"; he I am sure will be looking forward to your return.'[66] But this letter was written in response to McCulloch voicing concern that things were moving far too slowly, and an ultimatum regarding his own professional advice and time. All the work so far had been done on a voluntary basis, he explained. A contract had not yet been presented for his directorship, let alone signed, and he had begun to fear that something was amiss.

Nonetheless, McCulloch continued with his plan as well as lobbying on behalf of the gallery. His 'Brief for Harry McClelland Art Gallery and Culture Hall' was submitted to the board of trustees in March 1966, on his return to Australia. In it he outlined a vision of a 'small scale gallery of strongly individual design with its galleries a series of linked spaces, containing natural lighting, views of the surrounding landscape from most of the galleries, one large open space, dividable by partitions, sculpture courtyard, HM [Harry McClelland]

Room and coffee Bar'—in effect, what McClelland was to eventually become.[67] McCulloch recognised that the 'setting was ideal for the display of outdoor sculpture' while providing 'a natural sanctuary for wildlife'.[68] In support of the vision he approached several prominent Melbournians to become board members, including businessman Baillieu Myer. Myer regretfully declined while emphasising his desire to 'play a part' in due course, which he did.[69]

Amid the uncertainty over the terms of his appointment to McClelland, McCulloch wrote to Sydney University's vice-chancellor, Sir Stephen Roberts, in September 1966 presenting a case for him to take on the new post of director/professor at the Power Institute. Although unsuccessful, McCulloch accompanied his resumé with an extract from the then soon-to-be published *Encyclopedia of Australian Art*. The entry outlined his role and the frustrations that had beset the project: 'In the same year he was appointed Director of the $200,000 McClelland Memorial Gallery to be built near Frankston, Victoria, legal anomalies in the will have frustratingly prevented commencement of this work and so far the main part of his activities have been absorbed as advisor for the architects.' McCulloch went on to describe the period he spent in France and the Netherlands in 1965 at the invitation of their governments 'to study architecture of galleries'.[70] He was very clear in his mind that despite the Grahams' protestations and the length of time that had elapsed, he was the person for the McClelland job.

In November 1966 McCulloch issued an ultimatum to the McClelland trustees that he be appointed immediately. His instruction to the architects was to 'proceed as fast as possible with the first stage of building', and he also requested the appointment of 'at least four additional trustees' or he would resign.[71] The reply from McClelland trustee WB Harrison was cool though conciliatory in tone. Harrison acknowledged the difficult situation in which they were placed and suggested they take the pressure off themselves.[72] In January 1967, the trustees announced in the *Age* that plans were now prepared and that, according to Harrison, they 'hoped building

would start within six months' and that they also 'hoped to employ a gallery director'. McCulloch's response to the announcement was blunt—he stated in a letter to the editor that 'in fact I had been appointed in July 1965' and he was 'anxious that this should be done as well and as quickly as possible'.[73]

Tensions escalated as McCulloch finalised the publication of the first *Encyclopedia of Art*. He wrote to Harrison asking, 'What exactly am I to say about "The McClelland Gallery and Cultural Hall?"', going on to assert that it now looked 'the most dismal failure of the whole book'.[74] This was answered with legal warnings. Receiving notice from James P Ogge & Co., the solicitors acting on behalf of the trustees, McCulloch was instructed not to write badly about McClelland, and notified that he had never been appointed director and that under the terms of the will an appointment would not be made until such time as the gallery was built. Furthermore, the notice stated that if he did not comply with these demands he would risk legal action.[75] McCulloch countered with a letter from his own legal counsel, Frank Galbally QC, containing the assertion that 'a statement concerning Alan not being appointed will be considered defamatory' and that they 'would welcome a statement for the Encyclopedia'.[76]

Based on independent legal advice that was subsequently provided by JA Gobbo, McCulloch and Galbally speculated several weeks later that this letter may have had the desired effect, since there had been no new response at that point.[77] In an about-turn that was to have far-reaching ramifications, a follow-up letter to McCulloch from his own counsel reconsidered the issue of whether Alan had been appointed director and found that it was 'difficult to assess on the available evidence but clouded ... URGING CAUTION'.[78]

On 20 December 1967, McCulloch made public his intention to resign from all connections with McClelland Gallery.[79] Although he later pontificated that it 'would never have been built in its present form had it not been for [his] participation',[80] he was left to ruminate on what might have been achieved under his directorship. The architects had no doubt of the significance of his role. Colin Munro

reported to McCulloch in December 1969 that the gallery was nearly complete, 'with little departure from the plans drawn up prior to [your? illeg.] resignation'.[81] A very public altercation in local newspapers, along with support and questions from Phillip Lynch, federal MP for the local seat of Flinders, meant that, according to McCulloch, the trustees had been finally 'stunned to action',[82] getting plans drawn up, with the building completed and a director appointed in 1972. The elegantly designed modernist building situated in a bush setting was one of the first of its kind built in Australia and a worthy precursor to Munro and Sargeant's award-winning design for Benalla Art Gallery, completed in 1975.

Mornington Peninsula Arts Centre

As Alan McCulloch fulminated over his treatment by the trustees at McClelland, he was already engaged in planning for a regional gallery at nearby Mornington. McCulloch wrote to Lynch on 25 January 1968, stating: 'The Peninsula Councils now know that a $1 million development is necessary and that it is possible to get it, and I can't see any of those interested being happy with less ... I have three [business] people interested, all prominent, efficient and with interests in Mornington.'[83]

Susan McCulloch relates how the seeds of such a gallery had been sown as early as 1950, through discussions with prominent artists, business leaders and philanthropists around the McCulloch kitchen table.[84] A comment made by McCulloch to a Mornington Shire councillor, Tom Hast, at an art opening at Manyung Gallery in 1968 sparked interest and then subsequent support from colleagues. At a council-organised event held on 23 July 1969, a Mornington Peninsula Art Development Committee and a Gallery Society were established.[85]

The importance of Mornington township as the site of a new Peninsula Arts Centre was set out retrospectively in a letter from McCulloch to art collector and friend Colonel Aubrey Gibson.[86] McCulloch's proposed management model was like the one that he

had advocated for Mildura Arts Centre in 1969. It would have a director as head of the institution, a board of management, and a gallery society for fundraising. These 'Must work in harmony ... *Must* have *local identity*', he ventured.[87] The building itself would aim to be 'a modern international-standard arts centre ... [with] provisions for art galleries, sculpture and display court, theatre for music, drama, lectures etc, restaurant and other facilities'.[88] The reality, of course, would be much different. Eight years later, McCulloch explained the situation in a letter to the Art Gallery of Ballarat's Margaret Rich: 'Basically I do everything though [am] only required to be there one afternoon per week.'[89]

The significance of the MPAC, and its important role in supporting Australian artists, was a fundamental principle from the outset. Writing to Mildura's director, Tom McCullough, in 1971, McCulloch noted that they would probably meet at the upcoming Regional Galleries Association conference, where he was going with a 'Mornington delegation': 'There's every prospect there of a Peninsula Arts Centre development (assisted by all those Westernport industrialists) that could be of real service to the Regional Galleries movement. Anyway I'm giving all the help I can.'[90] He explained to long-time MPAC supporter and philanthropist Gwen Martyn that same year that the aim of the gallery was to 'educate the people of their particular region by providing facilities for them to see art of all kinds *at top level*'. McCulloch went on to suggest: 'The purpose of the Spring Festival of Drawing is not to make money for the gallery or for artists whose work may be acquired or bought, but to present to the Mornington Peninsula a display of the best drawings currently being done in Australia.'[91]

McCulloch had recognised that such lofty aims would only be possible through bringing together like-minded and well-connected people. The Mornington Peninsula was well served in this regard, with a swathe of Melbourne's wealthy and influential families maintaining second houses or properties there. This included the extended Myer family; prominent Melbourne businessman Bruce Wenzel,

whose sister was married to the art collector Jack Manton; and others such as Betty Meagher, who had set up the nearby Manyung Gallery. Wenzel was to offer his resignation from the MPAC committee in 1974, citing other business commitments, at which point McCulloch thanked him for his service and hinted at their aim:

> The help you have given the gallery has been of immense benefit— it was help that came when most needed and it will certainly not be forgotten. You will be interested to know that the Mornington Council has now secured that land and maybe our plans for the new Arts Centre will now go ahead faster than anticipated.[92]

Alan McCulloch was announced as director of the newly formed Mornington Peninsula Arts Centre at a gallery event held in May 1971. Things moved quickly, as Susan McCulloch has elucidated in her essay commissioned as part of the gallery's 50th-anniversary celebrations in 2020. Its first exhibitions had been held in council offices over 1969–70, including one on the Boyd family, but a visionary design for a new gallery had soon followed, to be built on 2 hectares of land in Mt Eliza: 'a three-level circular building with an open central courtyard. External walls were windowless, to be encased in pebbled concrete and angled inwards to form a small circular opening at the top with a theatre below; the gallery was wrapped around an internal sculpture court on ground level'.[93]

Sadly, this building did not eventuate, but by April 1971 the gallery had taken up residence in a converted and refurbished council-owned weatherboard house in Vancouver Street, Mornington. This cottage, framed by two date palms, served the gallery well for nearly twenty years. At the same time, McCulloch continued to advocate and develop proposals for a purpose-built gallery that would match his vision for the Mornington Peninsula as a cultural centre to rival the Louisiana in Denmark. Writing to McCulloch from his home in London in response to a letter from Betty Meagher, president of the development committee, artist Arthur Boyd said that he was 'glad to hear of the Mornington venture', adding in scratchy pen beneath: 'P.S. Would you please advise me what you would like me to give the

Mornington Development. Would it be something to sell for funds or for some other purpose.'[94]

McCulloch's hopes for the new gallery were also outlined in a letter to Sydney critic and friend Elwyn Lynn in 1971, while progress of the new MPAC and a proposed arts scholarship was outlined to philanthropist Neilma Gantner in June of the same year.[95] Local architect Don Fulton, who had worked on plans for a potential gallery to be situated at another stunning peninsula location, the Briars Homestead and bush property in Mt Martha, duly thanked McCulloch for sending him a press clipping regarding Mornington's 'proposal for a civic centre master plan' and 'enclosed initial outline material sent to Shire Engineer'.[96] McCulloch wrote hopefully to Judy Blythe in Toowoomba: 'MPAC exhibitions have become quite famous incidentally and we've made our submission to Mornington Council for the proposed new Arts Centre (six galleries, theatre, all facilities in a superb bush setting). I hope I live to see its completion but in any case I'm going to enjoy building it.'[97]

Assembling the collection and mounting exhibitions claimed most of McCulloch's attention in the early stages of MPAC's development. He commented to the editor of *Art International*, James Fitzsimmons:

> The MPAC is very fast-growing. We intend to build a large arts complex and the shire council has acquired a large acreage of land for this purpose. If all goes as planned I might turn the 1977 event into an international Festival of Drawing. Drawing, as I may have mentioned to you, has always been my first love, so the Festival is the culmination of a cherished ambition. Nothing I would like better.[98]

McCulloch launched the Spring Festival of Drawing and the Prints Acquisitive exhibitions in 1973 and 1974, primarily to help build a national collection of drawing and works on paper. The first Spring Festival was a huge success. 'Half the political and artistic population of Victoria came to the opening [as well as people who] descended upon us from all parts of Australia', he wrote proudly to Ian Purvis,

commanding officer of the Cerberus naval base and an artist himself, in nearby Crib Point.[99] To the ageing Sydney artist Desiderius Orban, who was wondering about the whereabouts of a work sent to MPAC, McCulloch commented: 'We got 330 entries for the Drawing Festival and it proved a magnificent success ... The exhibition was extended owing to the great public interest but it was not possible to intimate this to the 330 entrants. The Festival will be a biennial event and should become the nation's top drawing award.'[100] McCulloch wrote to sculptor Noel Hutchison in March 1972 along the same lines:

> We have been held up with the building alterations at the Mgtn Art Centre so I won't give a firm date on your show here. The new building opens with a show of Blackman's drawings, mainly in colour, which he has loaned us for five years. Since we don't have any endowments and are operating on a shoestring I'm going to make the MPAC a centre for drawings. An Australian Fogg Museum perhaps? Who knows?[101]

McCulloch's ambition to make Mornington a 'national centre for drawing' was assisted by the acquisition of notable works by 'Kemp, Williams, Baldessin, Tanner, Macqueen, Franz Kemp, Hopkins and several others for the permanent Mornington collections', he explained to John Cooper from the Gold Coast Art Centre.[102] Through these endeavours, McCulloch not only helped to develop an important niche collection of prints and drawings but was also part of a wider push and renaissance in Australian graphic arts. While regional galleries such as Newcastle Art Gallery were intent on developing comprehensive collections of works on paper, state gallery curators developed specialist exhibitions designed to promote the cause of contemporary Australian drawing, such as Lou Klepac during his second period at the Art Gallery of Western Australia (1974–80).

McCulloch's support for contemporary artists in the early years of the gallery reached fruition in the many survey exhibitions and mini retrospectives initiated by him and his small but dedicated band of staff and volunteers. In the first few years this included solo

exhibitions by Charles Blackman, Jan Senbergs, Leonard French, Noel Counihan, Fred Williams, Tate Adams, Will Dyson, Arthur Boyd and Constance Stokes, to name a few. Inviting Marc Besen, head of Sportsgirl and a major art collector, to attend the Senbergs show, McCulloch commented: 'This will be superb—Jan's first one-man show in an Australian public gallery (despite that he represented Australia at the Biennale of São Paulo last year). The MPAC will cover two decades of his work.'[103] McCulloch wrote to Blackman:

> I also feel I owe you an apology about the non-appearance of my Blackman review. Do you mind if I save some of my admiring comments on the gallery and the show for a moment as I would like to do a piece on the regional galleries which is rather less of a hallelujah than usual and says some tough things about the absense [sic] of coherent and knowledgeable exhibition planning. The Blackman show is in such marked opposition to this that I'd like to use it as a counterweight.[104]

McCulloch's letter to Counihan in February 1975 was written in response to an appreciative assessment of their longstanding friendship and in the aftermath of criticisms that had been levelled against the NGV that it did not support the work of contemporary artists. A semi-retrospective exhibition of Counihan's work had been mounted by Eric Westbrook in 1973 and McCulloch was building on this when he posed the question: 'Has Mornington made its point to other galleries that it is the function of public galleries to further the recognition of important Australian artists?'[105]

Among the many touring exhibitions mounted in these early years were *Fred Williams: Bass Strait*, comprising paintings from the Tasmanian Museum and Art Gallery, Hobart; *Groote Eylandt Barks* from the Leonhard Adam collection, University of Melbourne; and the Lurcat tapestries, sponsored by the Peter Stuyvesant Company. By 1975, McCulloch was proud to claim that 'in five years and from a standing start we've brought it to a point where we can run an important national competitive art exhibition'.[106]

In 1979, McCulloch reported to the annual Regional Galleries Association of Victoria meeting:

> The MPAC collections continue to grow and we received a fine Margaret Preston war picture (one of the few if not the only one of its kind) as a result of the new Tax Incentives Scheme, subject of one of the [Australian Gallery Directors Council] talks. Our year's collecting ends on a high note. After long and protracted negotiations with the artists and their representatives and the Caltex/Ministry Acquisitions Committee (the negotiations begun two years ago), we have at last been informed that our application for assistance to purchase a special parcel of fifty-three drawings has been granted. The drawings include—ten Roger Kemps, six Dobells, twenty Sam Fullbrooks and seventeen small Drysdales.[107]

Russell Drysdale had written previously to McCulloch from Boudi Farm, New South Wales, in 1978 to say, 'I shall be very pleased to let you have a set of drawings for the Peninsula Arts Centre for $2,000.'[108]

CHAPTER 12

THE LATER YEARS

To see a world in a grain of sand
And a heaven in a wildflower
Hold infinity in the palm of your hand
And eternity in an hour ...

William Blake[1]

IN A 36-PAGE 'farewell' piece looking back on the thirty years he had spent as art critic with the Melbourne *Herald* (1951–81), Alan McCulloch ruminated on his philosophies, his contribution to Australian art and his high regard for certain artists. Maintaining his independence and elevated standards to the end, he declared in an exchange with the features editor, Pat Hinton, that the copy he had provided to him should not go ahead as planned: 'No—not/ good enough/ stopped it.'[2] The feature did go ahead, but with the suggested changes. One month later the *Herald* board saw fit to award McCulloch a 'gratuitous payment of $5,000', in recognition of his longstanding service to the newspaper.[3]

Melbourne's art fraternity, in particular, showed their appreciation as they wistfully looked back on the end of an era. Rachell Howley wrote on behalf of the Acland Street Gallery and her artist husband John Howley, Jeffrey Bren and Jim Wigley, saying: 'I am sure you will

be missed by all Australian artists ... [we] always thought very highly about your approach to critics and artists.' Christine Abrahams, director of the fashionable Axiom Gallery, penned a moving tribute: 'I want to tell you that we all appreciated your fair, measured and enthusiastic criticism. Your service to the artists as well as the galleries has been an invaluable one over many years.' Patrick McCaughey, then chairman of the visual arts department at Monash University, wrote: 'I was so touched to see that the end of an era had come last week when you stepped down from the *Herald*. You achieved so much for Australian art over a long period of service but must feel sometimes that you face an ungrateful and unremarking world.' Artist Diana Mogensen recorded simply: 'What a magnificent, stunning 30 years of critical writing.'[4]

McCulloch had begun to receive accolades for his career and contribution to Australian art much earlier. In 1973, he was offered 'the first Honorary Membership of the Australian Division of the AICA in acknowledgement of the initiative work [he] did for its establishment'.[5] This was followed in 1976 with the award of an AO for services to the arts. The many letters of congratulation from artists, critics and gallery staff were an indication of widespread admiration and respect.[6] Federal Labor MLA Barry Jones offered his 'belated but sincere congratulations on your appointment as an Officer of the Order of Australia'. He further noted that the *Encyclopedia of Australian Art* had 'become an indispensable part of my life since it came out in 1968'.[7] Fred and Lyn Williams proudly conveyed their sentiment that the award was 'not only for you, but also Ellen, that you are amongst the first recipients under the new system'.[8]

Plans for a documentary on McCulloch and his era were proposed and discussed in 1974. The film was to be financed through the Visual Arts Board and other private sponsors. Jenny Hook, the director, referred to a student at the Australian Film School who was 'falling over himself to help with production, research and editing', telling McCulloch, 'I think you will find him something less of a philistine in the areas of Australian art and literature, than I am.'

She was talking about the young filmmaker and later distinguished curator and art consultant John Cruthers.[9]

Further accolades followed in 1987 when McCulloch received an Hon. Doctor of Laws from the University of Melbourne. This award was conferred following sustained encouragement by his old friend Clem Christesen. Christesen was capitalising on moves afoot in the fine arts department, Melbourne University—noting that Monash had a similar idea 'several years ago' but didn't act upon it.[10] In late November 1987, David Caro, Vice-Chancellor, University of Melbourne, wrote to McCulloch to congratulate and invite him to an official ceremony the following April.[11] McCulloch's subsequent address, entitled 'One man's incidental view of university life', was a heartfelt speech that reminisced about his life and his connections with prominent Melbourne University scholars including Sir Joseph Burke and First Nations art academic Leonhard Adam. McCulloch had used 'incidental' in the title of the speech to reference the fact that he had never had the opportunity to attend university—and because of this had always felt slightly inferior or lacking a '"proper" education'.[12]

At the same time as he was preparing a submission in support of McCulloch's AO, Christesen also pushed for McCulloch to receive due recognition by submitting a proposal to the Australian Visual Arts and Craft Board for an emeritus fellowship. According to Christesen, Jan Senbergs had taken the first steps but his application had been passed over.[13] Requested to resubmit, Christesen wrote of his intentions: 'No matter—let's start again.' McCulloch responded with an updated resumé and a list of 'possible supporters' but despite their best efforts, he was awarded the emeritus medal posthumously in 1992.[14]

In the final decade of his life, McCulloch deflected some of these personal accolades by gaining recognition for others whom he felt were more deserving of public recognition. Part of this process included bringing colleagues back into the fold and healing some old rifts and wounds. One of those rifts concerned Christesen himself.

Throughout 1980, McCulloch petitioned the new editor of *Meanjin*, Jim Davidson, to properly recognise Christesen's longstanding contribution to the magazine.[15] This gathered momentum in a fierce exchange of letters between the two men in the lead-up to a dinner to celebrate the 40-year anniversary of the magazine, a dinner that Christesen had chosen not to attend.

McCulloch was increasingly being called upon to support the achievements of others, through letters of condolence and published obituaries. The late 1970s and 1980s witnessed a changing of the guard in Australian art. Many of the chief protagonists and supporters of post-war modernism succumbed to age and infirmity. McCulloch wrote to artist Jean Bellette on the passing of her husband, art critic and artist Paul Haefliger, commenting on his contribution to Australian art. Bellette replied from their home in Majorca, Spain that the sentiments would have been much appreciated and wrote of her sadness in dispersing Haefliger's art collection.[16]

An obituary written on pioneering Sydney gallerist Rudy Komon for *Art and Australia* was placed by the editor next to one they had commissioned from artist Alun Leach-Jones.[17] Komon's wife, Ruth, thanked McCulloch for his letter of condolence and the tantalising admission. 'You've known him longer than I have (28) years ... How wonderful that you did help Rudy way back—by sending him that list of artists—who knows he might not have got going at all as an Art Dealer if you hadn't helped him!'[18]

McCulloch also supported numerous others in receipt of Orders of Australia, including Joseph Stanislas Ostoja-Kotkowski in 1990. For Roger Kemp, McCulloch recorded that he was 'deeply honoured' to have been asked to comment on the recommendation for election to Order of Australia—'no Australian painter is more worthy of election to the Order of Australia since none has had a better and more widespread influence over contemporary painting'.[19]

The Chilean émigré artist Juan Davila, who had fled President Augusto Pinochet's repressive regime to make Australia his home in the mid-1970s, was to later express his appreciation to McCulloch,

who had supported him in his applications to stay in Australia. McCulloch characterised Davila's solo exhibition in 1977 as that of 'an artist in deep mourning'.[20] In a letter to McCulloch, Davila expressed his great appreciation, eventually gifting one of his major screenprints, *Bretonism*, to MPAC as a sign of his gratitude.[21]

Setting things straight

Other things begged to be put in order. One of the most pressing concerns for McCulloch was the return of a gift of a sacred stone from Central Australia. In 1965, Alice Rowan, the daughter of pioneering Australian museum director, anthropologist, artist and art collector Sir Walter Baldwin Spencer, presented McCulloch with a carved tjurunga. This sacred Aboriginal stone was one of two that had been given to Spencer by Arrernte elders and Rowan was now passing it on to McCulloch in appreciation of his role in promoting the Spencer Collection held in the National Museum of Victoria.

In 1980, McCulloch wrote to Ruth McNicholl from the Australian National Gallery, explaining how he had come into possession of the tjurunga, and why he wanted to send it back. 'My Tjuringa is unique', he explained, 'but I've always felt that I was only its custodian. So hearing a few months back about a racket in tjuringas I decided to give it back to whoever was responsible.'[22]

Acting on McNicholl's advice, McCulloch approached the Central Land Council based in Alice Springs with an offer to return the work.[23] One of their officers, Ross Howie, subsequently replied:

> I have been concerned to endeavour to understand more clearly the people to whom and the place to which the tjuringa relates ... What has emerged is that the tjuringa is associated with a wallaby dreaming and with a place on Anningie Station known as Mt Peak or Black Hill. The control or custody of the tjuringa should be with Sid Potter, a respected senior Aboriginal man who now resides at the Aboriginal owned cattle station at Mount Allan.[24]

Once repatriated to its rightful owners, John Coldrey, Director of Legal Services, CLC Alice Springs, acknowledged its receipt and helped to fill in some of the gaps as well as illuminate the powerful symbolism of the object. 'The tjuringa was shown to a number of senior Aboriginal men including Sid Potter, Wenten Rubuntji and Engineer Jack. All of them were delighted that the object was once again in Aboriginal custody.' He ended with the assurance that the tjurunga would be stored safely, as well as 'retrieved for use in ceremonies by the Aboriginal custodians'.[25]

As one of the oldest critics still practising in Australia, McCulloch was now frequently called upon to comment upon Australian art and the art world from the 1920s on. With each request, he took the opportunity to set the record straight based on his direct observations and participation. In March 1981 he replied to a letter from a student outlining his fears concerning the rise of bureaucrats and the proper appreciation of art:

> The problem your generation will face increasingly will be bigger and bigger exhibitions mounted by a new breed of curator (common in the USA but just coming up in Australia). The educated entrepreneur with no feeling for the arts and with a burning ambition to fill his gallery and arts centre with whatever makes news or attracts attention. The Triennial is a good example. It is mostly a PR exercise and art—specifically the art of sculpture is a secondary consideration—Sculpture is what you feel when you walk into the Louvre for the first time ... Or it's the tactile thrill experienced by holding in one's hand a carving or a casting by Brancusi or fondling a tchuringa engraved on ironstone by the ancient Arunta artists.[26]

Declining an invitation to comment on the role of art competitions and prizes in Australian painting in 1981, he instead posed the question: 'Ask yourself thus: "Who would have supported the artists in the '60s if not the prizes?" There was no government patronage. They had value in that they provided continuous representative interstate exhibitions—now alas, non-existent. But they attracted hordes

of pot-hunters, which was one thing which killed them.'[27] The role of the Georges Art Prize in fostering the collections of regional galleries was also outlined in a letter to politician Susan Hunt, at that time a Sydney University arts student.[28]

In addition to his letter writing and public engagements, McCulloch used his weekly *Herald* column in the late 1970s and early 1980s to engage with what he saw as the most pressing issues of the day. In this way, he was able to reinforce some of his own ideas and philosophies regarding the nature and direction of modern and contemporary art and lend his support to both friends and colleagues.

He continued to raise the consternation of NGV directors with his assessments of significant gallery purchases and critiques of major touring shows. This included Eric B Rowlinson, a museum professional who had joined the gallery from New York's MoMA, in mid-1976. In April 1977, McCulloch joined another media dissenter, Maureen Gilchrist, art critic of the *Age*, who had challenged the extent to which the presentation and Esso sponsorship of the exhibition *Heritage of American Art* from the Met, New York, was overshadowing the actual work and tainting the show with inclusions such as 'a giant mock-up of a Bald Eagle, presented as a curious sort of American shrine' at the entrance.[29]

While McCulloch recognised the need for continuing financial support from major Australian businesses and international corporations (he had personally helped to shape the Esso art collection in Australia) he publicly declared his admiration for Gilchrist's brave stance, postulating that 'in using huge advertising posters, banners and an American eagle, Esso ... appeared to be drilling for oil on the sacred precincts of culture'.[30] The issue of the relationship of major sponsors to exhibitions was not one that would go away, and it galvanised Australian art critics in the years to follow.

McCulloch issued a critique of the NGV acquisition policy, including the process for purchasing artworks and, despite the many successes, detailed what he perceived as a history of buying overpriced pieces by European old masters. Some of these, he postulated

in controversial words, came with dubious provenance and questions hanging over their authenticity. This was in contrast to the ANG, whose policy McCulloch stated was the more proactive in 'searching out and annexing masterpieces [which] is likely to pay handsome dividends'.[31]

McCulloch couldn't resist revisiting the NGV purchase of JMW Turner's epic and by now much-loved atmospheric landscape study *Val d'Aosta* (c. 1845). The painting had 'cost $474,000 in 1973' but was now worth many times that figure.[32] Other important works such as those by Pablo Picasso, he surmised, had been passed over for more inferior works and this had been done at the expense of its support for Australian artists who, 'from the beginning … have had a raw deal from the National Gallery of Victoria'. Rowlinson responded strongly to this assertion in an open letter to the editor, in which he stoutly defended the suggestion of questionable authorship and 'as many mistakes as triumphs'. 'To suggest', he wrote furthermore, 'that Australian art should be moved to a separate gallery is to encourage an isolationary examination of Australian art which should be avoided at all costs.'[33]

McCulloch also challenged the erosion of Melbourne's street culture and the demolishment of key historical buildings in the mid-to-late 1970s and early 1980s. This had gathered momentum in the 1970s with demand for new office and commercial towers. In 1976, McCulloch followed the lead of art historian Virginia Spate, who had recently returned from Europe to witness the fabric of her city being destroyed. The tenants of numbers 5, 7 and 9 Collins Street had been served with eviction notices. For Spate, McCulloch and others, these buildings were an integral part of the city's history and culture, having served as artists' studios since their construction in the 1880s. McCulloch lamented the destruction of the city's heritage and its replacement by glass-box studios, arguing that such things should be sacrosanct from development.[34]

In the mid-1980s, McCulloch came together with Arthur Boyd in defence of another Melbourne landmark—the Arts Centre spire.

This was still in development but being progressively reduced in size. Boyd wrote to McCulloch:

> About the spire of the gallery which we both agree is important. I had lengthy conversations with various engineers and architects and it appears that it is quite practical and would not be as expensive and troublesome to do as some people in authority have thought. I suggested at the time that I would offer a substantial contribution in the form of a painting to a fund for that purpose. Your suggestion of writing to Race Mathews is a good idea.[35]

McCulloch backed up their joint opposition to the idea of employing an artist from overseas to light the Arts Centre spire in a letter to Clem Christesen.

> If it had to be done of course Ostoya should be the one to do it ... [it is a] real Westbrook gimmick to shove a laser spectacular on top of the tower. We'd probably get it flashing out the initial letters of the two characters who have done most to wreck the Arts Centre.[36]

McCulloch had always wanted to make the Mornington Peninsula Regional Gallery a key repository for Arthur Boyd paintings and research. His personal and professional association with Arthur and Yvonne Boyd over the 1980s and early 1990s reveals a continuing and deep connection. In 1980 Yvonne had typed a note to McCulloch from Arthur, one of many written in this way. Boyd expressed his sadness to hear of illness among their friends and gave his unqualified support for the idea of a museum at the Briars (a rural property at Mt Martha on the Mornington Peninsula). 'Most of my early Peninsula paintings went to the ANG', he wrote, but 'I would have liked very much to have some of those paintings in such a place as the Briars instead.'[37]

In keeping with their longstanding association, McCulloch was invited by Anne Purves from Australian Galleries to write on Boyd's early work from 1934 to 1945. This was for an exhibition and publication, and 'Arthur [was] financing the project himself'. Purves continued:

Arthur is eager to have a permanent record of this collection of pictures before they are dispersed [and] I know that you and your brother, Wilfred, were closely involved with Arthur around those years and when titling the paintings recently with Arthur in London he remarked about one of *Sand Dunes, Back Beach Rye* that he had been with Wilfred McCulloch on that occasion.

McCulloch was happy to comply and declined payment.[38] The publication did not go ahead due to what Arthur called its 'astronomical costs' and Anne Purves apologetically returned Alan's foreword, though not before Yvonne Boyd had also written to personally thank Alan for his catalogue piece, which they had both read 'with a mixture of nostalgia and also smiles'.[39]

Both Arthur Boyd and Alan McCulloch looked back on their times together with great pleasure. Writing from his base in Ramsholt in the United Kingdom in 1986, Boyd thanked McCulloch for his letter and remarked: 'It made me very nostalgic for those lovely early days at Gardiner with your mother and Wilfred and our painting times together.' Boyd subsequently invited McCulloch to paint with him when he was back in Australia at their home on the Shoalhaven River.[40]

McCulloch travelled to the Boyd's Shoalhaven property in New South Wales to spend time with Arthur and paint together again in the landscape two years later, in 1988. Gwendolyn Thorne, a friend from MPAC, wrote to McCulloch enquiring, 'Was your painting session with Arthur Boyd productive? What a joy for you both to get together in such an idyllic part of NSW.'[41] Due to the Boyds' generosity, McCulloch returned to Victoria with two major paintings from Arthur's Mornington Peninsula years, the complete set of *Lysistrata* etchings and a host of other drawings. These valuable works were transported back to the Mornington Peninsula in the boot of McCulloch's VW Golf.

Although McCulloch and Boyd were old friends, the letters between Alan, Arthur and Yvonne Boyd also reveal that the relationship was tested over the years. In October 1984, McCulloch wrote in

response to an interview that had appeared in the *Age*: 'You are my oldest artist friend (50 years?) and I would be no friend at all if I did not give my reaction to that piece of jazzed up publicity.'[42] Yvonne replied with an 'interim' letter (in lieu of a reply from Arthur) written on a postcard, expressing the personal hurt caused by McCulloch's perhaps overly candid admission (as she recounted it) that he hadn't 'cared for [Arthur's] work since the 40s or 50s' and that fundamentally Arthur was the same man that she had been with for forty years.[43] Arthur may not have sent his own letter, as Yvonne's response to McCulloch's next letter was written at Bundanon. She reproached herself for writing, as she thought Arthur would not have liked it if he knew, and thanked Alan 'for trying again to explain your liking about him/his work'.[44]

Arthur and Yvonne's final letter to McCulloch in 1990 was a heartfelt summation of their life friendship. Having learnt of McCulloch's diagnosis of Parkinson's disease and the subsequent restrictions on his activities caused by its onset, they wrote:

> It was lovely to receive your letter here where we a [*sic*] little isolated from the world for a while and we would like to most heartily congratulate you on your achievement M.P.A.C., in the new home. It sounds very prestigious and that is very fitting. We hope that you will now feel rewarded by all your devotion over the years to the gallery.[45]

Arthur was the last person outside the McCulloch family to see Alan before he died. Susan McCulloch took Arthur and Yvonne to visit him, and in conversation Alan said that he worried about Arthur's responsibility and pressures as being the 'greatest living Australian artist'. Arthur responded: 'Well you were the one that made me that!'[46]

Melbourne artist Noel Counihan was another of the many artists with whom McCulloch developed a lifelong friendship that withstood the challenges of time. Their association began in the early 1930s when Wilfred McCulloch introduced them. McCulloch employed Counihan as a cartoonist at the *Australasian* in the 1940s, a time when

Counihan's Communist Party sympathies had placed him squarely in opposition to mainstream art-world politics and ideologies. The inevitable sparring between them over political allegiances reached a high point in the 1950s with a robust public discussion on the relative merits of art from Eastern Bloc countries, including Romania, and ended with a long and interesting discussion on their bond in 1976.[47]

Two years later, in 1978, Counihan painted McCulloch's portrait. According to McCulloch, it 'made me look like a rather tatty retired English colonel who has taken up reading or perhaps philosophy as a hobby to bide him over the years of dotage. Ellen likes the portrait and if I could be objective about it I'd say it's a strongly modelled very professional job.'[48] Later, in 1990, Bernard Smith wrote to McCulloch asking for help with his research on Counihan. He ended with the comment: 'PS I chuckle over your at times sparring relationship with Noel … but you both seemed to come out creditably!'[49]

The terms of endearment that McCulloch developed in response to Boyd and Counihan were symptomatic of the way he approached all artists. At the core of these terms was a deeply felt humanism that extolled the virtues of individual temperament and artistic change as something that emerged from the traditions of great art that responded to the circumstances of its own epoch.

In this way, McCulloch could easily decry the Australian exponents of minimalist painting and sculpture but praise the work of American Ad Reinhardt for 'reacting to his life's experience of art practice and art history'. According to McCulloch, Reinhardt had 'earned the right to reject that with which he had become disillusioned'.[50] The demise of the New York School and the death of the avant-garde became a beacon call for McCulloch as artists, he felt, became increasingly divested from life in an age oversaturated by media and technology. For example, he noted regarding a Helen Frankenthaler exhibition organised by the innovative Ewing Gallery, University of Melbourne, that an unanswered question raised here, 'as by most New York School painting', is: 'What part of it is attributable to individual creative expression and what to mere technological innovation?'[51]

In contrast, Melbourne-based exponents with links to overseas trends were assessed on their ability to assimilate key ideas and techniques in the process of establishing their own style and credentials. Howard Arkley, in his monochrome spray paintings of the mid-1970s, was praised by McCulloch for his ability to strip painting back 'so that he can go so close to painting nothing—and still leave an impression of being an artist of refinement and sensibility'.[52] McCulloch also warmed to Peter Booth and his semi-abstract and figurative apocalyptic paintings and drawings of the late 1970s and early 1980s, which helped him to find his way out of a minimalist impasse. Booth, he wrote in October 1978, was a 'painter with the strength of courage to be himself' and had emerged from the 'negative of his all-black paintings ... to more optimistic climes'.[53]

One of the few critics to support Joy Hester in the 1950s and 1960s, McCulloch acknowledged in unequivocal terms a large survey of ninety-eight works held at Tolarno Galleries, Melbourne, in 1976. He appreciated the fact that Hester had 'responded directly to the force of her emotions and the force was a powerful one'.[54] In his last review of her work, 'A Survey of Drawings', he spoke in relation to the works on paper, all done before 1947, that 'as concerns Australian art [they] were far ahead of her time'. This, McCulloch felt, had 'earned her a place of increasing importance in Australian art of the period'.[55]

While we now accept such ambit claims as a matter of course, the conception of the artist's ideas being tied to 'genuine' feelings and emotions was the sort of humanist ideal that continued to sustain McCulloch at a time when the 'death of the author' was being hotly debated in Australian art circles. When young Sydney artist Imants Tillers held his first exhibition in Melbourne, McCulloch had little choice but to frame it in an anti-Western culture rhetoric. Tillers' exhibition at RMIT Gallery consisted of his trademark use of small pre-primed academy boards that were numbered in sequence and painted to make a unified whole. McCulloch commented: 'Like Duchamp's Tillers' real direction is coolly intellectual, embodying

an intellectual's rejection of society along with its institutions and its arts.'[56]

Mornington Peninsula Regional Gallery

Although mostly retired from writing, McCulloch was still deeply involved throughout the 1980s in redeveloping the Mornington Peninsula Arts Centre and presenting a full list of programs. This involved organising surveys of the work of local artists as well as continuing to secure important touring shows. McCulloch was not averse to using his *Herald* column to promote the centre's ambitious exhibition program. In June 1980, he promoted MPAC as the only regional Australian gallery to get *Contemporary European Drawings*, an exhibition comprising the work of international artists that had been organised as part of the Biennale of Sydney.[57]

McCulloch secured many important touring shows using personal and professional connections and developed ones that followed his passions. *Art and the Theatre in Victoria 1844–1984* was such an enterprise. This 1985 exhibition premiered at Mornington and toured to ten venues under the auspice of the Regional Galleries Association of Victoria. It was an ambitious exhibition and included some of McCulloch's own designs for the costumes and choreography of Laurel Martyn's *Heraldiques* ballet in 1946.

In 1980, McCulloch wrote to the Hon. WL Grayden requesting written support to attract more funds for Mornington and his big plans for 1981.[58] In 1983, he asked if the former premier Rupert (Dick) Hamer would consider becoming chairman of the MPAC management committee. Hamer's response was no, but encouraging: 'You have done wonders down there … I do wish you well in your efforts to build a new Regional Gallery in a bush setting. I can't imagine anything more appropriate for the Peninsula and it would be a fine tribute for your great work for the region.'[59]

McCulloch's vision for the gallery as part of a larger civic plan followed arrangements for the amalgamation of three separate

Mornington Peninsula councils into one entity in 1994. Eventually, he had to settle for a revised design that would be built in the position the gallery still occupies. This was essentially a large paddock where Council intended to relocate the shire offices and build a gallery, new library and performing arts space, on the eastern side of Nepean Highway. An exhibition at Vancouver Street, Mornington, included a display of the new gallery models and vision for MPAC, which consisted of three exhibition spaces with vaulted ceilings, internal sculpture courtyards and ample theatrettes and ancillary spaces.

Despite good intentions, progress was slow and difficult. In his 'Report given to RGAV Directors' Conference' in December 1986, McCulloch went so far as to propose the benefits of a merger between MPAC and his former 'brainchild' McClelland.[60] Fundraising efforts continued, including those of Susan McCulloch, who organised a major art exhibition fundraiser at Australian Galleries and a gala dinner in the NGV Great Hall in 1987. The joint event raised $125 000 for the building and towards the furnishing of the proposed McCulloch library.

MPAC eventually opened at its new premises off Tyabb Road, Mornington, on 17 November 1990. McCulloch's godson, Ed Burston, penned a glowing tribute and noted the 'standing ovation McCulloch received at the opening of the art centre'.[61] The building of the new gallery represented a remarkable achievement. It had increased the gallery's capacity to present major exhibitions and store its collections. However, there were mixed feelings: it had been reduced dramatically in scale and feel from the original plan. Originally costed at $6 million to build, it was constructed at the reduced cost of approximately $1.6 million. Two of the barrel-vaulted galleries were omitted, along with most of the attractive internal and external spaces. While the MPAC building may not have lived up to expectations and the exhibition budget was tight, this was offset by the collection that McCulloch and his successors developed and the gallery's ambitious exhibition and collection program.

In November 1990, Clem Christesen wrote to McCulloch to enquire who was to be the new director of MPAC. He issued a 'word of caution: don't put off deciding too long—that could prove most unwise and could lead to all sorts of trouble ... As an old friend ... Now is the time to call it a day.'[62] Ironically, McCulloch was still involved in forward planning, such as organising major new shows that supported the work of contemporary artists. Jan Senbergs, then Visiting Professor, Chair of Australian Studies, Harvard University, wrote to thank McCulloch for a letter he received at Harvard, telling him about his experiences there and responding to a request to do a retrospective survey of his work: 'Declines—50 too young he suggests, proposing an exhibition of large drawings.'[63]

McCulloch built upon the gallery's collection of drawings through his strong connections with prominent local patrons and collectors as well as artists. Although primarily associated with McClelland Sculpture Park and Gallery, where she supported major acquisitions of sculpture, Dame Elisabeth Murdoch was made an honorary life member of MPAC Gallery Society in 1988.[64] Maisie Drysdale wrote to McCulloch in 1988 thanking him for a memorable tea party and chat:

> We cover such a similar span—it makes me sorry I live so far away... When I looked in the cupboard for the Daryl Lindsay house I promised you, I also found a rather nice *Roe Deer* by Mary McQueen, of whom I am a great fan, + a Thake woodcut called *Nuns on the Geelong Road*. Would you like them or are those artists over re-presented in the Collection?[65]

Joan Lindsay wrote from nearby Mulberry Hill, Baxter: 'PS. I haven't forgotten to return the Joan Lindsay drawings you want and as soon as possible.'[66]

Clem and Nina Christesen were also major beneficiaries, donating most of their art collection to the Mornington gallery, including a rare and beautiful wartime painting by Margaret Preston. Gallery secretary Gwendolyn Thorne wrote to acknowledge the 'Great news

of Christesen's gift comprising over 100 works. The MPAC must be bursting at the seams with the marvellous collection.'[67] At the same time she proposed her own generous gift of $25 000 to the gallery building fund 'or for another purpose—leave for your judgement'. This was followed by a thank-you note regarding her gift to the gallery. 'It makes me happy to know that the gallery's collection will benefit from it.'[68]

In the obituary he wrote for *Art and Australia*, Lou Klepac observed that McCulloch's

> Spring Festival of Drawing did much to advance drawing, and with modest means but great determination he put together one of the finest collections of works on paper in this country. Looking back on his career, I now see where and how his efforts were slighted by lesser people. He took it all in his stride. His enthusiasm and great sense of humour served him well.[69]

By the time of McCulloch's retirement, MPAC boasted a collection of over a thousand works, the majority works on paper, that had been either acquired or gifted from artists, patrons and gallery directors with whom he had developed strong friendships, or through the Spring Festival of Drawing and Prints Acquisitive exhibitions. Eclectic in nature, the collection reflected the vision and predilections of its inaugural director/curator, a legacy that continues to grow in its strength and diversity.[70]

Finding suitable permanent homes for other significant works of art that he had received over the years was high on McCulloch's wish list. This included making gifts of some of his own art as well as of his extensive art library. In July 1988, Gough Whitlam wrote to McCulloch on behalf of the National Gallery of Australia Council thanking him for the donation of seven prints from the 1937–40 period.[71] These figured among some of his first etchings and were both artistically and historically important. Created at a time when he was instructing the younger Arthur Boyd on some of the finer points of etching using his own mangle press, they demonstrate how he saw art as a way of commenting on society and also his

keen sense of humour and use of satire. Approximately 1150 books and catalogues were presented to the Fogg Museum at Harvard in 1990. Jan Senbergs thanked McCulloch for this generous donation of Australian books and catalogues to Harvard on 'behalf of the Australian artists, commercial and state galleries, on January 16'.[72] The majority of his library was presented to MPAC to be housed in the proposed Alan McCulloch Library.

McCulloch continued to support the work of the Victorian Regional Galleries Association network through his *Herald* column and maintained his canvassing of politicians and attendance at regional forums and events. He capped off a life's work promoting art in a regional context in fine style. In 1990, the executive director of the Robert Holmes à Court collection acknowledged McCulloch's suggestion that Janet Holmes à Court 'consider the establishment of a network of regional galleries in Western Australia as a memorial to the memory of her late husband'.[73]

The encyclopedia's revised editions

The Encyclopedia of Australian Art, which had taken up so much of McCulloch's life, went to reprint with minor corrections in 1978. It was subsequently published as a revised second edition in 1984. Perhaps considered his defining achievement, a third edition was released posthumously in 1994 (completed by Susan McCulloch).

In 1981, McCulloch applied to the Australian Research Council for a grant for research and development to finish the encyclopedia. He wrote to Tim Pascoe, chairman of the Australia Council, enquiring about a special grant and stating that the *EAA* 'must be completed by the middle of 1982'. He exhorted: 'I was a young man when it all started, I'll be an old man when it's finished, and after some seven additional years of intensive work, worry and expense I don't want to fall over at the final hurdle', going on to note that he had already applied in vain to the Visual Arts Board, 'my third unsuccessful application since 1977'.[74]

The sheer scale and complexity of the task he now realised was beyond him. In a letter to Clem Christesen, McCulloch lamented the lack of financial support and his determination to press on. He sent off a VAB grant submission regardless: 'Anyway the complicated situation I'm in is largely my own fault for two reasons: (1) I've always been reluctant to seek official help. (2) I've never been able to resist the excitement of The Challenge. The bigger the problem the greater the excitement.'[75]

A small Special Purpose Grant from the Literature Board for travel and research costs was forthcoming in May 1982. Upon receiving the grant, McCulloch reminisced: 'The book began as a card filing system soon after I began writing professional art criticism for the *Argus*, in 1944. Reason was the number of letters received regarding information about artists. The material accumulated steadily, and intensive work began in 1960 with the MSS being completed in 1967.'[76] In the same month, arts administrator Katrina Rumley informed McCulloch that 'the VAB grant of $5,000 towards research of revised editions of the *Encyclopedia of Australian Art*' had been successful.[77]

The new and revised encyclopedia was launched at the National Gallery of Victoria's library on 2 October 1984. In his speech, McCulloch outlined his debt to Bernard Smith's seminal *Place, Taste and Tradition*, which led him to William Moore's *Story of Australian Art* 'and an abiding interest in the art history of our country'. Downplaying his own contribution and shortcomings, he once again humbly pointed to his own struggle with words and a lack of erudition 'that you get with Smith and Patrick McCaughey'.[78]

CHAPTER 13

POSTSCRIPT: WRITING AUSTRALIAN (ART) HISTORY

A work of art has to create a sensation in our minds never experienced before.

Goethe[1]

ALAN McCULLOCH'S CONTRIBUTION to the artistic and cultural life of Victoria ran deep. Arts editor of the *Age* Anthony Clarke acknowledged this in an article published on 17 October 1987, writing: 'Melbourne has been blessed with a few—a very few—men and women who, although not practising artists themselves, have played an immense role in supporting and nurturing our city's visual arts.' Among them he listed John and Sunday Reed, Georges Mora, Bernard Smith and Patrick McCaughey. 'I'm equally sure', he went on to say, 'that if some historian of the future labours to produce a definitive guide to the most influential chroniclers and shapers of the visual arts of our times, Alan McCulloch will stand tall among this art world elite.'[2]

While his many selfless deeds and adopted causes have been noted, McCulloch's legacy as an arts writer, historian and critic is harder to gauge. His contemporary Bernard Smith did not think him his intellectual equal. Some that he crossed paths with later, such as

Patrick McCaughey, Donald Brook and Terry Smith, were often in vehement disagreement with his views. They felt that he misinterpreted and misunderstood the work of the artists of their generation. A third generation of writers who knew him late in his life described him impassively as well meaning.

It is often said that critics respond best when they speak the language of their own generation, and Alan McCulloch is no exception to the rule; however, his was a long career and it meant that he was constantly being introduced to new art and new artists. It also meant that he had a chance to change his opinions, influence others and form new ones as the need arose. McCulloch's major writing on Australian art came at a time when Australian art was ready for fresh interpretations and an academic canon for writing and thinking about art was still being formed. Herbert Badham's and William Moore's books on Australian art were the only two general texts available when McCulloch first entered the field in the 1940s, along with Bernard Smith's *Place, Taste and Tradition* that was published in 1945. It is hard to believe that there was such scarcity of writing and ideas to draw upon: nothing expansive on the Heidelberg School, hardly a book on individual artists to be seen and certainly nothing on the modernist artists of the early to mid twentieth century that were making their mark at the same time as McCulloch was finding his own way.

One measure of a successful writing career is the ability to transform and adapt as one's experience grows. McCulloch did this quite often. He claimed, for example, that he found it difficult to respond to the early folk and expressionist art of Sidney Nolan in the 1940s, as he was still captivated by the more cultivated academic painting of George Lambert. But his taste and understanding of art matured. Criticised by some for what they took to be a blind allegiance towards the work of Antipodean artists such as Arthur Boyd, Sidney Nolan, Albert Tucker and John Perceval, he embraced a range of newly emerging artists in the 1950s and 1960s, including Jan Senbergs, Erica McGilchrist, Fred Williams, Roger Kemp and others.

In the 1970s and 1980s, McCulloch struggled to come to terms with many new and often short-lived art 'styles', including conceptual art. Sculpture for McCulloch was tactile and experiential—something that thrilled you when you could hold it in your hand or walk around it, not simply an idea without content. Nevertheless, he still covered the work of conceptual artists in his weekly columns and tried to place the work of their many adherents and other international exponents such as Christo against his own values and ideas. In this way, he defied the overly narrow categorisation of him as an apologist for the one generation over another. McCulloch certainly looked to uphold time-honoured visual traditions, but he also showed a preparedness to be stretched and expand upon his thinking.

A second indication of a successful critic is the ability to distinguish between art that will not only survive its own generation but also flourish in the next. Again, McCulloch proved himself usually adept at this, pointing, for instance, to his many years of 'eulogising' the achievements of Fred Williams, his lifelong support of Joy Hester and his adoption of two generations of 'migrant' artists, including being one of the early and most voracious supporters of post-war Australian sculpture.

A third criterion for success is the ability and desire to write, speak and broadcast over a variety of media and platforms. Like his French hero André Malraux, McCulloch was equally at home in print, on radio and on television, though he continued to tap one finger at a time on a serviceable but antiquated Remington typewriter.

Although painted as a moderate or conservative, McCulloch was abreast of and ahead of his time in some areas. He embraced the art of the Asia-Pacific region long before it was popular to do so. He championed Indigenous art and culture both in Australia and overseas during a period in which Aboriginal and Torres Strait Islander people still did not exist as Australian citizens or have the right to vote.

McCulloch was committed to democratic ideals of art and in making art accessible to as many people as possible. This extended

from the development of popular public art exhibitions such as the *Herald Outdoor Art Show* through to his adaption to new avenues of broadcasting. He was an important player in the relaunching of the Australian book publishing industry and part of a new wave of art scholarship that championed local, modern artists in the 1950s and 1960s. He drew people together, cultivated enduring relationships and combined three separate skill sets—making art, writing about it and organising exhibitions and other events.

Underlying all of this was McCulloch's pre-digital opus, *The Encyclopedia of Australian Art*, the first and possibly last of its kind, and the two books he produced for Lansdowne in 1967 and 1977. *The Golden Age of Australian Painting* made an important early contribution to a canon of writing by establishing the groundwork for a greater awareness of Australian Impressionism. In a sense it paved the way for later revisionist texts by focusing on the similarities and differences in the stylistic approaches of the major artists, identifying the essentially urban nature of the movement (if not the subject matter), recognising black and white artists such as ST Gill as important precursors, and teasing out the convoluted relationship between Australian Impressionism and its multitude of European sources. This was followed by *Artists of the Australian Gold Rush*, a book characterised by writer and academic Sasha Grishin in 2015 as a 'valuable contextual assessment of Gill [that] did not attract the attention it deserved'.[3] For McCulloch, Gill represented one of the great artists of the mid-nineteenth century, combining skills in painting, drawing and lithography as well as providing a wide-ranging perspective on colonial life.

McCulloch the writer traversed two ideals. One was as a compiler of facts—laboriously sorting and sifting biographical details, much of it severely lacking or difficult to access when he was active, to the extent that the exacting process of getting things right preoccupied him from the 1930s through to the late 1960s. The other writer undertook sorting and sifting of a different sort. In his forty years' work as an arts writer, author and critic he remained steadfast in the

idea—and more opinionated from beginning to end—that artists possessed a unique capacity to inspire, inhabit and liberate people's hearts and minds. It was his job to draw out and elucidate upon the best (and deter the less convincing) efforts. As McCulloch, recounting from his hero Goethe, expressed it: 'Individuality of expression is the beginning and end of all art.'

NOTES

Introduction
1 Alan McCulloch, diary entry, 1959, McCulloch Family Papers.
2 Sheridan Palmer, *Hegel's Owl: The Life of Bernard Smith*, Power Publications, Sydney, 2016, p. 1.

Chapter 1 Call to Arms
1 Alan McCulloch, 'The Question Mor', unpublished manuscript, undated, MS13506, Alan McCulloch Papers, La Trobe Australian Manuscripts Collection, State Library Victoria (hereafter SLV), Box 10, unpag.
2 ibid.
3 ibid. Along with the example of his parents, McCulloch had contact with other artistic types who impacted upon his desire to become an artist, either by chance or good design. They included artist Francis Rodriguez, who painted watercolours with Alan's family and was married to singer Gladys Crighton, and a Mrs Sheldon, with whom McCulloch had his first drawing lessons in 1922.
4 McCulloch, 'The Question Mor'.
5 The Leyshon White School attracted many aspiring artists, including, most famously, the young Sidney Nolan. The artists McCulloch met there became part of his circle of friends.
6 McCulloch, quoted in Christopher Heathcote, 'Conversations with Alan McCulloch', *Art Monthly Australia*, April 1993, no. 58, p. 15.
7 ibid., p. 15. See also Bernard Smith, *Noel Counihan: Artist and Revolutionary*, Oxford University Press, Melbourne, 1993, pp. 52–4.
8 In 'The Question Mor', McCulloch commented: 'My father's sketchbooks had been my first inspiration; later had come the Phil May book presented to me by Uncle Matthew and the Charles Keene book he had given to Kookaburra Bill [Wilfred]. To these books I owed everything for they showed me a way and the rest was a matter of hard work, of trial and error, of alteration and experiment.'

9 Draft of unpublished fictional biography, Alan McCulloch Papers, SLV, Box 23.
10 After he left Australia in 1930 Dyson continued to correspond with McCulloch. A typed note preserved on Chelsea Arts Club letterhead recorded: 'Dear Mr McCulloch, A very, very belated acknowledgement of your little book. Congratulations on it. I think the Drawings have a real touch. Best of all good wishes. Will Dyson.' 22 October 1935, McCulloch Family Papers.
11 McCulloch, quoted in Vane Lindesay, 'Alan McCulloch: Cartoonist of Distinction', *La Trobe Journal*, nos 93–94, September 2014, p. 176.
12 See also McCulloch, letter to Vane Lindesay, 25 February 1976, SLV, Box 51. Here McCulloch responds to Lindesay's research request regarding his *Inked-in Image* monograph and talks of his association with Will Dyson.
13 Richard Lane, letter to McCulloch, 18 June [1939]. Lane recalls meeting McCulloch 'one afternoon at Norman Lindsay's studio in Sydney'. McCulloch Family Papers.
14 McCulloch, letter to JR Flanagan (undated), SLV, Box 55. See also E Sullivan, letter to McCulloch, 6 September 1932, SLV, Box 55, in which he notes with satisfaction that McCulloch has 'succeeded in interesting Norman Lindsay in connection with your proposed book'.
15 E Sullivan, letter to McCulloch, 25 June 1930, SLV, Box 55.
16 Associate Editor, *The Australasian*, letter to McCulloch, 31 January 1930, SLV, Box 55.
17 McCulloch, letter to HR Gollan, 5 July 1933, SLV, Box 55.
18 Unknown writer, letter to McCulloch, 7 October 1934, SLV, Box 47.
19 Hayler, letter to McCulloch, 23 May 1936, SLV, Box 55.
20 Pike Bros. Director, letters to McCulloch, March–July 1939, SLV, Box 47.
21 Allan McCoy & Co., letter to McCulloch, 11 November 1937, SLV, Box 47.
22 Neville Smith, letter to McCulloch, 2 December 1938, SLV, Box 47.
23 McCulloch, 'Speech for the official opening of an exhibition of Sidney Nolan Wimmera paintings at Benalla Art Gallery', 25 May 1987, SLV, Box 49.
24 ibid. An excellent description of Alan and Wilfred McCulloch's experiences as students at the National Gallery School is provided in the same speech.
25 Sedon Galleries, invoice dated 12 February 1931, SLV, Box 55.
26 *Herald*, 13 January 1931, SLV, Box 40. See also McCulloch's letter to a family friend in England in which he gives rare and interesting thoughts on his art, 5 January 1931, SLV, Box 55.
27 Undated newspaper cutting, SLV, Box 37.
28 McCulloch, unpublished fictional autobiography, August 1990, SLV, Box 23.
29 For a comprehensive examination of the exhibition and its Australian background, see Eileen Chanin and Steven Miller, *Degenerates and Perverts: The 1939 Herald Exhibition of French and British Contemporary Art*, Miegunyah Press, Melbourne, 2005.
30 McCulloch, 'Speech for the official opening of an exhibition of Sidney Nolan Wimmera paintings'.
31 McCulloch, quoted in Lou Klepac, 'Salute to Alan McCulloch', *Art and Australia*, vol. 29, no. 2, 1993, p. 179.

32 Sue Beatty, https://taggerty.wordpress.com/the-story/chap-11-mcbeatsome/
33 The article was published by Elwyn Lynn in the Contemporary Art Society's *Broadsheet* in 1963. See Clem Christesen, letter to McCulloch, 10 September 1963, SLV, Box 45.
34 Boyd, letter to McCulloch, undated, on League of Soldiers' Friends letterhead, SLV, Box 39.
35 McCulloch, 'Unpublished speech notes', 1985, SLV, Box 18.
36 See Raymond Moyser, Acting Editor, *Picture News*, letter to McCulloch, 23 August 1940, SLV, Box 47. Moyser was informing McCulloch of his plan 'to discontinue the Gulderbrandt cartoons as of this week'.
37 McCulloch, letter to Captain FG Sutton, and Commanding Officer, Southern Command Defence, 19 June 1940; Sutton, letter to McCulloch, 22 June 1940, SLV, Box 47.
38 McCulloch, letter to Robert Menzies, 11 July 1940, SLV, Box 47. There was also a far more outlandish request to join the Australian Camel Corps that received the following response: 'the formation of such a Corps is not yet at present contemplated'. McCulloch, letter to the Secretary for War, 2 September 1940, SLV, Box 47.
39 Basil Burdett, *Herald*, 30 July 1940, SLV, Box 47.
40 Richard Haese, *Rebels and Precursors: The Revolutionary Years of Australian Art*, Allen Lane, London, 1981, p. 130.
41 McCulloch, letter to the Hon. Secretary, Artists Unity Congress, 26 March 1944; Herbert McClintock, letter to McCulloch, 28 March 1942, SLV, Box 55.
42 McCulloch, letter to HG Jones, undated [1944]; Jones, letter to McCulloch, 11 July [1944], SLV, Box 55.
43 McCulloch, letter to Manager, CBA, 18 July 1944, SLV, Box 55.
44 McCulloch to Governor, CBA, undated [July 1944]; CBA Governor to McCulloch, 6 September 1944, SLV, Box 55.
45 CE McKenzie, letter to McCulloch, 5 February 1944, SLV, Box 47.
46 'Ballets Russes Australian tours (1936–1940)', Trove, http://trove.nla.gov.au/list?id=1194
47 Catherine O'Donoghue, 'Astonish Me! Australian Responses to the Ballets Russes', *Creative Australia and the Ballets Russes*, Arts Centre, Melbourne, 2009, p. 11.
48 McCulloch, 'Theatre Art', unpublished manuscript, SLV, Box 54.
49 McCulloch, 'Design for the Theatre', National Theatre Arts Festival, Souvenir Programme, 1952, SLV, Box 37.
50 Robin Grove, 'Borovansky, Edouard (1902–1959)', Australian Dictionary of Biography, National Centre of Biography, Australian National University.
51 Janet [illeg.], letters to McCulloch, McCulloch Family Papers, 28 May 1944 and 14 July 1944.
52 Unknown writer, *Herald*, August 1944, SLV, Box 40.
53 Harold Herbert, 'The Ballet in Pencil and Paint', *Argus*, undated; CT, 'Art and the Ballet', undated, SLV, Box 37.
54 Macgeorge, letter to McCulloch, 19 January 1946, McCulloch Family Papers. Norman Macgeorge, *Borovansky Ballet in Australia and New Zealand*, Cheshire, Melbourne, 1946. *Russian Dancers*, pen and wash by Alan McCulloch, was

reproduced on p. 52. McCulloch's *Sea Legend* was replaced by one of Norman Macgeorge's paintings of the same subject, p. 61.
55 *Argus*, 20 May 1944.
56 Alan Brissenden and Keith Glennon, *Australia Dances: Creating Australian Dance 1945–1965*, Wakefield Press, Adelaide, 2010.
57 GWH, *Argus*, 10 March 1947, p. 6.
58 Schonbach, letter to McCulloch, 28 November 1946, SLV, Box 46.
59 Llewellyn, letter to McCulloch, 1 December 1946, SLV, Box 46.
60 McCulloch, letter to MacDonald, undated, SLV, Box 47.
61 McCulloch, unpublished manuscript, c. 1942–43, SLV, Box 55.
62 Pike, letter to McCulloch, [1942], SLV, Box 47.
63 Robert Haines, Director of Georges Gallery, letter to McCulloch, 25 March 1946, SLV, Box 47.
64 Gary Kinnane, *George Johnston: A Biography*, Thomas Nelson Australia, Melbourne, 1986, pp. 70–84.
65 McCulloch, 'Biographical Information', McCulloch Family Papers.
66 McCubbin, letter to McCulloch, 6 March 1945, SLV, Box 48.
67 Counihan, letter to McCulloch, 25 March 1945, SLV, Box 48.
68 McCulloch, letter to Mr Knox, 5 March 1946, SLV, Box 46. At the same time, McCulloch also recommended Ronald Renn and William Monk, 'Memo to Mr Knox', 5 March 1946, SLV, Box 46.
69 Catherine Caris, letter to McCulloch, undated [1945], SLV, Box 47.
70 Flower, letter to McCulloch, undated [1945], SLV, Box 47.
71 Gea… [illeg.], letter to McCulloch, 12 February 1945, SLV, Box 47.
72 Schonbach, letter to McCulloch, 28 November 1946, SLV, Box 46. A few years later, McCulloch was able to help Schonberg with contacts and places to stay while he visited Europe. In return, Schonberg sent back a lovely illustration of 'a sick Fritz in hospital recovering from mumps', 9 January 1950, SLV, Box 39.
73 Smalley, letter to the Editor, *Australasian Post*, 12 May 1946, SLV, Box 47.
74 Martin, letter to McCulloch, 26 November 1946, SLV, Box 47.
75 McCulloch, 'Memo to George Johnston', undated [April/May 1946], SLV, Box 47.
76 Major-General Lloyd to Johnston, 9 May 1946, SLV, Box 47.
77 McCulloch, *Argus*, 21 August 1945.
78 McCulloch, *Argus*, 7 November 1945.
79 Vike, letter to the Editor, undated [1945], SLV, Box 47.
80 *Argus*, 31 October 1944.
81 *Argus*, 21 August 1945.
82 *Argus*, 18 September 1946.
83 *Argus*, 23 July 1946.
84 'Confidential notes of interview with Messrs Neville Smith, Atkinson, Brown and Grant', 3 October 1945, SLV, Box 46.
85 Smith, letter to McCulloch, 28 July 1945, SLV, Box 47.
86 McCulloch, letter to the Editor, [1946], SLV, Box 46.
87 'Five drawings—by Constance Stokes, Karl Dorn, Noel Counihan, Harald Vike, and Alan McCulloch—have been purchased for the National Gallery.

The last three artists are well-known contributors to *The Australasian Post.*' *Argus,* 10 June 1946, p. 2.
88 JH Rasmussen, letter to McCulloch, 11 December 1946, SLV, Box 46.
89 Richard Haese, in conversation with McCulloch, 1974, in *Rebels and Precursors,* p. 287.
90 McCulloch, letter to Mr Knox, 12 December 1946, SLV, Box 48.

Chapter 2 On the Road
1 The issue of exactly where to go, how to get around and for how long generated interest and debate. Friends were quick to offer advice. Amateur artist Guy Lynch wrote from Darwin, where he was stationed with Works of Housing, saying that he was surprised that Alan had lasted as long as he did at the *Argus,* counselling him against going to Mexico and the Americas first: 'It is your duty to go to the cradle of civilisation through the Middle East + onto Europe.' Lynch, letter to McCulloch, 7 January 1947, SLV, Box 46. Where did he go first? Well America, of course. His journey there echoed the experiences of one of the original Cape Schanck artists, Donald Town, who wrote to McCulloch from New York describing his trip and the wealth of art on show during visits to San Francisco, Los Angeles and New York, where at the Met he had seen 'no less than 10 Goyas' and 'each country [was] represented by a room'. Donald Town, letter to McCulloch, 22 June 1936, SLV, Box 46.
2 McCulloch, letter to Mr Bonney, 16 December 1946, SLV, Box 47.
3 Kevin Murphy, letter to McCulloch, 30 December 1946 and 31 December 1946, SLV, Box 55.
4 McCulloch, letter to Daryl Lindsay [1947], cover note and accompanying letter addressed to Professor Sizer, Met, undated, SLV, Box 55. McCulloch, letter to The President, General Federation Women's Clubs, Washington DC, 7 January 1947, SLV, Box 55.
5 Murdoch, letter to McCulloch, 5 February 1947; McCulloch to Murdoch, 4 February 1947, SLV, Box 55.
6 McCulloch, letter to Annie McCulloch, 2 May 1947, SLV, Box 55.
7 McCulloch, letter to Annie McCulloch, 25 May 1947, SLV, Box 55.
8 McCulloch, letter to Dr Grace L McCann Morley, 6 June 1947. See also Morley to McCulloch, 23 May 1947, SLV, Box 55.
9 McCulloch, letter to Annie McCulloch, 9 July 1947, SLV, Box 55.
10 McCulloch, *Highway Forty,* Cheshire, Melbourne, 1951, p. 33.
11 McCulloch, letter to Annie McCulloch, 12 June 1947, SLV, Box 55.
12 Kevin Murphy, letter to McCulloch, 11 June 1947, SLV, Box 40.
13 McCulloch, letter to Annie McCulloch, 23 June 1947, SLV, Box 55.
14 Susan McCulloch, conversation with the author, May 2023.
15 Alan McCulloch, letter to Annie McCulloch, 14 August 1947, SLV, Box 55.
16 Alan McCulloch, 'A Fictionalised Biography', McCulloch Family Papers.
17 Allen, letter to McCulloch, 26 October 1951, SLV, Box 39.
18 Alan McCulloch, letter to Art Studens League of New York, 1947, McCulloch Family Papers.
19 Ellen McCulloch, letter to Annie McCulloch, 5 November 1957, SLV, Box 55.

20 Alan McCulloch, 'John Russell', *Herald*, undated, McCulloch Family Papers.
21 McCulloch, letter to Annie McCulloch, 9 July 1947, SLV, Box 55.
22 George Grosz, letter to McCulloch, 29 April 1948, SLV, Box 55.
23 ibid.
24 McCulloch, 'The Stickmen', 12 April – 1 May 1947, McCulloch Family Papers.
25 McCulloch, unpublished diary, 17 August 1947, SLV, Box 44.
26 Thomas, letter to McCulloch, 5 September 1947, SLV, Box 40.
27 McCulloch, letter to Annie McCulloch, 20 August 1947, SLV, Box 21.
28 ibid.
29 Bailey, letter to McCulloch, 19 December 1947, SLV, Box 21.
30 Bailey, letter to McCulloch, 13 April 1948, 28 April 1948 and 5 May 1948, SLV, Box 21.
31 Invoice to the Curtis Publishing Company, Philadelphia, 11 November 1947 and 6 April 1948, SLV, Box 21.
32 McCulloch, letter to Annie McCulloch, 14 October 1947, SLV.
33 McCulloch, letter to Yates, 13 April 1948, SLV, Box 21.
34 Ellen McCulloch, letter to Annie McCulloch, 19 April 1948, McCulloch Family Papers.
35 Hine, letter to McCulloch, 11 March 1949, SLV, Box 39.
36 McCulloch, 'The Painted Portrait in Art', *Genre*, vol. 1 no. 2, pp. 4–5; 'Popularity Is No Criterion', *Genre*, vol. 1 no. 1, 1946.
37 Annois, letter to McCulloch, 9 August 1947, SLV, Box 39.
38 Annois, letter to McCulloch, undated [1947], SLV, Box 39.
39 Haughton James, letter to McCulloch, 23 March 1948, SLV, Box 39.
40 Annois, letter to McCulloch, no date [1949], SLV, Box 39.
41 Annois, letter to McCulloch, 4 August 1949, SLV, Box 39.
42 McCulloch, letter to Adrian Bury, 9 November 1966, SLV, Box 48.
43 Fabinyi, letter to McCulloch, 21 October 1946 and 12 December 1946, SLV, Box 17.
44 Hoff, letter to McCulloch, 30 June 1947, SLV, Box 17.
45 Lindsay, letter to McCulloch, 30 October 1947, SLV, Box 17. In a follow-up letter to McCulloch, Andrew Fabinyi concurred that while he had enjoyed reading his articles 'very much' and that they 'are a convincing sort of criticism … Nevertheless I myself felt that a considerable amount of re-arranging, re-writing and further research is needed before your contribution can be fitted into the whole scheme of the book'. 7 November 1947, SLV, Box 17.
46 McCulloch, letter to Lindsay, 25 November 1947, SLV, Box 17; Hoff, letter to McCulloch, 15 November 1947, SLV, Box 17.
47 Lindsay, letter to McCulloch, 30 October 1947, SLV, Box 17.
48 McCulloch, unpublished manuscript [1947], SLV, Box 18.
49 Joan Lindsay, letter to McCulloch, 11 November [1947]; 17 June [1948], SLV, Box 17.
50 Fabinyi, letter to McCulloch, 26 August 1949, SLV, Box 17.
51 McCulloch, letter to Fabinyi [September 1947], SLV, Box 17.
52 Klippel, letter to McCulloch, 31 July 1962, SLV, Box 46.
53 McCulloch, unpublished diary entry, 17 July 1948, SLV, Box 44.
54 Emily McCulloch-Childs, interview with the author, 2017.

55 The eight-day congress was attended by critics from thirty-five countries, and according to McCulloch it 'opened more doors to the art world of France than we could normally have expected to enter in a year'. *Trial by Tandem*, Cheshire, Melbourne, 1950; reprinted 1951, p. 8.
56 Myers, letter to McCulloch, 13 July 1948, SLV, Box 39.
57 McCulloch, unpublished manuscript, April 1949, SLV, Box 54.
58 *Trial by Tandem*, p. 115.
59 Ibid. p. 207.
60 Alan McCulloch, diary entry, 1949, SLV, Box 2.
61 Nibbi, letter to McCulloch, 7 December 1948, SLV, Box 40.
62 Nibbi, letter to McCulloch, 1 January 1949, SLV, Box 40.
63 Nibbi, letter to McCulloch, 5 February 1949, Box 39.
64 Nibbi, letter to McCulloch, [1949], SLV, Box 39.
65 Vike, letter to McCulloch, 17 February 1949, SLV, Box 40.
66 Richmond, letter to McCulloch, 5 March 1949, SLV, Box 40.
67 Warren, letter to McCulloch, 8 May 1946, SLV, Box 47.
68 Eric Newton, *Sunday Times*, 4 September 1949.
69 Tucker, letter to McCulloch, undated [1949], SLV, Box 39.
70 McCulloch, 'Lines of Communication', unpublished manuscript reworked as 'Education of the Layman'—a plea to 'simplify the job of understanding art', not to 'bludgeon them into submission' [1949], SLV, Box 54.
71 Tucker, letter to McCulloch, undated [1949], SLV, Box 39.

Chapter 3 The Critic Responds
1 McCulloch, letter to Mary Jakowenko, 5 October 1971, SLV, Box 50.
2 Simon Plant, *Patrolling the Frontiers: The Art Criticism of Alan McCulloch 1951–1962*, MA thesis, University of Melbourne, 1995.
3 Unpag. newspaper cutting, *Age*, 30 November 1949, SLV, Box 40.
4 Arnold Shore, review of Alan McCulloch exhibition, undated; *Age* art critic, undated, SLV, Box 40. See also WD Fall, 'AM Italian Paintings', undated, SLV, Box 55.
5 Swanton, letter to McCulloch, 10 March 1953, SLV, Box 47.
6 Treanea Smith, letter to McCulloch, 4 June 1953 and 2 July 1953, SLV, Box 21.
7 Jim and Sue Sharp, letter to McCulloch, 29 July 1953, SLV, Box 47.
8 *Sydney Morning Herald*, 30 July 1953.
9 Ostoja-Kotkowski, letter to McCulloch, 3 October 1953, McCulloch Family Papers.
10 Brack, letter to McCulloch, 16 June 1953, SLV, Box 21.
11 Reg Campbell, letters to and from McCulloch, 4 June 1950, 19 July 1950 and 8 August 1950, SLV, Box 47.
12 Allen, letter to McCulloch, 26 October 1952, SLV, Box 39.
13 RY Walker Advertising, Melbourne, 15 July 1958, SLV, Box 47.
14 McCulloch, letter to Valerie Dunn, 19 September 1951, SLV, Box 47.
15 Usborne, letter to McCulloch, 11 July 1949; Augustus Baker, letter to McCulloch, 27 February 1950, SLV, Box 38.
16 Hine, letter to McCulloch, 15 February 1949, SLV, Box 39.
17 Hine, letter to McCulloch, 19 November 1949, SLV, Box 39.

18 Fabinyi, letter to McCulloch, 5 January 1950, SLV, Box 21.
19 Hetherington, 'Two on a Tandem in Europe', *Herald*, 11 November 1950, p. 16.
20 *Courier-Mail*, 22 December 1951, *Sunday Herald*, 13 January 1952, *Advertiser* (Adelaide), [undated], SLV, Box 21.
21 *Age*, 8 December 1951, SLV, Box 21.
22 'Art Critics Angles in America', Radio Australia script, undated; *Australian Women's Weekly*, 19 December 1951, SLV, Box 21.
23 Porter, *New Statesman*, 6 December 1952, pp. 688, 690; See also *Sunday Sun and Guardian*, 17 February 1952, p. 17, SLV, Box 21.
24 Fabinyi, letter to McCulloch, 4 February 1953, SLV, Box 21.
25 McCulloch, 'Contemporary Art Trends', unpublished manuscript [1952], SLV, Box 54.
26 G Charlton, letter to McCulloch, 2 April 1952, SLV, Box 39.
27 For example, 'Alan writes simply and does not strive to impress you with big words and strangely phrased remarks': Mary de Selle, letter to McCulloch, 27 June [1951], SLV, Box 39.
28 Jean Lyle, letter to the Editor, *Herald*, 3 October 1951; see also James D McMahon, letter to the Editor, *Herald*, 2 October 1951, SLV, Box 39.
29 Thomas, 'Memo to McCulloch', 19 August 1952, SLV, Box 46.
30 Thomas, letter to McCulloch, 25 January 1955, SLV, Box 52.
31 McCulloch, undated draft memo, SLV, Box 46. See also McCulloch's memo to Sir John Williams on editorial proprietorial control following up on discussions they had had 'about art prizes and mention of the names of companies in my column'. Sir JF Williams, letter to McCulloch, March 1964, SLV, Box 46.
32 Editor, letter to McCulloch, 3 May 1966, SLV, Box 55.
33 Editor, letter to McCulloch, 18 March 1966, SLV, Box 54.
34 Millar, letter to McCulloch, 30 October [1980s], SLV, Box 46.
35 McCulloch, letter to Douglas R Ray, 17 October 1956, SLV, Box 48.
36 McCulloch, biographical information supplied to Clem Christesen, undated, SLV, Box 12.
37 Kemp, letter to McCulloch, 12 September 1951, SLV, Box 55.
38 McCulloch, letter to Valerie Dunn, 19 September 1959, SLV, Box 47.
39 Christesen, letter to Alan and Ellen McCulloch, 8 February 1955, SLV, Box 45.
40 Christesen, letter to McCulloch, 14 March 1956, SLV, Box 45.
41 Christesen, letter to McCulloch, 6 October 1959, SLV, Box 45.
42 McCulloch, 'The Art of ST Gill', *Meanjin*, vol. 10, no. 1, 1951, pp. 27–32; 'The Drawings of Louis Kahan' and 'Paintings by Roger Kemp', *Meanjin*, no. 40, Autumn 1951, pp. 45–7 and p. 48.
43 See also McCulloch, 'The Drawings of Ostoja-Kotkowski', *Meanjin*, no. 46, Spring 1951, pp. 256–7.
44 McCulloch, 'Paintings by Roger Kemp'.
45 Christesen, letter to McCulloch, 22 May 1951, SLV, Box 45.
46 McCulloch, 'The Drawings of Arthur Boyd' and 'Leonard French, Artist of Promise', *Meanjin*, no. 45, Winter 1951, pp. 155–6 and p. 154.
47 Although Smith had at this stage returned to employment at the Art Gallery of New South Wales, McCulloch, who had had to work in a day job for eighteen

years before his first art appointment, would have had a right to feel envious of Smith's career trajectory, which included the study in London, a follow-up scholarship that commenced in 1952 at the newly established Australian National University, where he completed a PhD, and his appointment as lecturer and then a senior lecturer in the University of Melbourne's fine arts department (1955–67). In 1967, the Smiths moved to Sydney, where Smith became the founding professor of contemporary art and director of the Power Institute of Fine Arts, University of Sydney. He held this position until his retirement in 1977. Source: *Wikipedia*.

48 McCulloch, 'Australian "Expressionism"', *Meanjin*, no. 48, Autumn 1952, p. 47; Bernard Smith, 'Australian Expressionism' and Alan McCulloch, 'Australian Expressionism', *Meanjin*, no. 50, Spring 1952, pp. 256–61.
49 Smith, letter to McCulloch, 25 June 1951, SLV, Box 55.
50 Christesen to Alan and Ellen McCulloch, 8 February 1955, SLV, Box 45.
51 Christesen, letter to McCulloch, 15 September 1959, SLV, Box 46.
52 Christesen, letter to McCulloch, 13 February 1956, SLV, Box 45. See also a letter dated 15 September 1959, SLV, Box 46.
53 *Herald*, 21 February 1951, SLV, Box 52. McCulloch took up this cause upon the *Herald* receiving a two-page international telegram from Len Voss Smith from Christie's in London questioning the authentication of the painting, which had been bought in Paris.
54 For a fulsome contemporary background to the purchase, see Christopher Marshall, 'Between Beauty and Power: Henry Moore's *Draped seated woman* as an Emblem of the National Gallery of Victoria's Modernity, 1959–68', *Art Journal*, no. 46, 29 January 2009.
55 McCulloch, 'World of Art', *Herald*, 22 June 1960, p. 22.
56 Mackay, letter to McCulloch, 31 July 1958, SLV, Box 47.
57 McCulloch, 'Have SE Asian Show Here', *Herald*, 4 April 1956.
58 Noel Goss, letter to McCulloch, 6 October 1956 and 3 May 1956, SLV, Box 54.
59 McCulloch, letter to JV Dillon, Under Secretary, Chief Secretariat Office, Treasury, 17 November 1967, SLV, Box 40.
60 *Herald*, 4 July 1951.
61 Adam, letter to McCulloch, 5 July 1951, SLV, McCulloch Family Papers.
62 Adam, letter to McCulloch, 23 July 1954, SLV, Box 55.
63 Adam, letter to McCulloch, 9 April 1955, SLV, Box 46.
64 Letter to McCulloch, 29 March 1954, SLV, Box 55.
65 George Bell, letter to McCulloch, 27 January 1954; and McCulloch's response, 18 March 1954, SLV, Box 52.
66 Thomson, letter to McCulloch, 23 March 1954, SLV, Box 52.
67 McCulloch, letter to Town Clerk, Darwin, 6 July 1962, SLV, Box 54.
68 McCulloch, letter to Dooling, 30 November 1956, SLV, Box 47.
69 Elizabeth Bragnetz, letter to McCulloch, 28 August 1958, SLV, Box 47; McCulloch's handwritten note is included on the letter from Bragnetz.
70 H Gordon Green, letter to McCulloch, 24 October 1958, SLV, Box 47.
71 'The Downfall of Albert Namatjira: Australians toasted an Aborigine's genius until his tragedy passed before their eyes', *Family Herald*, Montreal 1958, McCulloch family papers. I am grateful to Susan and Emily McCulloch for

bringing my attention to the article and its contents which are as challenging today as it was in the 1950s when it wasn't able to be published in Australia due to its confronting nature.

72 McCulloch, 'Battle Cry of Antipodeans', *Herald*, 5 August 1959.
73 Smith, letter to McCulloch, 6 August 1959, SLV, Box 52.
74 McCulloch, 'Sculpture Show Is Spirited', *Herald*, 26 August 1959.
75 Pugh, letter to McCulloch, 9 July 1959, SLV, Box 48.
76 Sarah Scott, 'A Colonial Legacy: *Australian Painting* at the Tate Gallery, London, 1963', in *Seize the Day: Exhibitions, Australia and the World*, edited by Kate Darian-Smith, Richard Gillespie, Caroline Jordan and Elizabeth Willis, Monash University ePress, Melbourne, 2008, pp. 19.1–19.22.
77 McCulloch, letter to McCusker, 22 March 1962, SLV, Box 46.
78 McCulloch, 'Shake-Out Is Needed at the Tate Show', *Herald*, and 'The Tate Show Nearly Makes It', *Herald*, 21 March 1962.
79 Counihan, letter to McCulloch, 1 April 1962, SLV, Box 46.
80 McCulloch, 'Shake-Out Is Needed at the Tate Show'.
81 Sime, letters to and from McCulloch, 25 and 28 March, 2 April 1962, SLV, Box 47.
82 Thomas, quoted in Scott, 'A Colonial Legacy'.
83 French, letter to McCulloch, 5 January 1963. See also a follow-up letter and report on the Tate show, 2 April 1963, SLV, Box 46.

Chapter 4 Galvanising the Critics

1 Tucker, letter to McCulloch, 30 April 1951, McCulloch Family Papers.
2 Smith, letter to McCulloch, 16 June 1960, SLV, Box 36.
3 McCulloch, letter to Smith, 24 June 1960, SLV, Box 47.
4 McCulloch, letter to J Russell, 24 April 1962, SLV, Box 36; HJ Russell, letter to McCulloch, 8 December 1960, SLV, Box 36.
5 Gille-Delafon, letter to McCulloch, 7 April 1964, SLV, Box 40.
6 Thornton, letter to McCulloch, 22 July 1963, SLV, Box 36.
7 McCulloch, letter to Thornton, 30 July 1963, SLV, Box 36.
8 McCulloch, letter to Gladys Foster, 7 January 1967, SLV, Box 40.
9 McCulloch, letter to Pyke, 23 October 1963, SLV, Box 36; McCulloch, letter to Sir Arthur Tange, 10 September 1963, SLV, Box 36.
10 McCulloch, letter to the Editor, *Spectator* [1962], McCulloch Family Papers.
11 McCulloch, letter to Bernard Smith, 19 April 1966, SLV, Box 40.
12 Alan McCulloch, 'Tritons and Mermaids: A Retrospective View of the Sydney Opera House', *Meanjin Quarterly*, Spring 1967.
13 Sheridan Palmer, *Hegel's Owl: The Life of Bernard Smith*, Power Publications, Sydney, 2016, p. 221.
14 Sheridan Palmer, in conversation with the author, 2013; Palmer, *Hegel's Owl*, p. 221.
15 Minutes, Fourth Annual Meeting Adelaide, AICA, 12 and 13 March 1966, SLV, Box 40.
16 Smith, letter to McCulloch, 24 March 1966, SLV, Box 40.
17 Salek Mink, letter to McCulloch, 5 August 1965, SLV, Box 40.
18 McCulloch, letter to Souillac, 18 March 1966, SLV, Box 40.

19 McCulloch, letter to the Secretary, Prime Minister's Department, Canberra, March 1966, SLV, Box 40.
20 Drysdale, letter to McCulloch, 22 May 1966; McCulloch to Drysdale, 14 May 1966, SLV, Box 40.
21 McCulloch, letter to Coombs, 15 July 1966, SLV, Box 40.
22 McCulloch, letter to Prime Minister Holt, 26 July 1966, SLV, Box 40.
23 McCulloch, letter to Seidel, 4 December 1967, SLV, Box 40.
24 Smith, letter to McCulloch, 25 September 1967, SLV, Box 40.
25 Smith, letter to McCulloch, 2 July 1966, SLV, Box 40.
26 JV Dillon, letter to McCulloch, 21 July 1967 and 17 October 1967, SLV, Box 40.
27 Lynn, letter to McCulloch, 21 February 1966, SLV, Box 40. Lynn went on to say that 'in any event DT thinks' that 'Bernard was not truly a critic, that he was a university man in essentials …'
28 McCulloch, letter to Seidel, 17 August 1966, SLV, Box 40.
29 McCulloch, letter to Kommer, 26 September 1966, SLV, Box 40. Charles Bush had had a part share in Leveson Street Gallery in Melbourne.
30 McCulloch, letter to Kommer, 12 November 1966; Kommer, letter to McCulloch, 1 November 1966, SLV, Box 40.
31 McCulloch, letter to Lynn, 16 November 1966, SLV, Box 40.
32 Smith, letter to McCulloch, undated, and McCulloch's point-by-point reply to Smith, 7 January 1967, SLV, Box 48.
33 Smith, letter to Kommer, 30 January 1967, SLV, Box 40.
34 Smith, letter to McCulloch, 25 September 1967, SLV, Box 40.
35 McCulloch, memo to Mr Daly, *Herald*, 9 October 1967; Smith, letter to McCulloch, 4 October 1967, SLV, Box 40.
36 McCulloch, letter to Smith, 23 October 1967, SLV, Box 40.
37 Smith, letter to McCulloch, 23 January 1968 and revised itinerary, 13 March 1968, SLV, Box 40.
38 McCulloch, letter to Smith, 22 November 1967, SLV, Box 40; Smith to McCulloch, 30 October 1967, SLV, Box 40.
39 McCulloch, letter to Smith, 22 November 1967, SLV, Box 40.
40 McCulloch, letter to Westbrook, 3 April 1968, SLV, Box 48.
41 Greenberg, letter to McCulloch, 7 June 1968, SLV, Box 48
42 Thomas, letter to McCulloch, 10 June 1968, SLV, Box 48.
43 McCulloch, 'Clement Greenberg's Visit: The Unsure Audience', unpublished manuscript, unpag., SLV, Box 40.
44 McCulloch, letter to the Editor, *Nation Review*, 18 September 1974, SLV, Box 51.
45 Olsen, letter to McCulloch, 24 April 1962, SLV, Box 46.
46 Turnbull, letter to McCulloch and McCulloch's same-day reply, 28 February 1968, SLV, Boxes 48 and 50.
47 Turnbull, letter to McCulloch, 3 December 1968, SLV, Box 48.
48 McCulloch, letter to Turnbull, 5 March 1969, SLV, Box 50.
49 McCulloch, *Herald*, 16 and 24 August 1968.
50 McCulloch, letter to Henshaw, 24 July 1968, SLV, Box 17.
51 Hickey, letter to the Editor, *Herald*, 28 June 1968, SLV, Box 48.

52 John Reed, letter to the Editor, *Herald*, 28 August 1968.
53 McCulloch, letter to Mervyn Horton, 5 March 1969, SLV, Box 50.
54 Fitzsimmons, letter to McCulloch, 5 April 1969, SLV, Box 37; McCulloch to Fitzsimmons, 17 April 1969, SLV, Box 50.
55 Fitzsimmons, letter to McCulloch, 21 April 1969, SLV, Box 37.
56 McCulloch, 'Letter from Australia', *Art International*, September 1969.
57 Fitzsimmons, letter to McCulloch, 6 July 1969, SLV, Box 37.
58 Terry Smith, letter to McCulloch, 12 January 1970, SLV, Box 37; Paramor, letter to Fitzsimmons, 4 December 1969, SLV, Box 37.
59 Terry Smith, letter to McCulloch, 12 January 1970, SLV, Box 37.
60 McCulloch, unpublished and unsent letter to Terry Smith, undated [1970], SLV, Box 37.
61 McCulloch, letter to Bernard Smith, 30 January 1970, SLV, Box 37.
62 McCulloch, letter to Lynn, 10 February 1970, SLV, Box 37.
63 Lynn, letter to McCulloch, 18 July 1970, SLV, Box 37.
64 Fitzsimmons, letter to McCulloch, 2 September 1970, SLV, Box 37.
65 McCulloch, letter to Fitzsimmons, 2 January 1971 and 28 October 1970, SLV, Box 37.
66 Fitzsimmons, letter to McCulloch, 2 May 1971, SLV, Box 37.
67 McCulloch, letter to Fitzsimmons, 14 May 1971, SLV, Box 37.
68 McCulloch, letter to Fitzsimmons, 14 May 1971, SLV, Box 37.
69 McCulloch, letter to Fitzsimmons, 4 January 1971, SLV, Box 37.
70 Fitzsimmons, letter to McCulloch, 18 January 1972, SLV, Box 37.
71 McCulloch, letter to Fitzsimmons, 25 March 1972, SLV, Box 37.
72 Fitzsimmons, letter to McCulloch, undated [1972], SLV, Box 37.
73 Myers, letter to McCulloch, 23 March 1952, SLV, Box 39.
74 ibid.
75 Myers, letter to McCulloch, 24 June 1954, SLV, Box 47.
76 McCulloch, 'The Drawings of Paul Haefliger', *Meanjin*, no. 49, Winter 1952, p. 151.
77 McCulloch, unpublished script for 'Art without Prejudice', Australian Broadcasting Commission, University of the Air, Program 2 [1962], SLV, Box 49.
78 Haefliger, letter to McCulloch, 1 January 1952, SLV, Box 39.
79 Alan, letter to Ellen McCulloch, 24 January [1956], SLV, Box 46.
80 Alan McCulloch, Susan McCulloch and Emily McCulloch Childs, *The New McCulloch's Encyclopedia of Australian Art*, Aus Art Editions and Miegunyah Press, Melbourne, 2006, p. 948.
81 McCulloch, letter to Thomas, 11 November 1970; Thomas to McCulloch, undated [1970], SLV, Box 50.
82 In a provocative personal letter written in 1971, Lynn related the 'traumatic experience' of attending a dinner party at the home of influential gallery director Violet Dulieu, where John Perceval had invited Mirka Mora and Ross Lansell: 'Why does she try to placate Lansell even if to please the wayward Perceval?' Lynn, letter to McCulloch, 25 January 1971, SLV, Box 50.
83 Horton, letters to McCulloch, 7 October 1964 and 10 November 1964; McCulloch to Horton, 14 November 1964, SLV, Box 48.

84 Horton, letter to McCulloch, 10 December 1964, SLV, Box 48.
85 Olsen, letters to McCulloch, 2 January 1965 and 18 December 1964, SLV, Box 48.
86 McCulloch, 'Art Writing and the Rubinstein', *Art and Australia*, June 1965; McCulloch, letter to Lynn, 22 July 1965, SLV, Box 48.
87 Lynn, letter to McCulloch, 7 November 1966, SLV, Box 48.
88 Lynn, letter to McCulloch, 7 August 1970, SLV, Box 50.
89 Lynn, letter to McCulloch, 5 September 1970, SLV, Box 50.
90 Lynn, letter to McCulloch, 30 August 1971, SLV, Box 50.
91 McCulloch, letter to Lynn, undated [1971], SLV, Box 50.
92 McCulloch, letter to Edith Horsley, 16 October 1964, SLV, Box 46.
93 Lansell, letter to the Editor, *Herald*, 25 January 1968, SLV, Box 48.
94 McCulloch, letters to and from Rudy Komon, 21 February, 23 February and 1 March 1968, SLV, Box 40.
95 McCulloch, letter to Brian Seidel, 1 September 1967, SLV, Box 40; AICA letter, *Nation*, no. 238, 2 March 1968.
96 Brook, letter to McCulloch, 27 November 1968, SLV, Box 48; letter to the Editor, *Herald*, 29 November 1969.
97 McCulloch, 'Gaiety in Sculpture', *Herald*, 20 November 1968.
98 Lynn, 'Art Prizes in Australia', *Art and Australia*, March 1969, pp. 314–19.
99 McCulloch, letter to McCaughey, 29 January 1969, SLV, Box 50.
100 McCaughey, letter to McCulloch, 8 February 1969, SLV, Box 50.
101 McCaughey, letter to McCulloch, 28 September 1972, McCulloch Family Papers.

Chapter 5 Friends and Foes
1 Alan McCulloch, 'Foreword', Georges Art Prize, exh. cat., 1969, unpag., McCulloch Family Papers.
2 ibid.
3 McCulloch, letter to Brian Kennedy, Senior Editor, *World Book* (Australia), 15 January 1986, SLV, Box 46.
4 Boyd, letter to McCulloch, November 1959, McCulloch Family Papers.
5 Alan McCulloch, 'The Drawings of Arthur Boyd', *Meanjin*, no. 45, Winter 1951, p. 154.
6 *Herald*, 18 September 1951.
7 Reed, quoted in Darleen Bungey, *Arthur Boyd: A Life*, Allen & Unwin, Crows Nest, NSW, 2007, p. 226.
8 Frater, letter to McCulloch, 10 April 1954, SLV, Box 46.
9 McCulloch, *Herald*, 8 July 1952.
10 David Boyd, letter to McCulloch, 21 November 1956, SLV, Box 55.
11 David Boyd, letter to McCulloch, 10 December 1961, SLV, Box 55.
12 McCulloch, letter to Lynn, 30 November 1971, SLV, Box 50.
13 Quoted in Geoffrey Smith, *Sidney Nolan: Desert and Drought*, National Gallery of Victoria, Melbourne, 2003, p. 100.
14 McCulloch, *Herald*, 23 June 1953.
15 Draft entry for *World Book* (Australia), 1986, SLV, Box 4.
16 Susan McCulloch, conversation with the author, 2015.

NOTES

17 See Patrick McCaughey (ed.), 'Introduction', *Bert & Ned: The Correspondence of Albert Tucker and Sidney Nolan*, Miegunyah Press, Melbourne, 2006.
18 Tucker, letter to McCulloch, c. 1956, McCulloch Family Papers.
19 Tucker, letter to McCulloch, 10 May 1954, SLV, Box 55.
20 Tucker, letter to McCulloch, 21 April 1957, SLV, Box 39.
21 Geoffrey Robertson, letter to McCulloch, 5 May 1961, SLV, Box 47.
22 Gray Smith, quoted in Kendrah Morgan, *Joy Hester: Remember Me*, exh. cat., Museum of Modern Art at Heide, 2021, p. 44.
23 *Age*, 7 February 1950.
24 Thomas, *Herald*, 6 February 1950.
25 McCulloch, *Herald*, 27 July 1955.
26 Morgan, *Joy Hester: Remember Me*, p. 44.
27 McCulloch, *Herald*, September 1963.
28 Blackman, letter to McCulloch, 7 February 1952, SLV, Box 46.
29 McCulloch, *Herald*, 19 February 1952; 'The Art of Charles Blackman', *Meanjin*, no. 48, Autumn 1952, pp. 44–5.
30 Blackman had returned from Sydney and offered to come to Shoreham to discuss exhibition plans for the Macquarie Galleries show. Blackman, letter to McCulloch, undated [1953], SLV, Box 21.
31 *Herald*, 10 February 1953.
32 Blackman, letter to McCulloch, undated [c. 1952], SLV, Box 40.
33 *Herald*, 12 May 1953.
34 McCulloch, *Herald*, 19 May 1953.
35 Barbara Blackman, letter to McCulloch, 29 June 1953, SLV, Box 47.
36 Charles Blackman, letter to McCulloch, undated [1954], SLV, Box 40.
37 Charles Blackman, letter to McCulloch, undated [1970], SLV, Box 50.
38 Barbara Blackman, letter to McCulloch, 27 February 1974, Box 51.
39 Pugh, letter to McCulloch, [c. 1959], SLV, Box 48.
40 French, letter to McCulloch, 15 November 1958, SLV, Box 47.
41 Carnegie, letter to McCulloch, 22 February 1963, SLV, Box 47.
42 Elizabeth Vassilieff, letter to McCulloch, 22 June 1959, SLV, Box 48. Earlier that year Elizabeth Vassilieff thanked Alan for his remarks on her husband's work and on Danila's life of simplicity and ideals at Diamond Creek, undated [1959], SLV, Box 48 and 30 October 1958, SLV, Box 52.
43 Thorpe, letter to Managing Director, *Herald*, 26 March 1952, SLV, Box 48. See also McCulloch's two-page reply, SLV, Box 48.
44 This was followed by a series of exchanges that drew in Counihan's fellow Communist Party member Len Fox in Sydney on art as sociology. McCulloch, letter to Fox, 4 August 1955, SLV, Box 46.
45 Louis Kahan, letter to McCulloch, 16 May 1963, SLV, Box 47; Lily Kahan, letter to McCulloch, 12 July 1963, SLV, Box 47.
46 Allan McGuire (a registered tax agent from Darwin) wrote to congratulate McCulloch on 'your kind tribute to Ian Fairweather—which is very true' [*Herald*, 13 May 1952] and to let McCulloch know of his Fairweather connections in Darwin. 16 May 1952, SLV, Box 47.
47 Orban, letter to McCulloch, 27 November 1957, SLV, Box 47.

48 Passmore, letter to McCulloch, 14 July 1962, SLV, Box 46. See also Passmore to McCulloch, 26 December 1954.
49 Miller, letter to McCulloch, 22 May 1954, SLV, Box 46.
50 Miller, letter to McCulloch, 19 March 1955, SLV, Box 40; Miller, letter to Alan and Ellen McCulloch, 26 December 1954, SLV, Box 39.
51 Miller, letters to McCulloch, 22 June 1958, SLV, Box 39, 6 March 1957, SLV, Box 40.
52 Miller, letter to McCulloch, 23 March 1959, SLV, Box 40.
53 Miller, letters to McCulloch, 23 May 1959, 17 May 1959, 23 January 1959, SLV, Box 40. See Ann Wookey, 'Miller, Godfrey Clive (1893–1964)', Australian Dictionary of Biography, National Centre of Biography, Australian National University, published first in hardcopy 2000.
54 *Herald*, 17 June 1959.
55 McCulloch, letter to Miller, 7 July 1960, SLV, Box 40.
56 Miller, letter to McCulloch, 22 May 1962, SLV, Box 40.
57 Miller, letter to McCulloch, 22 May 1962 and letter to the Editor of *The Encyclopedia of Australian Art*, which McCulloch was working on, to advise them that he not be included or any reference made to him in the book: Miller to Editor, Hutchinson Publishing, 12 September 1962, SLV, Box 40.
58 'In Memoriam Godfrey Miller', *Art and Australia*, vol. 2, no. 2, 1964. Working manuscript in SLV, Box 40. McCulloch's reply to a fan of Miller's work gives a good insight into his life and work: 'Dear Mr Shaw, yes, I knew Miller well, that is to say as well as anyone could ever get to know so elusive a personality. But it would take more than a letter to try and explain what you asked about colour, attitude etc … The basis of it all was his drawing and what he called his "balancers", but what we might call points of tone-colour emphasis. Almost equally important was the sepia base with which he started and of course the key to his whole activity was the philosophy which integrated his painting with his life.' McCulloch, letter to Mr Shaw, 9 July 1966, SLV, Box 48.
59 Whisson, letter to McCulloch, 13 May 1964, SLV, Box 47.
60 *Herald*, 1 April 1952.
61 Whisson, letter to the Editor, *Herald*, 1 April 1952, SLV, Box 46.
62 Whisson, letter to McCulloch, 5 June 1952, SLV, Box 39; McCulloch to Whisson, 3 April 1952, SLV, Box 46.
63 *Herald*, 24 November 1953.
64 Whisson, letter to McCulloch, 16 April 1968, SLV, Box 48.
65 McCulloch, letter to the Visual Arts Board, 8 July 1973, SLV, Box 56.
66 *Herald*, 2 September 1959.
67 James C Sourris, 'Artist Interview Series 2016–2017 Gareth Sansom', Interviewer: Steve Cox, 21 December 2016, http://www.slq.qld.gov.au/__data/assets/pdf_file/0006/381255/Gareth-Sansom-Digital-Story.pdf.
68 Sansom, letters to and from McCulloch, undated [1964], SLV, Box 48; Sansom, letter to McCulloch, 29 January 1964, SLV, Box 36.
69 Sansom, letter to McCulloch, 26 January 1966, Box 36.
70 Frances Lindsay, *Gareth Sansom Paintings 1956–1986*, University of Melbourne, exh. cat., 1986.

71 'Gareth Sansom' Wikipedia, 28 February 2023, https://en.wikipedia.org/wiki/Gareth_Sansom.
72 Sansom, letters to and from McCulloch, 26 October 1966, SLV, Box 46; 1 September 1966, SLV, Box 48; 17 August 1966, SLV, Box 55.
73 Sansom, letter to McCulloch, 6 March 1970; McCulloch to Sansom, 16 March 1970, SLV, Box 50.
74 Sansom, letters to and from McCulloch, 30 October 1976, 18 November 1976, SLV, Box 51; Sansom, letter to McCulloch, 19 May 1971, SLV, Box 46.
75 McCulloch, letter to RB Fisher, Registrar, University of Sydney, 4 August 1973, SLV, Box 51.
76 See Rodney James, 'Ivan Durrant Blood Red', *Ivan Durrant: Barrier Draw*, National Gallery of Victoria, Melbourne, 2020, pp. 68–85.
77 McCulloch to and from Durrant, *Herald*, 2 and 12 February 1976.
78 McCulloch, letter to Claudio Alcorso, 16 and 20 September 1969, SLV, Box 37.
79 McCulloch, letter to John Kaldor, 3 October 1969, SLV, Box 50.
80 McCulloch, 'It IS Art', *Herald*, 28 November 2019. The negatives of Christo wrapping Little Bay lie dormant in an envelope addressed to McCulloch and marked 'Alan McC with Rapotec', SLV, Box 40.
81 Kaldor, letters to and from McCulloch, 8 and 17 December 1970, SLV, Box 50.
82 Quoted in Susan McCulloch, 'Australian Galleries: Fiftieth Anniversary', *Art and Australia*, vol. 43, no. 4, Winter 2006, p. 610.
83 Caroline Field, in conversation with the author, 18 January 2019.
84 Thomas Purves, letter to McCulloch, 11 April 1956, SLV, Box 52.
85 *Herald*, 20 May 1956.
86 *Herald*, 6 June 1956.
87 Thomas Purves, letter to McCulloch, 14 November 1956, SLV, Box 52. Contemporary photographs show how Australian Galleries was designed using wire mesh for hanging artworks suspended out from the white walls. This was also a HOAS innovation that had been utilised by the CAS Gallery of Contemporary Art in Tavistock Place, Melbourne.
88 Caroline Field, in conversation with the author, 18 January 2019.
89 *Herald*, 5 March 1958.
90 John Reed, letter to McCulloch, 2 May 1956, SLV, Box 52.
91 *Herald*, 6 June 1956; see also *Herald*, 20 May 1956.
92 *Herald*, 18 July 1956.
93 McCulloch, letter to Reed, undated, SLV, Box 52. Reed to McCulloch, 4 June 1957; McCulloch's undated response and Reed's reply, 7 June 1957, SLV, Box 52.
94 Burns, letter to McCulloch, 16 October 1951, SLV, Box 46.
95 McCulloch, *Herald*, 30 April 1958.
96 Alan McCulloch, Susan McCulloch and Emily McCulloch-Childs, *The New McCulloch's Encyclopedia of Australian Art*, Aus Art Editions and Miegunyah Press, Melbourne, 2006, p. 1108.
97 Baker, letter to McCulloch, 1958, SLV, Box 47. McCulloch, *Herald*, June 1958.
98 Reed, letter to McCulloch, 5 August 1958, SLV, Box 52.
99 McCulloch, letter to the Editor, *Herald*, 22 July 1959, SLV, Box 46.

100 McCulloch, letter to Cecil Edwards, 23 July 1959, SLV, Box 46.
101 Sime, letter to Williams, 31 August 1959, SLV, Box 52.
102 *New McCulloch's Encyclopedia of Australian Art*, p. 1148.
103 Guy-Smith, letter to McCulloch, 22 July 1953, SLV, Box 47.
104 Skinner to McCulloch, 20 May 1953, SLV, Box 47.
105 Skinner to Ellen and Alan McCulloch, 6 February 1958, SLV, Box 57.
106 Skinner, letter to McCulloch, 26 March 1958, SLV, Box 47.
107 Skinner, letter to McCulloch, 12 May 1958, SLV, Box 47.
108 Skinner, letter to McCulloch, 29 July 1958, SLV, Box 47.
109 Skinner, letters to McCulloch, 4 June and 19 July 1959, SLV, Box 47.
110 Lenore Nicklin, 'Komon, Rudolph John (Rudy) (1908–1982)', Australian Dictionary of Biography, National Centre of Biography, Australian National University, published first in hardcopy 2007.
111 McCulloch, 'Rudy Komon' manuscript, SLV, Box 52. Later published in *Art and Australia* [1983].
112 ibid. See also McCulloch, letters to and from Rudy Komon, 16 May and 23 May 1963, SLV, Box 47. Patrick McCaughey's view differs from McCulloch's. He relates how Leonard French introduced Fred Williams to Rudy Komon in 1955, setting in train the success of the Melbourne-based artists in Sydney.
113 Komon, letter to McCulloch, 23 May 1963; McCulloch to Komon, 16 May 1963, SLV, Box 48.
114 Reed, letters to and from McCulloch, 14 February, 18 February and 6 March 1967, SLV, Box 48. Art historian Richard Haese has written extensively elsewhere on the case and its outcome.
115 William Lasica, letter to McCulloch, 6 March, 27 February, 17 January 1967, SLV, Box 48.

Chapter 6 Big Ideas
1 McCulloch, letter to Sir Stephen Roberts, 17 September 1966, SLV, Box 54.
2 *Keith Murdoch: Journalist*, Herald and Weekly Times Ltd, Melbourne, 1952.
3 McCulloch, Memo to *Herald* General Manager, 21 March 1966, SLV, Box 54.
4 *Herald*, 9 November 1955.
5 McCulloch, undated proposal to *Herald* editors, [July 1961], SLV, Box 22.
6 McCulloch, letter to Balfour, [1961], SLV, Box 22.
7 Hunter, letter to McCulloch, 13 September 1961, SLV, Box 22. The resulting exhibition was called *Treasures from the Commonwealth: Commemorative Catalogue at the Royal Academy of Arts*, Piccadilly, London, 17 September to 13 November 1965.
8 McCulloch, letter to Sweeney, 2 January 1967, SLV, Box 54.
9 McCulloch, memo to *Herald* General Manager, 21 March 1966, SLV, Box 54.
10 McCulloch, *Herald* proposal, 2 December 1966, SLV, Box 54.
11 Tim Burstall, *The Memoirs of a Young Bastard: The Diaries of Tim Burstall*, Miegunyah Press, Melbourne, 2012.
12 Christopher Heathcote, *The Quiet Revolution: The Rise of Australian Art, 1946–1968*, Text Publishing, Melbourne, 1995, p. 18.
13 Rodney James, in conversation with Christabel Blackman, May 2023.

14 Counihan, letter to McCulloch, 27 October 1963, SLV, Box 46.
15 'Minutes of initial meeting of Herald Open Air Art Exhibition', 28 August 1953, SLV, Box 46.
16 *Herald*, 17 October 1953.
17 McCulloch, *Herald*, 6 December 1953, SLV, Box 54. See also Beatrice [illeg.], letter to McCulloch, 5 April 1954, SLV, Box 46.
18 Felicity St John Moore, *Charles Blackman: Schoolgirls and Angels*, National Gallery of Victoria, Melbourne, 1993, p. 18. Email correspondence from Christobel Blackman, 22 May 2023.
19 Perceval, letter to McCulloch, 5 November [1953], SLV, Box 47.
20 Craig, letter to McCulloch, 27 January 1954, SLV, Box 52.
21 Shore, *Age*, 4 January 1954.
22 Open letter from *Herald* art critic, February 1955, SLV, Box 52.
23 Sharp, letter to McCulloch, 23 February 1955; Stan Ostoja-Kotkowski, letter to McCulloch, undated [1954], SLV, Box 46.
24 In an internal memo dated 17 January 1955, the *Herald*'s Frank Maloney questioned McCulloch on whether it was important to seek wider representation: 'I feel myself that we need the support of all schools and that we should go after it rather than hope it comes.' SLV, Box 52.
25 McCulloch, open letter, February 1955, SLV, Box 52.
26 Brack, letter to McCulloch, 19 February 1955, SLV, Box 46.
27 Reid, letter to Hester, March 1955, Smith Collection, quoted in Deborah Hart, *Joy Hester and Friends*, National Gallery of Australia, Canberra, 2001, p. 81.
28 *Herald*, 16 March 1955.
29 Miller, letter to McCulloch, 1 May 1954, SLV, Box 39.
30 Miller, letter to McCulloch, 20 May 1955, SLV, Box 39.
31 Thomas, letter to McCulloch, 29 December 1955, SLV, Box 46. *Sun* promotions, 31 August 1955.
32 McCulloch, undated circular to artists, [1956], SLV, Box 52.
33 *Herald*, 15 March 1955; Huntington, letter to McCulloch, 15 March 1955, SLV, Box 52.
34 Moloney, *Herald* staff memo cc'ed to McCulloch, 17 November 1961, and 7 December 1961, SLV, Box 46.
35 Moloney, letter to W Thorrowgood, 5 September 1967, SLV, Box 55.
36 Susan McCulloch, email to the author, 18 March 2008.
37 McCulloch, letter to Ellen and Susan McCulloch, 2 November 1965, SLV, Box 36.
38 Diana Fisher, letter to McCulloch, undated [1973], SLV, Box 54.
39 McCulloch, letter to Jones, 19 March 1973, SLV, Box 47.
40 *Age*, 17 March and 21 March 1973.
41 McCulloch, letter to Olsen, 27 June 1968, SLV, Box 22.
42 McCulloch, 'A note on the paintings', letter to Komon, 28 June 1968, SLV, Box 22.
43 Kempf, letter to McCulloch, undated [1968], source unknown.
44 McCulloch, letter to Clement Greenberg, 14 August 1968, SLV, Box 48.
45 McCulloch, letter to Len Voss Smith, 7 August 1968, SLV, Box 48.
46 See McCaughey, *Age*, 7 August 1968, SLV, Box 22.

47 McCulloch, letters to and from Greenberg, 14 August and 23 August 1968, SLV, Box 48.
48 Franz Philipp, 'Rhythms of Shore and Sea', *Herald*, 7 August 1968.
49 Boyd, letter to McCulloch, 14 July 1969, SLV, Box 50.
50 McCulloch, letter to Fitzsimmons, 30 March 1970, SLV, Box 37.
51 McCulloch, letter to Fitzsimmons, 28 May 1970, SLV, Box 37.
52 McCulloch, letter to Betty Meagher, 9 October 1970, SLV, Box 51.
53 McCulloch, letters to and from Komon, 1 February and 10 February 1971, SLV, Box 51.
54 Meagher, letter to Purves, 14 April 1971, SLV, Box 51.
55 McCulloch, letter to Lillian, Director of the Gold Coast Art Gallery, 14 June 1971, SLV, Box 50.
56 *Australian Women's Weekly*, 28 June 1972, p. 55.
57 Killeen, letter to McCulloch, 29 June 1972, SLV, Box 45.
58 GC Shannon, letter to McCulloch, 1 September 1972; see also McCulloch, letter to Vin Kane (6 August 1972), which gives a valuable description about his tapestry and the 1968 show of New Guinea subjects, SLV, Box 45.
59 McCulloch, letter to Frank Galbally, 11 September 1978, SLV, Box 53.
60 McCulloch, 'Speech given by Alan McCulloch at the opening of the new Mornington Peninsula Arts Centre', 17 November 1971, MPRG archives.
61 McCulloch, letter to Fitzgerald, 25 March 1975, SLV, Box 22.
62 McCulloch, memo to editor, 18 August 1975, SLV, Box 22.
63 Jack Cannon, Promotions Manager, letter to McCulloch, 1 September 1975; McCulloch to Bernie Stewart, Sec. in charge of Finance, *Herald*, 10 September 1975, SLV, Box 22.
64 Letter regarding *The Heroic Years of Australian Painting 1940–1965*, SLV, Box 54.
65 Flowers, letter to Melbourne Lord Mayor, 18 May 1976, SLV, Box 54.
66 MacPherson, *Sun*, 2 April 1977, SLV, Box 57.
67 Horton, letter to McCulloch, 20 January 1978, SLV, Box 40.
68 *Australian*, 19 April 1977.
69 McCulloch, letter to Hamer, 10 September 1975, SLV, Box 22.
70 Hamer, letter to McCulloch, 23 September 1975; see also Westbrook, letter to McCulloch, 30 September 1975, [undated], SLV, Box 22.
71 McCulloch, 'Memo to John Fitzgerald', 13 November 1975, SLV, Box 22.
72 Hood, letter to McCulloch, 3 August 1976, SLV, Box 22.
73 *Herald*, 30 March 1977; 'Our Greatest Picture Show', 17 March 1977; Paul Ormond, 'Why This Show Is the Greatest', 31 March 1977; 'The Australian Art Show of the Century', 1 April 1977, SLV, Box 57.
74 *Herald*, 31 March 1977. *Portrait of Joshua Smith* was later withdrawn from the exhibition after three venues and sent back to Sir Edward in Sydney because cold winter weather was affecting its paint surface. McCulloch, letter to Sir John Pagan, 7 June 1977; see also Pagan to McCulloch, 11 January 1977, Box 22.
75 *Herald*, 17 March 1977, SLV, Box 57.
76 Speech notes for *The Heroic Years of Australian Painting*, undated [1958], and unpublished notes for McCulloch's opening speech delivered at the Art Gallery of Western Australia, 26 September 1978, SLV, Box 57.

77 The exhibition's works travelled across the Nullarbor Plain in a specially insulated truck provided by General Motors Holden, with one security guard/driver, and a second truck manned by education officer John Anderson and B Stewart (Secretary of the Ministry for the Arts). In an unwitting invitation to hijack the trucks, Perth's *Sunday Times* charted the course of the 'loosely-guarded' convoy, where in 'every town big enough to have a police station, the convoy was parked in front of the police carpark overnight for safe keeping'. Undated, SLV, Box 22.
78 Skinner, letter to McCulloch, 4 October 1978, SLV, Box 22.
79 McGilchrist, *Age*, 7 April 1977, SLV, Box 57.
80 Purves, letter to McCulloch, 2 June 1978; McCulloch, letter to Purves, 8 June 1978, SLV, Box 22. McCulloch simply pointed out to Purves that he had had to limit the selection to artists who had made their reputations during the period covered by the exhibition.
81 Jeffrey Makin, *Sun*, 6 April 1977, SLV, Box 57.
82 See McCaughey, letter to McCulloch, 11 September 1978 and the spirited four-page typed answer by McCulloch, undated (1968) SLV, Box 53.
83 David Dolan, *Advertiser*, 9 August 1978, SLV, Box 22.
84 McCulloch, letter to Satelly, 10 August 1978, SLV, Box 22.

Chapter 7 Exhibiting Australian Aboriginal Art

1 McCulloch to JV Dillon, Under Secretary, Chief Secretariat Office, Treasury, 17 November 1967, SLV, Box 40.
2 McCulloch, *Herald*, 19 February 1968.
3 Stanner, 'The Great Australian Silence', from *After the Dreaming: Black and White Australians—An Anthropologist's View*, republished in *The Boyer Collection: Highlights of the Boyer Lectures 1959–2000*, selected and introduced by Donald McDonald, ABC Books, Sydney, 2001, p. 187.
4 McCulloch, 'Gallery Lacks Moderns', *Herald*, 16 May 1951; 'Emphasis Is on Ethnology', *Herald*, 21 April 1954.
5 See letter to McCulloch, 29 March 1954, SLV, Box 55.
6 For example, see McCulloch, 'Save Art of the Aborigines', *Herald*, 4 July 1951. Although visionary in some of his attitudes, McCulloch was also a man of his times. He consistently maintained that post-European contact had weakened and would ultimately lead to the destruction of a 'genuine' Aboriginal art and culture, rather than either enhancing, adding to or aspects being assimilated back into it.
7 *Primitive Art*, National Museum of Victoria, 1929, was the first major exhibition of Aboriginal art. It was followed by *Primitive Art Exhibition*, National Gallery and National Museum of Victoria, Melbourne, 1943, and '*Australian Aboriginal Art: The Fine Arts Exhibition*, part of the 1956 Olympic Games in Melbourne.
8 Margaret Williams, Museum of Fine Arts, Houston to Rodney James, 8 and 12 January 2010. On Sweeney's American career, see also Lee Sorensen, 'J. J. Sweeney 1900–1986', *Dictionary of Art Historians*, 27 November 2000.
9 Lindy Allen, letter to Rodney James, 21 January 2010. McCulloch was also not aware of the inclusion of eleven bark paintings and two pen drawings by Tommy McRae from the Victorian collection included in *Art of Australia*

1788–1941. This large survey exhibition was sent to the United States under the auspices of the Carnegie Corporation in 1941, shown at twenty-nine venues including the Museum of Modern Art in New York.

10 Jonathan Sweet, 'UNESCO and Cultural Heritage Practice in Australia in the 1950s: The International Touring Exhibition *Australian Aboriginal Culture 1948–55*', *Asia Pacific Journal of Arts and Cultural Management*, vol. 4, no. 1, February 2006, pp. 209–18.

11 A selection of twenty works from *Australian Aboriginal Art*, an exhibition curated by Tony Tuckson and organised by the Art Gallery of New South Wales, 1960–61, were sent to VI Bienal de São Paolo, Museu de Arte Moderna, Brazil, 1961. Steven Miller, Archivist, Art Gallery of New South Wales, to Rodney James, 22 January 2010. This was followed by *Australian Aboriginal Bark Paintings 1912–1964*, organised by the Australian Institute of Aboriginal Studies, Canberra, for the Commonwealth Arts Festival Exhibition, Walker Art Gallery, Liverpool 17 September – 2 October 1965; *Aboriginal Bark Paintings from Australia*, Museum of Fine Arts, Houston, Texas, 17 December 1965 – 30 January 1966; and *Aboriginal Art from Australia*, bark paintings and sculpture loaned by the National Gallery of South Australia, Worcester Art Museum, 17 February – 3 April 1966, Allentown Art Museum, 14 April – 12 May 1966.

12 Plans to bring Sweeney to Australia in 1963 fell foul, so he was invited to Australia for the following year.

13 McCulloch, letter to Arthur Rylah, October 1964, SLV, Box 22.

14 Sweeney, letter to McCulloch, 14 June 1964, SLV, Box 22.

15 McCulloch, letter to Sweeney, 31 July 1964, Archives, Museum of Fine Arts, Houston.

16 Sweeney, letter to the Chairman, Board of Trustees, NMV, 31 August 1964, SLV, Box 22.

17 McNally, letter to Sweeney, 14 October 1964, Archives, Museum of Fine Arts, Houston.

18 McCulloch, letter to Sweeney, 16 October 1964, SLV, Box 22.

19 Sweeney, letter to McCulloch, 17 October 1964, SLV, Box 22.

20 McCulloch, letters to Galbally, 21 October 1964; Eric Westbrook, 21 October 1964; AG Rylah, undated [October 1964], 21 October 1964; to James MacDonald, 28 October 1964, SLV, Box 22.

21 McCulloch, letter to Rylah, undated [October 1964], SLV, Box 22.

22 McCulloch, letter to Rylah, 21 October 1964, SLV, Box 22.

23 According to McCulloch, he and Sweeney were given 'a first-class lesson on how *not* to handle fragile works; Sweeney shuddered with horror when he saw the nails through the paintings and the way they were unceremoniously hauled out of the racks by McNally and assistant butchers …', Alan McCulloch, letter to Eric Westbrook, 21 October 1964. Westbrook wrote in reply that he 'could see it coming', 10 November 1964, SLV, Box 22.

24 Sweeney, letter to McCulloch, 21 October 1964, SLV, Box 22, although Sweeney's recollection was in part incorrect. Following the showing of *Art of Australia 1788–1941* at MoMA, New York in 1941, several works from the Museum of Victoria collection were withdrawn from the American and Canadian tour amid concerns that some of the bark paintings were suffering

irreparable damage. See Louise Ryan, Forging Diplomacy: A Socio-Cultural Investigation of the Carnegie Corporation of New York and the *Art of Australia: 1788–1941* exhibition, MA thesis, UNSW, 2007, pp. 113–14. McCulloch's damning indictment of the decision, which he now considered as 'a national scandal', was followed by a second letter to Arthur Rylah in which he offered his services at no cost to document and catalogue any bark paintings sent to Houston, 'supervise mounting of barks not already mounted' as well as undertake 'everything necessary for their safe dispatch': McCulloch, letter to Rylah, 21 October 1964, SLV, Box 22.

25 Sweeney, letter to McCulloch, 29 October 1964, SLV, Box 22.
26 Rylah, letter to McCulloch, 13 January 1965, SLV, Box 22.
27 MacDonald, letter to McCulloch, 19 January 1965, SLV, Box 22.
28 McCulloch, letter to Sweeney, 14 April 1965, SLV, Box 22. McCulloch registered the contrary evidence that works from the Spencer Collection had been loaned before. In addition, eleven works collected by Spencer from Arnhem Land in 1912 were listed in *Australian Aboriginal Art*, an exhibition organised by the state galleries of Australia, 1960–61.
29 McCulloch, letter to Sweeney, 14 April 1965.
30 Sweeney wrote to McCulloch: 'The Adelaide Melville Island barks sound exciting. I hope you get them. Are two or three enough? What about Melville Island grave-posts?' 10 June 1965, SLV, Box 22.
31 In a very exciting turn of events, this work was finally attributed in 2022 to a Mr Majumbu, a senior patriarch, from an area just east of Oenpelli: '… almost identical to a rock painting known to have been painted by Majumbu in a rock shelter where his family regularly camped'. See Taçon et al., 'Returning a name to an artist', *The Conversation*, 23 February 2023.
32 Lindy Allen, 'The Early Collection and Exhibition of Artwork by Aboriginal artists', in *A Museum for the People: A History of Museum Victoria and Its Predecessors 1854–2000*, Scribe Publications, Melbourne, 2001, p. 142. The formation of the NMV's collection of Aboriginal barks and the complex story of Spencer's relationship with Cahill and subsequent commissioning of works through him has been well documented by Allen and other scholars including DJ Mulvaney. For Baldwin Spencer's own account of his travels and the art he collected, see *Wanderings in Wild Australia*, Macmillan, London, 1928.
33 McCulloch wrote approvingly to Sweeney that 'All those nail holes and such defacements have been taken care of and where the bark has warped it has been built up at the back with a light bridge; experiments showed that in cases where the bark was split it was better to leave it honestly that way rather than attempt to fake it. He has made the frames of maximum strength but in such a way that the barks themselves are readily accessible. All that is needed to get into the glass is to remove the two coach screws at each corner and the screws at the back; this is important as it might be necessary to clean any dead borer dust shaken out during the voyage'. 24 August 1965, SLV, Box 22.
34 McCulloch, letter to Sweeney, 15 September 1965, SLV, Box 22.
35 McCulloch, letter to McNally, 25 August 1965, SLV, Box 22.
36 McCulloch, letter to Sweeney, 24 August 1965, SLV, Box 22.

37 ibid.
38 McCulloch, letter to Sweeney, 8 September 1965, SLV, Box 22.
39 McCulloch, letter to Sweeney, 8 September 1965, SLV, Box 22.
40 Kupka, letter to McCulloch, 12 October 1965, SLV, Box 36.
41 McCulloch, letter to Sweeney, undated [October 1965], Archives, Museum of Fine Arts, Houston.
42 McCulloch, letter to Sweeney, 20 October 1965, Archives, Museum of Fine Arts, Houston.
43 McCulloch, letter to Sweeney, 4 November 1965, Archives, Museum of Fine Arts, Houston.
44 I am grateful to Lindy Allen, Museums Victoria, for teasing out the authorship of the extended list of works in the catalogue. The initial descriptions, she suggests, are derived from the museum's catalogue, while the expanded commentary, which includes comments about 'dreamtime', 'pattern of life' and 'contact with Europeans' were a commentary from the author(s). Lindy Allen, email to Rodney James, 21 January 2010.
45 For an extended analysis of Kupka's philosophies and their links with Lévi-Strauss, see Will Owen's blog, *Aboriginal Art & Culture: An American Eye* and the four-part post 'Aborigines, Art, France: History in Review', 2005–06.
46 Like Spencer, Chaseling identified the necessity of preserving the material culture of what was seen as an increasingly compromised and diminishing race, with many of the works he collected later distributed for 'safekeeping' among state museums around Australia. Both men were motivated by humanitarian values, but each had divergent views on what should be collected and why. See his *Yulengor: Nomads of Arnhem Land*, The Epworth Press, London, 1957. Belying his scientific training and an immersion in social Darwinian theories, Spencer argued for careful and intensive study of the paintings and their meanings and the collecting of artefacts 'uncontaminated' by white contact and outside change. The barks he collected at Oenpelli in 1912 were evidence of an essentialist Aboriginality, at one point decrying the 'substitution of red rag for parakeet feathers in a basket'. Quoted in John Mulvaney, '"Annexing All I Can Lay Hands On": Baldwin Spencer as Ethnographic Collector', in *The Makers and Making of Indigenous Australian Museum Collections*, edited by Nicolas Peterson, Lindy Allen and Louise Hamby, Melbourne University Press, Melbourne, 2008, p. 147.
47 McCulloch, letter to Sweeney, 17 November 1965, Archives, Museum of Fine Arts, Houston
48 Alan to Ellen McCulloch, 10 December 1965, SLV, Box 36.
49 ibid.
50 For example, Ronald Berndt (ed.), *Australian Aboriginal Art*, Ure-Smith, Sydney, 1964.
51 Eleanor Kempner Freed, 'Art of the Most Primitive People on Earth', *The Houston Post*, January 1966; Marguerite Johnston, 'No Time to Farm, but to Paint, Yes', *The Houston Post*, 19 January 1966.
52 McCulloch, letter to Sweeney, 4 January 1966, Archives, Museum of Fine Arts, Houston.
53 Sweeney, letter to McCulloch, 31 January 1966, SLV, Box 22.

54 McCulloch, letter to McNally, 23 February 1966; McNally to McCulloch, 25 February 1966, SLV, Box 22.
55 McCulloch, letter to McNally, 4 May 1966, SLV, Box 22.
56 McCulloch, letter to Sweeney, 24 June 1966, SLV, Box 22.
57 McNally wrote to Sweeney in good spirit at the conclusion of the exhibition, thanking him for the catalogues and noting: 'I am most impressed with the excellence and quality of the production and very pleased indeed that our material was treated in such an excellent way.' 10 February 1966, Archives, Museum of Fine Arts, Houston. See also his letters to McCulloch in which he outlined the trustees' decision to concentrate on the 'display of the barks either in the Museum, or in one of the adjacent exhibitions'. 6 June 1966, SLV, Box 22.
58 Rowan, letter to McCulloch, 13 June 1966; 25 February 1968, SLV, Box 22.
59 MacDonald letter to McCulloch, 10 March 1966, SLV, Box 22.
60 McCulloch, letter to MacDonald, 18 March 1966, SLV, Box 22.
61 McCulloch, 'Here's Our Chance to Show Hidden Art Treasure', *Herald*, 19 February 1968.
62 McCulloch, letter to Elwyn Lynn, 10 February 1970, SLV, Box 37.
63 McCulloch, letter to Dillon, 21 September 1967, SLV, Box 40.
64 McCulloch, letters to Rossiter and Hamer, 25 September 1967, SLV, Box 40.
65 Dillon, letter to McCulloch, 17 October 1967; McCulloch to Dillon, 17 November 1967, SLV, Box 40.
66 McCulloch, letter to Dillon, 21 September 1967, SLV, Box 40.
67 McCulloch, 'What's Good Enough for Prince Phillip ...', *Herald*, 12 June 1968.
68 McCulloch, letter to Helpmann, 25 July 1968, SLV, Box 48.

Chapter 8 Encyclopedia of Australian Art

1 *Herald*, 10 January 1962.
2 McCulloch, unpublished draft of self-biographical outline, SLV, Box 49.
3 McCulloch, letter to Voss Smith, 6 January 1961, SLV, Box 49.
4 McCulloch, letter to the Secretary, Hutchinson Publishing Group, 8 January 1961, SLV, Box 49.
5 Geoffrey Howard, letter to Len Voss Smith, 16 October 1961, SLV, Box 49. In a follow-up letter by Editorial Director Iain Hamilton, Voss Smith was advised of the importance of timing: 'I gather that there is not direct competition between the Penguin and this proposed volume, but I think it would he highly desirable to get our book out first.' 14 November 1961, SLV, Box 49.
6 Horsley, letter to Voss Smith, 1 December and 8 December 1961, SLV, Box 49.
7 Horsley, letter to Voss Smith, 28 December 1961, SLV, Box 49.
8 McCulloch, letter to Nolan, 14 March 1962, SLV, Box 46.
9 McCulloch, unpublished draft of self-biographical outline, SLV, Box 49.
10 Horsley, letter to McCulloch, 6 July 1962, SLV, Box 6.
11 McCulloch, letter to Horsley, 9 June 1966, SLV, Box 6.
12 Colin Roderick, editor and then director of Angus & Robertson (1945–65) declared: 'Mr James Gleeson, the Sydney artist and critic, has been engaged for the best part of a year in the preparation of such a dictionary ... Mr Gleeson's plan comprehends the treatment of all the graphic arts in Australia in all media, from the earliest work by convict artists like Thomas Watling to that

of our own day. His dictionary will include all artists worthy of note, schools, movements, awards and the like.' SLV, Box 47. Although the dictionary failed to materialise in that form, Gleeson did eventually go on to publish *Masterpieces of Australian Painting*, Lansdowne, 1969, and three volumes on Australian art (*Colonial Painters 1788–1880, Impressionist Painters 1881–1930* and *Modern Painters 1931–1970*), also for Lansdowne, in 1971.

13 McCulloch, letter to Horsley, 12 December 1962, SLV, Box 6.
14 Smith, letter to McCulloch, 24 June 1960, SLV, Box 47.
15 McCulloch, letter to J McCusker, Prime Minister's Department, Canberra, 22 March 1962, SLV, Box 46.
16 McCulloch, letter to Horsley, 16 October 1964, SLV, Box 46.
17 Judy Blythe's (nee Benson) many letters to Alan make for an interesting, erudite and impassioned collection. These were written from her home in nearby Rosebud and then from Toowoomba, Queensland, where she and her husband moved in around 1968. Fiercely loyal to McCulloch, Blythe railed against criticism of the final encyclopedia, cast Robert Hughes as an upstart and contributed a great deal to the typing and organisation of the manuscript. SLV, Box 46.
18 Passmore, letter to McCulloch, 12 March 1962, SLV, Box 46.
19 Passmore, letter to McCulloch, 14 July 1962, SLV, Box 46.
20 Passmore, letters to McCulloch, 5 April 1963 and 3 April 1963, SLV, Box 46.
21 Klippel, letter to McCulloch: 'I don't know if you remember me in Paris when we went around some galleries together—that was 1949 or 50?', 31 July 1962, SLV, Box 46.
22 McGilchrist, letter to McCulloch, 27 July 1962, SLV, Box 46.
23 McGilchrist, letter to McCulloch, 29 August 1962, SLV, Box 46.
24 McGilchrist, letter to McCulloch, 8 May 1963, SLV, Box 46.
25 Larter, letter to McCulloch, 15 May 1967, SLV, Box 46.
26 Miller, letter to McCulloch, 22 May 1962, SLV, Box 40.
27 Thomson, letter to McCulloch, 22 November 1963, SLV, Box 46.
28 McCulloch, letter to Horsley, 9 July 1964, SLV, Box 6.
29 Horsley, letter to McCulloch, 3 November 1966, SLV, Box 6.
30 McCulloch, letter to Horsley, 24 February 1966, SLV, Box 6.
31 McCulloch, letter to Horsley, 9 April 1968, SLV, Box 6.
32 McCulloch, letter to Horsley, 31 May 1967, SLV, Box 6.
33 McCulloch, letter to Horsley, 23 July 1967, SLV, Box 6.
34 McCulloch, letter to Blythe, 5 July 1967, SLV, Box 6.
35 McCulloch, letter to Horsley, report of official book launch, 26 October 1968. In a follow-up letter to Horsley, McCulloch also responded to concerns over the durability of binding. 10 November 1968, SLV, Box 6.
36 Laurie Thomas, *Australian*, 19 November 1968; Joseph Burke, *Herald*, 23 October 1968. See also Pamela Ruskin, *Australian Jewish News*, 1 November 1968; Ross Campbell, *Daily Telegraph*, 16 November 1968; Pat Rapolt, *Advertiser* (Adelaide), 9 November 1968. SLV, Box 6.
37 McCulloch, letter to the Editor, *Age*, 26 October 1968, SLV, Box 6.
38 Lansell, letter to McCulloch, 21 November 1968, SLV, Box 48.

39 For example, Joseph Burke, *Herald*, 23 October 1968; Hilary Merrifield, *West Australian*, 9 November 1968; Lou Klepac, *Australian Book Review*, December–January 1968–69; Elwyn Lynn, *Bulletin*, 23 November 1968. Lynn was sympathetic to the task at hand but blunt about its perceived shortcomings, claiming its entries ranged from 'engagingly discursive to almost pointless'.
40 McCulloch, letters to and from Daniel Thomas, 29 October and 1 November 1968, SLV, Box 6.
41 McCulloch, letter to the Editor, *Bulletin*, 7 December 1968, SLV, Box 6.
42 Burke, letter to McCulloch, 31 October 1968, SLV, Box 6.
43 McCulloch, letter to Christesen, 8 February 1969, SLV, Box 45.
44 Leach-Jones, letter to McCulloch [1968], SLV, Box 48.
45 Esther B? [illeg.] to McCulloch, 1 March 1969, SLV, Box 48.
46 Mora, letter to McCulloch, 6 November 1968, SLV, Box 6.
47 McCulloch, letter to Sir Robert Lusty, 14 May 1969, SLV, Box 49.
48 McCulloch, letter to Lusty, 29 April 1970, SLV, Box 49.
49 Horsley also raised other shortfalls of the book and suggestions for future editing. Horsley, letter to McCulloch, 11 May and 2 June 1970, SLV, Box 6.
50 McCulloch, note in margin of John Curtain (Lansdowne), letter to McCulloch, 1 June 1976, SLV, Box 12.
51 McCulloch, letter to Lusty, 11 June 1973, SLV, Box 49.
52 McCaughey, letter to McCulloch, 29 May 1973, SLV, Box 49.
53 McCaughey, Memorandum to the Board, 13 June 1973, SLV, Box 56.
54 McCulloch, letter to the Executive Officer, Australia Council, 23 October 1973, SLV, Box 56. See also a follow-up announcement in June in connection with the new edition that $100 be set aside and paid per article for commissioning of specialist articles and that this should be paid for by Hutchinson, 2 July 1973, McCaughey, letter to McCulloch, 2 July 1973, SLV, Box 49.
55 McCulloch, letter to Mrs Shaw, 12 August 1975, SLV, Box 6.
56 McCulloch, letter to Leon Paroissien, Director, Visual Arts Board, 27 February 1977, SLV, Box 40.
57 Pulbrook, letter to McCulloch, 17 June 1976, SLV, Box 49.
58 McCulloch, letter to Elizabeth Douglas, 30 October 1976, SLV, Box 49.
59 Douglas, letter to McCulloch, 28 January 1977, SLV, Box 49.
60 'A Dated Look at Australian Art', *National Times*, 21 April 1979.
61 McCulloch, letter to the Editor, *National Times*, 23 April 1979; Elizabeth Douglas, letter to the Editor, *National Times*, 19 May 1979, SLV, Box 6.
62 McCulloch, letter to Susan McCulloch, 10 July 1978, SLV, Box 53.
63 Charles Nodrum, conversation with the author, 2019.
64 Kolenberg, letter to McCulloch, 25 October 1978, SLV, Box 6.
65 McCulloch, letter to Bail, 2 February 1979, SLV, Box 6.
66 Elwyn Lynn, 'Art Books: Taste and Status', *Quadrant*, July 1980, pp. 30–5.
67 McCulloch, *Herald*, 18 August 1980. Scarlett, conversation with the author, 2022.

Chapter 9 Writing and Publishing
1 Annois, letter to McCulloch, 27 October 1948, SLV, Box 39.
2 Thomson, letter to McCulloch, 14 January 1952, McCulloch Family Papers.

3 ibid., 4 February 1953.
4 McCulloch, letter to Henry McCulloch, 14 April 1953, SLV, Box 57.
5 Myers, letter to McCulloch, 24 June 1954, SLV, Box 47.
6 Myers, letter to McCulloch, 14 June 1961, SLV, Box 54.
7 Myers, letters to and from McCulloch, 21 November and 29 November 1966, SLV, Box 54.
8 Myers, letter to McCulloch, 14 February 1952, SLV, Box 39.
9 Myers, letter to McCulloch, 9 September 1954, SLV, Box 46.
10 Myers, letter to McCulloch, 9 May 1955, SLV, Box 46.
11 McCulloch, unpublished manuscript [1954], SLV, Box 54.
12 Drysdale, letter to McCulloch, 1953, McCulloch Family Papers.
13 Passmore, letter to McCulloch, 22 May 1954, SLV, Box 55.
14 Missingham, letter to McCulloch, 19 August 1954, SLV, Box 46.
15 Pevsner, letter to McCulloch, 1 October 1958, SLV, Box 47.
16 McCulloch, letter to Henry McCulloch, 23 March 1960, SLV, Box 57.
17 McCulloch, letters to and from Smith, 26 October, 8 November, 11 November, 23 November and 6 December 1960, SLV, Box 54.
18 Tucker, letter to McCulloch, 10 May 1954, SLV, Box 55.
19 Smith, letter to McCulloch.
20 Smith, letter to McCulloch, 17 April 1961, SLV, Box 47.
21 Smith, letters to McCulloch, 18 October and 28 November 1963, SLV, Box 47.
22 Smith, letter to Tucker, 9 February 1963, Bernard Smith Papers. Kindly accessed through Sheridan Palmer.
23 McCulloch, letter to Lynn, 10 April 1968; Lynn, letter to McCulloch, April 1968, SLV, Box 48.
24 Uhl, letter to McCulloch, 4 March 1968, McCulloch Family Papers.
25 Miller, letter to McCulloch, 9 February 1968, SLV, Box 17.
26 McCulloch, list of chapter headings and artists, unpublished manuscript, undated, SLV, Box 17.
27 McCulloch, letters to and from Henshaw, 15 February, 16 February and 20 February 1968, SLV, Box 17.
28 Henshaw, letter to McCulloch, 9 April 1968; McCulloch, letter to Henshaw, undated [April 1968]. Henshaw replied: 'Your idea of tracing Impressionist influences seems very sound.' Henshaw to McCulloch, 28 April 1968, SLV, Box 17.
29 O'Neil, letter to McCulloch, 11 June 1968, SLV, Box 17.
30 Henshaw, letter to McCulloch, 24 July 1968, SLV, Box 17.
31 Peter Quick, letter to McCulloch, 3 December 1968. See also McCulloch's reply, 20 December 1968; SLV, Box 12.
32 Hoff, letter to McCulloch 18 March 1969, SLV, Box 17.
33 McCulloch, letter to Quick, 10 June 1970, SLV, Box 17.
34 McCulloch, undated, McCulloch Family Papers.
35 See also Leigh Astbury, *City Bushmen: Heidelberg School and Rural Mythology*, Oxford University Press, Melbourne, 1985.
36 Alan McCulloch, *The Golden Age of Australian Painting: Impressionism and the Heidelberg School*, Lansdowne, Melbourne, 1969, p. 1.

37 For example, Janine Burke, *Australian Women Artists: 1840–1940*, Greenhouse Publications, Victoria, 1980.
38 Keith Macrae Bowden, *Samuel Thomas Gill: Artist*, published by the author, Maryborough, Vic., 1971.
39 McCulloch, letter to Christina Heron, 20 July 1981, SLV, Box 53.
40 McCulloch, letter to Terry Ingram, 16 May 1977, SLV, Box 11.
41 Quick, letter to McCulloch, 1 May 1970; 12 April 1970, SLV, Box 12.
42 McCulloch, letter to Ross, 11 February 1971. McCulloch was unequivocal in one letter to his agent Peter Quick: 'I will not relinquish copyright to Lansdowne.' 7 January 1971, SLV, Box 12.
43 McCulloch, letter to Ross, 23 February 1972, SLV, Box 12.
44 McCulloch, letter to John A Guthrie, 12 September 1974; McCulloch to E Greenwood, 12 December 1976, SLV, Box 12.
45 McCulloch, letter to Frank Cusack, 1 September 1977, SLV, Box 13.
46 Cusack, letter to McCulloch, 16 August 1977, SLV, Box 12.
47 Whitlam, letter to McCulloch, 19 April 1977, SLV, Box 40.
48 Hoad, 'Too Many Dropped Threads', *24 Hours*, July 1977, SLV, Box 12; McCulloch, letter to the Editor, ABC's *The Critic*, 6 July 1977, SLV, Box 11.
49 McCulloch, letter to the Editor, *Times Literary Supplement*, 3 March 1978; Quartermaine, 'From Pick to Palette', *Times Literary Supplement*, 4 November 1977, SLV, Box 12.

Chapter 10 Home on the Range
1 McCulloch, letter to *Peninsula Post*, undated, McCulloch Family Papers.
2 McCulloch, letter to Len Yeardsley, 8 November 1975. McCulloch subsequently wrote to Geoffrey Hayes, Minister for Planning, backing the state government's plan for the conservation of the Mornington Peninsula, 16 November 1976, McCulloch Family Papers.
3 McCulloch, letter to Cec, 5 May 1973, SLV, Box 51.
4 Hoskin, letter to McCulloch, 8 May 1973, SLV, Box 51.
5 Winter, letter to McCulloch, 19 January [1968], SLV, Box 48.
6 McCulloch, letter to James Fitzsimmons, 5 September 1970, SLV, Box 37.
7 McCulloch, letter to the Editor, *Peninsula Post*, 14 October 1959, SLV, Box 57. See also McCulloch's letters to and from state MLA Roberts Dunstan, 22 June, 6 July and 11 July 1959, SLV, Box 57.
8 McCulloch, letter to Gladys [illeg.], 15 October 1972, SLV, Box 52.
9 McCulloch, letter to Gorton, 3 June 1970 and Whitlam, letter to McCulloch, 10 June 1970, SLV, Box 50.
10 McCulloch, letter to TS Duckmanton, 26 October 1977, SLV, Box 40.
11 McCulloch, letter to Whitlam, 26 October 1977, SLV, Box 40.
12 McCulloch, letter to Hamer, 15 April 1973, SLV, Box 52.
13 McCulloch, letter to Whitlam, 29 November 1975, SLV, Box 12.
14 McCulloch, letter to Whitlam, 11 December 1977, SLV, Box 40.
15 McCulloch Family Papers.
16 McCulloch, letter to Holt, 10 August 1966, SLV, Box 40.
17 McCulloch, letter to Holt, 10 July 1967, SLV, Box 40.

18 McCulloch, letters to and from Dillon, 21 September and 17 October 1967, SLV, Box 40.
19 Margaret Rich, 'The Development of Regional Galleries', in *Understanding Museums: Australian Museums and Museology*, edited by Des Griffin and Leon Paroissien, National Museum of Australia, Canberra, 2011.
20 McCulloch, letter to Secretary, Visual Arts Board, [1973], SLV, Box 56.
21 McCulloch, letter to Secretary, Visual Arts Board, 11 August [1973], SLV, Box 56.
22 Tanner, letter to McCulloch, 19 July 1971, SLV, Box 56.
23 McCulloch, letter to Pugh, 7 March 1973, SLV, Box 52.
24 McCulloch, letters to and from Fitzsimmons, 12 June and 16 August 1973, SLV, Box 37.
25 Fitzsimmons, letter to McCulloch, 3 September 1973, SLV, Box 37.
26 McCulloch, letter to Hayden, 7 October 1980, SLV, Box 53.
27 McCulloch, letter to Ryan, 10 February 1981, SLV, Box 53.
28 McCulloch, letter to Ryan, 16 February 1983, SLV, Box 52.
29 McCulloch, letter to Maureen [Gilchrist], 2 April 1979, SLV, Box 53.
30 Eggleston, letter to McCulloch, 18 February 1955, SLV, Box 46.
31 Macdonald, letter to McCulloch, 1 February 1957, SLV, Box 47.
32 Nathan, letter to McCulloch, 7 March 1957, SLV, Box 47.
33 Spencer, letter to McCulloch, undated, SLV, Box 48.
34 Newspaper clipping, *Herald*, 2 November 1950, SLV, Box 39.
35 McCulloch, letter to Williams, 5 April 1955, SLV, Box 52.
36 Malcolmson to McCulloch, 1 March 1961, SLV, Box 39.
37 McCulloch, 'The Cultural Centre Has Character', *Herald*, 23 February 1961.
38 McCulloch, letter to Westbrook, 23 March 1961; Westbrook to McCulloch, 30 March 1961, SLV, Box 39.
39 Smith, letter to McCulloch, 27 June 1961, SLV, Box 48.
40 Horton, letter to McCulloch, 27 September 1968, SLV, Box 48. See McCulloch, 'Victorian Arts Centre: Norma Redpath's Bronze Coat of Arms' and '"Carpet in the Sky": Leonard French's Ceiling for the New National Gallery of Victoria' [*Art and Australia* 1968]. Manuscripts, SLV, Box 48.
41 Brian Kitching, 'Councillors Divided on Square's Design', *Age*, 26 October 1963, SLV, Box 57.
42 Geoffrey J Wallis, *Peril in the Square: The Sculpture that Challenged a City*, Indra Publishing, Victoria, 2004, p. 12.
43 Alan McCulloch, 'Planning the Square', *Herald*, 8 February 1967.
44 *Age*, 24 July 1969. A distinguished judging panel was assembled that included architects Harry Seidler, Robin Boyd and Brian Lewis, Professor of Architecture, University of Melbourne.
45 *Age*, 25 July 1969.
46 Brown, letter to McCulloch, 12 August 1969, SLV, Box 57.
47 McCulloch, letter to Town Clerk, City of Melbourne, 19 August 1969, SLV, Box 57.
48 Alan McCulloch, 'Planning the Square/ The Master Plan', unpublished manuscript, undated and 1 July 1969, SLV, Box 57.

49 McCulloch, letter to John Denton, 27 June 1977, SLV, Box 40.
50 See Wallis, p. 19.
51 For example, Janine Burke, 'Alienating Sculpture in a City Oasis', *National Times*, August 1978 and Graeme Sturgeon, 'Identity Crisis in Public Art', *Weekend Australian Magazine*, 26–27 August 1978.
52 McCulloch, 'Now Isn't That a Perfect Setting for Dirty Doings!', *Herald*, 8 August 1978.
53 McCulloch, 'How's This for an Art Centre', *Herald*, 9 May 1969. The Hakone Open-Air Museum was to open in a blaze of glory in 1969 as the first of its type in Japan. Its collection of inspiring modern art and stunning landscaped grounds struck a responsive chord with McCulloch, who canvassed for the creation of a similar-styled international sculpture park and exhibitions in Australia. He had envisaged a smaller-scale development integrating sculpture and drawing, utilising the natural bush at McClelland Gallery, Victoria. Instead, he turned to Canberra, the nation's rapidly growing capital, to build and stage a nation-wide event.
54 The National Capital Development Commission had been entrusted by Prime Minister Menzies in 1957 with a charter to complete the establishment of Canberra as the seat of government. See Margaret Plant, *Love and Lament: An Essay on the Arts in Australia in the Twentieth Century*, Thames & Hudson, Melbourne, 2017, p. 272.
55 McCulloch, letters to and from Overall, 16 June and 4 July 1969, SLV, Box 50.
56 McCulloch, letter to Overall, 22 August 1969, SLV, Box 45.
57 Overall, letter to McCulloch, 25 September 1969, SLV, Box 45.
58 McCulloch, letter to Gorton, 9 December 1969 and 'Proposed Canberra Sculpture Project', handwritten notes, undated, unpag., SLV, Box 45.
59 Gorton, letter to McCulloch, 8 January 1970, Box 45.
60 GC Shannon, letter to McCulloch, 5 February 1973, SLV, Box 45.
61 Shannon, letter to McCulloch, 30 April 1973, SLV, Box 45. Shannon was referring specifically to McCulloch's recommendations for the committee to purchase works from the Mildura *Sculpturescape*, of which three were selected.
62 O'Connor, letter to McCulloch, 1960, SLV, Box 47.
63 WS Glover, letter to McCulloch, 17 March 1961, SLV, Box 47.
64 In December 1983, LN Elliott, managing director of Georges, wrote to inform McCulloch that the prize was to be discontinued, 12 December 1983, SLV, Box 50.
65 McCulloch, letter to Bernadette Sullivan, 27 June 1980, SLV, Box 50.
66 Alan McCulloch, 'Introduction', Georges Art Prize, 1980, SLV, Box 50.
67 McCulloch, letters to and from AD Fitch, Georges Marketing Manager, 8 and 14 March 1962, SLV, Box 36.
68 Alan Forbes, letter to McCulloch, 13 April 1962, SLV, Box 36.
69 McCulloch, letters to and from Forbes, 4 and 9 May 1962, SLV, Box 36.
70 Olsen, letter to McCulloch, undated [1963], SLV, Box 47.
71 ibid.
72 Warren, *Sun News Pictorial*, 9 May 1962.
73 Harris, letter to Daniel Thomas, undated, SLV, Box 39.

74 Daniel Thomas, in conversation with the author, c. 2012. See also Thomas, 'The Week in Art: This Week Was Olsen's Week', *Sunday Telegraph*, 12 May 1963. Reprinted in Hannah Fink and Steven Miller (eds), *Daniel Thomas: Recent Past: Writing Australian Art*, Art Gallery of New South Wales, Sydney, 2022, pp. 36–7.
75 McCulloch, 'Our Biggest Art Prize', *Herald*, 8 May 1963.
76 Forbes, letter to McCulloch, 3 March 1964, SLV, Box 36.
77 McCulloch, letter to Thomas, 11 March 1964, SLV, Box 36.
78 McCaughey, *Age*, 16 May 1967.
79 McCulloch, letter to the Editor, *Age*, 17 May 1966.
80 Blackman, letter to Forbes, 29 May 1967, SLV, Box 50. Forbes, in turn, passed the letter on to McCulloch.
81 McCulloch, unpublished list of artists [1964], SLV, Box 39.
82 Sansom, letters to McCulloch, 29 January 1964 and 26 January 1966, SLV, Box 36.
83 Harris, letter to McCulloch [1965], SLV, Box 36.
84 McCaughey, letter to McCulloch, 15 April 1967, SLV, Box 50. McCaughey must have had a change of heart, as he resubmitted his list less than eleven days later and giving his six preferences, perhaps predictably, as 1. Michael Taylor, 2. Mirka Mora, 3. Asher Bilu, 4. Tony McGillick, 5. Peter Dickie and 6. David Aspden. Later, after a trip to Sydney, he wanted to add Michael Johnson and Dick Watkins to the list as 'of all the painters work I saw in Sydney these two impressed the most'. McCaughey, letters to McCulloch, 26 April 1967 and 30 January 1968, SLV, Box 50.
85 McCulloch, 'Foreword', Georges Art Prize, 1968.
86 McCulloch, letter to Lynn, 23 November 1970, McCulloch Family Papers.
87 McCulloch, letter to Thomas, 2 April 1970, SLV, Box 50.
88 McCulloch, letter to Kaldor, 12 February 1971 and McCulloch, letter to Lynn, 2 April 1971, SLV, Box 50.
89 McCulloch, letter to Janine Burke, 25 June 1979, SLV, Box 53.
90 McCulloch, letter to Judges, 28 October 1981, SLV, Box 50.
91 McCulloch, letters to and from George Hawkes, 5 April and 30 May 1967, SLV, Box 48.
92 DR Bunney, letters to and from McCulloch, 24 and 26 February 1971, SLV, Box 50.
93 McCulloch, letter to Andrew Whist, 20 March 1973, SLV, Box 52.
94 Alan McCulloch, Susan McCulloch and Emily McCulloch Childs, *The New McCulloch's Encyclopedia of Australian Art*, Aus Art Editions and Miegunyah Press, Melbourne, 2006, p. 1178.
95 The Travelodge Collection, exhib. cat., 1969.
96 *Age*, 9 December 1968.
97 McCulloch, McCulloch Family Papers. See also Steven Tonkin, 'Donald Laycock: Star Cycle', *Art Journal*, 6 July 2017.
98 McCulloch, letter to Parker, 1 January 1970, SLV, Box 51. Donald Laycock won with a work entitled *Wings*. According to the *Age* writer (30 October 1970), the real winner on the night was Fred Williams, with the purchase of his *Silver and grey* for $12 000. Other works acquired for the Travelodge collection

were by David Aspden, Sam Fullbrook, John Olsen and Clifton Pugh. See McCulloch, letter to Fitzsimmons, 28 October 1970, Box 37.
99 McCulloch, letter to Parker, 24 February 1971, SLV, Box 50.
100 *Age*, 10 November 1971.
101 McCulloch, letter to Parker, 14 November 1971, SLV, Box 50; McCulloch, *Herald*, 3 November 1971.
102 Transfield Art Prize Press Release, SLV, Box 37.
103 McCulloch, letter to JA Fitzgerald, 27 October 1971, SLV, Box 50.
104 BF Kilgariff, MLC, 'Presidents 3rd Annual Report', 1973, SLV, Box 51; McCulloch, 'Centre of Attraction', *Herald*, 11 October 1972.
105 McCulloch, 'Centre of Attraction'.
106 Susan McCulloch, in conversation with the author, 2019.
107 McCulloch, 'Centre of Attraction'.
108 'Kaapa Tjampitjinpa', National Museum Australia, https://www.nma.gov.au/exhibitions/papunya-painting/papunya-painting/artists/kaapa-tjampitjinpa.
109 Dargie was at the time a member of the CAAB, which had helped acquire works for the NGA in its early developmental years.
110 McCulloch, letter to Shannon, 14 October 1972, SLV, Box 45.
111 McCulloch, letter to Wardle, 17 October 1972, SLV, Box 51.
112 Wardle, letter to McCulloch, 26 October 1972, SLV, Box 51.
113 D Cleaver, Hon. Sec., The Alice Springs Art Foundation, letter to McCulloch, 10 November 1972, SLV, Box 51.
114 'The idea of putting Alice Springs on the map by holding a national art competition was conceived in 1969, and in 1970 the first Alice Prize was born. The brave group of volunteer administrators was led by businessman and MLA Bernie Kilgariff, who became the founding President of the Alice Springs Art Foundation Inc. With prestigious judges, attractive prize money and free air freight, The Alice Prize was an enticing event.' http://aliceprize.com/history.html.

Chapter 11 The Australian Public Gallery Movement
1 McCulloch, 'Introduction', Georges Art Prize, 1978, SLV, Box 50.
2 'Proposed Victorian Decentralised Galleries Exhibition', March–June 1966, SLV, Box 40.
3 McCulloch, 'Herald and Weekly Times Regional Arts Foundation Proposal' undated, SLV, Box 47.
4 Westbrook, letter to McCulloch, 10 September 1959, SLV, Box 39.
5 McCulloch, letter to Seidel, 17 August 1966, SLV, Box 40.
6 McCulloch, letter to Bolte, 19 September 1966, SLV, Box 48.
7 McCulloch, letter to Westbrook, 17 October 1963, SLV, Box 36.
8 McCulloch, letter to Ruth McNicoll, 30 November 1973, SLV, Box 51.
9 McCulloch, 'The Future and Development of Provincial Galleries', undated, SLV, Box 39.
10 CJ Beaumont, letter to McCulloch, 15 November 1965, SLV, Box 48.
11 McCulloch, letter to Fitzsimmons, 24 April 1971, SLV, Box 37.
12 McCulloch, letter to Mollison, 1971, SLV, Box 50.
13 McCulloch, letter to Blythe, 8 October 1974, SLV, Box 51.

14 McCulloch, letter to Whitlam, 6 and 7 November 1973; Michael Delaney, letter to McCulloch, undated, SLV, Box 51. Delaney was Whitlam's personal secretary.
15 McCulloch, letters to and from Voss Smith, 16 January and 20 February 1974, Box 51. See also McCulloch's article in the *Herald*, 18 July 1973.
16 Lindsay, letters to and from McCulloch, 3 and 14 October 1974, SLV, Box 51.
17 McCulloch, letter to Gordon Thomson, 1974, SLV, Box 51.
18 McCulloch, letter to Hackett, 6 May 1976, SLV, Box 51.
19 McCulloch, letters to and from Staley, 1 and 28 1977, SLV, Box 47.
20 McCulloch, letter to the Editor, *Courier Mail*, 15 March 1960, SLV, Box 39.
21 Don Edgar, *Art for the Country: The Story of Victoria's Regional Galleries*, Australian Scholarly Publishing, North Melbourne, 2019, p. 170.
22 McCulloch, letter to John Cooper, 8 July 1970, SLV, Box 50.
23 McCulloch, letter to Director, Gold Coast Art Gallery, 1 and 2 June 1971, SLV, Box 50.
24 Margaret Cossins, letter to McCulloch, undated [1980s], SLV, Box 46.
25 John Baily, letters to and from McCulloch, 9 February, 21 February and 29 March 1973, SLV, Box 52.
26 Alan McCulloch, Susan McCulloch and Emily McCulloch Childs, *The New McCulloch's Encyclopedia of Australian Art*, Aus Art Editions and Miegunyah Press, Melbourne, 2006, p. 821.
27 According to Margaret Rich, 'This organisation emerged out of the earlier and smaller Victorian Public Galleries Group (VPGG), formed in the late 1940s through the initiative of the National Gallery of Victoria (NGV) to develop, support and provide greater access to the state's widely dispersed public art collections.' See Margaret Rich's article for Museums Australia, 'The Development of Regional Galleries', in *Understanding Museums: Australian Museums and Museology*, edited by Des Griffin and Leon Paroissien, National Museum of Australia website, 2011.
28 *New McCulloch's Encyclopedia of Australian Art*, p. 1011. In 1988, McCulloch wrote to the editor of the *Age*'s *Good Weekend* in response to an article on the importance of the regional gallery movement, extolling the role of Donald Webb, 'the man who, as chairman of the RGA of V for nearly twenty years, voluntarily built up the entire regional gallery movement in Australia'. 15 June 1988, SLV, Box 46.
29 KD Green, Secretary, Department of the Premier, letter to McCulloch, 24 October 1977, SLV, Box 47.
30 Gibson, letter to McCulloch, 2 January 1956, SLV, Box 47.
31 McCulloch, letter to Shelmerdine, 30 April 1958, SLV, Box 47.
32 McCulloch, letter to Marjorie Wymark, 21 August 1975, SLV, Box 51. McCulloch had corresponded with Thomas in 1974.
33 Press release, 8 August 1980, SLV, Box 31.
34 Conversation with Ron Radford, MPRG, c. 2012. Radford and Castlemaine Art Gallery director Peter Perry had previously made a case for the strengths and significance, in monetary terms, of regional collections in Victoria, which they put at in 'excess of 30 million'. 'Value of the Importance of RGAC

Collections', undated, SLV, Box 41. See also Margaret Rich, 'The Development of Regional Galleries', 2011, unpag. According to McCulloch, Radford had pushed for the conservation centre at the RGAV conference in 1975, followed in May–June 1976 with the exhibition of 'works crammed into front upstairs galleries with attention [drawn to] what [conservation work] each work needed …', Conservation Centre, first annual report, 1977, SLV, Box 41. McCulloch served on the RGAV Conservation Advisory Committee with Radford from 1978.

35 Rowlinson, Report for Annual RGAV meeting, Benalla, April 1979, SLV, Box 41.
36 McCulloch, notes to RGAV Conservation study, 1979, SLV, Box 41.
37 See Susan McCulloch, 'Behind the Parrot Door: The First Twenty Years', in *Mornington Peninsula Regional Gallery 1970–2020*, MPRG, 2020, pp. 7–19.
38 McCulloch, Speech notes in defence of regionals, undated, SLV, Box 41.
39 McCulloch, letter to FJ Williams, Secretary, Warrnambool Florado Festival, 30 March 1963, SLV, Box 30.
40 John Dean to McCulloch, 24 August 1965, SLV, Box 31.
41 McCullough, letter to McCulloch, 12 March 1969, SLV, Box 50. See also the relevant 'Directors Report', 28 February 1969, SLV, Box 31.
42 McCulloch, letter to McCullough, 17 April 1969, SLV, Box 50.
43 McCulloch, letter to Hamer, 23 July 1972, SLV, Box 52.
44 McCulloch, letter to Vin Kane, 6 August 1972, SLV, Box 45.
45 GC Shannon, letter to McCulloch, 6 August 1973, SLV, Box 45.
46 McCulloch, letter to McCullough, 6 July 1978, SLV, Box 53.
47 Barry Hayes, letter to McCulloch, 4 June 1979, SLV, Box 53.
48 McCulloch, letter to Hayes, 26 July 1979, SLV, Box 53.
49 McCulloch, letter to Rogers, 5 May 1973, SLV, Box 52.
50 McCulloch, letter to Davidson, 16 January 1974. See also correspondence between McCulloch and Colonel SR Birch, Administrator, National Trust, 18 and 30 January 1974, SLV, Box 51.
51 McCulloch, letter to David Thomas, 16 October 1974, SLV, Box 51.
52 Maidie McGowan, letter to McCulloch, 4 April 1951, SLV, Box 47.
53 McCulloch, letter to Gantner, 9 July 1962, SLV, Box 48.
54 See Andrew Gaynor, *McClelland: The Bohemian Legacy*, McClelland Gallery, exh. cat., 2007.
55 Office bearers of the McClelland Gallery Group in 1966 were: Patrons: Sir Robert Knox, Mr John Tallis; Life members: Sir Daryl Lindsay, John Rowell, Mollie Graham; President: Colin McGowan; Secretary: Maidie McGowan. The Peninsula Arts Society had been established in 1954 by Colin and noted George Bell–trained artist Maidie with the first meeting held at the Mechanics Hall, Frankston and then shifted to 'The Barn', owned by the McClellands.
56 McGowan, letter to McCulloch, 15 March 1965. See McCulloch's report, 5 May 1965, SLV, Box 40.
57 McCulloch, Notes of the Report, undated, SLV, Box 40.
58 McCulloch, letter to Ron Appleyard, 4 June 1965. 'Invoice for expenses from McClelland Gallery', SLV, Box 40. The formation of an Australian-wide association of museum professionals had been mooted in December 1963 when

a circular had been sent out under the auspice of RG Appleyard, Assistant Director, AGSA. Gordon Thomson from the NGV wrote to offer McCulloch help for him attend as an observer. 4 June 1965, SLV, Box 40.
59 McCulloch, 'Contract with Alan McCulloch as Director', Harry McClelland (Memorial) Gallery and Cultural Centre, undated [1965], SLV, Box 40.
60 Notes for meeting at Ogge & Co. offices, 21 September 1965, SLV, Box 40.
61 McCulloch, *Southern Peninsula Gazette*, 4 August 1965, SLV, Box 40.
62 Souillac, letters to McCulloch, 19 August and 3 September 1965. McCulloch also sent overtures to the Dutch government, and Clem Christesen aided him with introductions. Christesen, letter to McCulloch, 15 September 1965, SLV, Box 48.
63 McCulloch, letter to Souillac, August 1965, SLV, Box 48.
64 McCulloch, letter to Ellen McCulloch, 20 October 1965, SLV, Box 36.
65 McCulloch, letter to Craig Forster, 11 October 1966, SLV, Box 48.
66 Jim and Molly Graham, letter to McCulloch, November 1965, SLV, Box 40.
67 McCulloch, 'Brief for Harry McClelland Art Gallery and Culture Hall', March 1966, SLV, Box 40.
68 McCulloch, 'McClelland Art Gallery Report', 1966, SLV, Box 40.
69 Baillieu Myer, letter to McCulloch, 16 June 1966, SLV, Box 40.
70 McCulloch, letter to Roberts, 17 September 1966, SLV, Box 55.
71 McCulloch, letter to Harrison and Graham, November 1966, SLV, Box 40.
72 Harrison, letter to McCulloch, 4 December 1966, SLV, Box 40.
73 *Age*, 14 January 1967; McCulloch, letter to the Editor, *Age*, 14 January 1967, SLV, Box 40.
74 McCulloch, letter to Harrison, 5 March 1967, SLV, Box 40.
75 Ogge, letter to McCulloch, 23 March 1967, SLV, Box 40.
76 Galbally and Peter O'Bryan, letter to James P Ogge and Co., 4 May 1967, SLV, Box 40.
77 Galbally, letter to McCulloch, 26 May 1967, SLV, Box 40; Gobbo, letter to McCulloch, 1 May 1967, SLV, Box 40.
78 'Memorandum: A McCulloch and Annie May McClelland Trust', 4 May 1967, SLV, Box 40.
79 McCulloch, letter to *The Standard*, 20 December 1967, SLV, Box 40.
80 McCulloch, letter to RR Etherington, 25 November 1971, SLV, Box 40.
81 Munro, letter to McCulloch, 22 December 1969, SLV, Box 40.
82 McCulloch, letter to Lynch, 29 January 1968, SLV, Box 40.
83 McCulloch, letter to Lynch, 29 January 1968, McCulloch Family Papers.
84 Susan McCulloch, 'Behind the Parrot Door', p. 7.
85 Written notes of Tom Hast's speech given at the opening of the MPRG, 1990, cited in ibid., p. 8.
86 McCulloch, letter to Gibson, 11 December 1972, SLV, Box 50.
87 McCulloch, 'Report on various matters discussed at meeting with Council', 11 July 1969, SLV, Box 40.
88 *Mornington Peninsula Art Development*, 1969, pamphlet, MPRG Archives.
89 McCulloch, letter to Rich, 30 October 1977, SLV, Box 53.
90 McCulloch, letter to McCullough, 30 March 1971, SLV, Box 50.
91 McCulloch, letter to Martyn, 17 April 1971, SLV, Box 52.

92 Wenzel, letter to McCulloch, 4 March 1974; McCulloch to Wenzel, 26 March 1974, SLV, Box 51.
93 Susan McCulloch, 'Behind the Parrot Door', p. 8.
94 Boyd, letter to McCulloch, 16 May 1970, SLV, Box 51.
95 McCulloch, letter to Lynn, [September] 1971, SLV, Box 50; McCulloch, letters to Gantner, 29 June 1971 and 7 August 1971, SLV, Box 51.
96 Fulton, letter to McCulloch, 14 March 1974, SLV, Box 51.
97 McCulloch, letter to Blythe, 8 October 1974, SLV, Box 5.
98 McCulloch, letter to Fitzsimmons, 8 September 1975, McCulloch Family Papers.
99 McCulloch, letter to Purvis, 15 April 1973, McCulloch Family Papers.
100 McCulloch, letter to Orban, 28 June 1973, SLV, Box 51.
101 McCulloch, letter to Hutchison, 25 March 1972, SLV, Box 37.
102 McCulloch, letter to Cooper, 29 July 1973, SLV, Box 51.
103 McCulloch, letter to Besen, 2 October 1975, SLV, Box 51.
104 McCulloch, letter to Blackman, 4 June 1972, SLV, Box 52.
105 McCulloch, letter to Counihan, 5 February 1975, SLV, Box 52.
106 McCulloch, letter to Marjorie Wymark, 21 August 1975, SLV, Box 51.
107 McCulloch, 'Report from annual RGAV meeting', April 1979, SLV, Box 41.
108 Drysdale, letters to and from McCulloch, 20 April and 3 May 1978, SLV, Box 53.

Chapter 12 The Later Years

1 From 'Auguries of Innocence' by William Blake, quoted by McCulloch at the opening of Mornington Peninsula Arts Centre, 17 November 1990.
2 Hinton, letters to and from McCulloch, 8 September 1981, SLV, Box 55.
3 KD Macpherson, letter to McCulloch, 22 October 1981, SLV, Box 55.
4 Howley, letter to McCulloch, 19 July 1981; Abrahams, letter to McCulloch, 24 July 1981; McCaughey, letter to McCulloch, 27 July 1981, and Mogensen, letter to McCulloch, 23 July 1981, SLV, Box 53.
5 George Berger, honorary secretary and treasurer, letter to McCulloch, 25 June 1973, SLV, Box 51.
6 Yvonne Boyd, letter to Alan and Ellen McCulloch, 15 February 1976; Lyn Williams, letter to McCulloch, 17 February 1976, and letters of congratulations from Joseph Brown, Eric Westbrook, Donald Webb, Andrew Grimwade, Patrick McCaughey, Maie Casey, Joseph Burke and Rudy Komon, SLV, Box 51.
7 Jones, letter to McCulloch, 16 February 1976, SLV, Box 51.
8 Fred and Lyn Williams, letter to McCulloch, 12 February 1976, SLV, Box 55.
9 Hook, letter to McCulloch, 28 June 1977, SLV, Box 51.
10 Christesen, letter to McCulloch, 26 January 1986, SLV, Box 46.
11 Caro, letter to McCulloch, November 1987, McCulloch Family Papers. The Doctor of Laws (Honoris Causa) ceremony was held on 9 April 1988.
12 McCulloch, 'One man's incidental view of university life', SLV, Box 57.
13 Christesen, letter to McCulloch, 8 July 1986, SLV, Box 46.
14 Christesen, letters to and from McCulloch, 9 February and 24 February 1989, SLV, Box 21.
15 McCulloch, letter to Davidson, 17 November 1980, SLV, Box 21.

16 Bellette, letter to McCulloch, 10 September 1982, SLV, Box 53.
17 Mervyn Horton, letter to McCulloch, 25 November 1982, SLV, Box 53.
18 Komon, letter to McCulloch, 14 November 1982, SLV, Box 53.
19 McCulloch, letter to Robin Rawson, Director Honours Secretariat, Govt House, 5 November 1985, SLV, Box 57.
20 *Herald*, 24 March 1977.
21 Davila, letter to McCulloch, 2 May 1977, MPRG Archives.
22 McCulloch, letter to McNicholl, 10 October 1980, SLV, Box 53.
23 McCulloch, letters to and from Ross Howie, Solicitor, Central Land Council, 17 February, 24 February and 24 March 1981, SLV, Box 53.
24 Howie, letter to McCulloch, 17 September 1981, SLV, Box 53.
25 Coldrey, letter to McCulloch, 13 September 1982, SLV, Box 53.
26 McCulloch, letter to Liz Christensen, 18 March 1981, SLV, Box 53.
27 ibid.
28 McCulloch, letter to Hunt, 27 May 1980, SLV, Box 53.
29 *Age*, 5 April 1977. Gilchrist raised the hackles of expatriate critic Robert Hughes, who challenged both her knowledge of American art and her understanding of the conditions in which international touring shows were conceived and lent. Robert Hughes, letter to the Editor, *Age*, 7 April 1977.
30 McCulloch, *Herald*, 14 April 1977.
31 McCulloch, *Herald*, 14 March 1976.
32 McCulloch, *Herald*, 28 April 1977. The title and subject of the work was subsequently reattributed by Turner scholars in 2013 based on new evidence that suggested it depicted the Rhine falls at Schaffhausen and is now known by the title *Falls of Schaffhausen (Val d'Aosta)*.
33 Rowlinson, letter to McCulloch, 3 May 1977. See also McCulloch's reply, *Herald*, 19 May 1977, SLV, Box 47.
34 Spate, *Age*, 1 June 1977; McCulloch, *Herald*, 10 June 1976.
35 Boyd, letter to McCulloch, 9 May 1986, SLV, Box 53.
36 McCulloch, letter to Christesen, 11 September 1981, SLV, Box 53.
37 Boyd, letter to McCulloch, 15 September 1980, SLV, Box 53.
38 Purves, letter to McCulloch, 21 July 1982, on which McCulloch wrote 'Done 24 Aug '82, payment declined', SLV, Box 53.
39 Purves, letter to McCulloch, 29 December 1982, SLV, Box 53; Boyd, letter to McCulloch, 7 October 1982, SLV, Box 53.
40 Boyd, letter to McCulloch, 9 May 1986, SLV, Box 53.
41 Thorne, letter to McCulloch, 8 May 1988, SLV, Box 52.
42 McCulloch, letter to Boyd, 30 October 1984, SLV, Box 53.
43 Boyd, letter to McCulloch, 12 December 1984, SLV, Box 40.
44 Boyd, letter to McCulloch, 18 December 1984, SLV, Box 40.
45 Arthur and Yvonne Boyd, letter to McCulloch, 4 October 1990, SLV, Box 40.
46 Susan McCulloch, correspondence with the author, 2023.
47 Counihan, letter to McCulloch, 3 May 1976, SLV, Box 51.
48 McCulloch, letter to Judy Blythe, 8 January 1978, SLV, Box 53.
49 Smith, letter to McCulloch, 28 July 1990, SLV, Box 57.
50 McCulloch, *Herald*, 25 March 1977.
51 McCulloch, *Herald*, 22 June 1978.

52 McCulloch, *Herald*, 19 August 1976.
53 McCulloch, *Herald*, 5 October 1978.
54 McCulloch, *Herald*, 7 October 1976.
55 McCulloch, *Herald*, 19 June 1980
56 McCulloch, *Herald*, 13 July 1978.
57 McCulloch, *Herald*, 20 July 1980.
58 McCulloch, letters to and from Grayden, 16 May and 10 July 1980, SLV, Box 53. 'Paper for Flinders Shire', 8 October 1985, SLV, Box 18.
59 Hamer, letter to McCulloch, 17 February 1983, SLV, Box 52.
60 'Report given to RGAV Directors' Conference', 12 December 1986, SLV, Box 52.
61 Burston, letter to McCulloch, 15 November 1990, SLV, Box 53.
62 Christesen, letter to McCulloch, 2 November 1990, SLV, Box 55.
63 Senbergs, letter to McCulloch, 12 July 1990, SLV, Box 57.
64 Murdoch, letter to McCulloch, 10 June 1988, SLV, Box 57.
65 Drysdale, letters to and from McCulloch, undated; 26 July 1988, SLV, Box 57.
66 Lindsay, letter to McCulloch, undated [1984], postmarked 9 November 1984, SLV, Box 52.
67 Thorne, letter to McCulloch, 12 July 1986, SLV, Box 52.
68 Thorne, letter to McCulloch, 12 July and 27 August 1986, SLV, Box 52.
69 Lou Klepac, 'Salute to Alan McCulloch', *Art and Australia*, vol. 29, no. 2 (Summer 1991), p. 179.
70 See *Mornington Peninsula Regional Gallery 1970–2020*, MPRG, 2020.
71 Whitlam, letter to McCulloch, 25 July 1980, SLV, Box 54.
72 Senbergs, letter to McCulloch, 14 March 1990, SLV, Box 57.
73 Jane Gilmour, Executive Director, The Robert Holmes à Court Collection, letter to McCulloch, 4 October 1990, SLV, Box 57.
74 McCulloch, letter to Pascoe, 17 November 1981, SLV, Box 56.
75 McCulloch, letter to Christesen, 12 June 1981, SLV, Box 53.
76 McCulloch, unpublished notes [1981], SLV, Box 55.
77 Rumley, letter to McCulloch, 7 May 1982, SLV, Box 55.
78 McCulloch, unpublished speech notes, 1984, SLV, Box 18.

Chapter 13 Postscript: Writing Australian (Art) History

1 Johann Wolfgang von Goethe, quoted by Alan McCulloch at Flinders Art Show opening, 1984.
2 Clarke, 'McCulloch: Magnate of Modern Art', *Age Saturday Extra*, 17 October 1987.
3 Sasha Grishin, *ST Gill and His Audiences*, National Library of Australia, Canberra, and State Library Victoria, Melbourne, 2015, p. 12.

BIBLIOGRAPHY

Archival sources
Alan McCulloch Papers, La Trobe Australian Manuscripts Collection, State Library Victoria. This collection of over 6000 papers documents Alan McCulloch's major contribution to Australian art during the twentieth century, including material relating to the *Encyclopedia of Australian Art*, a number of drafts of an unpublished autobiographical novel, journals and notebooks from the 1950s to the 1970s, and a comprehensive collection of letters relating to the Australian and international art scene.
Frederick W Schonbach, Cartoon collection, State Library Victoria, Melbourne.
Godfrey Miller, Letters 1954–61, State Library Victoria, Melbourne.
Gwendolyn Thorne Papers, State Library Victoria, Melbourne.
Lina Bryan Papers, State Library Victoria, Melbourne.
McCulloch Family Papers, Victoria.
Mornington Peninsula Regional Gallery Archives, Victoria.
Papers of Bernard Smith, National Library of Australia, access courtesy of Dr Sheridan Palmer.
Percival Serle and Len Annois Papers, State Library Victoria, Melbourne.

Interviews and correspondence
Lindy Allen
Leigh Astbury
Christabel Blackman
Ed Burston
Ivan Durrant
Caroline Field
Sasha Grishin AM FAHA
Rosalind Hollinrake
Barry Humphries AO CBE
Lou Klepac OAM
Susan McCulloch OAM

Emily McCulloch Childs
Steven Miller
Charles Nodrum
Sheridan Palmer
Barry Pearce
Peter Perry OAM
Margaret Plant FAHA
Ron Radford AM
Ken Scarlett AO
Bernard Smith
Bernadette Sullivan
Daniel Thomas AM
Rene White
Lyn Williams AO

Alan McCulloch: List of works
Unpublished
Alan McCulloch, 'The Question Mor', unpublished manuscript, undated, MS13506, Alan McCulloch Papers.

Monographs
Masterpieces of the National Gallery of Victoria, edited by Ursula Hoff, text by Ursula Hoff, Alan McCulloch and Joan Lindsay, with an introduction by Daryl Lindsay, Cheshire, London, 1949.
Trial by Tandem, text and illustrations by Alan McCulloch, Cheshire, Melbourne, 1950; reprinted 1951.
Highway Forty, text and illustrations by Alan McCulloch, Cheshire, Melbourne, 1951.
Australian Art Today, Australian News and Information Bureau, Department of Interior, Canberra, 1954.
Encyclopedia of Australian Art, Hutchinson, London, 1968 (with corrections, Hutchinson, Melbourne, 1977); revised edition, two volumes 1984; third edition (with Susan McCulloch), Allen & Unwin, St Leonards, NSW, 1994.
The Golden Age of Australian Painting: Impressionism and the Heidelberg School, Lansdowne, Melbourne, 1969.
Artists of the Australian Gold Rush, Lansdowne, Melbourne, 1977.
Selected Drawings from the Collections of the Mornington Peninsula Arts Centre, Mornington Peninsula Arts Centre, Mornington, 1983.
McCulloch, Alan, Susan McCulloch and Emily McCulloch Childs, *The New McCulloch's Encyclopedia of Australian Art*, Aus Art Editions and Miegunyah Press, Melbourne, 2006.

Illustrated books and pamphlets
So This Was the Spot: Being Several Simple Centenary Reflections Reflected in Words and Pictures / by Alan McCulloch, WB Litho Co., Melbourne, 1934.
Smalley, JL, and Alan McCulloch, *Ballet Bogies*, illustrations by Alan and Wilfred McCulloch, Lionel Smalley, Melbourne, 1938.

Xmas 1938: A Few Ballet Ideas from Henry Buck's, text and illustrations by Alan McCulloch, Henry Buck Pty Ltd, Melbourne, 1938.
Mickle, Alan D, *The Case of Timothy Tout*, illustrations by Alan McCulloch, National Press, Melbourne, 1944.
Mickle, Alan D (Alan Durward), *The Treasure of Captain Carbuncle*, illustrations by Alan McCulloch, National Press, Melbourne, n.d.
Macgeorge, Norman, *Borovansky Ballet in Australia and New Zealand*, assisted by artists, musicians and dancers, FW Cheshire, Melbourne, 1946.
Mickle, Alan D, *Rupert the Red*, illustrated by Alan McCulloch, National Press, Melbourne, n.d.
Pot Luck: A Patriotic Party Book, arranged by Mary Lundqvist and edited and illustrated by Alan McCulloch, WD Vaughan in conjunction with BT Addison and Son, for Women's Auxiliary Social Patriots Organisation, 1941.
Aldous, Allan, *Danger on the Map*, illustrations by Alan McCulloch, Cheshire, Melbourne, 1947.
Going Places and How!, text and illustrations by Alan McCulloch, Neptune Oil Co., Melbourne, 1951.

Recordings
University of the Air: a television programme for thinking people, August–October 1962, 14 pp. Programmes 1–6 had the title: *Australian Art*. The programmes were presented by Alan McCulloch, the Melbourne art critic. Some topics touched on were Heidelberg School, Rupert Bunny, John Russell, Phillips Fox, George W Lambert, the Dobell case.

Exhibitions
Sedon Galleries, Melbourne, 1930 (two works).
Her Majesty's Theatre, Melbourne, 1943 (group exhibition of ballet-related sketches).
Park Galleries, Melbourne, 1945 (group exhibition of ballet drawings and paintings).
Stanley Coe Gallery, Melbourne, 1951 (solo exhibition).
Georges Gallery, Melbourne, 1968 (solo exhibition).
Manyung Gallery, Mt Eliza, 1968 (one work).
Manyung Gallery, Mt Eliza, 1971 (group tapestry exhibition).

Selected essays, articles and exhibition catalogues
Argus, 1944–47.
Genre, 1946.
The Australasian, 1947–48.
Australian Artist, 1947–49.
The Herald, 1951–81.
Meanjin, 1951–77.
Art International, 1969–72.
'Popularity Is No Criterion', *Genre*, vol. 1, no. 1, 1946.
'The Painted Portrait in Art', *Genre*, vol. 1, no. 2, 1946, pp. 4–5.
'Reflections on the Meaning of Drawing', *Australian Artist*, vol. 1, no. 1, 1947, pp. 13–15.

'Namatjira and Rootsey', *Family Herald Magazine*, Canada, 1958.
'Four Australian Painters', *Australia Today*, 1963.
'In Memoriam: Godfrey Miller', *Art and Australia*, vol. 2, no. 2, August 1964.
Aboriginal Bark Paintings from Australia, Museum of Fine Arts, Houston, Texas, 1965.
The Heroic Years of Australian Painting 1940–1965, Herald and Weekly Times Ltd, Melbourne, 1977.
'Dyson', *Overland*, 86, 1981, pp. 27–31.
'Introduction', *Selected Drawings from the Collections of the Mornington Peninsula Arts Centre*, MPAC, Mornington, Vic., 1983, pp. 5–8.
Art and the Theatre in Victoria 1844–1984, Mornington Peninsula Arts Centre, Mornington, Vic., 1985, pp. 6–7.

Interviews and obituary

Bellamy, Louise, 'Critics Do Not Make or Break Artists', *Age*, 6 January 1990, p. 9.
Heathcote, Christopher, 'Conversations with Alan McCulloch', *Art Monthly Australia*, April 1993, no. 58, pp. 13–17.

Works in public collections

Art Gallery of Ballarat, Victoria
Art Gallery of Western Australia, Perth
Australian War Memorial, Canberra
Mornington Peninsula Art Gallery, Mornington
National Gallery of Australia, Canberra
National Gallery of Victoria, Melbourne
Performing Arts Collection, Arts Centre Melbourne
State Library Victoria, Melbourne

FURTHER READING

Theses
Eckett, Jane, 'Centre Five Sculptors: The Formation of an Alternative Professional Avant-garde', PhD thesis, University of Melbourne, 2016.
Geissler, Marie, 'Arnhem Land Bark Painting: The Western Reception 1850–1990', PhD dissertation, University of Wollongong, 2017.
James, Rodney, 'Relationships between Art, Criticism and the Press 1979–1983', BA (Hons) thesis, Visual Arts Department, Monash University, 1984.
Plant, Simon, 'Patrolling the Frontiers: The Art Criticism of Alan McCulloch 1951–1962', MA thesis, University of Melbourne, 1995.
Ryan, Louise, 'Forging Diplomacy: A Socio-Cultural Investigation of the Carnegie Corporation of New York and the Art of Australia: 1788–1941 exhibition', MA thesis, UNSW, Sydney, 2007.
Sullivan, Bernadette, 'Georges Art Prize', BA (Hons) thesis, Monash University, 1980.

Books and articles
Allen, Lindy, 'The Early Collection and Exhibition of Artwork by Aboriginal Artists', in *A Museum for the People: A History of Museum Victoria and Its Predecessors 1854–2000*, Scribe Publications, Melbourne, 2001.
Allen, Traudi, *John Perceval: Art and Life*, Melbourne University Press, Melbourne, 1976.
Anderson, Patricia, *Elwyn Lynn's Art World*, Pandora Press, East Sydney, NSW, 2001.
Astbury, Leigh, *City Bushmen: Heidelberg School and Rural Mythology*, Oxford University Press, Melbourne, 1987.
Brissenden, Alan, and Keith Glennon, *Australia Dances: Creating Australian Dance 1945–1965*, Wakefield Press, Kent Town, SA, 2010.
Brook, Donald, 'The Little Bay Affair', *Art and Australia*, vol. 7, no. 3, December 1969, pp. 230–5.
Bungey, Darleen, *Arthur Boyd: A Life*, Allen & Unwin, Crows Nest, NSW, 2007.
Burke, Janine, *Australian Women Artists: 1840–1940*, Greenhouse Publications, Collingwood, Vic., 1980.

——*The Eye of the Beholder: Albert Tucker's Photographs*, Museum of Modern Art at Heide, Bulleen, Vic., 1998.
——*Australian Gothic: A Life of Albert Tucker*, Random House, Ryde, NSW, 2011 (1st edn 2002).
Burstall, Tim, *The Memoirs of a Young Bastard: The Diaries of Tim Burstall*, Miegunyah Press, Melbourne, 2012.
Catalano, Gary, *The Years of Hope: Australian Art and Criticism 1959–68*, Oxford University Press, Melbourne, 1981.
Chanin, Eileen, and Steven Miller, *Degenerates and Perverts: The 1939 Herald Exhibition of French and British Contemporary Art*, Miegunyah Press, Melbourne, 2005.
Chaseling, Wilbur S, *Yulengor: Nomads of Arnhem Land*, Epworth Press, London, 1957.
Eckett, Jane, 'Renewed Vows: Centre Five and the Post-War Remarriage of Melbourne Sculptors and Architects', Interspaces: Art + Architectural Exchanges from East to West Conference [Proceedings], University of Melbourne, August 2010.
Edgar, Don, *Art for the Country: The Story of Victoria's Regional Galleries*, Australian Scholarly Publishing, Melbourne, 2019.
Edwards, Deborah (with contributions by John Henshaw and Ann Wookey), *Godfrey Miller: 1893–1964*, Art Gallery of New South Wales, Sydney, 1996.
Field, Caroline, *Australian Galleries: The Purves Family Business: The First Four Decades, 1956–1999*, Australian Galleries, Melbourne, 2019.
Fink, Hannah, and Steven Miller (eds), *Recent Past: Writing Australian Art: Daniel Thomas*, Art Gallery of New South Wales, Sydney, 2020,
Gaynor, Andrew, *McClelland: The Bohemian Legacy*, McClelland Sculpture Park and Gallery, Langwarrin, Vic., 2007.
Genocchio, Benjamin (ed.), *The Art of Gentle Persuasion: Australian Art Criticism 1950–2001*, Craftsman House Fine Art Publishing, St Leonards, NSW, 2002.
Gibson, Aubrey, *The Rosebowl*, FW Cheshire, Melbourne, 1952.
Gleeson, James, *Australian Painters*, Lansdowne Press, Sydney, 1976 (1st edn 1971).
Goad, Philip, 'Concrete Ambitions: Art, Architecture and the National Gallery of Australia', in *Vision: Art, Architecture and the National Gallery of Australia*, Black Inc., Melbourne, 2022, pp. 18–82.
Grant, Kirsty, et al., *John Brack*, National Gallery of Victoria, Melbourne, 2009.
Greenberg, Clement, *Art and Culture: Critical Essays*, Beacon Press, Boston, 1961.
Grishin, Sasha, *The Art of John Brack*, Oxford University Press, Melbourne, 1990.
——*ST Gill and His Audiences*, National Library of Australia, Canberra, and State Library Victoria, Melbourne, 2015.
——*Australian Art: A History*, Miegunyah Press, Melbourne, 2015.
Grove, Robin, 'Borovansky, Edouard (1902–1959)', Australian Dictionary of Biography, National Centre of Biography, Australian National University, published first in hardcopy 1993.
Haese, Richard, *Rebels and Precursors: The Revolutionary Years of Australian Art*, Allen Lane, London, 1981.
Hansen, David, 'Put and Look: Towards a History of Regional Gallery Collections', in *HG60*, Hamilton Art Gallery, 2021, pp. 22–9.

Harding, Lesley, 'A Gesture towards Eternity: Albert Tucker and Sidney Nolan in Rome 1954', in *A Link and a Trust: Albert Tucker and Sidney Nolan's Rome Exhibition*, Museum of Modern Art at Heide, Bulleen, Vic., 2004, pp. 20–35.
Hart, Deborah, *Joy Hester and Friends*, National Gallery of Australia, Canberra, 2001.
—— *Arthur Boyd: Agony & Ecstasy*, National Gallery of Australia, Canberra, 2014.
Heathcote, Christopher, *The Quiet Revolution: The Rise of Australian Art, 1946–1968*, Text Publishing, Melbourne, 1995.
—— *Inside the Art Market: Australia's Galleries 1956–1976*, Thames & Hudson Australia, Port Melbourne, Vic., 2016.
Hughes, Robert, *The Art of Australia*, Pelican, Melbourne and London, 1966.
James, Rodney, 'The Artists' Retreat: Discovering the Mornington Peninsula 1850s to the Present', Mornington Peninsula Regional Gallery, Mornington, Vic., 1999, pp. 4–35.
—— 'The Battle for the Spencer Barks: From Australia to the US 1963–65', *La Trobe Journal*, nos 93–94, September 2014, pp. 181–95.
—— 'MPRG at Fifty: 1991–2011', in *Mornington Peninsula Regional Gallery 1970–2020*, Mornington Peninsula Regional Gallery, Mornington, Vic., 2020, pp. 20–9.
—— 'McCulloch, Alan McLeod 1907–1992', *Australian Dictionary of Biography*, vol. 19: 1991–1995, Australian National University Press, Canberra, 2021.
James, Rodney, Susan McCulloch, Clem Christesen and Barry Pearce, *Arthur Boyd: The Emerging Artist*, Mornington Peninsula Regional Gallery, Mornington, Vic., 2001, pp. 6–43.
Keith Murdoch: Journalist, Herald and Weekly Times Ltd, Melbourne, 1952.
Kinnane, Gary, *George Johnston: A Biography*, Thomas Nelson Australia, Melbourne, 1986.
Klepac, Lou, 'Salute to Alan McCulloch', *Art and Australia*, vol. 29, no. 2 (Summer 1991), p. 179.
Lindesay, Vane, *The Inked-In Image: A Social and Historical Survey of Australian Comic Art*, Hutchinson, Richmond, Vic., 1979.
—— 'Alan McCulloch: Cartoonist of Distinction,' *The La Trobe Journal*, nos. 93–94, September 2014, pp. 175–80.
Lindsay, Frances, *Gareth Sansom Paintings 1956–1986*, University of Melbourne, Melbourne, 1986.
Lynn, Elwyn, 'Clement Greenberg Sees Australia', *Art and Australia*, vol. 6, no. 3, September 1968, pp. 150–2.
McCaughey, Patrick (ed. and intro.), *Bert & Ned: The Correspondence of Albert Tucker and Sidney Nolan*, Miegunyah Press, State Library Victoria and Heide Museum of Modern Art, Melbourne, 2006.
—— *Strange Country: Why Australian Painting Matters*, Miegunyah Press, Melbourne, 2014.
McCulloch, Susan, 'Australian Galleries: Fiftieth Anniversary', *Art and Australia*, vol. 43, no. 4, Winter 2006, p. 610.
—— 'Behind the Parrot Door: The First Twenty Years', in *Mornington Peninsula Regional Gallery 1970–2020*, Mornington Peninsula Regional Gallery, Mornington, Vic., 2020, pp. 7–19.

McCulloch, Susan, and Daniel Thomas, *Wilfred McCulloch*, Melbourne Fine Art, Melbourne, 1992.
Marshall, Christopher, 'Between Beauty and Power: Henry Moore's *Draped Seated Woman* as an Emblem of the National Gallery of Victoria's Modernity, 1959–68', *Art Journal*, no. 46, 29 January 2014.
Moore, Felicity St John, *Charles Blackman: Schoolgirls and Angels*, National Gallery of Victoria, Melbourne, 1993.
Morgan, Kendrah, *Joy Hester: Remember Me*, Heide Museum of Modern Art, Bulleen, Vic., 2020.
O'Donoghue, Catherine, 'Astonish Me! Australian Responses to the Ballets Russes', *Creative Australia and the Ballets Russes*, Arts Centre, Melbourne, 2009, pp. 7–12.
Palmer, Sheridan, *Hegel's Owl: The Life of Bernard Smith*, Power Publications, Sydney, 2016.
Pearce, Barry, *Arthur Boyd Retrospective*, with contributions by Hendrik Kolenberg, Deborah Edwards, Grazia Gunn, Beagle Press in conjunction with the Art Gallery of New South Wales, Sydney, 1993.
——*Arthur Boyd: Landscape of the Soul*, Bundanon Trust, NSW, 2019.
Peterson, Nicolas, Lindy Allen, and Louise Smith (eds), *The Makers and Making of Indigenous Australian Museum Collections*, Melbourne University Press, Melbourne, 2008.
Philip, Franz, *Arthur Boyd*, Thames & Hudson, London, 1967.
Plant, Margaret, *Love and Lament: An Essay on the Arts in Australia in the Twentieth Century*, Thames & Hudson Australia, Port Melbourne, Vic., 2017.
Pugh, Judith, *Unstill Life: Art, Politics and Living with Clifton Pugh*, Allen & Unwin, Crows Nest, NSW, 2008.
Rich, Margaret, 'The Development of Regional Galleries', in *Understanding Museums: Australian Museums and Museology*, edited by Des Griffin and Leon Paroissien, National Museum of Australia website, 2011.
Rosenberg, Harold, *The De-Definition of Art: Action Art to Pop to Earthworks*, Secker & Warburg, London, 1972.
Scarlett, Ken, *Australian Sculptors*, Thomas Nelson, Melbourne, 1980.
Scott, Sarah, 'A Colonial Legacy: *Australian Painting* at the Tate Gallery, London, 1963', in *Seize the Day: Exhibitions, Australia and the World*, edited by Kate Darian-Smith, Richard Gillespie, Caroline Jordan and Elizabeth Willis, Monash University ePress, Melbourne, 2008.
Smith, Bernard, *Place, Taste and Tradition: A Study of Australian Art since 1788*, Ure Smith, Sydney, 1945.
——*Australian Painting 1788–1970*, Oxford University Press, Melbourne, 1971 (first published 1962).
——*The Antipodean Manifesto: Essays in Art and History*, Oxford University Press, Melbourne, 1976.
——*Noel Counihan: Artist and Revolutionary*, Oxford University Press, Melbourne, 1993.
Spate, Virginia, *Tom Roberts*, Lansdowne, East Melbourne, Vic., 1978.
Stanner, WEH, 'The Great Australian Silence', from *After the Dreaming: Black and White Australians: An Anthropologist's View*, republished in *The Boyer Collection:*

Highlights of the Boyer Lectures 1959–2000, selected and introduced by Donald McDonald,, ABC Books, Sydney, 2001.

Sturgeon, Graeme, *The Development of Australian Sculpture 1788–1975*, Thames & Hudson, London, 1978.

Thomas, Daniel, *Outlines of Australian Art: The Joseph Brown Collection*, 3rd edn, Macmillan, South Melbourne, Vic., 1979 (1st edn 1973).

—— 'Netting the Big and the Little Fish: Monographs and Biographies', *Artlink*, December 2009.

Tonkin, Steve, 'Donald Laycock: Star Cycle', *Art Journal*, 6 July 2017.

Wallis, Geoffrey J, *Peril in the Square: The Sculpture that Changed a City*, Indra Publishing, Briar Hill, Vic., 2004.

Wittman, Richard, *William Frater: A Life with Colour*, Miegunyah Press, Melbourne, 2000.

Wookey, Anne, 'Miller, Godfrey Clive (1893–1964)', Australian Dictionary of Biography, National Centre of Biography, Australian National University, published first in hardcopy 2000.

LIST OF ILLUSTRATIONS

Cover
Andrew Sibley, *Alan McCulloch* 1980, pencil on paper, 54.0 × 44.0 cm, National Portrait Gallery, Canberra, Gift of the artist 2002. Donated through the Australian Government's Cultural Gifts Program © Andrew Sibley/Licensed by Copyright Agency, Australia.

Section I
1. Wilfred McCulloch, *Portrait of Alan McCulloch* c. 1940, charcoal on paper, McCulloch Collection. © Estate of the artist.
2. Wilfred McCulloch, *Heat Haze, Mornington Peninsula* c. 1938–40, oil on board, McCulloch Collection. Photo: Viki Petherbridge. © Estate of the artist.
3. Wilfred McCulloch, *Arthur Boyd* c. 1937, oil on canvas, 72.0 × 57.0 cm, McCulloch Collection. © Estate of the artist.
4. Photographer Unknown, *Artist's camp: Gunnamatta Back Beach* c. 1937, silver gelatin photograph, McCulloch Collection.
5. Alan McCulloch, *Untitled (Gunnamatta, Victoria)* 1944, oil on artist's board, 27.0 × 40.0 cm, McCulloch collection. Photo: Mark Ashkanasy. © Estate of the artist.
6. Alan McCulloch, *Death of Venus* 1940, etching, 11.8 × 12.9 cm, National Gallery of Australia, Canberra. Gift of the artist, 1988. © Estate of the artist.
7. Alan McCulloch, 'Neutrals', *Picture News*, 1940, pen and ink, 44.7 × 17.2 cm, Collection: Art Gallery of Ballarat. Purchased with funds from the Colin Hicks Caldwell Fund. © Estate of the artist.
8. Margaret Preston, *Tank traps* 1943, oil on canvas, 43.0 × 53.5 cm, Mornington Peninsula Regional Gallery, Victoria. Gift of Dr and Mrs CB Christesen. © Margaret Preston/Licensed by Copyright Agency of Australia.
9. Alan McCulloch, *Pirouette – des Pyjamas*, Henry Bucks catalogue 1938, printed pamphlet, McCulloch Collection. Photo: Mark Ashkanasy. © Estate of the artist.
10. Alan McCulloch, *Colonel de Basil* c. 1938, pen and ink, Alan McCulloch Papers, State Library Victoria, Melbourne. © Estate of the artist.

11. Alan McCulloch, 'Whimsical Witch' costume design for *Contes Heraldiques*, Ballet Guild 1946, gouache and pencil on paper, 50.5 × 35.3 cm, State Library Victoria, Melbourne. Gift of Mr Colin Badger, 1993. © Estate of the artist.
12. Alan McCulloch, Witch costume design for *Contes Heraldiques* 1959, gouache and pencil on paper, 47.0 × 65.8 cm, State Library Victoria, Melbourne. Gift of Mr Colin Badger, 1993. © Estate of the artist.
13. Jean Stewart, Noel Murray as 'The Witch', Maxwell Collis as 'Sit Humbolt', Corrie Lodders and Grace McLean as 'Princess' in *Contes Heraldiques*, Victorian Ballet Guild 1946, photograph—production still, 12.0 × 16.5 cm, Victorian Arts Centre Trust, Melbourne. © Victorian Arts Centre, Melbourne.
14. Sybil Craig, *Opening of the Women Painters exhibition by Alan McCulloch* c. 1947, oil on paper, 42.0 × 67.5 cm (sight), State Library Victoria, Melbourne. Purchased with funds from the Sybil Craig Bequest 1998. © Estate of Sybil Craig.
15. Lina Bryans, *Alan McCulloch* 1942, oil on canvas, 38.5 × 37.8 cm, Kerry Stokes Collection, Perth. Photograph courtesy of Kerry Stokes Collection. © Estate of the artist.
16. Alan McCulloch, *New York* 1947, pen and brown ink on spiral sketchpad, Alan McCulloch Papers, State Library Victoria, Melbourne. © Estate of the artist.
17. Alan McCulloch, *Paris* 1948, pen and brown ink on spiral sketchpad, Alan McCulloch Papers, State Library Victoria, Melbourne. © Estate of the artist.
18. Albert Tucker, *Alan McCulloch* 1948, pencil on spiral sketchpad, 34.8 × 27.0 cm, Mornington Peninsula Regional Gallery. Purchased, 1999. © Albert & Barbara Tucker Foundation. Courtesy of Smith & Singer Fine Art.
19. Photographer Unknown, *Alan & Ellen McCulloch in Paris 1948*, photograph, McCulloch Collection. © Estate of the artist.
20. Photographer Unknown, *Alan & Ellen McCulloch on their tandem, Paris 1948*, gelatin silver print, McCulloch Collection. © Estate of the artist.
21. Alan McCulloch, *Positano* 1949, gouache, pencil and pastel on paper, 42.0 × 55.0 cm sight, Collection of Rene White. Photo: Mark Ashkanasy. © Estate of the artist.
22. Alan McCulloch, *Palio di Siena* 1948, gouache, pencil and pastel on paper, 62 × 48 cm, McCulloch Collection. Photo: Viki Petherbridge. © Estate of the artist.
23. Photographer Unknown *Allan, Ellen and Susan McCulloch, Melbourne 1950*, photograph, McCulloch Collection. © Estate of the artist.
24. Susan McCulloch, *Alan McCulloch outside the Whistlewood studio he built in 1951* c. 1957, photograph, McCulloch Collection. © Estate of the artist.
25. Susan McCulloch, *Ellen and Alan McCulloch, and Albert Tucker, Whistlewood, Shoreham* 1961, photograph, McCulloch Collection. © Estate of the artist.
26. Charles Blackman, *The swimmer* 1952, crayon and charcoal on tracing paper, 59.7 × 68.8 cm irreg. (sheet), National Gallery of Victoria, Melbourne. Purchased, 1985. Charles Blackman/Licensed by Copyright Agency, Australia. © Courtesy of the Charles Blackman Family.
27. Charles Blackman, *Man floating* 1953, oil on composition board, 44.5 × 57.5 cm, Private collection. Photograph courtesy of Deutscher and Hackett. Charles Blackman/Licensed by Copyright Agency, Australia. © Courtesy of the Charles Blackman Family.

28. Danila Vassilieff, *Woman with monkey* 1950, Lilydale marble, 35.0 × 18.5 × 15.5 cm, Heide Museum of Modern Art, Melbourne. Bequest of John and Sunday Reed 1982. © Courtesy of Heide Museum of Modern Art, Melbourne.

Section II
29. Joy Hester, *Lovers [II]* [1956], ink and wash, 75.3 × 55.5 cm (image and sheet), National Gallery of Australia, Canberra. Purchased 1973. © Joy Hester/ Licensed by Copyright Agency, Australia, courtesy of the artist's estate.
30. Elwyn Lynn, *Betrayal* 1957, oil on composition board, 91.0 × 121.4 cm, National Gallery of Victoria. Purchased, 1957. © Elwyn Lynn/Licensed by Copyright Agency, Australia, courtesy of Robin Gibson Gallery, Sydney.
31. Albert Tucker, *Lunar landscape* 1957, synthetic polymer paint on composition board, 95.6 × 130.3 cm, Museum of Modern Art, New York. Purchased 1958. Digital image, courtesy The Museum of Modern Art, New York/Scala, Florence. © Albert & Barbara Tucker Foundation. Courtesy of Smith & Singer Fine Art.
32. Mirka Mora, *Self-portraits* (also known as *People*) 1960, enamel and oil on composition board, 61.0 × 137 cm, Private collection, courtesy of William Mora Galleries, Melbourne, and Deutscher and Hackett.
33. Photographer Unknown, *Mirka Mora and Maurcie Chevalier at the Herald Outdoor Art Show, March 1960* 1960, photograph, courtesy of William Mora Galleries, Melbourne, and Deutscher and Hackett.
34. Henry Moore, *Draped seated woman* (1958), bronze, 224.1 × 244.0 × 183.2 cm (overall), National Gallery of Victoria, Melbourne. Felton Bequest, 1960. © Henry Moore/DACS, London. Licensed by Copyright Agency, Australia.
35. Godfrey Miller, *Nude and the moon 1954–59*, oil, pen and black ink on canvas, 61.6 × 104.2 cm, Art Gallery of New South Wales, Sydney. Gift of the Art Gallery Society of New South Wales, 1959. Image courtesy of Art Gallery of New South Wales. © Estate of Godfrey Miller.
36. Gareth Sansom, *He sees himself* 1964, oil and enamel paint, pencil, crayon, polyvinyl acetate, chalk and gelatin silver photograph on composition board, 167.8 × 137.0 cm, National Gallery of Victoria, Melbourne. Presented by the National Gallery Society of Victoria, 1965. © National Gallery of Victoria.
37. Richard Larter, *First Hand Panorama Way* 1970, oil on board, 123.5 × 183.5 cm, Collection: Art Gallery of Ballarat. Purchased with the assistance of the Visual Arts Board, Australia Council, 1977. © Richard Larter Estate, courtesy of Utopia Art Sydney.
38. Richard Larter, 'Letter to Alan McCulloch' 1967, pen and ink, Alan McCulloch Papers, State Library Victoria, Melbourne.
39. Hickey & Robertson, *Aboriginal Bark Paintings from the Cahill and Chaseling Collection*, National Museum of Victoria, Australia. 17 December 1965 – 30 January 1966, Museum of Fine Arts, Houston, courtesy of the Museum of Fine Arts, Houston Archives.
40. Catalogue cover, *Aboriginal Bark Paintings from the Cahill and Chaseling Collection*, 1965. Photo: Mark Ashkanasy. McCulloch Collection.
41. Photographer unknown, *Treasury Fountain Installation 1965–69*, State Library Victoria, Melbourne. Photograph courtesy of Jane Eckett.

42. Norma Redpath, *Treasury Fountain, Parkes ACT Canberra 1965–69*, bronze, Department of Capital Treasury, Canberra. © The artist's estate. Image courtesy of the National Capital Authority.
43. Ron Robertson-Swann, *Vault* 1980, steel, paint, 615.0 × 1184.0 × 1003.0 cm, Commissioned by the City of Melbourne, City of Melbourne Art and Heritage Collection. Photo: Patrick Rodriguez. © City of Melbourne.
44. Ron Robertson-Swann, *Sydney Summer* 1969, acrylic on canvas, 192.0 × 179.0 cm, Transfield Collection, Sydney. © Ron Robertson-Swann/Licensed by Copyright Agency, Australia, courtesy of the artist and Australian Galleries, Melbourne.
45. Donald Laycock, *Wings* 1971, oil on canvas, 181.0 × 202.5 cm, Private collection, courtesy of Charles Nodrum Gallery, Melbourne. © Courtesy of the artist.
46. Sandra Leveson, *Series D – 2D Optics* 1972, oil on canvas, 212 × 212 cm, Araluen Art Collection, Alice Springs. © Courtesy of the artist.
47. Fred Williams, *Upwey landscape* 1956–1966, etching and aquatint, plate 29.9 × 18.5 cm; (oval). sheet 39.0 × 26.2 cm, Mornington Peninsula Regional Gallery. Gift of the artist, 1971. Photo: Mark Ashkanasy. © Estate of Fred Williams.
48. Jenny Watson, *Portrait of Nick* 1977, gouache and coloured pencils paper, 56.7 × 76.2 cm (sheet), Mornington Peninsula Regional Gallery. Gift of the Visual Arts Board, Australia Council, 1984. © Courtesy of the artist and Roslyn Oxley9 Gallery, Sydney.
49. Jan Senbergs, *Port Liardet* 1982, pastel and acrylic on paper, 78.0 × 118.3 cm (sight), Gippsland Art Gallery, Sale. Donated by Georges Australia Ltd, from the Georges Art Prize, 1982. © Jan Senbergs /Licensed by Copyright Agency, Australia, courtesy of Niagara Galleries, Melbourne.
50. Juan Davila, *Bretonism* 1989, colour screenprint, 124.8 × 80.0 cm (image and sheet), Mornington Peninsula Regional Gallery, Victoria. Gift of the artist 1987. © Juan Davila. Licensed by Kalli Rolfe Contemporary Art.
51. Arthur Boyd, *Shoalhaven* undated, oil on board, 44.0 × 59.5 cm, Private collection, courtesy of Menzies Art Brands. © The Arthur Boyd Estate, courtesy of Bundanon.

ACKNOWLEDGEMENTS

SEVEN DECADES OF Alan McCulloch's life and his interaction with the Australian and international art world are preserved in the form of letters, unpublished manuscripts, diaries and notebooks. This raw material formed the basis for countless articles, lectures, speeches, books and the *Encyclopedia of Australian Art*. The archive has also provided the mainstay of my own research, alongside a lengthy fictionalised account of his life, interviews and extended contact with McCulloch's family, friends and former colleagues.

Sensibly, the bulk of Alan McCulloch's papers were acquired by the State Library Victoria in the early 2000s. I am indebted to the SLV for making the material available, over many years. This commenced in 2008, when I was awarded the inaugural (and, sadly, only) Dr Joseph Brown AO Fellowship for art history. The award enabled the necessary time and space to peruse the collection, make copious handwritten notes and gain access to many other texts and manuscripts by McCulloch and his contemporaries. I am grateful to the SLV staff who assisted me in those early days—too many to mention—and to Mornington Peninsula Shire and Mornington Peninsula Regional Gallery colleagues for allowing me to take up such a wonderful opportunity to spend twelve months part-time in the library.

The immediate McCulloch family, daughter Susan, granddaughter Emily and godson Ed Burston, have each played valuable roles in the development of the text and my understanding of Alan McCulloch. I thank Susan McCulloch OAM for inviting me to assume the challenge of writing about her father's work and for encouraging and guiding me along the way. It has been a slow burn, but Susan, and Emily, have supported and nurtured the project over many years. The successful realisation of the book is as much theirs as it is mine.

In a similar vein, I thank Rene White, one of Alan McCulloch's stalwarts at the Mornington Peninsula Regional Gallery (or Mornington Peninsula Arts Centre, as it was known then). Over the years, Rene has also been a good friend and essential for her timely encouragement and personal knowledge of and friendship with Alan.

Art-world colleagues and luminaries have provided a backdrop to the production of this book. Interviews, correspondence and conversations with Lindy Allen, Leigh Astbury, Christabel Blackman, Ivan Durrant, Caroline Field, Sasha Grishin AM FAHA, Rosalind Hollinrake, Lou Klepac OAM, Stephen Miller, Charles Nodrum, Sheridan Palmer, Barry Pearce, Peter Perry OAM, Margaret Plant FAHA, Ron Radford AM, Ken Scarlett AO, Bernard Smith, Bernadette Sullivan, Daniel Thomas AM and Lyn Williams AO have added the necessary texture to the research and writing by providing personal knowledge of McCulloch and his multifaceted art-world personality and dealings.

Melbourne University Publishing and its imprint Miegunyah Press—a great fit for this book given its content and previous role as Australian distributor of Susan McCulloch's Aus Art Editions of *The New McCulloch's Encyclopedia of Australian art* (2006)—have been a writer's dream to work with, especially Duncan Fardon, Louise Stirling and Catherine McInnis. Their professionalism and diligence have been much appreciated. Independent copy editor Eugenie Baulch deserves a special credit for her role in making sense of the text and bringing it to life, literally, while the cover designers

Pfisterer + Freeman are also to be congratulated for their fresh and contemporary design.

On a very practical level, the diversity of the book and its many fine reproductions—something deemed essential in a book about an art critic who loved art and artists—would not have been otherwise possible without the generous response of individuals and institutions to my appeal for image reproduction rights and copyright fee discounts and exemptions. For this I thank: Charles Blackman Family, Estate of Charles Blackman; Eddie Butler-Bowdon and Amelia Dowling, City of Melbourne; Alex Clark, Bonhams; Juan Davila and Kalli Rolfe, Kalli Rolfe Contemporary Art; Chris Deutscher and Ella Perrottet, Deutscher and Hackett; Paul Duldig and Phizz Telford, State Library Victoria; Tony Elwood, National Gallery of Victoria; Robin Gibson, Robin Gibson Gallery; Simon Gregg, Sale Regional Art Gallery; Bradley Hammond, Dennis Tritaris, and Luca and Guido Belgiorno-Nettis, Transfield Holdings; Chloe Jones and Lesley Harding, Heide Museum of Modern Art; Christopher Hodges and Bryan Hooper, Utopia Arts Sydney; Museum of Fine Arts, Houston; Robyn Hovey, Louise Tegart and Ben Cox, Art Gallery of Ballarat; Donald Laycock, artist; Sandra Leveson (Amanda Bilson); Susan McCulloch and Emily McCulloch Childs; Cameron Menzies, Asta Cameron and Jacqueline Boyd, Menzies Fine Art; Nick Mitzevich, Ellie Kate Misios and Monica Tran, National Gallery of Australia; Sarah Murray and Bill Nuttall, Niagara Galleries; Kate and Charles Nodrum, Charles Nodrum Gallery; Estate of Joy Hester; Stuart Purves, Australian Galleries; Ron Robertson-Swann, artist; Mark Rubbo, Norma Redpath Estate and Jane Eckett; Rights and Permissions, Art Gallery of New South Wales; Narelle Russo and Danny Lacy, Mornington Peninsula Regional Gallery; Jan Senbergs, artist; Geoffrey Smith, Albert Tucker Estate/Smith and Singer; Mike Stitfold, Injalak Arts, Gunbalanya; Jennifer Thompson and Rachel Kent, Bundanon Trust, Nowra; Steven Tonkin and Claudia Funder, Arts Centre Melbourne; Jenny Watson and Roslyn Oxley9 Gallery; Lyn Williams, Estate of Fred Williams; Stephen Williamson, Araluen

Art Collection; William Mora Galleries; Sarah Yukich and Kerry Stokes, Kerry Stokes Art Collection; and James and Paul Bryans, the Estate of Lina Bryans.

And for facilitating additional reproductions and photography: Mark Ashkanasy; Sue Beatty, https://taggerty.net/the-story/; Deborah Clark; Adele D'Souza and Philip White, National Gallery of Victoria; Angie McDuff; Phizz Telford, State Library Victoria; Marie Wise, Managing Archivist, Museum of Fine Arts, Houston.

My family circle, close friends and work colleagues have been staunch supporters and launching pads for discussions. I acknowledge: Mark Anderson, Peter Bennett, Wendy Dunstan, Caroline Field, Wendy Garden, Vivien Gaston, Debbie Golvan, Ainsley Gowing, Kirsty Grant, Glen Haffenden, Carol Hedger, Jean and Graeme James, Ryan and Nick James; Paul James; Caroline Jones, Greg and Kerrie von Menge, Alex Prins; Grietscha Prins; Greg Roberts and Ian Reed, Elisa Ryan and Stephanie Trigg and Rowena Wiseman.

Trish James has endured the highs and lows of living with the long-distance researcher and writer, and I thank her for her forbearance and reassurance. Trish has lived this book from the mountain rainforests of Lombok through to the cafe culture of the Amalfi Coast, and everywhere else in between.

And I thank her profoundly and dedicate the book to her.

INDEX

Aboriginal and Torres Strait Islander material culture, 72, 74
Aboriginal art. *See* Australian Aboriginal art
Aboriginal Bark Paintings from Australia exhibition, 160–3
 conservation and presentation for display, 169–70
 launch, 172–3
 negotiations, 163–6
 reception, 173
 selection of works, 166–9
 transportation, 169–70, 172
Abrahams, Christine, 265
abstractionists, 102, 103
Acland Street Gallery, 264
Adam, Leonard, 73, 266
Adams, Tate, 262
Alcorso-Sekers Award, 102
Alice Prize, 234–7
Alice Springs Caltex Art Award, 236
Allen, Mary Cecil, 39–40
Angry Penguins, 43
Annois, Len, 23, 24, 44, 45, 195
Antipodean Manifesto (Smith), 76
Antipodeans, 89, 92–3, 106, 107
Antipodeans exhibition, 75–6
anti-war movement, 209–10
Archibald Prize, Sydney, 98, 101, 125–6

Argus (newspaper), 13, 15, 21, 26–33
Arkley, Howard, 276
Art and Australia (journal), 99, 100, 102, 103, 178, 219–20
art classes, 10–11
Art Gallery of New South Wales, 82, 139, 146, 148, 161, 165, 241
Art Gallery of Western Australia, 261
Art International (journal), 91–6, 100
art patrons, 127–36
art prizes, 225–6, 269–70
 see also names of prizes
Artists of the Australian Gold Rush (McCulloch), 205–7, 286
Artists Unity Congress (AUC), 20–1
Asian art, 72, 148–9
Aspden, David, 94
Atyeo Sam, 11, 48
Australasian (magazine), 21, 26–33, 66
Australia at War exhibition, 29
Australian (newspaper), 86–7
Australian Aboriginal art, 72, 73–5, 99, 106, 141, 168–9, 182, 235–7
Australian Aboriginal Art exhibition, 167
Australian Academy of Art, 31
Australian Artist (magazine), 44–5
Australian Broadcasting Commission (ABC), 210–11
Australian Council for the Arts, 212–16, 247

INDEX

Australian Galleries, 128–30
Australian Gallery Directors Council, 216, 247
Australian Impressionism, 202, 203, 286
Australian Journal, 58
Australian National Advisory Committee for UNESCO, 81, 92
Australian National Gallery, 241–4, 271
Australian Painting (Smith), 183
Australian Painting exhibition, 75, 76, 77
Australians at War exhibition, 29
awards and honours, 265–7
Axiom Gallery, 265

Baily, John, 245
Baldessin, George, 92
Ballarat Gallery, 245, 247, 248
ballet, 21, 22–5
Ballets Russes, 22, 23
Banks, Norman, 55
Bardon, Geoffrey, 235
Barr, Alfred, 40, 45
Battarbee, Rex, 74
Bazaine, Jean René, 151
Beatty, Harold, 18
Bellew, Peter, 81
Benalla Art Gallery, 250
Bendigo Art Gallery, 239
Berkman, Chris, 192
Biennale of Sydney, 72, 277
Bilu, Asher, 229
black and white art, 11–15, 32, 43
Blackman, Barbara, 113, 114, 115
Blackman, Charles, 57, 64, 76, 113–15, 130, 141, 142, 143, 145, 229, 262
Blake Prize, Sydney, 71, 99
Bloomfield, John, 125
Blue poles (Pollock), 242–3
Blumann, Elise, 29–30
Bonython, Kym, 127
Bonython Gallery, Paddington, 234
Booth, Peter, 276
Borovansky, Edouard, 23, 24

Boyd, Arthur, 11, 17, 18, 19, 21, 27, 30, 31, 57, 64, 67–8, 76, 92, 107–8, 123, 135, 143, 145, 150, 151, 196, 259–60, 262, 272–4
Boyd, David, 76, 108
Boyd, Robin, 217
Boyd, Yvonne, 107, 273, 274
Brack, John, 57, 58, 64, 76, 135, 143, 145, 234
Braund, Dorothy, 143
Bromley Moscovitz, Ellen. *See* McCulloch, Ellen (spouse)
Brook, Donald, 95, 100, 101, 102
Brown, Mike, 229
Bryans, Lina, 29
Burdett, Basil, 17, 20, 129, 138
Burke, Joseph, 44, 98, 142, 187, 188–9, 266
Burns, Peter, 131
Burston, Ed, 278
Bush, Charles, 23, 86–7

Cahill, Paddy, 168
Canberra, public sculpture, 223–5
cartoons, 12–13, 14–15, 20, 21, 26–9
Central Desert artists, 72
Central Street Gallery, Sydney, 89, 93, 100, 102
Chagall, Marc, 231–2
Chaseling, Wilbur S, 168–9, 172
Cheshire (publisher), 46, 59–60, 197
Christensen, Clem, 65, 66, 67, 69, 266–7, 279–80
Christensen, Nina, 66, 279
Christo, 126–7
Cité Internationale des Arts project, Paris, 83, 84–6
Clunes Gallery, Sydney, 130
Cohn, Ola, 143
Comalco Invitation Award for Sculpture, 232
commercial illustration work, 12–13, 14–15
Commonwealth Art Advisory Board (CAAB), 77, 85, 215

Contemporary Art Society (CAS), 30, 31, 94, 130–1
Contemporary Painting in Australia (McCulloch), 197–9
Coombs, HC (Nugget), 83, 85
corporate support for the arts, 231–4, 270
Counihan, Noel, 11, 27, 30, 44, 45, 78, 116, 142, 262, 274–5
Craig, Sybil, 143, 144
Crooke, Ray, 233
Cruthers, John, 266
Cusack, Frank, 206

Dargie, William, 11, 235, 236
David, Allen, 57
Davidson, Jim, 267
Davila, Juan, 267–8
Dawson, Janet, 145
de Basil, Wassily, 22
Del Corso, Gaspero, 51
Dent, Aileen, 29
Dickerson, Robert, 76, 130
Dobell, William, 26, 44, 64, 68–9, 135, 136, 156, 234
Dolan, David, 157–8
Douglas, Elizabeth, 192
Draped seated woman (Moore), 70–1
Drysdale, Maisie, 279
Drysdale, Russell, 57, 64, 68–9, 85, 107, 135, 198, 234, 263
Duchamp, Marcel, 39
Durrant, Ivan, 125–6
Dyson, Will, 11–12, 15, 37, 41, 105, 262

early life, 8–9
Edgar, Don, 244
El Greco, 36
Encyclopedia of Australian Art (McCulloch), 55, 92, 120, 198, 255, 256, 286
 challenges to production, 182–7
 critical reception, 187
 reprint, 190–4
 revised editions, 281–2
 vision for, 179–82
environmental activism, 209
exhibitions
 international touring exhibitions, 71, 75–6, 77–9, 90, 138, 140
 see also names of exhibitions
exhibitions of McCulloch's art
 in London, 51–3
 in Melbourne, 56–7, 148, 149–53
 in Sydney, 57–8
 tapestry, 151–3
expressionism, 68–9, 111, 113, 114

Fabinyi, Andrew, 48, 60, 61, 197, 213
Fairweather, Ian, 64, 117, 155, 233
family background, 8–9
Fawkes, Kay, 38
The Field exhibition, 91, 93, 94, 103, 176
Finemore, Brian, 204
Fitzsimmons, James, 92, 93, 94, 95, 96, 234
Flanagan, JR, 12
Flett, James, 11
Flower, Cedric, 28
France, 48–9, 170–1, 253–4
Fraser, Malcolm, 243
Frater, William, 108
freedom of speech, 210–11
French, Leonard, 57, 64, 67, 79, 92, 113, 115–16, 131, 143, 145, 151, 169, 172, 216–17, 262
French Painting Today exhibition, 71
French Tapestries exhibition, 71
Fried, Michael, 95
Friedberger, Klaus, 28
Friend, Donald, 47

Galbally, Ann, 203
galleries
 public galleries. *See* public art galleries
 see also names of galleries
gallerists, 127–36

INDEX

Gallery A, Melbourne, 124
Gallery of Contemporary Art, 127, 128, 130–1
Gardner, John, 74
Garrett, Tom, 30–1
Geelong Gallery, 245, 247
Genre (broadsheet), 44
George, Waldemar, 49, 148–9
Georges Art Prize, Melbourne, 82, 88, 106, 123–4, 226–31, 270
Georges Gallery, Melbourne, 112, 149
Gibson, Aubrey, 245
Gilchrist, Maureen, 270
Gill, TS, 67, 286
Gille-Delafon, Simone, 82
Gleeson, James, 178, 182, 183, 203
Gold Coast City Gallery, 244
The Golden Age of Australian Painting (McCulloch), 201–5, 207, 286
Gorey, George, 236
Gorton, John, 224
government support for the arts, 211–16
Greenberg Clement, 87–90, 95, 103, 150, 230
Grishuna-Hetz, Isolde, 50, 51
Grosz, George, 25, 26, 40–1, 48, 105
Gullifer, Pamela, 250
Gunnamatta artists' camp, 18–19

Haefliger, Paul, 45, 68, 98, 101, 267
Haines, Robert, 244
Hall, Anne, 229
Hall, Bernard, 10
Hamer, Rupert, 155, 212, 277
Hammerstein, Dorothy, 39, 48
Hammerstein, Oscar, 39
Harris, Max, 228, 230
Harrison, WB, 254–5
Heide Museum of Modern Art, 132
Heidelberg School, 196, 284
Hele, Ivor, 157
Helena Rubenstein Prize, 84–5, 99, 100

Henshaw, John, 201, 202, 203
Herald (newspaper)
 art column, 62–5, 70, 73, 74, 76–7, 78, 92
 art exhibitions, 16–19, 106
 art patronage, 137–41
 retirement, 264
 travelogues by McCulloch, 59
Herald Exhibition of French and British Contemporary Art, 16–19, 138, 154
Herald Outdoor Art Show, 127–8, 141–8
The Heroic Years exhibition, 106, 153–8, 206
Hester, Joy, 111–13, 145–6, 276
Hickey, Dale, 91, 102, 143, 229, 233
Highway Forty (McCulloch), 59, 60–1
Hine, Jane, 43, 59
Hoad, Brian, 207
Hodgkinson, Roy, 11
Hoff, Ursula, 46, 47, 203
Hofmann, Hans, 40
Holiday (magazine), 42, 43, 59
Hood, Kenneth, 155
Hook, Jenny, 265–6
Horn, William Austin, 169
Horsley, Edith, 180–2, 186, 190
Horton, Mervyn, 99, 154–5, 219–20
Hughes, Robert, 99, 101, 178, 181, 183, 186
humanism, 103, 105, 185, 275, 276
Humphries, Barry, 143
Huntington, Isabel, 147
Hutchinson Publishing Group, 180, 190, 191–2

Impressionism, 202
International Association of Art Critics (Australian Branch) (AICA), 80–7, 92, 226, 227–8, 265
International Congresses of Art Critics
 Paris, 1948, 49, 80–1
 Paris, 1949, 52–3, 81
internationalist versus regionalist debate, 89, 90–6, 103

Italian Art of the 20th Century exhibition, 71, 139
Italy, 50–2

James, Richard Haughton, 44, 45–6
Jardine, Walter, 12
Johnson, George, 27, 29, 233
Johnson, Michael, 102
Johnstone, Brian, 127
Johnstone, Marjorie, 127
Jones, Barry, 265
Jordan, Col, 102, 233

Kahan, Louis, 66, 67, 117
Kaldor, John, 126, 127, 231
Kaufmann, George, 46, 48
Kemp, Roger, 30, 57, 64, 67, 113, 267, 284
Kempf, Franz, 149–50
Kitching, Michael, 229
Klepac, Lou, 261, 280
Kolenberg, Hendrik, 193
Komon, Rudy, 101–2, 127, 135–6, 149, 267
Kozminsky Galleries, Melbourne, 30–1, 121
Kupka, Karel, 161, 170–2, 174

Lambert, George, 284
Lansdowne Press, 190, 201, 202–3, 205–6
Lansell, Ross, 95, 101–2, 188
Larter, Richard, 185
Laycock, Donald, 143, 233, 234
Leach-Jones, Alun, 189
Leason, Percy, 39
Lebrun, Rico, 36–7
lectures, 61
Lee-Brown, Mitty, 48
Lennie, Yvonne, 21
Leveson, Sandra, 235
Lindesay, Vane, 28
Lindsay, Daryl, 24, 46–7, 240, 243, 245, 246, 251, 252

Lindsay, Joan, 46, 47, 251, 279
Lindsay, Lionel, 16
Lindsay, Norman, 12, 15
London, 52–3
Los Angeles, 36–8
Lovell, Frank, 28
Lynn, Elwyn, 86–7, 94, 99, 100, 102, 138, 188, 236

MacDonald, JS, 17, 26
MacInnes, Colin, 52
MacPherson, KD, 154, 155
Macquarie Galleries, Sydney, 57
Macqueen, Mary, 29
Makin, Jeffrey, 157, 222
Malraux, André, 85, 170, 239, 285
Manyung Gallery, Mt Eliza, 152
Martin, William, 28
Martyn, Laurel, 23, 24, 277
Masterpieces of the National Gallery of Victoria (Fabinyi), 46–8
May Day Art Prize, 142
McCaughey, Patrick, 88, 94, 103–4, 157, 188, 191, 222, 229, 230, 233–4, 265, 282, 283
McClelland, Annie May (Nan), 251–2
McClelland, Harry, 251–2
McClelland Sculpture Park and Gallery, 244, 248, 250–7, 279
McClintock, Herbert, 11
McCulloch (nee Bromley), Ellen (spouse), 42, 49, 55, 209
McCulloch (nee McLeod), Annie, 8–9
McCulloch, Alexander (father), 8–9
McCulloch, Henry (brother), 8
McCulloch, Jack (brother), 8, 9
McCulloch, Susan (daughter), 55, 148, 162, 210, 258, 259, 274, 278, 281
McCulloch, Wilfred, 8, 10, 11, 17, 18, 19, 21, 22, 107, 273, 274
McCullough, Tom, 249
McGilchrist, Erica, 184–5, 284
McGillick, Paul, 93
McGillick, Tony, 102

McGowan, Maidie, 251, 252
McInnes, WB, 10
McNally, John, 162, 170, 175
Meagher, Betty, 152
Meanjin (magazine), 61, 65–70
Melbourne
 City Square, 220–3
 Cultural Centre, 218–20, 240–1, 271–2
 development, 216–18, 271–2
Melbourne Public Library (State Library Victoria), 11
Meldrum, Max, 16
Menzies government, 56, 76
Mildura Arts Centre, 248, 249–50, 258
Millar, Ronald, 150
Miller, Arthur, 37
Miller, Godfrey, 64, 117–20, 146, 155, 185, 201
Missingham, Hal, 198–9
Modern Art News, 69–70
modern art/modernism, 17–19, 30–1, 32, 71, 117–20
The Modern World Encyclopedia, 195–6
Mogensen, Diana, 265
Mollison, James, 242, 247
Moloney, FH, 147
Molvig, Jon, 135, 136
Moomba Festival, Melbourne, 141, 144, 146
Moore, Henry, 70–1
Moore, William, 181, 282, 284
Mora, Georges, 125, 283
Mora, Mirka, 125, 189
Mornington Peninsula Regional Gallery, 49, 277–81
Mornington Penisula Arts Centre (MPAC), 214, 231, 239–40, 244, 257–63, 272
Mortensen, Kevin, 214
Moscovitz, Ellen, *See* McCulloch (nee Bromley), Ellen
Murdoch, Elisabeth, 279
Murdoch, Keith, 35, 48, 138–9

Murdoch, Rupert, 134, 146–7
Murdoch Prize, 134
Musée des Arts Africains et d'Océaniens, 161
Museum of Fine Arts, Houston, 160–1, 169, 172–3
Museum of Modern Art (later MOMAD), Melbourne, 65, 91, 111, 116, 130, 131–2
Museum of Modern Art (MoMA), New York, 132, 165
Myers, Bernard, 49, 97–8, 196–7
Myers, Shirley, 196

Namatjira, Albert, 74
National Capital Development Commission (NCDC), 223–5
National Gallery of Victoria (NGV), 26, 35, 176, 195, 240–1
 exhibitions, 29, 46–8, 91, 94, 119, 146, 232, 241, 270
 Felton bequest, 16, 70
 Ian Potter Centre, 241
 purchases, 32, 70–1, 124, 147, 240, 241, 243, 270–1
 relocation, 218–20, 247
 Travelling Scholarship, 84, 86
National Gallery School, 10–11, 12
National Guggenheim Art Awards, 81
National Museum of Victoria (NMV), 72, 88, 160, 164, 166, 175, 177
Netherlands, 253, 254
New York, 38–43, 48
New York school, 39–40, 88, 275
New Yorker, 42
Newcastle Art Gallery, 261
Nibbi, Gino, 51
Nodrum, Charles, 193
Nolan, Sidney, 30, 31, 51, 64, 107, 108–9, 135, 187, 196, 232, 284
Northern Territory Art Show, 235

O'Brien, Justin, 71
Olsen, John, 90, 99–100, 135, 145, 151

Olympic Games, Melbourne, 1956, 66, 71
Orban, Desiderius, 117
Ostoja-Kotkowski, Joseph Stanislaus (Stan), 57, 58, 144, 267
Overall, John, 223–4

Papunya School, 72, 235–6
Paramor, Wendy, 93
Paris, 48, 109–10
Passmore, John, 64, 98, 117, 157, 184, 198
Peart, John, 102
Peninsula Arts Society, 251
Perceval, John, 76, 129, 143–4, 151, 203, 284
Perth Prize, 226
Peter Bray Gallery, Melbourne, 109, 145
Peter Stuyvesant Trust, 231–2
Philip Morris Foundation, 232
Philipp, Franz, 150–1
Place, Taste and Tradition (Smith), 96, 181, 282, 284
Plant, Margaret, 203
politics and philosophy, 208–11
Pollock, Jackson, 140, 242
Positano, Italy, 50–1
Powditch, Peter, 234
Power Bequest, 100, 138
Power Gallery of Contemporary Art, Sydney, 138
Power Institute, 88, 93, 95, 100, 138, 194, 230
Price, Janet, 205
Priestley, JB, 58
Proctor, Thea, 187
public art galleries
 national and state institutions, 240–1
 public art gallery movement, 238–40
 regional galleries, 215, 234–5, 239–40, 244–50, 281
Pugh, Clifton, 76–7, 115, 200, 214
Purves, Anne, 127, 128–9, 157, 272–3
Purves, Thomas (Tam), 127, 128–9

Quartermaine, Peter, 207
Queensland Art Gallery, 243–4

Radford, Ron, 247
Rapotec, Stanislaus, 145
Redpath, Norma, 223
Reed, John, 65, 91, 108, 111, 127, 130, 131, 132, 283
Reed, Sunday, 65, 132, 283
Reed, Sweeney, 136
regional art galleries, 215, 234–5, 239–40, 244–50, 281
Regional Galleries Association of Victoria (RGAV), 245–6, 277, 281
regionalist versus internationalist debate, 89, 90–6, 103
Reinhardt, Ad, 275
Rich, Margaret, 247
Richman Gallery, Melbourne, 122–3
Richmond, Oliffe, 50, 52
Roberts, Tom, 196, 203
Robertson-Swann, Ron, 222, 234
Rogers, Ken, 250
Rooney, Robert, 102, 123, 229
Rootsey, Joe Alimindjin, 74
Rowan, Alice, 165, 268
Rowell, John, 10, 24, 252
Rowlinson, Eric, 247, 271
Russel, Caroline, 40
Russell, John, 40
Ryan, Susan, 215
Rylah, Arthur, 165, 166

San Francisco, 35–8
Sansom, Gareth, 123–5, 229–30
Scarlett, Ken, 194
Schonbach, Fred (Fritz), 25, 28
School of Paris, 18, 49, 88, 198
Sedon Galleries, Melbourne, 16
Senbergs, Jan, 92, 123, 262, 279, 281, 284
Shannon, Michael, 232
Sharp, Jim, 144–5
Shepparton Art Gallery, 248, 250
Shore, Arnold, 144

INDEX

Sibley, Andrew, 101
Sime, Dawn, 78–9, 188
Sime, Ian, 132–3
Skinner, Joe, 127, 133, 157
Skinner, Rose, 127, 133–4
Skinner Galleries, 133–4, 152
Smart, Jeffrey, 157
Smith, Bernard, 32, 68–9, 76, 83, 84, 86, 87, 92, 95–6, 178, 181, 183, 194, 199, 230, 282, 283, 284
Smith, Colvin, 18, 19
Smith, Terry, 93, 94, 95, 100
Smith's Weekly, 13
South Yarra Gallery, 124
Southern, Clara, 205
Spate, Virginia, 203
Spencer, William Baldwin, 72, 160, 166, 168, 171, 176, 177, 268
Spencer Collection, 13, 72, 88, 160–3, 176, 177
 see also Aboriginal Bark Paintings from Australia exhibition
St Georges Gallery, London, 52–3
Stanley Coe Gallery, Melbourne, 56
Stokes, Constance, 29, 30, 262
Streeton, Arthur, 203
Strines Gallery, Melbourne, 136
Stuart, Guy, 233
Sturgeon, Graeme, 155, 194
Sullivan, E, 13
Sumner, Alan, 23
Sutherland, Jane, 205
Sweeney, JJ, 82, 92, 160–1, 162, 163–4, 167, 172, 173, 224, 229, 242
Sydney Biennale, 72, 148
Sydney Opera House, 66, 83
Szeemann, Harald, 95, 230

Tanner, Edwin, 214
tapestry, 71, 151–3
Tasmanian Museum and Art Gallery, 262
Tate Gallery, London, *Australian Painting* exhibition, 75–6, 77–9
Teague, Violet, 74

television programs, 61, 98, 183
theatre, set design, 23–4
Thomas, AK, 62–3
Thomas, Archer, 141
Thomas, Daniel, 82, 188, 228, 229
Thomas, Laurie, 98–9, 101, 112, 146, 187
Thomson, Gordon, 138, 185
Thorne, Gwendolyn, 279
Thornton, Wallace, 81, 82
Thorpe, Lesbia, 116
Tillers, Imants, 276–7
Tjampitjinpa, Kaapa, 236
tjurunga, return of, 268–9
Tolarno Galleries, St Kilda, 125, 276
Town, Donald, 18
Traill, Jessie, 74
Transfield Art Prize, 102, 234
Travelodge Prize, 232–4
Trial by Tandem (McCulloch), 49, 59, 60
Tucker, Albert, 27, 30, 31, 48, 49, 51, 53, 64, 81, 107, 109–11, 196, 199–201, 284
Tuckson, Tony, 167, 241
Turnbull, Clive, 90, 246
Turner, JMW, 243, 271
Two Decades of American Painting exhibition, 90, 140
Tye's Art Gallery, Melbourne, 108

UNESCO, 81–2, 88
Upton, Robert, 136
Ure Smith, Sydney, 16
Utzon, Jorn, 66, 83

Vassilieff, Danila, 30, 116, 143
Venice biennale, 50
Victorian artistic and cultural life, McCulloch's contribution, 283–7
Victorian Artists Society (VAS), 44–6, 75–6
Victorian Public Galleries Group, 245
Vike, Harald, 23, 27, 52
Visual Arts Board, 213, 216, 245, 265
Voss Smith, Len, 243

INDEX

Wallace-Crabbe, Chris, 123
Warren, Alan, 150
Warrnambool Gallery, 248, 250
Watkins, Dick, 233
Webb, Donald, 245
Westbrook, Eric, 71, 155, 165, 213, 222, 240, 245, 246, 252
Western Port, 209
Whisson, Ken, 120–2, 143
'Whistlewood,' Shoreham, 55, 114, 118
White, Sam, 48
Whiteley, Brett, 135
Whitlam, Gough, 206–7, 211, 212, 280

Williams, Fred, 92, 135, 145, 228, 262, 265, 284
Winter, William, 59, 210
World War II, 19–22
writing and editing
 art column for *Herald*, 62–5
 essays, 61, 67, 92–3, 95
 first start, 25–6
 travelogues, 49, 58–61
 see also names of publications
Wynne Prize, Sydney, 98

Young, Elizabeth, 81

THE MIEGUNYAH PRESS

This book was designed and
typeset by Cannon Typesetting
The text was set in 11¼ point Berthold Baskerville Book
with 16 points of leading
The text was printed on 80gsm uncoated woodfree
This book was edited by Eugenie Baulch